Pleasing Everyone

Pleasing Everyone

MASS ENTERTAINMENT IN RENAISSANCE LONDON
AND GOLDEN-AGE HOLLYWOOD

Jeffrey Knapp

OXFORD
UNIVERSITY PRESS

OXFORD
UNIVERSITY PRESS

Oxford University Press is a department of the University of Oxford.
It furthers the University's objective of excellence in research, scholarship,
and education by publishing worldwide. Oxford is a registered trade mark of
Oxford University Press in the UK and certain other countries.

Published in the United States of America by Oxford University Press
198 Madison Avenue, New York, NY 10016, United States of America.

Library of Congress Cataloging-in-Publication Data

Names: Knapp, Jeffrey (Professor of English) author.
Title: Pleasing everyone : mass entertainment in Renaissance London
and golden-age Hollywood / Jeffrey Knapp.
Description: New York : Oxford University Press, 2017.
Identifiers: LCCN 2016027980| ISBN 9780190634063 (hardback) |
ISBN 9780190634087 (epub) | ISBN 9780190634094 (online content)
Subjects: LCSH: Theater—England—London—History—16th century. |
Theater—England—London—History—17th century. |
Theater and society—England—London—History—16th century. |
Theater and society—England—London—History—17th century. |
Motion pictures—United States—History—20th century. |
Motion pictures—Social aspects—United States. |
BISAC: ART / Film & Video. | PERFORMING ARTS / Film & Video /
History & Criticism. | LITERARY CRITICISM / Shakespeare.
Classification: LCC PN2596.L6 K647 2017 | DDC 792.09421/0903—dc23 LC record
available at https://lccn.loc.gov/2016027980

1 3 5 7 9 8 6 4 2
Printed by Sheridan Books, Inc., United States of America

To
Dori and Maddie
and
James and Sam

CONTENTS

Acknowledgments ix

Introduction **1**

PART 1: **The Individual and the Mass**

1. Which Moll? **47**

2. The Real John Doe **67**

PART 2: **Show Business**

3. I Must Be Idle **95**

4. One Step Ahead of My Shadow **112**

PART 3: **Junk and Art**

5. Mocked with Art **147**

6. Throw That Junk! **165**

Epilogue: The Author of Mass Entertainment **197**

Coda: A Second Look **228**

Notes 235
Works Cited 269
Index 287

ACKNOWLEDGMENTS

It's wonderful to have this chance to thank the many friends and colleagues who helped me write this book. At several stages throughout the process, Oliver Arnold, Victoria Kahn, and D. A. Miller boosted my spirits and gave me superb advice. I'm extremely grateful to them, as well to my colleagues at *Representations* and in the Early Modern Working Group at Berkeley; to my students, especially the brave souls who took my first graduate seminar on mass entertainment; and to Mark Goble, Stephen Greenblatt, Jesse Knapp, and Nancy Ruttenburg. I received expert assistance from the staff at the Margaret Herrick Library, the Wesleyan Cinema Archives, and the Cinematic Arts Library and Warner Bros. Archives of the University of Southern California. Jesse Cordes Selbin was a truly extraordinary research assistant; Wendy Xin and Aileen Liu were a great help with proofreading. My thanks to Brendan O'Neill for his faith in my project, and to Norman Hirschy for seeing me through; it was a pleasure to work with Stephen Bradley, Andrew Ward, and Amy Whitmer as well. My audiences at the University of Chicago, the CUNY Graduate Center, Caltech, Columbia, Yale, King's College London, and Berkeley made an enormous difference to my thinking about this book. And I'm deeply indebted to the University of California, Berkeley, for the research support I received first from a Chancellor's Professorship and then from the Ida Mae and William J. Eggers, Jr. Chair in English.

I would never have begun this book, let alone completed it, without the indefatigable encouragement and support of James Schamus and Samuel Otter. I dedicate the book to them, and to the two lights of my life: Dorothy Hale, always my first and best reader, and Madeline Hale, who just might read this one.

Pleasing Everyone

Introduction

> Nothing contrasts more starkly with a work of art
> completely subject to (or, like film, founded in)
> technological reproduction than a stage play.
> Any thorough consideration will confirm this.
>
> —Walter Benjamin, *"The Work of Art in the Age of*
> *Its Mechanical Reproducibility"*

For most writers on the subject, "Shakespeare and film" means Shakespeare *in* film: the plays adapted to the screen.[1] The imprecision confuses no one because the alternative meaning of comparing Shakespeare *to* film seems to make little obvious sense. What substantive connection could there possibly be between two media so technologically different and historically distant from one another as sixteenth-century theater and twentieth-century cinema? But the connection turns out to be a surprisingly strong one, and it is consequential for more than our understanding of the theater and the cinema, because Renaissance plays and Hollywood movies share an identity that our current theories of modernity and mass culture do not allow them to share. At every level of artistic content, in plot, characterization, and theme, both the drama and the film were designed to meet the same formidable demand: they were both intended to please a mass audience.

Three-quarters of a century ago, this claim seemed less implausible than it now appears to be. In his influential book *Shakespeare's Audience* (1941), the theater historian Alfred Harbage argued that the original audiences of Shakespeare's plays were just as "universal"—that is, just as "socially, economically, [and] educationally heterogeneous"—as "the moving-picture clientele" of Harbage's own day. A few years later, in his

equally influential *Shakespeare and the Popular Dramatic Tradition* (1944),
S. L. Bethell drew on modern film as well as Renaissance drama to analyze
"the essential psychology of the popular audience." And yet both scholars
ultimately shied away from the cross-historical "parallel" they invoked.
"The analogy between the modern movies and the Elizabethan theater,"
they decided, was "in many ways a poor one," and the shortcomings were
all on the side of film. According to Harbage, modern developments in
technology and "salesmanship" had rendered film audiences more passive
and powerless than their Renaissance counterparts. Bethell went further:
"modern popular entertainment" was not only "more calculatedly com-
mercialized" than Renaissance drama but also "depraved in values, super-
ficial in ideas, false in sentiment, and insensitive to the quality of words."
For both critics, in other words, the fundamental problem with comparing
Shakespeare to film was the perceived disparity in artistic merit between
them—even though every one of Bethell's charges against movies had fig-
ured prominently in Renaissance attacks on plays, as I'll soon show.[2]

Only in recent years have the comparative projects of Harbage and
Bethell been revived in earnest.[3] The first important new work on the
subject was Michael Bristol's *Big-Time Shakespeare* (1996), which, how-
ever, offered no reassessment of film's artistic value: Bristol, too, expressed
contempt for "the frenzied environment of commercial popular cul-
ture," "where hyperactivity and distraction are preferred to the more
difficult pleasures of traditional literature." What inspired Bristol to treat
Shakespeare and film as related forms of "show business" was instead a
perceived narrowing of the *historical* gap between them. Most Renaissance
scholars now characterize the period they study as "early" modern, and
Bristol consequently defined Renaissance drama as an early version of
modern mass entertainment. "Shakespeare's durable popularity," he
maintained, reflected "the success of the culture industry" that *began*
"in urban centers like London in the latter part of the sixteenth cen-
tury."[4] Yet for all its explanatory appeal, the claim of Shakespeare's
relative contemporaneity with our own era has many obvious limita-
tions, too—his drama has nothing to say about automobiles, for
instance, or electricity, or corporations—and most theater historians
would therefore agree with Harbage and Bethell that modern commer-
cial and technological innovations in particular constitute an impass-
able historical barrier between Shakespeare and film. By calling the
Renaissance theater mass entertainment, I don't mean to make a broader
historical claim than these other theater scholars do; I'm not arguing
that Renaissance drama belongs to the same *longue durée* as film does.
In my view, it's not the modernity of the sixteenth-century theater that
links it so powerfully to twentieth-century cinema: it's the audience, the
mass audience.[5]

When Bristol and others define Shakespeare's theater as a rudimentary form of the modern culture industry, they do more than downplay the historiographical objections to their approach. They also deny the theater the status of a fully developed mass entertainment in its own right, and as a result, they tend to overlook just how revelatory the modern commentary on mass entertainment can be when it is applied to Renaissance plays as well as modern films. To take advantage of the insights such commentary yields, I'll draw throughout this book on the theorists of film who produced their most influential work during cinema's own classical period: the Anglo-American writers Gilbert Seldes, Iris Barry, Robert Sherwood, and Paul Rotha, for instance, along with such Frankfurt School writers as Walter Benjamin, Theodor Adorno, Max Horkheimer, and Siegfried Kracauer. For decades now, the study of mass entertainment has been anchored in the work of the Frankfurt School, and for that reason I'll pay special attention to this group of theorists, particularly to the debates between the pro-cinematic Walter Benjamin and the anti-cinematic Theodor Adorno. Where Benjamin celebrated the power of mass entertainment to promote equality, to build community, to demystify art, and to make it accessible to all, Adorno accused mass entertainment of deceiving, exploiting, and debasing its audiences. Both positions, I'll argue, are major preoccupations in the plays and movies I discuss.

So probing, indeed, are these plays and movies on the subject of mass entertainment that they illuminate as much in the theoretical literature as the literature illuminates in them. Too often, the Frankfurt School thinkers have been allowed to overshadow the works they have been called upon to elucidate, as if the ability to conceptualize mass entertainment depended on a high-theoretical detachment from it. Adorno, for one, was not as removed from the culture industry as his criticism might indicate: he socialized with Hollywood luminaries, read scripts for the director William Dieterle, and even pitched a film project to Jack Warner and Dore Schary.[6] Nor did the Frankfurt critics devise their theories ex nihilo. They offered unusually sophisticated and compelling elaborations of views that were widely held in the culture at large and that were disseminated through such mainstream media as film. Movies did more than merely transmit these views, however; they also helped formulate them. In every chapter of *Pleasing Everyone*, I'll pursue detailed readings of individual plays and movies in order to show how these works often analyze mass entertainment with greater shrewdness and ingenuity than many modern theorists bring to the question.[7] In part, this self-conceptualizing power of plays and movies depends on the intellectual flexibility that fictional license provides them. But I also want to argue, against the detractors of mass entertainment, that the

ambition to please a large heterogeneous audience can have a compli-
cating rather than reductive effect on entertainments. Scholars often
take this point for granted in relation to Renaissance drama, without
recognizing its implications for film. Writing around the same time as
Benjamin and Adorno, Harbage declared that the breadth of Shakespeare's
audience "compelled" breadth in him, and justified it, too. "The subtle-
ties missed by one" playgoer were "not missed by his neighbor," Harbage
maintained; "Shakespeare's meanings" were instead "caught in the mesh
of a thousand minds."[8]

But if mass entertainment is as cross-historical a phenomenon as
I claim it is, why match film with Shakespearean drama in particular,
rather than with any other form of mass entertainment? During the
Renaissance itself, writers frequently compared the vast theater audi-
ences of their day to classical antecedents. For instance, Philip Massinger
begins *The Roman Actor* (acted 1626) by situating his play in the theatri-
cal tradition first of Greek tragedy and then of Roman drama—per-
formed, as the title character declares, in an "Amphitheater" that "hath
giv'n full delight / Both to the eye, and ear of fifty thousand / Spectators
in one day." In 1633, the theater-hating William Prynne linked his charge
that "the whole City" is regularly drawn "to a Play-house" with "the
Poet *Juvenal*'s complaint of old": "*Totam hodie Romam Circus capit,*"
"the Circus holds all of Rome today." According to Horace in Ben
Jonson's 1604 translation of the *Ars Poetica*, the only time in theater
history when the "seats" were "not yet / So over-thick, but, where the
people met, / They might with ease be numbered" was the immemorial
past.[9] My purpose in focusing on the connections between Renaissance
drama and modern film is not at all to deny the existence of mass enter-
tainment in other times or places.[10] On the contrary, I hope that my
research might prompt other scholars to explore different mass enter-
tainment linkages than the ones I address here. Ease of comparison has
led me to confine myself to works in English, and I've focused on
Renaissance drama rather than on later material such as the nineteenth-
century British novel so that any correlations with film will be less read-
ily attributable to historical proximity. But the lofty status accorded to
Renaissance drama in our own time also gives it a special power to
broaden our conception of related entertainments such as film by
enhancing the artistic credibility of works designed to please everyone.
Admittedly, some recent theorists of mass entertainment are already so
confident about its artistic merit that they drop the term "entertain-
ment" altogether and refer to film as "mass art," but that characteriza-
tion narrows film in its own way, by disregarding the fundamentally
uneasy relation of mass entertainment to art.[11] Though few would now
scoff at calling Shakespeare's plays art, many would have done so during

Shakespeare's lifetime. Associating Renaissance drama with film broadens our conception of the drama, too, by helping us recognize the often self-confessed cheapness and vulgarity in Renaissance plays that their current cultural prestige belies.

Within the history of the theater and the cinema, I've singled out two comparably transformative periods when the makers of plays and movies understood that they were addressing a newly expanded audience. In each case, the change galvanized the enemies as much as the advocates of the entertainment in question. I concentrate on the decades of Renaissance English drama that are widely considered its heyday, the 1590s to the 1610s, when the drama took full advantage of a technological innovation that had been instituted a decade or so earlier: the construction of England's first amphitheaters, which made possible a regularly returning mass audience. For some contemporaries, this new environment for theater lifted English drama to heights that few had ever imagined it could reach: in 1599, the poet Thomas Weever proclaimed that London's playwrights, actors, and playhouses now rivaled or else surpassed their ancient Roman counterparts.[12] At the same time, many other contemporaries viewed the multitudes "swarming on every side" to plays as marking a new cultural low. So open, accessible, and unrestrained had entertainment become in the theaters, one critic lamented in 1587, that "a man may buy his damnation there for two pence."[13] In my discussions of film, I've similarly chosen to focus on a period that is now regarded as a golden age: Hollywood from the late 1920s to the early 1940s. During these decades, too, the cinema increased its viewership by embracing a technological innovation, talking pictures, that both raised and lowered film's reputation. It was in 1935 that the Museum of Modern Art opened its Film Library, dedicated to the "art" of the movie "you see every time you go to a motion picture house"—to the art, that is, of "the commercial product mainly and chiefly."[14] Yet talking pictures also provoked charges that film had vulgarized itself beyond redemption; even movie-lovers such as the British filmmaker and critic Paul Rotha declared in 1930 that the talkies were "harmful and detrimental to the culture of the public."[15]

The emphasis I'm placing on periods of technological change might seem to be at odds with my insistence that the audience is the bottom line for mass entertainment. By arguing for the primacy of audience over technology, however, I am not opposing one factor to the other. A technology can help assemble a mass audience; it can even make possible a mass audience that would not be able to assemble without the technology; and it surely influences the design of the entertainment that it disseminates to the audience. But a mass audience requires no specific technology in order to be assembled; in some cases it requires no technology at all; and it's for the audience, not the technology, that the entertainment

is devised in the first place. The dominant argument against characterizing Renaissance drama as mass entertainment takes the opposite view: that mass entertainment could not begin until modern technologies made possible the mass production and distribution of entertainment. In the remaining sections of the introduction, I'll first examine this belief in technology as the defining issue for mass entertainment. Next, I'll take a closer look at some of the chief historical as well as technological differences between Renaissance drama and Golden Age film that theorists assume must stand in the way of regarding these plays and movies as comparable modes of mass entertainment. I'll then highlight three crucial issues from the modern commentary on mass entertainment that I'll be using throughout my book as a means of comparing the drama and film, and I'll briefly expand on these issues by showing how they figure in three late silent pictures. Finally, I'll end the introduction by outlining the structure of my book and then summarizing each of its chapters.

Technology vs. Audience

In "The Work of Art in the Age of Its Technological Reproducibility," an essay that he drafted and redrafted throughout the 1930s, Benjamin treats mass entertainment as the unprecedented consequence of twin technological "processes" that have shattered all the traditional theories and practices of art. The first of these processes, Benjamin argues, is the mechanical reproduction of artworks, which replaces their "unique existence" with "a mass existence" of copies. The second process is the mass distribution of the copies, which allows "the reproduction to reach the recipient in his or her own situation." For Benjamin, the "most powerful agent" of both processes, and thus the definitive form of the entertainment they generate, is the incontrovertibly modern medium of film.[16]

To begin, it makes sense to weigh Benjamin's technocentric account of mass entertainment on its own terms and ask why the technological preconditions of mass production and distribution had not already been met hundreds of years before the invention of film, with the advent of print. While Benjamin acknowledges "the enormous changes brought about in literature by movable type," he does not consider print to be a "truly revolutionary means of reproduction," nor does he allow that it generated any literary form of mass entertainment. "Film," he argues in the second version of his "Work of Art" essay (1936), "is the first art form whose artistic character is entirely determined by its reproducibility." Benjamin's admirer Alain Badiou (2005) echoes this claim when he calls film "the first great art that is mass *in its essence*."[17] But print is just

as reproducible as film: before digital media, indeed, the publishing industry often issued more copies of individual books than the film industry produced of individual films. Conversely, mass reproduction is no less contingent a feature of film than it is of print. If it were an essential element, as Badiou claims, then a film could not count as a film unless it were mass-reproduced.

Even theorists who more fully credit print as a technological breakthrough share Benjamin's resistance to granting the title of mass entertainment to any medium earlier than film. In his *Philosophy of Mass Art* (1998), for example, the film theorist Noël Carroll asserts that "mass art" did indeed "develop in tandem with the onset of the printing press," but he repeatedly introduces a time lag to this synchronism that betrays his merely nominal interest in any "mass art which pre-dates our current age of mass culture." "The printing press," he writes, "made possible the *emergence* of *early* forms of mass art, such as the novel"; as the language of nascency suggests, Carroll relegates the novel to the prehistory of genuine mass entertainment, as one of "the first *potentially* mass-art forms." Under pressure, Carroll is "willing to bite the bullet" and allow that, by his own lights, "eighteenth-century novels of the gothic variety" must also count as mass art, but he never explains why mass art had to wait three centuries after "the onset of the printing press" before these "early forms" of it could first emerge.[18] Like Benjamin, Carroll downplays print because it undermines the historical uniqueness for modern mass entertainment that his technological theory is intended to secure. Carroll's explicit goal in *A Philosophy of Mass Art* is to define mass entertainment in such a way as to distinguish "the relevant popular art of our times from popular art construed ahistorically." Hence his investment in the technology of a "mass delivery system," which "commands our attention once we try to differentiate the kind of art people are attempting to characterize in debates about contemporary art." But since he concedes that "printing" was "the first major" mass delivery system "to emerge in the West," Carroll is forced to add a further technological criterion to the mix and argue that a piece of entertainment cannot count as mass art unless it has been distributed by the same "power technologies" that fuel "the routine, automatic, mass production of multiple instances of the same product." From the start, the printing press routinely mass-produced multiple instances of the same product, which were then widely distributed; why did this production and distribution have to become "automatic" before mass entertainment could occur? Carroll's answer: to make "the discussion" of mass entertainment "a pressing one for our century."[19]

Yet even the restriction of mass entertainment to an electrically powered production and distribution system has its limits in helping Carroll

differentiate mass entertainment from other art forms. As he himself points out, "esoteric art" may also be "technologically distributed," but that distribution does not by itself turn such art into mass entertainment. To address this complication, Carroll must demote technology from its starring role as "*the* significant feature" of mass entertainment and promote the intended audience instead. "Mass art," he declares, "is art that is designed to be consumed by lots and lots of people. That is why it is produced on such a large scale and distributed by mass technologies." But "lots and lots of people" consumed art before film came along. To make mass entertainment seem unprecedentedly modern even when a large audience is its deciding feature, Carroll must define a mass audience as so numerous and far-flung that they can be reached only through the distributive mechanism of "power machinery": by "lots and lots of people," he means "consuming populations" who "cross national, class, religious, political, ethnic, racial, and gender boundaries." Yet printed books crossed such boundaries centuries before movies did. Within a few years of its initial publication in 1605, *Don Quixote* was being sold throughout Europe in translations as well as Spanish-language versions; some copies even made their way to Peru.

The crucial difference, for Carroll, is the *size* of the audiences that *Don Quixote* reached in its own day: thousands, not the millions who watch movies. "Scale," as Carroll rightly insists, is an "utterly relevant" standard for defining mass entertainment; if it were not, then the very notion of distinguishing a specifically "mass" form of entertainment would be meaningless.[20] But why must the benchmark for mass entertainment be *millions* of consumers? What categorical difference do these millions make, aside from a historical one? According to Badiou, who thinks of cinema as "a mass art on a scale that brooks no comparison with any other art," not even millions is a number large enough to distinguish the audiences for film from the audiences for print. "In the nineteenth century," he notes, "there were writers of the masses, poets of the masses," such as "Victor Hugo in France" or "Pushkin in Russia," who "had, and still have, millions of readers." Consequently, Badiou believes that *many* millions are needed to differentiate "the scale" of Hugo's and Pushkin's popularity from "that of cinema's greatest hits."[21] Carroll takes Badiou's premise still further: only works that aim to reach "the *largest possible* audience" he argues, should be classified as mass art.[22] But since no artwork has ever reached the largest possible audience, it's hard to distinguish one entertainment from another on this basis, and if we instead take Carroll's "largest possible" to mean the largest audience that circumstances allow, then the largest possible audience might be one or two people, not a mass. These problems with Carroll's formulation suggest that it makes better sense to define a mass

audience in terms of minimum rather than maximum requirements. And that is how I define it throughout this book: as an audience large enough to seem indefinite in social composition as well as size—the sort of audience, again, that printed books reached centuries before film.

Carroll himself is not entirely convinced that the *actual* size of the audience ultimately matters. Just as a work intended for the few remains "esoteric" even when it is widely distributed, so, Carroll maintains, an entertainment "may be a work of mass art even if it is a bungled attempt" at entertaining the masses. "As long as it can be established that the work in question was intentionally designed to be generally accessible, even if it is not, it still counts as a work of mass art."[23] According to this argument from design, in other words, the audience that defines a work as mass entertainment is a notional entity: an entertainment should count as mass entertainment when it has been *conceived* for a mass audience. There's no question that, in making it possible to address larger audiences than ever before, modern technological developments encouraged the production of works that were specifically intended "to elicit mass engagement," as Carroll puts it. But the technology did not create the desire for such engagement, nor would technological limitations have kept earlier entertainers from aspiring to reach mass audiences.[24] In 1632, Shakespeare's contemporary Thomas Heywood boasted that an earlier play cycle of his had "at sundry times thronged three several Theaters, with numerous and mighty Auditories." Carroll worries that broadening the category of mass entertainment to include such precinematic crowd-pleasers would only obscure the "historical specificity" of the phenomenon; I hope to demonstrate instead that Renaissance plays help sharpen our focus on mass entertainment by disentangling it from modernity.[25]

Many of these plays, it is important to keep in mind, were not merely theatrical events: they also drew on the mass-distributive technology of print. Books were often the sources of plays, and plays themselves often became books.[26] "During Shakespeare's lifetime," as Lukas Erne has reminded us, "*The First Part of Henry IV* would not only have been watched by a great number of spectators, but also read by all those who bought the printed playbooks that appeared in no fewer than six editions." Print thus gave drama the ability to satisfy both of Benjamin's technological preconditions for mass entertainment: a play could be reproduced in multiple copies, and those copies could meet the consumer in his or her own situation. This always potential second life for a play meant that print was never far from the consciousness of dramatists. As Erne observes, Shakespeare "could not help knowing that his plays were being read and reread, printed and reprinted, excerpted and anthologized as he was writing more plays."[27]

But many Renaissance commentators also regarded the theater as a mass delivery system of its own, comparable to print rather than subsidiary to it. A 1551 proclamation by Edward VI singled out "Players of Interludes" alongside "Printers" and "Booksellers" for disturbing "the quiet of the realm"; the authorities often regarded playing as no less effective than printing at "spreading" trouble.[28] In the 1563 edition of his *Acts and Monuments*, John Foxe took the side of the troublemakers and praised "players" as well as "Printers" and "Preachers" for constituting "a triple bulwark, against the triple crown of the Pope, to bring him down."[29] These testaments to the reach of this sort of entertainment, which could be repeated, revived, and taken on tour, preceded the construction of amphitheaters on the outskirts of London that were capable of holding thousands of playgoers at a time. Shortly after the first of those amphitheaters opened in 1576, the preacher John Northbrooke spoke of plays as "now" being "universally" performed "amongst us," and for decades afterward contemporaries marveled at the crowds who would "flock" or "press" or "throng" to plays, stuffing the theaters "so full" that they seemed to "crack" with the strain.[30] These were no ordinary gatherings, the theater-hating Prynne insisted in 1633: audiences "swarm so thick in every Play-house," he claimed, that they "almost crowd one another to death for multitude."[31]

Modern commentators prefer to think of the throngs in Renaissance theaters as "popular" rather than "mass" audiences. But in Renaissance usage the term "popular" was strongly class-coded: it signified the common people, as opposed to the "better sort" of gentlemen and aristocrats. To call Renaissance audiences popular, then, is to imply that they were restricted to the common people, whereas contemporaries regularly bore witness to the social heterogeneity as well as the size of the crowds at plays. "Truly you may see daily what multitudes are gathered together at those Plays, *of all sorts*," Northbrooke observed. "At a new Play," wrote another author in 1609, the theater can be seen to "swarm with *Gentiles* mix'd with *Grooms*." According to Sir John Davies in 1594, "a thousand townsmen, gentlemen, and whores, / Porters and servingmen together throng" at plays. Playwrights often boasted of their ability to win "grace / In the full Theater," but they also often complained about the social divisions in the amphitheaters especially, where a genteel spectator could find himself "choak'd / With the stench of Garlic" or "pasted / To the barmy Jacket of a Beer-brewer."[32] How were all the different interests and demands of these "promiscuously" mixed assemblies to be met? "Neither quick mirth, invective, nor high state, / Can content all," laments the prologue to John Day's 1606 *Isle of Gulls*: "such is the boundless hate / Of a confused audience." Day's expectation of trouble for his play suggests not only that he had experienced the

discordancy of "confus'd applause" in "a full-throng'd theater" but also that he had written his play with the possibility of such a mixed reception in mind.[33]

Mass audiences were indeed so conventional a feature of commercial Renaissance drama that playwrights assumed their presence even in their absence. "For all the period's references to 'the multitude' or 'ten thousand spectators' or 'Throng'd heapes'" at plays, the theater historian Paul Menzer has recently asserted, "early modern actors, far more often than not, surveyed half-empty houses from the lip of the stage."[34] It was of course commercially advantageous for theater people to pretend that everyone was going to plays all the time, so that no one would want to miss out. And it made equally good business sense to persuade theatergoers that the best way to see a play was in a throng of other spectators. As Menzer puts it, in the slightly paranoid terms that often appeal to critics of mass entertainment, "players, playwrights, and playhouses colluded to give the crowd a domesticated experience of itself." Theaters, indeed, made mass audiences conspicuous to themselves in more ways than by gathering the audiences together. Oftentimes, a character in a play would describe to playgoers how they looked from the stage, thus encouraging them not only to visualize themselves as an audience but also to regard themselves as a constitutive feature of the theatrical experience. Midway through the induction to Ben Jonson's *Every Man Out of His Humor* (1599), one character speaking with others suddenly catches sight of the audience and declares, "I not observed this throngèd round till now. / Gracious and kind spectators, you are welcome."[35] A less overt and not coincidentally less positive reversal of perspective occurs in the second part of Shakespeare's *Henry VI* (c. 1590), when the Duchess of Gloucester laments to her husband as she is being led in penance through London's streets, "Look how they gaze! / See how the giddy multitude do point / And nod their heads, and throw their eyes on thee!"[36] In both cases, the audience are prompted to recognize not only how they play a role in the theater but also how the theater has *amassed* them—a notion of the theatrical experience that even its enemies helped promote: "Were not Players the mean[s], to make these assemblies," wrote Stephen Gosson in 1579, "such multitudes would hardly be drawn in so narrow room."[37]

Historical Differences

To help make sense of the mass entertainment in sixteenth-century playhouses as well as in twentieth-century cinemas, I will regularly draw on the historical context of the works I discuss. Defining mass entertainment as

a cross-historical phenomenon does not mean ignoring the cultural and technological differences between Renaissance plays and Hollywood movies, any more than defining both *The Aeneid* and *Paradise Lost* as epics means ignoring the historical dissimilarities between Virgil's time and Milton's. But historical context is not the only determinant of artistic content, and scholars who focus exclusively on it tend to exaggerate historical variations into categorical distinctions. However remarkable and important they may be, many of the differences between the Renaissance theater and Hollywood cinema are also often more relative than they appear, and these differences cannot be accurately understood without taking into account the strength of the congruities between the theater and the cinema as well.

Modern theorists of mass entertainment generally assume that the technological divide between Renaissance plays and modern film is irreducible because it promotes and reflects profound sociological transformations: above all, the seismic shift from a monarchic society to a democratic or else mass society. According to Badiou, cinema counts as the first real mass art "because it is the democratization" of all the others. The claim has a long history. In his 1911 tract *The Religious Possibilities of the Motion Picture*, for instance, Herbert Jump celebrated movies for their "popularizing of a privilege which previously had been confined to a few."[38] Before the advent of cinema, as a 1918 editorial in the fan magazine *Photoplay* similarly argued, "painters, musicians, poets and sculptors lived on the bounty of monarchs and princes," and their only care was to please "their royal patrons"; "art scorned democracy." But "then came the moving picture, and democracy clasped it to its heart," as the art that was at long last "of the people" and "for the people."[39] In his 1931 *History of the Movies*, Benjamin Hampton called film "the one triumph of democracy in creating an effective agency of its very own." Movies "provide entertainment for the high and mighty, and for the meek and lowly, without distinction," wrote Robert Sherwood in 1923; "the films which are displayed at command performances in St. James's Palace are also shown, in exactly the same form, at the Rosebud Theater in Gopher Prairie." Once inside the new "cinema palaces," Lloyd Lewis observed for the *New Republic* in 1929, "every man is a king and every woman a queen"; "all men enter these portals equal, and thus the movies are perhaps a symbol of democracy."[40]

Centuries earlier, however, similar claims had already been made for the Renaissance theater, which itself provided entertainment for the meek and lowly as well as the high and mighty. A Florentine dispatch from London in 1613 reported that "anyone at all" could attend commercial plays "for a few pence." Taking a jaundiced view of this accessibility, the Renaissance dramatist Thomas Dekker maintained in 1609

that the theater was "a place...so free in entertainment...that your Stinkard has the self-same liberty to be there in his Tobacco-Fumes, which your sweet Courtier hath: and that your Carman and Tinker claim as strong a voice in their suffrage, and sit to give judgment on the play's life and death, as well as the proudest *Momus* among the tribe of *Critic.*" Dekker's satire raises the question whether the values of the theater were as democratic as its box office. Officially, Shakespeare and his fellow actors were hardly beholden to the "suffrage" of the lower classes: they were the servants of James I, the King's Men. But for many contemporary observers the reality was different. "Howsoever he pretends to have a royal Master or Mistress," another satirist claimed of the "common player," "his wages and dependence prove him to be the servant of the people." Actors and playwrights were frequently irked by this dependence, and they often wished that they could write for gentlemen or aristocrats exclusively. But they just as frequently celebrated their special connection with the thousands they entertained. Even the notoriously prickly and arrogant Ben Jonson welcomed "all" spectators to his 1629 comedy *The New Inn*, just as he had professed his desire "to delight all" in his 1614 comedy *Bartholomew Fair*.[41]

The very revulsion that some contemporaries expressed toward the theater's audiences suggests how conspicuously democratizing a force the theater seemed to be at a time when democracy had little currency in the culture generally. Throughout the Renaissance, as the theater historian Ian Munro observes, "some of the most explicit and intense invocations of the many-headed monster as a violent mass" appeared in the "antitheatrical discourse" of the period. Speaking for his fellow theater-haters, Henry Crosse in 1603 declared that "the common haunters" of plays were "for the most part, the lewdest persons in the land," "the very scum, rascality, and baggage of the people." Faced with such an audience, the players, the antitheatricalists assumed, had no choice but to debase themselves, "for exempt their licentiousness only out of Plays," then "too too small alas will be their gettings to maintain their idle life; that being the thing which most pleaseth the multitude."[42] What especially appalled theater-haters was the servile willingness of actors to derive "glory" from "the vulgar opinion" and to sacrifice every other proper allegiance to "that great master the multitude." "There is no passion wherewith the king, the sovereign majesty of the Realm[,] was possess'd, but is amplified, and openly sported with, and made a Maygame to all the beholders," Crosse went on to complain. Northbrooke and many others called the theater the place to go "if you will learn...how to disobey and rebel against Princes"; the indignant author of the 1615 *Refutation of the Apology for Actors* put "*Tyrannous* Kings and Queens" at the head of a list of parts that crowd-pleasing actors

loved to play.[43] Taking stock of such contemporary attacks on the the-
ater's rabble-rousing, the literary scholar Franco Moretti has compel-
lingly argued that Renaissance drama did indeed help undermine the
credibility as well as the prestige of the English monarchy. The theater,
in his view, constituted "one of the decisive influences in the *creation* of
a 'public' that for the first time in history assumed the right to bring a
king to justice." Even as the theater confirmed the worst fears of some
contemporaries, moreover, it encouraged others to evaluate "the multi-
tude" in positive new ways. Opposing those who "maintain *Contempt /
'Gainst common Censure*," a character in the induction to John Marston's
1601 comedy *What You Will* argues that "*Music and Poetry* were first
approv'd / By common sense; and that which pleased most, / Held most
allowed pass." "The theater," as Harbage concludes, "was a democratic
institution in an intensely undemocratic age."[44]

Centuries later, the cinema fanned similar prejudices against the
masses and promoted similar democratic reassessments of them.
Unwittingly echoing Renaissance theater-haters, Paul Rotha in 1930
complained that American film had generated "a new type of audience,
a vacant-minded, empty-headed public, who flocked to sensations, who
thrilled to sensual vulgarity, and who would go anywhere and pay any-
thing to see indecent situations riskily handled on the screen." For the
influential journalist William Allen White in 1936, Hollywood's dis-
graceful truckling to the masses left every film "at the mercy of its stu-
pidest patrons." In his 1937 column "The People and the Arts," by
contrast, Gilbert Seldes echoed the Renaissance theater-lover Marston
when he argued against "the principle that only those things are worth
communicating which comparatively few people will understandingly
receive." "A substantial proportion of the most successful movies," Seldes
maintained, had also been "good pictures," which proved that "millions
of people who have little experience with the principles of the great
arts" might be a discriminating audience, and that an entertainment
"specifically intended to please" these masses might constitute a great
work of art.[45]

For other cinephiles, film could do more than meet popular stan-
dards: it could elevate the mass audience. Badiou assumes that such
democratic uplift is a unique capacity of film. "With cinema," he argues,
"*you have the possibility of rising*. You can start with your most com-
mon ideas, your most nauseating sentimentality, your vulgarity, even
your cowardice. You can be an absolutely ordinary film viewer. You can
have bad taste in your access, in your entry, in your initial attitude. But
that doesn't prevent the film's allowing you to rise." And yet Renaissance
theater-lovers made exactly the same claim about commercial plays.
Even as the preface to the 1609 quarto of Shakespeare's *Troilus and*

Cressida disparaged the vulgar "multitude" who normally attend plays, it confidently asserted that "all such dull and heavy-witted worldlings, as were never capable of the wit of a Comedy," have "found that wit" at Shakespeare's comedies "that they never found in themselves, and have parted better-witted than they came." Thomas Dekker echoed this sentiment in the prologue to his *If This Be Not a Good Play, the Devil's in It* (1612): a talented playwright, he asserted, "can draw . . . even creatures / Forg'd out of th' *Hammer* . . . to *Reach* up, / And . . . clap their *Brawny hands*, / T'*Applaud*, what their *charm'd* soul scarce understands." Thomas Heywood expressed the same view the same year, though without Dekker's contempt for the "ordinary spectator": "so bewitching a thing is lively and well-spirited action," Heywood declared, "that it hath power to new-mold the hearts of the spectators and fashion them to the shape of any noble and notable attempt."[46]

For some film-lovers as well as theater-lovers, part of the uplift in mass entertainment came from encouraging the audience to think more highly of themselves *collectively* than as a "giddy multitude." Hampton in his 1931 *History* argued that the continuing popular demand "for better and better pictures" powerfully refuted "the dogma that mass mentality could not, or would not, move ahead." "The common people," he claimed, had instead made "remarkable progress in creating for themselves a form of entertainment that carried with it an immeasurable quantity of stimulation, enlightenment, and education."[47] "What possibilities lie in this art, once it is understood and developed, to plant new conceptions of civic and national idealism?" asked the 1922 preface to Vachel Lindsay's *Art of the Moving Picture*; "how far may it go in cultivating concerted emotion in the now ungoverned crowd?" When Heywood spoke of drama that had "inflam'd" spectators with lofty aspiration, he was referring to Renaissance history plays such as Shakespeare's *Henry V*, where the Chorus's opening address to the audience as "gentles all" anticipates King Henry's own conferral of universal nobility on the "band of brothers" in his army: "For there is none of you so mean and base / That hath not noble luster in your eyes"; "For he to-day that sheds his blood with me / Shall be my brother; be he ne'er so vile, / This day shall gentle his condition." Throughout the choruses to *Henry V*, Shakespeare links Henry's vision of patriotic fellowship to the theater's concentration of diverse energies inside its "wooden O." While apologizing for the attempt to "cram" such "mighty" forces "within the girdle of these walls," the choruses also suggest that the theater has a special power to compress the audience into an image of English solidarity—"like little body with a mighty heart."[48]

Benjamin, perceiving "the masses" of the twentieth century as "a matrix from which all customary behavior toward works of art is

today emerging newborn," expected that moviegoers would achieve a far more radically democratic fellowship than Shakespeare ever could have imagined. But he downplayed the more striking difference between theater and cinema that his essay on reproducibility evoked: not egalitarian but rather fascist "attempts to organize the...masses" through film. There is no real political equivalent to fascism in Renaissance commentary on the theater's mass audiences. Contemporaries understood that the government occasionally enlisted the theater in propaganda campaigns, particularly against Catholic and puritan enemies.[49] Arguments were also made for regarding the theater as a means of social control, although these generally took the weak, Juvenalian form of claiming that plays were a distraction from politics; the story was often told that "when Augustus reproached a certain player because through his occasion there was a tumult among the people, he answered, *It is good for thee, O Caesar, that the people be withheld by our idle exercises, from busying their brains about other matters*."[50] But no Renaissance commentator, to my knowledge, anticipated the claims of modern theorists such as Horkheimer and Adorno that mass entertainment amounts to an illusion of popular consensus generated by a "culture industry" whose aim is the methodical "breaking down of all individual resistance" to the status quo. With the help of mass entertainment, Dwight Macdonald contended in 1944, "everything and everybody are being integrated—'coordinated' the Nazis call it—into the official culture-structure."[51]

This is not to say that the Renaissance lacked any notion of the drama as mass deception. That claim was in fact a staple of antitheatrical fulmination, with the crucial difference that theater-haters identified the deceiver as the devil, not capital. Players, William Rankins declared in his 1587 *Mirrour of Monsters*, "are sent from their great captain Satan...to deceive the world, to lead the people with enticing shows to the devil." Calling plays "the doctrine and invention of the Devil," Stephen Gosson maintained in 1582 that they "drag such a monstrous tail after them, as is able to sweep whole Cities into his lap." The political moral of such diatribes was if anything the reverse of Horkheimer and Adorno's: the devil's aim in deluding the people, Gosson argued, was to "break our order," not to shore it up. And yet Renaissance attacks on the theater as "Satan's Synagogue" did nevertheless share the most counterintuitive feature of Horkheimer and Adorno's assault on mass entertainment: the theory that such entertainment amounts to *systematic* deception, perpetrated by a *unified* agency.[52] Why would both Renaissance and modern commentators regard the manifest abundance and variety of mass entertainment as camouflaging a hidden sameness? Since these commentators do not agree about the nature of that same-

ness, their concurrence must be based on some other feature of mass entertainment that they do agree upon, and the one element that is common not only to plays and to films but to every piece of mass entertainment is the mass audience for which each piece is conceived—an audience that *in itself* presents critics with an image of unified multiplicity, which the critics then read back into the entertainment.

Horkheimer and Adorno spread the blame for mass deception beyond the deceivers. It's not just capitalist collusion, they maintain, that has turned film into an unprecedented "means of domination and integration": it's also the machine, which has dehumanized entertainment in its reception as well as its production and distribution. What makes "the sound film" the "most characteristic" product of the culture industry, Horkheimer and Adorno argue, is the way it forces the audience to "react automatically" to its own automated display. Talking pictures "are so designed that . . . sustained thought is out of the question if the spectator is not to miss the relentless rush of facts."[53] But the claim that mass entertainment stupefied its audience was nothing new. Renaissance commentators similarly condemned the theater for "bewitching" the "minds" and "benumbing" the "souls" of spectators. A play, wrote Gosson in 1582, "is a block in the way of reason"; "such force have their enchantments of pleasure to draw the affections of the mind," another theater-hater asserted in 1580, that "no man" is safe once he is caught in their "webs."[54] Even the "relentless rush" that Horkheimer and Adorno attributed to movies was a recurring theme in Renaissance theater criticism, which often censured commercial plays for their tendency to "outrun the apprehension of their auditory." Whereas "the mind," according to Henry Crosse, "is stored with wisdom, the life bettered and settled in quietness" by "reading good books," that same "mind" is tumultuously overstimulated at the theater, "carried from one thing to another" by plays that "swiftly run over in two hours' space, the doings of many years, galloping from one country to another." As if to prove Crosse's point, the chorus to *Henry V* boasts that "our swift scene flies / In motion of no less celerity / Than that of thought."[55]

Those who view film as categorically different from earlier entertainments would counter that the machine enabled film to homogenize as well as mesmerize its audiences. In his 1925 essay "The Monotonization of the World," Stefan Zweig blamed film for spreading "a herdlike taste that is everywhere the same" and for thus effectively "mechanizing humanity." "The photoplay is a standardized commodity," Frances Taylor Patterson declared in 1928: "entertainment has been deftly and dexterously canned like vegetables in neat, tin containers."[56] During the Renaissance, however, publishers had already managed to package plays in the neatly reproducible containers of printed books, and by that

time, critics had been complaining about hackneyed repetition in enter-tainment for centuries. Modern machines did not introduce standard-ization, but they did augment it, and they also substantially altered the language for describing standardization, by providing critics such as Patterson with compelling new metaphors and analogies for cultural uniformity.

A more radically transformative effect of the machine on the theatri-cal experience was the elimination of live performance. Whether this change distanced the actor from the audience has long been a matter of debate. For commentators such as Iris Barry in 1926, "the personal pres-ence of the actors, so important to the theater, is, I think, compensated by the cinema's increased intimacy, by the possibility of seeing the actor's very thoughts as well as his eloquent gestures and his changes of expres-sion" in close-ups.[57] Harder to deny is what Harbage called the loss of "immediacy" and therefore of "reciprocity" in the relationship between entertainer and audience. As Benjamin explains, "The film actor lacks the opportunity of the stage actor to adjust to the audience during his performance, since he does not present his performance to the audience in person." For Benjamin, surprisingly, this change strengthened the audience, by liberating them from the actor's charismatic aura and thus allowing them "to take the position of a critic." But Harbage assumed that the dissociation of the actor from the audience disempowered the audience, who could no longer "participate in the creation of a play," and whose "influence upon creative artists" would now be "exercised through deputies not of its own choosing." Even the cinephilic Benjamin acknowledged that film audiences were not currently as effectual as he hoped they would eventually become. "So long as moviemakers' capital sets the fashion," he conceded, "as a rule the only revolutionary merit that can be ascribed to today's cinema is the promotion of a revolution-ary criticism of traditional concepts of art."[58] Harbage's belief that live performance strengthens the audience seems reflected in movies such as *Citizen Kane* (1941), where Kane is far less successful at inducing opera-goers to accept the fiction of Susie's singing prowess than he is at per-suading newspaper readers to accept the fiction of Spain's military aggression. Although Kane claims that his goal as a newspaper publisher is to give "the people" what they want, his consumers are always repre-sented indirectly: through circulation numbers, for instance, or as stacks of newspapers waiting to be sold, or by newsboys hawking papers for which we never see a buyer.[59] Yet in thus associating the mediation of audience demand with newspapers, *Citizen Kane* also aligns that media-tion with print rather than with theatrically exhibited film.

To end this preliminary survey, let me consider one final difference between theater and film from among the many I have yet to discuss: the

mechanical incorporation of multiple visual perspectives in film. Film editing liberated the audience from the single point of view to which the theatrical stage limited them, effectively giving each spectator the eyes of many. Yet if Renaissance drama lacked the technological means for this multiperspectivality, it did not lack the ambition. The choruses to *Henry V*, for instance, urge the audience to "shift" their imaginative sights almost line by line. While celebrating the power of film to offer "a treatment of theme that is extensive and panoramic … in a fashion that no stage of ancient or modern times could hope to equal, still less surpass," William Hannon in 1915 nonetheless emphasized that "the photodrama" was "like the drama since the days of Shakespeare" in flouting "two of the trinity of unities held so sacred by the Greek dramatists; namely, the unity of time and the unity of place." What could be more extensive and panoramic, asked Eric White in 1928, than Shakespeare's *Antony and Cleopatra*, which "in places … reads more like a film scenario than a drama"? From White's perspective, film perfected what theater had already begun; as White put it, "the drama mothered the cinema."[60]

Critical Motifs

To test the comparison of Hollywood film with Renaissance drama, I focus throughout this book on three issues that scholars have treated as hallmarks not only of mass entertainment but also of its essential modernity. The first of these issues is the crisis of the individual in the mass; the second, the blurring of boundaries between work and leisure; and the third is the confusion of art and junk. To put these motifs in more practical terms: mass entertainment addresses itself to lots of people, who require lots of occasions on which they can be entertained, and lots of products with which they can be entertained. Critics charge that mass entertainment thus undermines distinctions between persons, between times or actions, and between things—that it dehumanizes, monotonizes, and trivializes. But proponents counter that mass entertainment levels *false* distinctions and thus constitutes a force for egalitarian change.

In order to elaborate on these issues and begin substantiating my claim that the mass entertainments I am discussing elaborate on them as well, I'll now briefly consider three works in which the critical motifs I have sketched figure *as* issues. I offer films rather than plays as my preliminary examples for two reasons. First, the contemporaneity of these films with such theorists as Benjamin and Adorno makes it less controversial at the outset to argue that the entertainments address the

same issues as the theorists do. Second, although the limited artistic credibility of films has encouraged the bias that they are merely vulnerable to theorists, who expose the false consciousness in them that the films themselves either fail to grasp or else strive to conceal, I want to show how movies are no less capable than other, more highly regarded art forms of anticipating the terms that commentators use to critique them. Each of the three films I'll glance at here tries to justify its stake in a version of the indiscriminateness for which mass entertainment is regularly blamed. My examples—*The Crowd* (1928), *The Jazz Singer* (1927), and *City Lights* (1931)—are all drawn from the years when Hollywood transitioned from silent to talking pictures.

ONE OF THE CROWD

"You have to protect yourself from the masses," Alfred Döblin cautioned his readers in 1932. "They are the calamity of the day and the genuine obstacle to being really human." Many contemporary reviewers thought that the 1928 melodrama *The Crowd* delivered the same message about the dehumanizing power of the masses. The film, wrote one critic, "shows how human personalities are submerged and crushed by our huge cities," while for another critic it portrayed "life as it is lived by millions in New York and other big cities where the crowd walks, pushes, tramples each individual member."[61] In 1938, the director of *The Crowd*, King Vidor, seemed to be espousing a Döblin-like opposition to the masses when he described himself as "a great believer in individualism" and boasted that his films bore "the stamp" of his own "individuality." The only reliable counterforce to "the mass-man," Ortega y Gasset declared in his *Revolt of the Masses* (1932), are "nobly disciplined minds" and "highly-endowed individuals," "the select man, the excellent man."[62] But the distinctive message that Vidor thought *The Crowd* conveyed was not about his scorn for the crushing herd: it was instead about "the common man's struggles." Before *The Crowd*, Vidor explained decades later, the only way that movies championed individualism was by removing their protagonists from the masses and placing them instead in the wide-open spaces of the westerns, where audiences could plainly see "all the glamorous Western heroes taking the law unto themselves and solving all the problems as individuals." But with *The Crowd*—a film that was "entirely" Vidor's idea, the *New York Times* assured its readers—Vidor maintained that he had rejected such stark dichotomies between the individual and the mass, choosing instead to dramatize a kind of tertium quid: the individual *in* the mass, or "one of the crowd," as he called it. In his own review of the film, Gilbert Seldes confirmed Vidor's sense of the picture's unconventionality: *The Crowd*,

Seldes argued, "breaks completely with the stereotype of the feature film. There is virtually no plot; there is no exploitation of sex in the love interest; there is no physical climax, no fight, no scheduled thrill. The characters, all commonplace people, act singularly unlike moving picture characters and singularly like human beings." At the heart of *The Crowd*, for Seldes as for Vidor, was the paradox of characters who "act singularly" when they seem most "commonplace."[63]

Other reviewers praised Vidor's focus on "the everyday man in the street" as a new method for giving films mass appeal: "the commonplaceness of the story," as Norbert Lusk put it, "is the very factor which makes us see ourselves in it."[64] Vidor himself described the protagonist of *The Crowd* as an everyman, or to be more precise, as an "Anyman." But the struggles of this common man also reflected Vidor's difficulties in trying to maintain a balance between the uniqueness and the representativeness of his central character. Vidor named his protagonist "John Sims"—an anonym, effectively, like "John Doe," but with even greater emphasis on undifferentiated sameness. In his early treatments for *The Crowd*, Vidor also satirized John as a "boastful, thoughtless fellow" whose "only distinction" was "to be born on July 4th, 1900," and whose one "claim to individuality" was "writing with his left hand."[65] In the film itself, John demonstrates little independence of judgment. "Much of *The Crowd*," as Gregory W. Bush has observed, "focuses upon John as a crowd-man, conceived as endlessly suggestible to the appeals of rules and the dictates of a consumer culture."[66] Even as John dreams of distinguishing himself, his terms for success reinforce his anonymity: he wants to become "*some*body." The irony is underscored when John comes up with an idea for an advertising slogan about cough syrup, dithers about submitting it, and then learns that he has been beaten to the punch: "That slogan, *A Carload Full of Coughs*, was mine!" he exclaims. "Only somebody sent it in first." "Somebody," the individual who prevents him from realizing his dream, is the same anonymous winner that he himself had dreamed of becoming.

The evolution of the film's title from *One of the Mob* to *One of the Crowd* to *The Crowd* suggests that Vidor shared some of John's indecisiveness.[67] The pseudonymous reviewer "Mae Tinee" criticized the film's "smeariness of outline"; Rotha complained that "the relation between the man and the crowd was ill-defined and slurred over."[68] In his autobiography, *A Tree Is a Tree*, Vidor admitted that he had had an especially "difficult time deciding on an ending" for *The Crowd*: "we made seven of them, and tried out each one at sneak previews in small towns." The ending he ultimately settled on shows John "with his wife and child sitting in the audience of a variety theater, laughing at a clown." The

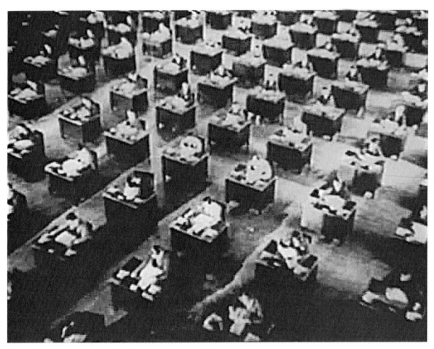

John Sims trying to make his mark at the office

point of this scene, Vidor implied, was that John could resolve the con-
flict between his individuality and his anonymity by participating in the
benignly organized mass experience of the theater: "since he managed
to enjoy life, and therefore conquer it, in this simple and inoffensive
way, the camera moved back and up to lose him in the crowd as it had
found him."[69] Others, however, have viewed this final shot as much
darker than Vidor allowed. "When the camera pans back," argues
David Grimsted, for instance, we see John and his family "as part of a
mass, now laughing *en masse*, hideously, mechanically, at the comedy
of their own lives." In his autobiography, Vidor resisted this vision of
mass entertainment as dehumanizing John by replacing him in his
mind's eye with the actor who had "turned in such a splendid perfor-
mance" as John. It was "*Murray* with his wife and child" whom Vidor
remembered seeing in the theater audience—James Murray, whom *The
Crowd* briefly made a star.[70]

With a little airbrushing, Murray's own life story conformed to an
astonishing degree with the story Vidor believed he was telling in *The
Crowd*. According to Vidor, Murray had been nothing more than an
extra at MGM when his very averageness caught Vidor's eye.[71] As the
press excitedly reported it, Murray "was literally lifted from one of the
vast crowds of extras into the leading role of 'The Crowd'"; "Mister
Cinderella," *Photoplay* called him.[72] But Murray's celebrity was short-lived.

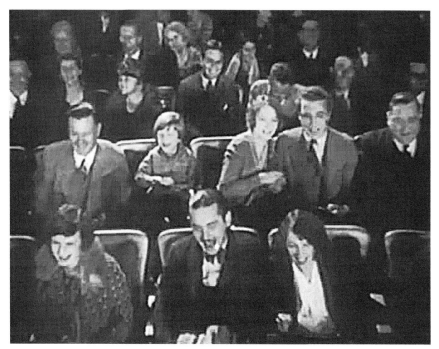
The Sims family at the theater

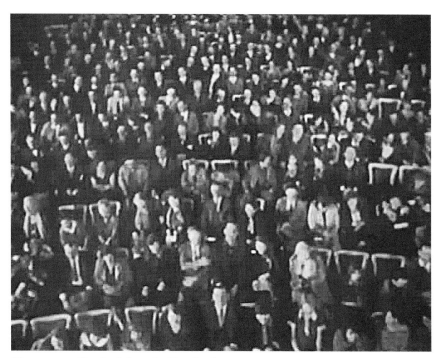
The camera pulling back from the Sims family

Once the movie had run its course, he fell back into obscurity, and a few years later, his body was "found floating in the Hudson River."[73] "Couldn't take it—couldn't take success," Vidor later explained to Richard Schickel; "he was too much of an average, common man." In Vidor's mind, however, Murray remained singular enough of a figure that, nearly fifty years after *The Crowd*, the director tried to make a movie about his former star. He just couldn't convince anyone else to film it.[74]

THE SHOW MUST GO ON

"A conception of the motion picture merely as idle entertainment for idle people is too limited," claimed a 1938 "manual" on the subject of *How to Appreciate Motion Pictures*.[75] A few years later, in their 1944 *Dialectic of Enlightenment*, Horkheimer and Adorno made the same point, though to condemn rather than applaud. What looked like idle entertainment in the cinema, they argued, was in reality a form of work, and the audience were toiling along with entertainers. The reason that "the term 'show business' is today taken utterly seriously," Adorno later maintained, is because "the domain of work" has expanded so prodigiously that even our "free time" has become "nothing more than a shadowy continuation of labor."[76] Yet the assimilation of entertainment to work was no shadowy feature of the landmark 1927 talking picture *The Jazz Singer*: it was instead one of the movie's central themes. Early in that film, Cantor Rabinowitz is appalled to find his young son Jakie—a future cantor, in his father's eyes—"singing raggy time songs" in "a saloon." To the cantor, such play is worse than a waste of time: it is shamefully degrading. By this point in the film, however, the cantor has already been criticized for his narrow-mindedness: a title card has warned us that he "stubbornly held to the ancient traditions of his race." "You're of the old world," the son later says to his disapproving father; Jakie, embracing the new, decides to transform himself into "Jack Robin" the entertainer. But the change does not make Jakie as deracinated and decadent as his father assumes it will. Rather than reject the sober work of cantoring for the idle play of jazz singing, Jakie insists on their vocational equivalence. "It is as honorable to sing in the theater as in the synagogue!" he declares to Cantor Rabinowitz. Part of what makes Jakie so committed to the stage is the devotional fervor for singing he inherits from his father. Yet that zeal would seem absurdly misplaced if it were not for the equally fervent commitment of Jakie's audience to the entertainment he provides them. "My songs," Jakie assures his father, "mean as much to *my* audience as yours to *your* congregation!"

In certain respects, the entertainer of *The Jazz Singer* works even harder at his vocation than the cantor does. For a start, Jakie's audience in his "big Broadway show" is much larger than his father's in the temple, a difference Jakie's mother comes to appreciate when she watches him singing on the stage and realizes that his audience can no longer be limited to Jews. "He's not *my* boy anymore," she declares; "he belongs to the whole world now." Unlike his father, moreover, Jakie doesn't regard his singing as a duty he must perform because the ancient traditions demand it; what commits Jakie to his calling is his professionalism. "We in the show business have our religion, too," he later exclaims: "the *show must go on!*" This insistence on the continual nature of his stage work further differentiates Jakie from his father, whose first words in the film associate his own vocation with the holy days ("Tonight Jakie is to sing Kol Nidre"), whereas it is a central tenet of Jakie's professional "religion" that the show must go on "*every day.*" Just as there are no special worshippers in show business, so there are no special days: the regularity of performance corresponds with the universality of the audience. The implicit contrast between the cantor's exclusivism and the jazz singer's inclusivism allows Jakie to frame his very break with the ancient traditions as a form of continuity. "Tradition is all right," he concedes to his father, "but this is another day," as if change ("another day") were the same thing as invariability ("another day").[77] But Jakie's inclusivism also produces disturbing complications for him: it means that neither he nor the film can entirely dismiss his father's condemnation of jazz singing. "You taught me that music is the voice of God!" Jakie exclaims in defense of his entertainments, and yet the very next scene of *The Jazz Singer* appears to confirm the cantor's fear that Jakie has indeed chosen "to debase the voice God gave him." "Rehearsals were rounding the 'April Follies' into—good form," the scene's opening title card explains. *April Follies* is the show that must go on? How can Jakie deny that he has trivialized his father's calling?

The Jazz Singer finds the beginnings of an answer to this "stubborn" question in an earlier scene, when Jakie takes a busman's holiday from show business and visits a theater while on tour in Chicago. The entertainer he sees there was at the time a real-life performer, Cantor Josef Rosenblatt, who had been made famous by his recordings, his concert hall appearances, and, surprisingly, by his work in vaudeville. What greater vindication of the continuity between his career choice and his father's could Jakie hope to discover than Cantor Rosenblatt's offering his "sacred songs" at "popular prices"?[78] And yet as Jakie watches Rosenblatt perform, he experiences this continuity, strangely enough, as a disruption. Alone among the audience members we glimpse, Jakie looks away from Rosenblatt, troubled, and when his gaze returns to the cantor, he sees his father and the synagogue in the place of Rosenblatt

and the theater. How are we to interpret Jakie's vision? Does it mean that Rosenblatt has now decisively convinced Jakie to regard his theatrical career as a worthy match to his father's cantorship? Or is the point rather that Cantor Rosenblatt has struck Jakie as a degraded image of his more zealous and therefore more admirable father? The only thing we know for certain is that Jakie has been *moved* by listening to Cantor Rosenblatt perform. Leaving the temple for the theater has not cut Jakie off from the ancient traditions, as his father assumed it would; rather, it has suffused the theater with the emotion of Jakie's continued attachment to his father's labors.[79]

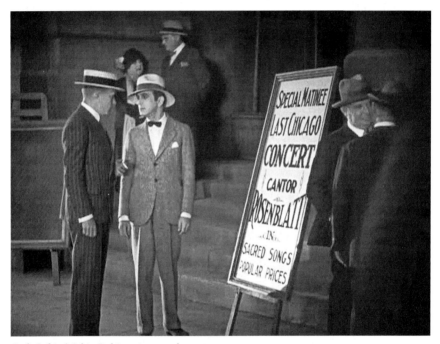

Jack Robin / Jakie Rabinowitz as a theatergoer

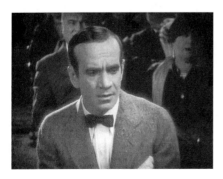

Jakie troubled as he listens to Cantor Rosenblatt

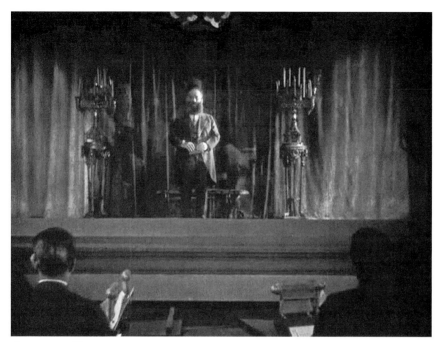

Cantor Rosenblatt onstage

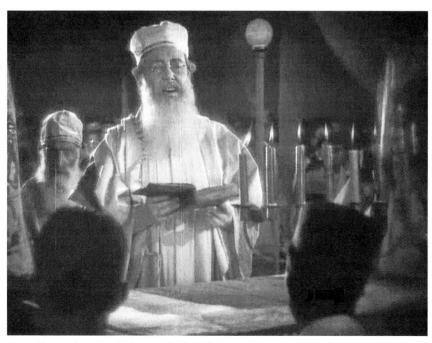

Rosenblatt replaced by the image of Jakie's father in the temple

A more extended convergence of temple and theater occurs for Jakie on Broadway, or rather backstage on Broadway, during the rehearsals for *April Follies*. Rehearsal is the part of show business that "goes on" beyond the show, exposing the hard work that makes entertainment possible, and a true professional therefore treats rehearsal and show with equal seriousness. "This dress rehearsal's just as important as the show tonight!" the producer of *April Follies* declares backstage, echoing Jakie's language for placing show business on the same footing as his father's religion. Backstage is also where Jakie learns that his father is seriously ill and that he wants Jakie to take his place for the Day of Atonement, Yom Kippur. Dolefully Jakie protests that he cannot abandon the stage: "The show must go on!" The next time we see him, he is in his dressing room, taking pains to prepare for the final rehearsal of *April Follies*. The camera lingers on him as he skillfully applies his blackface makeup and assures a fellow performer that "I'm going to put everything I've got into my songs." Yet the very intensity of Jakie's self-sacrificing commitment to the show seems to call his father to mind. Getting up to wash his hands, Jakie catches sight of his blackened face in a mirror, and now it's his own image that gets replaced by the image of his father in the synagogue. Once again, Jakie's vision points us in two different directions at once. On the one hand, his blackface seems to reveal to him that show business is just as debasing as his father claimed

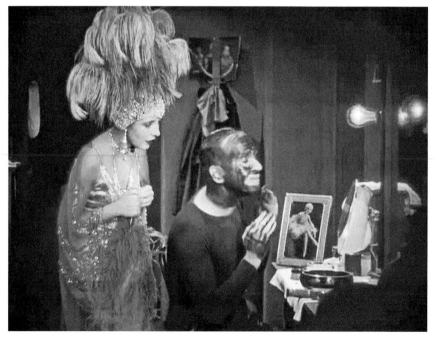

Jakie applying his blackface

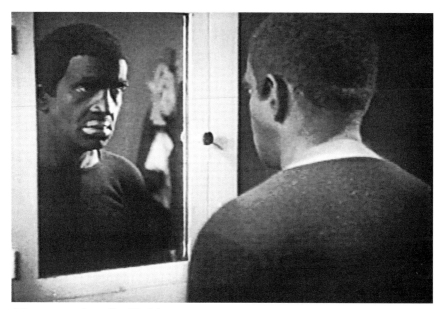

Jakie gazing at himself in blackface

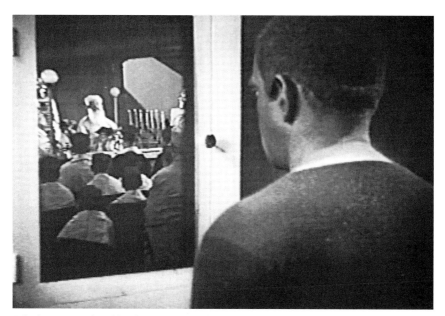

Jakie's image replaced by the image of his father in the temple

it was: Jakie now tearfully confesses that "the Day of Atonement is the most solemn of our holy days—and the songs of Israel are tearing at my heart." On the other hand, his blackface appears to *elicit* this sense of deep connection to his Jewishness, and not merely by contrast.[80] The inclusivist tendency of show business to make one thing seem "just as

important as" another helps Jakie convert the outward racial marking of
his blackface into the inward "cry" of his "race." Backstage, during
rehearsal, show business goes on past *April Follies* to disclose a passion in
Jakie that cannot definitively be assigned to either the temple or the theater.

 The Jazz Singer ends with the irresolution of this "tear" that Jakie
experiences backstage. Jakie decides after all to leave the show so that
he can take his father's place as cantor, but he also then returns to the
show after all, as its star. The film never explains how or whether Jakie
has managed to reconcile these two careers. All we're told after Cantor
Rabinowitz's death is that "the season passes—and time heals—the
show goes on."[81] Yet the show doesn't go on for Jakie as if his father's
death never happened. His final performance in *The Jazz Singer*—his
greatest success as an entertainer—captivates his audience with his
expression of the deep yet also conflicting emotions he feels at losing
the father who loathed his jazz singing. While Jakie's professionalism
may have broken down the walls that separated the work of cantoring
from the play of *April Follies*, it never erases their differences entirely.[82]
His blackface, which we first see him wearing only after he learns that
his father is dying, epitomizes both his self-assertiveness and his self-
doubt. Blackface, that is, marks him out as a star, distinguishing him
from all the other white-faced entertainers in the show, yet it also con-
verts him into the lone figure of abjection on the stage.[83] According to

The crowd waiting to see Jakie's Broadway show

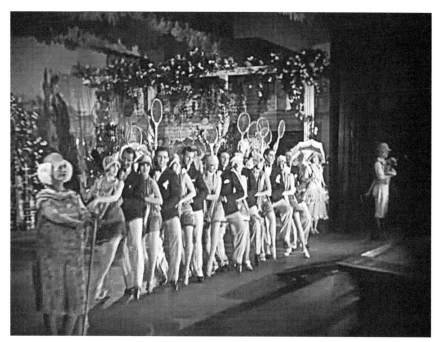

Jakie's fellow entertainers

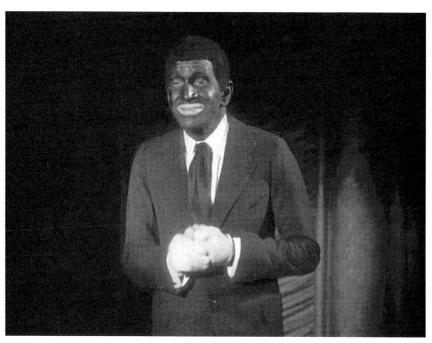

Jakie's abjection onstage

The Jazz Singer, mass entertainment requires such mixed signals from its players, who can hope to reach everyone on every day only by putting everything they've got into their work.

THE VALUE OF WORTHLESS MATERIAL

Why, Robert Sherwood asked in 1923, do critics refuse to accept movies as art? Because, he answered, "the movies belong to the masses and not to the few." In the eyes of the "intelligentsia," Sherwood complained, "when a work of art is put within reach of the yokelry it ceases to be a work of art"; what it becomes instead is trash, like the yokelry themselves. "The cheap show for cheap people" is how some early pundits referred to film.[84] Other contemporaries attributed the bias against movies to the different but related issue that movies depended on many people for their creation as well as their reception. According to influential theorists such as Herbert Read in his 1937 *Art and Society*, "the practice and appreciation of art are individual," and so, as Gilbert Seldes commented in 1929, "it has been held against the movie as an art that it is never the work of a single man." In his 1939 novel *The Day of the Locust*, Nathanael West portrayed the film industry as the absolute negation of Read's artistic principles. Shortly before West's protagonist is nearly trampled to death by a mob at a movie premiere, he sees a garbage heap behind a movie studio that makes him recognize Hollywood for what it truly is—a "dream dump."[85]

To defend the movies from such patronizing contempt, Sherwood and his fellow cinephiles looked for aid from one champion of film before all others: Charlie Chaplin. They viewed Chaplin as far more than a massively popular entertainer. In 1943, Alexander Woollcott declared himself ready "to defend the proposition that this darling of the mob is the foremost living artist." Remarkably, Chaplin had not reached such heights by devoting his films to lofty subjects. On the contrary, as Minnie Maddern Fiske had long before observed in her 1916 essay "The Art of Charles Chaplin," "many thoughtful persons are beginning to analyze the Chaplin performances with a serious desire to discover his secret for making irresistible entertainment out of more or less worthless material."[86] "Everything that comes within range of Chaplin at once assumes importance," Rotha asserted in his 1931 *Celluloid*. "A flower, a banknote or a horseshoe becomes alive as soon as touched by Chaplin, alive in our imaginations as well as alive in its own surroundings."[87] A famous outtake from Chaplin's 1931 *City Lights* seems to prove Rotha's point. The outtake shows Chaplin as the tramp stepping to one side of a busy city street, where he notices a stick protruding from a sewer grate. Idly, he uses his cane to try to push the stick

through the grate, but the trash won't drop into the sewer. Again and again he tries and fails, soon becoming so obsessed with the stick that he takes no notice of the crowd forming to watch him. Kevin Brownlow has described the outtake as "the essence of Chaplin's art. For he, more than anyone else in pictures, could take the smallest object, the least promising prop, and turn it into a fabulously funny sequence."[88] But it's not just the "worthless material" that makes this sequence so characteristic an example of Chaplin's art; it's also the masses who become absorbed in the tramp's attempts to dispose of trash.

Why does the tramp even notice the stick in the first place? The stick sticks out; perhaps he wants it to fit through the grid of the grate and vanish in the same way that he hopes his conspicuous shabbiness will disappear beneath the show of his gentlemanly bearing. It's the tramp's poverty, after all, that leads him to the stick; everyone else on the street moves hurriedly past it because they have business to attend to, something better to do. But the surprise of the scene is that the tramp's shiftless interest in the stick interests the others as well. His absorption is catching, which suggests that the rush of the passersby is more mechanical than purposeful, like the automobile traffic we see racing past them. Perhaps the moral of the crowd's attention to the tramp and the stick is that they are desperate to be interested in anything.[89] But the tramp's investment in the stick remains absurdly disproportionate to its object, making his fixation akin to the blank stupidity of the gaping teenager who at one point takes the place of the spectating crowd.

The tramp and the stick

The crowd watching the tramp and the stick

A patronizing clothing store manager who watches the action in grow-
ing frustration from behind his shop window repeatedly exhorts the
tramp to use his head. Perhaps, then, Chaplin means to underscore that
it's simply foolish to care about the stick; the crowd of passersby have
only been diverted from their mindless hurry to gaze like sheep at some-
thing of no real substance or value—precisely the charge that cinephobes
leveled at film as mass entertainment. And yet the disgusted clothing
store manager gets equally wrapped up in the scene. For all his conde-
scension to the tramp, he interrupts his own business to solve not one
but two problems: first, how to push the stick through the grate, and
second, how to communicate this plan of action through the sound bar-
rier of a window. From the perspective of the city's workaday routine
and the grid along which its traffic flows, an interest in the stick may
appear to be mindless, but the very triviality of the stick also contrast-
ingly highlights the surplus of mental energy that the tramp and the
clothing store manager expend on it. Seldes used similar terms to praise
"everything incongruous and inconsequent" in slapstick comedy, which,
he claimed, has the power to liberate us from our "dull and business-
like lives." Even Horkheimer and Adorno celebrated the "mindless
artistry" of such entertainments for helping to distinguish "what is human"
from "the social mechanism."[90] Using one stick to move another, the
tramp exhibits an almost pre-technological inventiveness: he is, as it
were, on the other side of the machine. Though Chaplin ultimately cut
the stick sequence from *City Lights*, he continued to emphasize the

Gaping at the tramp

"Use your head!"

special connection between the tramp's humanity and his eye for trash in the final version of the film, whose climactic action begins when the tramp spots a flower in the gutter that leads him to the woman he loves.[91]

It's not hard to guess why Chaplin cut the stick sequence: the scene is interminable. Chaplin was notorious for his own overabsorption in problem solving. Another sequence in *City Lights*, the tramp's first encounter with the flower girl, still holds the *Guinness* record for the most retakes of a movie scene (342, to be precise).[92] Chaplin's son Charles viewed such obsessiveness as an expression of his father's consummate professionalism: when Chaplin directed Paulette Goddard in *Modern Times*, his son reported, "he absolutely refused to be satisfied with second-best, even in the most minute gesture of facial expression.

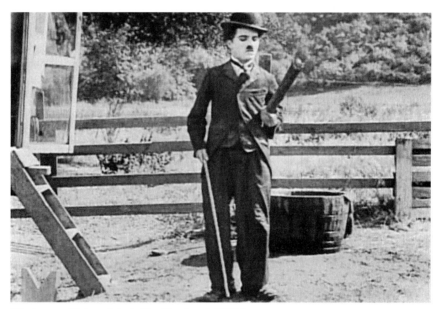

The tramp with two sticks in The Vagabond *(1916)*

The flower in the gutter at the end of City Lights

'Try it again. Try it again. Try it again.'" But so detail-oriented and repetitive a working method sounds disturbingly like the assembly line that Chaplin satirized in *Modern Times*. For admirers such as Fiske, Chaplin required such "unfaltering" dedication to his craft in order to combat the elitist bias against movies. "A constantly increasing body of cultured, artistic people," Fiske claimed, "are beginning to regard the young English buffoon, Charles Chaplin, as an extraordinary artist."[93] The chief piece of more or less worthless material that Chaplin managed to turn into gold, Fiske implied, was Chaplin himself. In the stick sequence, the tramp is Chaplin's version of Jakie in blackface, the nobody who nevertheless attracts mass attention. Yet by the time *City Lights* premiered, as Sabine Hake has pointed out, the tramp had also become "a highly standardized" figure in Chaplin's films; "I keep repeating what I am," Chaplin acknowledged in a 1957 interview. Was this repetition a sign of the painstaking artistry that enabled Chaplin to break through the routine of modern times, or was it rather a version of that same trivializing mechanization, now transferred to the screen? "In its slightness rests its power," Rotha proclaimed of *City Lights*, although he also felt compelled to acknowledge that the film "bored" some filmgoers "to death."[94]

Structure of the Book

I've divided my book into three parts, each of which devotes a chapter on theater and a chapter on film to one of the three motifs under discussion. By organizing the issues this way, I don't mean to imply that they can be cleanly distinguished from one another. In the outtake from *City Lights*, for instance, the tramp's distinctive anonymity and busy idleness as he fixates on a stick suggest instead that the boundaries between questions of individuality, action, and value in the sequence are fluid and ill-defined. This indeterminacy is crucial to mass entertainment: as much as it encourages the vagueness or confusion for which mass entertainment is commonly derided, it also licenses an impressive subtlety of treatment. To help me address the related premium that mass entertainment places on another form of breadth—popularity—I've chosen plays and films that many readers will already know, or at least know of: *Hamlet*, the first part of *Henry IV*, *The Roaring Girl*, and *The Alchemist* among the plays; *Citizen Kane*, *Footlight Parade*, *Meet John Doe*, and *City Lights* among the films. I've selected these particular works not so much for their representativeness—which can hardly be claimed for any play or film, given the vast number of works to choose from—but rather for their manifest engagement with the motifs I'm highlighting, as well

as for their resonances with each other. Throughout this book, finally, I'll recur to an image that prominently figures in all three of the movies I've just discussed: the sight of a crowd of spectators, which allows a play or movie to register its self-awareness by asking its audience to see themselves from the entertainment's point of view.

The first part of *Mass Entertainment*, "The Individual and the Mass," begins with a chapter on the 1611 comedy *The Roaring Girl*. When Adorno claimed that mass entertainment "impedes the development of autonomous, independent individuals who judge and decide consciously for themselves," he was repeating a common Renaissance objection to the theater. While contemporaries regularly denounced the theater for subjecting otherwise virtuous individuals to "ungodly company," many also worried that the sheer number of playgoers was the problem. Appalled that an audience of "a thousand men" should dare to question the "undoubted wit" of the playwright John Fletcher, Francis Beaumont (1610) accused this herd or "rout" of groupthink: "not one" amongst them, he claimed, "hath / In his own censure an explicit faith." William Fennor (1617) similarly condemned the "multitude" who were hostile to Ben Jonson: if "one but ask the reason why they roar / They'll answer, 'cause the rest did so before." The only way to preserve one's autonomy in the theater, John Northbrooke had earlier suggested, was to follow the example of Diogenes, who one day entered the theater as others were leaving it and, "being demanded why he did so," explained that he wanted to "differ from the multitude."[95] *The Roaring Girl* rejects such claims that the individual and the mass audience are fundamentally at odds with one another. The title character of the play, Moll Cutpurse, is a supremely social figure, always "i' the midst" of company and yet also always unshakably self-possessed. To explain her power to mingle so imperturbably with the crowd, the play gives Moll an identity that reflects the crowd's own variety, making her seem at once masculine and feminine, honest and roguish, generically and yet also singularly named. Moll, in short, exemplifies a mass individuality, and she champions this individuality as much for the masses as for herself. Generalizing from her own experience of "full playhouses," she defines theatergoing as an opportunity not only for enjoying the action on the stage but also for sizing up one's own place in the audience.[96]

"Masses is a herd term—unacceptable, insulting, degrading," the film director Frank Capra proclaimed in his autobiography. "When I see a crowd, I see a collection of free individuals: each a unique person; each a king or queen." As my second chapter explains, Capra's 1941 *Meet John Doe* seems to tell a different story about the masses and the entertainments they consume—a story closer to Paul Rotha's 1930 account of Hollywood film as "calculated to appeal to the lowest grade of intelligence."

In the movie's early sequences, a media conglomerate creates a folksy character named John Doe who so effortlessly captivates his mass audience that, after hearing only one of his radio speeches, they form John Doe clubs around the country. Encouraged by such credulity, the fascist owner of the conglomerate plans to use the clubs to propel himself into the presidency. As one contemporary reviewer observed, *Meet John Doe* thus appears to show "how easy it would be for a resourceful man to switch America into the totalitarian column."[97] Even more damning for Doe's mass audience is the character of the man they so instantaneously admire: a weakly amoral and seemingly witless drifter named Long John Willoughby who merely pretends to be John Doe and who never catches on to the full dimensions of the John Doe scheme until one of his handlers opens his eyes for him. Like Horkheimer and Adorno, Capra in *Meet John Doe* seems intent on demystifying the charismatic "supermen" at the head of fascist movements by revealing how they are merely "functions of their own propaganda machine," blank screens on which "the powerless ego of each individual" in the masses can be projected.[98] But like *The Roaring Girl*, *Meet John Doe* also strives to dramatize an individuality that can genuinely represent the masses while at the same time retaining its own distinctiveness. Over the course of his public performances as John Doe, Long John turns out to develop a version of Moll's uniquely composite personality. The difference from Moll is that Long John feels fractured by the audience he flies around the country to address as well as by the part he plays, and this heightened sense of incompleteness is what the film suggests ultimately legitimates him as a spokesperson for both the singularity and the multiplicity of his fellow John Does.

The second part of my book, "Show Business," takes its cue from the modern commentators who deny that mass entertainment constitutes any real diversion from labor. "More wearying and complicated than our work do we find the amusements that are offered us," says the cameraman narrator of Pirandello's 1915 novel *Si Gira*, translated in 1926 as *Shoot!*[99] The film theorist Miriam Hansen explains the point this way: "The imbrication of play with technology, along with the large-scale industrialization of leisure and amusement (in the West) since the mid-nineteenth century, complicates any clear-cut opposition of play and work or, rather, play and (alienated) labor."[100] But the historical specificity of Hansen's analysis is itself complicated by the much earlier transformation of play during the Renaissance, when, to the chagrin of many moralists, London's new theaters turned playing into an ostensible profession. Relishing the paradox, the satirist John Earle said of the "Player" in 1628 that "his life is not idle for it is all Action." The joke here depends on more than a pun: it's the *regularity* of playing in the permanent theaters

that makes Earle think of the actor as acting "all" the time and as thus undermining ordinary distinctions between labor and leisure. With the increased demand for new plays to satisfy the theaters' returning audiences, playwriting, too, came to be more and more frequently conceptualized as work. In 1605, an admirer commended Jonson for his "grave and learned toil" in playwriting; in 1612, John Webster applauded his fellow dramatists Shakespeare, Dekker, and Heywood for their "right happy and copious industry"; and in 1616, Jonson published his plays as *Works*.[101] Some contemporaries worried that the new theaters had even begun to professionalize playgoing itself: while endorsing "the *moderate* use and recourse which our *Gentlemen* make to *Plays*," Richard Brathwait (1630) "wholly" condemned "the daily frequenting of them: as some there be (especially in this City) who, for want of better employment, make it their Vocation."[102] My third chapter examines Shakespeare's career-long correlation of mass entertainment with such unsettling mixtures of work and play. In *The Comedy of Errors*, characters suffer confusion about the status of their actions when they are exposed to an urban crowd; in *1 Henry IV*, Prince Hal chooses to jumble work and play together, perversely dallying with commoners as a laborious strategy to "recreate" the kingship his father has devalued; while in *Hamlet* the prince is disgracefully distinguished by his half-pretended inability to separate the "action" in "enterprises of great pitch and moment" from the "actions that a man might play."[103] Through the characters of Hal and Hamlet especially, Shakespeare explored the costs and benefits of his audience's as well as his own commitment to what a later Renaissance commentator defined as "*play-work*."[104]

If show business is an explicit topic of discussion in *Hamlet*, it's the whole story in the 1933 Jimmy Cagney vehicle *Footlight Parade*. Like *The Jazz Singer*, *Footlight Parade* is a "backstage" musical, dramatizing all the hard work that goes into live song-and-dance shows.[105] The very notion of such a movie genre, not to mention its popularity, indicates how much more socially acceptable the idea of professional play had become by the twentieth century. And yet *Footlight Parade* continues to associate show business, as *1 Henry IV* and *Hamlet* had, with a maddening inability to parcel out time into different and distinguishable actions. A 1929 newspaper article described the director of *Footlight Parade*, Lloyd Bacon, as a workaholic who "usually" spends "his leisure moments" not getting away from it all but rather watching a film at the local "moving picture theater," like the "postman" who "goes for a hike on his vacation." In another article for the movie's pressbook, Bacon claimed that he, the cast, and the crew of *Footlight Parade* had "worked ourselves dizzy" to make the picture.[106] Bacon's counterpart in the film itself, Cagney's character Chester Kent, similarly toils round the clock

to put on song-and-dance shows; like Bacon, he seems unable to find a time for leisure apart from labor because he labors in the leisure industry. The difference between Chester and Bacon, however, is that Chester's workaholism sets him apart from the rest of his collaborators. He *overworks*, and *Footlight Parade* links Chester's special power to satisfy the demands of a mass audience with his special enslavement to his own internal compulsions. Movies had long been disparaged for their photographic dependence on objective reality, which, many critics assumed, left no room for artistic invention. But in *Footlight Parade*, Chester demonstrates his creativity by staging musical extravaganzas that begin to exceed and even overwhelm reality. His shows translate his obsessive overwork into a phantasmagorical boundary breaking that enables them to match the superabundance of their audience.

The third part of my book, "Junk and Art," focuses on a problem that twentieth-century writers regularly viewed as distinctly and depressingly modern. According to Aldous Huxley in 1934, for instance, recent technological "advances" in catering to "an enormous public" meant that "in all the arts the output of trash is both absolutely and relatively greater than it was in the past."[107] In no other medium did this "garbage flood," as the theater critic George Nathan (1921) called it, seem more painfully apparent than in the mass entertainment of the movies, which Nathan accused of practicing a kind of reverse alchemy: "they have bought literature and converted it, by their own peculiar and esoteric magic, into rubbish."[108] Hundreds of years earlier, however, Erasmus had similarly bewailed the "flood" or "mob" of "indiscriminate rubbish" that had been generated by the printing press, and many others joined him in exclaiming over a "vast" new "*Chaos* and confusion of books."[109] In his *Histrio-mastix*, William Prynne fulminated against the profusion of cheap "*Quarto*-Play-books" in particular, which had now "come forth in such abundance, and found so many customers, that they almost exceed all number." Contrasting the admirable "paucity and fewness" of classical plays to "the multitude" of "these modern Plays, wherewith the world is now so pester'd," Henry Crosse declared that plays had become as "vulgar and common" in their "method of writing" as in their "time, place, and company."[110]

My fifth chapter, "Mocked with Art," takes up this question of the garbage flood *within* Renaissance plays by examining Jonson's attack on the dramatists of "this age" who "utter all they can, however unfitly," in order to please the rude multitude. How, Jonson asks, can you pursue artistic distinction if you cater to an indiscriminate mass? Many theater historians have consequently decided that Jonson eschewed any similar ambition to engage "an enormous public," but *The Alchemist* (1610) paints a different picture: it shows Jonson attempting to strike a balance

between art and mass entertainment by deceiving the multitude into believing that he is giving them the trash they desire.[111] In the second half of the chapter, I turn to a contemporaneous play of Shakespeare's that takes Jonson's account of the playwright as con artist further than Jonson was willing to go with it. When Shakespeare at the end of *The Winter's Tale* (1610) reveals that the exquisitely wrought statue of Hermione is actually a sham, he does not thereby disclaim art for entertainment, any more than Jonson disclaims entertainment for art. *The Winter's Tale* suggests instead that the mass entertainment of the theater precariously merges these different identities, just as it provisionally unites a mixed audience whose fellowship the playwright only ever joins in part.

"Junk" is the final word spoken in Hollywood's most famous art project, *Citizen Kane*. My final chapter connects this strange incongruity to the difficulties that contemporary movie-lovers encountered when trying to reconcile film as art with film as mass entertainment. In his landmark book *The 7 Lively Arts* (1924), Gilbert Seldes defended the "artistic value" of the "simple and cheap" over the "serious and pretentious." Echoing Seldes in her later essay "Trash, Art, and the Movies" (1969), Pauline Kael claimed of movies that "the wellspring of their *art*, their greatness, is in not being respectable." Yet to call movies art was to make them respectable, and so cinephiles from Seldes onward continually wavered in their assessments of film. "Movies are so rarely great art," Kael contradictorily asserted in her "Trash" essay, "that if we cannot appreciate great *trash*, we have very little reason to be interested in them."[112] *Citizen Kane* offers us three different registers for understanding its own persistent intermingling of art and junk. The first is Charles Foster Kane's dual career as a newspaper publisher and an art collector; the second, Kane's cross-class marriage to the shopgirl Susan Alexander; and the third is the film's signature visual motif, which I call a *scatterform*. Comparing these features of *Kane* with similar features in a more conventional Hollywood film, *My Best Girl*, the chapter shows how *Kane* seizes on film's categorical indeterminacy as a mark of its aesthetic independence—and film "must be unique," Seldes claimed, if it is to count as "art."[113] That is why *Citizen Kane* ties its own artistic bravura less to the statuary that Kane amasses than to such mass-consumed junk as his childhood sled.

I close my book with an epilogue on a fourth motif of mass entertainment that I have already discussed at length in my book *Shakespeare Only*: the paradox of the single author in mass entertainment. "To please all," the Renaissance dramatist Thomas Heywood asserted in 1624, a playwright must "fashion" himself "to a multitude." Heywood's fellow dramatist Shirley (1647) similarly emphasized the need for a "vast

comprehension" in the mass-entertaining playwright, who must possess "a *Soul miraculously* knowing, and conversing with all mankind." For a third dramatist, John Dryden, writing in 1679, the chief exemplar of such superhuman breadth was Shakespeare, whose "Universal mind … comprehended all Characters and Passions."[114] This notion of Shakespeare's singular comprehensiveness, I argued in *Shakespeare Only*, had already emerged in his own lifetime, drawing strength not only from his popularity and his extraordinary dramatic range but also from his professional versatility as an actor-playwright. Yet earlier playwrights, too, had been praised for their crowd-pleasing breadth: the ideal that Shakespeare fulfilled belonged to mass entertainment before it belonged to Shakespeare.[115] My epilogue shows how mass entertainment promoted this same ideal in the movies as well, where the comprehensive dramatist reappeared in the guise of the film *auteur*.

Critics of the *auteur* have tended to represent him or her as a scheming latecomer to the cinema, yet by 1921 a book called *How to Become a Film Artiste* could already take it as an "easily" graspable "fact" that a director "is, or should be, the 'master mind' of the studio." The "hallmark" of a "great" director, the book went on to claim, is his "versatility": "he must be actor, author, mechanic, electrician, camera man and artist combined"; "he must possess a profound knowledge of human nature and psychology"; and he must even "be thoroughly competent when handling and directing large crowds"—in all respects fashioning himself to a multitude.[116] For many contemporaries, the cinematic author who best filled this comprehensive bill was Chaplin. Not only was Chaplin "the everyman of the twentieth century": his every film was "almost literally a one-man show."[117] Yet if Chaplin was indeed a "one-man dynamo who was used to doing everything for himself," where did this leave his collaborators, or, for that matter, his audience? Focusing on *City Lights*, in particular on the connection between the film's opening mockery of statues and its final tragic close-up on the Tramp, my epilogue demonstrates how Chaplin's ambition to achieve a Shakespearean comprehensiveness committed him as much to abasing as to promoting himself in the public eye. The film scholar Richard Ward speaks of a fundamental "disconnect" in Chaplin's movies: "how to be taken seriously as an artist while clad as a low-grade clown." But this incongruity is never simply a problem for Chaplin: as my epilogue explains, it's also the secret to his success as a mass entertainer.[118]

PART 1

The Individual and the Mass

1

Which Moll?

No man is the lord of any thing,
Though in and of him there be much consisting,
Till he communicate his parts to others.

—Ulysses in Shakespeare's *Troilus and Cressida*

Something's missing from the only surviving contemporary drawing that takes us inside an Elizabethan theater. (Actually, the drawing itself is missing: what survives is a copy of the original.) Around 1596, the Dutch traveler Johannes de Witt visited the newly built Swan theater and sketched a cutaway illustration of it in his notebook.[1] In his drawing, we see three actors on a bare stage. Behind them are eight figures in a balcony: these may be wealthy spectators enjoying an Elizabethan version of box seats, or they may be musicians, like the trumpeter in the doorway of the hut above the stage, or they may be more actors. What we don't see is a single playgoer in any other part of the Swan's vast auditorium, even though an accompanying note by de Witt states that the Swan was capable of seating three thousand spectators.[2] Taking the sketch literally, the theater historian Paul Menzer has described it as the recording of a commercial flop: on most days, Menzer claims, Renaissance English playhouses failed to attract anything close to a capacity crowd. But the audience is not simply meager in de Witt's illustration: aside from the eight balcony figures, who might not even be playgoers, there are no spectators at all.[3] A. M. Nagler more plausibly guesses that the Swan was empty when de Witt drew it because "a rehearsal was in progress." But John Gleason casts doubt on this equally literal-minded reading of the audience's absence by noting the similarities between de Witt's drawing and Justus Lipsius's cutaway illustration of the Roman Colosseum

in his *De Amphitheatro* (1584), which shows gladiators and animals battling in the arena before a solitary spectator, the emperor. Gleason argues that we must interpret both illustrations in the light of the pictorial "conventions" they follow: in his view, de Witt as well as Lipsius regarded their drawings as "schematic" rather than "photographic," a "picture of the theater in its essentials" that was "intended to show how the theater *worked*." Although neither artist bothered to sketch in the audience "laboriously head by head," "this does not mean that no one was present; it means simply that an audience, as a functioning part of a public performance, could be taken for granted."[4] But Lipsius doesn't take the emperor for granted: Gleason's purely practical account of pictorial convention glosses over the ideological implications of Lipsius's decision to exclude every spectator but the emperor from his representation of a working theater.[5] Another convention shared by the two illustrations is their impossibly lofty point of view, which allows each artist to scan the theater from above it, not from within it, and thus further dissociate himself from the crowd. In a sense, then, Gleason is right: both Lipsius and de Witt regard the mass audience as *in*essential to the theater. [6]

Modern theorists of mass entertainment tend to share de Witt's vision of Renaissance playhouses. There were no mass audiences in *any* theaters, these writers assume, until theaters became the places for seeing movies rather than plays. Strangely enough, this more recent denial of the crowds who filled Renaissance playhouses has only been reinforced by the sort of ideological alignment with the masses that Lipsius and de Witt eschewed. According to Marxist commentators such as Walter Benjamin, for instance, mass entertainment first arose in tandem with "the mass movements of our day," when technological advances in "reproducibility" enabled such new media as film not merely to reach but also to "mobilize" the masses, by providing them with "an object of simultaneous collective reception" that encouraged a "new mode" of mass "participation." And yet Benjamin's belief in movies as mass community builders closely mirrors the views of Renaissance theater-lovers who welcomed the audiences that de Witt barred from his illustration. According to the Elizabethan dramatist Thomas Nashe, for instance, London's new amphitheaters were themselves a technological advance in addressing the masses, and Nashe claimed that the plays for these amphitheaters—particularly, it seems, the first part of *Henry VI*—were inspiring a new sense of mass solidarity among the audience. "How would it have joyed brave *Talbot* (the terror of the French)," Nashe wrote in 1592, "to think that after he had lien two hundred years in his Tomb, he should triumph again on the Stage, and have his bones new embalmed with the tears of ten thousand spectators at least (at several

Aernout van Buchell's copy of Johannes de Witt's sketch of the Swan Theater (c. 1596).
Utrecht, University Library, Ms. 842, fol. 132r

times), who, in the Tragedian that represents his person, imagine they behold him fresh bleeding."[7] Contrary to Lipsius's elitist focus on the emperor as a sufficient audience of one, Nashe emphasizes that his audience spans class divisions: whereas the memory of English heroes, Nashe claims, had once been confined to "worm-eaten books" and therefore to the relative few who could buy and read books, now those heroes have been "raised from the Grave of Oblivion, and brought to plead their aged Honors in open presence." "Open presence": the phrase is telling in its ambiguity. So exclusively does the stage define the theatrical

Justus Lipsius's engraving of the Colosseum in his De Amphitheatro *(1584)*.

experience in de Witt's drawing that no human figure appears outside our sight lines to the proscenium. But Nashe's "open presence" blurs the distinction between stage and auditorium: it defines the theatrical experience inclusively, as the presence of the actors and the audience to one another.

Even in Nashe's celebratory account of the theater, however, there is a shadow of de Witt's and Lipsius's aversion to the crowd. Community building as Nashe describes it requires sacrifice: the singularly heroic Talbot promotes solidarity among the "ten thousand" in the audience only through his suffering, his "bleeding." (In *1 Henry VI*, "ten thousand" is the number of English soldiers sent to aid Talbot at the start of the play, but it's also the number of French soldiers in the force that later kills him.)[8] For Nashe, it seems, power cannot belong to the lone figure on the stage and to the mass audience simultaneously: the audience can achieve an integral unity only if the bleeding Talbot appears to lose his own. In his drawing, Lipsius similarly placed the one in competition with the many, although he solved the problem by simply erasing the masses from the theatrical scene. Elizabethan theater critics emphasized another version of the conflict, this time between the throngs in

playhouses and individual playgoers. "I dare boldly say, that few men or women come from Plays and resorts of men with safe and chaste minds," John Northbrooke warned in 1577, "for what mind can be pure and whole among such a rabblement, and not spotted with any lust?" In Northbrooke's eyes, the paradigmatically imperiled theatergoer was a woman: it was in "resorting to such open place" as the theater, he claimed, that "the daughters of Israel" made themselves vulnerable to "the Benjamites," just as it was the desire of the Sabine women "to be present at open spectacles" that exposed them to rape. Almost by definition for Northbrooke, the individual who joined the open presence of the theater would sacrifice her wholeness and integrity, for "what safeguard of chastity can there be, where the woman is desired with so many eyes, where so many faces look upon her, and again she upon so many?"[9]

If Benjamin echoed Nashe's enthusiasm for the mass audience, he also shared the anxiety of Nashe as well as Northbrook about the fate of the individual in mass entertainment. An alternative to the historical synchronism of film and mass movements haunts Benjamin's "Work of Art" essay: the simultaneous emergence of film and fascism. Benjamin ends his essay by acknowledging how successfully film can be used to organize and then dehumanize the masses. Yet his utopian reading of mass entertainment is undermined even before he admits the political contingency of the "progressive" outcome he desires, by his correlation of the masses with the mass reproduction that robs artworks of their "authenticity." Taken to its logical conclusion, Benjamin's analogy between masses of people and masses of copies would seem to drain individuals as much as artworks of any distinctive value, leaving them equal only insofar as they are equally inauthentic.[10] That is precisely the conclusion reached by such modern enemies of mass entertainment as Clement Greenberg, Theodor Adorno, and Max Horkheimer. According to Greenberg, the masses in mass entertainment crowd out "the cultivated spectator" and reduce culture to "the general mass-level." So, too, Horkheimer and Adorno envision mass entertainment as a battleground where "the thinking individual" is inevitably "defeated" by "the power of the generality."[11]

For the rest of this chapter, I want to show how these dystopian as well as utopian accounts of the masses in modern theories of mass entertainment already figured prominently not only in the Renaissance commentary on the theater but also in the drama itself. My example will be a comedy that was first performed less than two decades after de Witt visited the Swan: Thomas Dekker and Thomas Middleton's *The Roaring Girl* (1611). In that play, T. S. Eliot famously observed, "we read with toil through a mass of cheap conventional intrigue, and suddenly realize that we are, and have been for some time without knowing it, observing

a real and unique human being." Eliot's admiration for the "unique" figure arising from the "mass" of *The Roaring Girl* reflects Dekker and Middleton's paradoxical investment in dramatizing both a distinctive character *and* a mass audience. For Dekker and Middleton, I'll show, these two entities do not so much compete with one another as define one another. The uncommon individual in *The Roaring Girl* is fundamentally mass-oriented, a woman who thrives in open presence, but she also champions a conception of mass camaraderie that is perfectly suited to her individualism. When the Renaissance theater replaced traditional festivity with performances "made available for purchase to a diverse audience of anonymous consumers," Michael Bristol has suggested, "a new kind of social interaction" began, based no longer on neighborly intimacy but now "on disengagement, social distance, and the acknowledgement of difference." The result, Bristol contends, was not inevitably the alienation that modern theorists associate with "mass" as opposed to "popular" culture: insofar as it was "a consensual undertaking between players and their audiences," the theater might also have encouraged an ethos of "mutual forbearance and urbane tolerance."[12] *The Roaring Girl*, I'll argue, presents itself as sponsoring a similarly loose yet cohesive sociality, which the play formulates in terms not only of the ambiguous Moll but also of its own equivocal nature as at once a stage show, a mass gathering, and a circulated reproduction in print.

Moll en Masse

Early in *The Roaring Girl*, a character reverses the normal line of sight in the theater and describes how the audience looks from the stage: he claims to see

> Stories of men and women, mixed together
> Fair ones with foul, like sunshine in wet weather.
> Within one square a thousand heads are laid
> So close that all of heads the room seems made;
> As many faces there, filled with blithe looks,
> Show like the promising titles of new books
> Writ merrily, the readers being their own eyes,
> Which seem to move and to give plaudities.[13]

Here are de Witt's missing heads, envisioned as a mass in the terms of two media at once. In the 1611 print version of *The Roaring Girl*, which appeared shortly after the play was first performed, Middleton boasted to readers that the play could now "be allowed both gallery room at the playhouse and chamber room at your lodging," and the passage on the

thousand heads seems to anticipate these twin spheres of reception for the play. But theater and print do more than complement one another in the passage. Print transforms the classical conceit of the many-headed multitude by associating the theater audience with the modern repro-ducibility that generates mass-distributable copies. The audience, in turn, help transform the conceptualization of print. With their faces likened to books and their eyes to readers, the audience become an image—a revealingly strained and chimerical image—of a print com-munity that was otherwise visible at the time in devotional settings only: in church, where worshipers could read from separate copies of *The Book of Common Prayer*, or at more irregular religious gatherings, where participants could consult their own copies of the Bible.[14] Over the course of the passage, this conceptual reciprocity between theater and print reflects and reinforces the mutuality of otherwise diverse spec-tators, "fair and foul," who, once they are "mixed together" in the thea-ter, appear uniformly "blithe," like mass-produced copies of similarly merry books. Joining forces in the passage as two distinct mass-delivery systems, print and drama appear to consolidate the audience into a con-sensual fellowship.

These utopian solidarities are quickly compromised, however, as the passage peers more deeply into the packed audience and sees that "here and there, whilst with obsequious ears / Thronged heaps do listen, a cut-purse thrusts and leers / With hawk's eyes for his prey." Now print and theater seem almost *too* effective at resolving differences among diverse spectators. Massed together by the play and then likened to mass-pro-duced books, the audience appear no longer as a merry fellowship but rather as "thronged heaps." And this dehumanizing reduction coincides with an "obsequious" absorption in the play that progressively narrows its spectators to "heads," then to "faces," "eyes," and "ears," leaving the rest of their persons vulnerable to a villainous exploiter of their shared good feeling: the predatory thief. Time and again throughout the Renaissance, playgoers were warned that crowded theaters made them an easy mark for pickpockets; often, the actors were said to be in cahoots with the thieves, distracting their victims while the pickpockets went to work. Some moralists claimed that actors were in any case a kind of pickpocket, because these "flattering coney-catchers" give us nothing for our money and thus, as Gosson marveled, "ransack our purses by permission."[15] The passage on the thousand heads links the theater's pickpocket with the theft of more than money: keen and wary, in sharp contrast to the blithe ignorance of thronged heaps, the lone cutpurse appears to have stolen the individuality as well as the agency of the playgoers, too. From a dream vision of the kind of fellowship that Benjamin hopes mass entertainment will generate, the account of the

audience in this passage seems to have degenerated into Horkheimer and Adorno's nightmare of "the deceived masses."[16]

Yet the entire description of the audience that I have been quoting from *The Roaring Girl* is the view of only one character in the play, and it is not even literally a description of the audience. It is spoken by a wealthy London citizen, Sir Alexander Wengrave, as he leads some similarly affluent dinner guests from an "inner room" that was "too close" to a more spacious and airy "parlor" in his home. After boasting that the furnishings in this parlor "cost many a fair gray groat," Sir Alexander promises to show his guests a third portion of his home "trimm'd up" with still finer treasures: the image of a thousand heads packed "close" together, as his guests just were, appears on a tapestry or painting in these "galleries," not in the "gallery room" of the theater that Middleton mentions in his prefatory letter.[17] In dramatic context, then, the character who tells the audience how they look from the stage denies that he is looking at them, talking about them, or even standing before them. And yet, at the same time as he distances himself from the audience, he takes advantage of their own compression within the narrow room of the theater to reduce them both as spectators and as spectacle: he transforms them, imaginatively, into a picture hanging on a wall, displayed for private viewing by the sort of connoisseur that Greenberg believes mass entertainment eradicates, "the cultivated spectator."

Money makes the difference, for Sir Alexander: before he speaks of the audience as mass-produced copies or thronged heaps, he stresses how many indistinguishable gray groats it took to purchase the image of them.[18] The passage, in short, characterizes the speaker as well as the audience: it gives him specific class interests for belittling them. In performance, the passage also undercuts the speaker's sense of superiority to the audience by placing him onstage before them. Dekker and Middleton's implicitly satirical connection of the perceived throng with the elitism of the perceiver retains its bite when applied to modern claims that mass entertainment dehumanizes its audience. "The culture industry as a whole," Horkheimer and Adorno declare, "has molded men as a type unfailingly reproduced in every product"; "now any person signifies only those attributes by which he can replace everybody else." The problem with taking the analogy between mass audiences and mass reproduction so literally is not merely the exaggeration that this totalizing claim requires. If "everybody" has been "unfailingly" reduced to copies of mass-produced entertainment and therefore to copies of each other, then how have Horkheimer and Adorno escaped the same fate?[19] Benjamin speaks more cautiously not of the sameness but rather of the "*sense* for sameness" that mass reproduction has encouraged. Horkheimer and Adorno fail to acknowledge that they might share this

sense, which is to say that they might have derived their faith in the identicality of consumer and consumed from the very culture they deride.[20]

Even as he distances himself from the theater's mass audience, Sir Alexander raises the specter of his entanglement with them by his discerning eye for an exceptional individual like himself *among* the audience—the cutpurse. Sir Alexander blurs the identification by depicting the cutpurse as little more than the negative of the audience, the public enemy who expropriates their value. "Every throng is sure of a pickpocket," another character in *The Roaring Girl* will later declare, as if the pickpocket were the logical corollary of the throng, its dialectical shadow.[21] So generic and conventional a figure in the theatrical scene does the cutpurse appear to Sir Alexander that he says the thief "need not" be identified: "By a hanging villainous look yourselves may know him." Distancing themselves from mass entertainment, Horkheimer and Adorno similarly dismiss the ostensible "individual" to be found there as nothing more than a "stereotype," a "deceitful substitution" for the real thing.[22] But to what extent, *The Roaring Girl* asks, does the enemy of mass entertainment share the merely antithetical and therefore stereotypical difference of the cutpurse from the masses, a spurious individuality that reflects the throng from which it illegitimately extracts its sense of self-worth?

Sir Alexander is not deaf to such unsettling inquiries, we soon learn: he is, rather, obsessed with the thought of being reduced to the general mass level. Before the parlor scene has ended, both the throng and the cutpurse become embodied for him in a single character who appears to have thrust her way into his private life. Her name makes her sound inhumanly generic, like the very personification of a villain: it is Cutpurse with a capital *C*, Moll Cutpurse, the hell-raising or "roaring" girl. And yet Sir Alexander believes that this "creature," this "thing," is so close to him that she threatens to become a member of his family, as the "drab" his son Sebastian plans to marry. In truth, Sebastian is only pretending to love Moll: the real object of his affection is another woman who also happens to be nicknamed Moll—Mary Fitzallard, the daughter of Sir Guy Fitzallard. As Sebastian informs us in the first scene of the play, which is followed by the scene in Sir Alexander's parlor, Sir Alexander has blocked Sebastian's marriage to Mary because he views even this high-class Moll as a comedown, a drain on the wealth that keeps him elite: "He reckoned up what gold / This marriage would draw from him, at which he swore, / To lose so much blood could not grieve him more." As Sebastian expects, his new attachment to the Roaring Girl proves to be infinitely more devastating to his father, above all because Moll loves to make a vulgar spectacle of herself. "Let this strange thing walk, stand, or sit," Sir Alexander exclaims, "no blazing

star draws more eyes after it." Indeed, Moll will later torment Sir
Alexander with the thought that her marriage to Sebastian will turn Sir
Alexander himself into the object of mass scrutiny: "You had no note
before, an unmarked knight; / Now all the town will take regard of you."
To avoid such a degrading immersion in the scene of mass entertain-
ment that he has captured and contained in his picture of a thousand
heads, Sir Alexander hopes that he can use his money to "draw" Moll
into a similarly constrictive trap. "Hunt her forth," he commands a
rogue he has hired for the purpose. "Cast out a line hung full of silver
hooks / To catch her to thy company. Deep spendings / May draw her
that's most chaste to a man's bosom."[23]

Yet Moll cannot herself be drawn: Sir Alexander's money repeatedly
fails to entice her, let alone to debauch her. How can so ostensibly cor-
rupt a figure prove so incorruptible? Sebastian, the first character in the
play to mention Moll, speaks of her with a mixture of contempt and
admiration:

> There's a wench
> Called Moll, Mad Moll, or Merry Moll—a creature
> So strange in quality, a whole city takes
> Note of her name and person.

To Sebastian, Moll is at once the most common and uncommon of
creatures. "Strange" as she is, she attracts the attention of "a whole
city," and this mass notoriety is hard for him and other characters in
The Roaring Girl to conceptualize. Again and again they weakly attempt
to capture Moll's unique commonness by adding minor specifications to
her otherwise generic name. "Mad Moll, or Merry Moll" is what
Sebastian calls her, and in the next scene his father repeats these nick-
names, "Mad, Merry Moll," as he strains to identify the particular
whore he has in mind. "Life, yonder's Moll," another character exclaims
in the third scene of the play, and when a companion asks him "which
Moll" he means, "Honest Moll" is all his friend can reply.[24]

In the close quarters of the city as the play presents it, individuality
can often seem as insubstantial as the "spangled feather" that a shopper
in this third scene prefers to the more fashionable or "general" feather a
saleswoman has offered him: "Tell me of general!" he snorts scornfully.
But *The Roaring Girl* also explores the possibility of a mass individual-
ity that cannot so easily be reduced to the throng from which it is dif-
ferentiated. In her magisterial work *The Printing Press as an Agent of
Change*, Elizabeth Eisenstein famously hypothesized that "the emer-
gence of a new sense of individualism" in Renaissance Europe might
have been generated by the very technologies that Horkheimer and
Adorno treat as inimical to individuality: the type, Eisenstein observed,

sets off the atypical, and it may be that "the more standardized the type, indeed, the more compelling the sense of an idiosyncratic personal self." Sebastian comes to offer a version of this typological argument when defending Moll to his father. Sir Alexander declares that the "very name" of Moll should repel Sebastian, because if he were to search "all London from one end to t' other," he would find "more whores of that name than of any ten other." But Sebastian counters that Moll's distinctiveness is only heightened by contrast with the promiscuity of her name and of the women who share it: her "honesty," he maintains, "should rather / Appear more excellent, and deserve more praise, / When through foul mists a brightness it can raise." The notion that one might define oneself "through" a crowd is simply meaningless to Sir Alexander, whose sense of self-worth depends on his being kept apart from the throng. "Wouldst thou fain marry to be pointed at?" he demands of Sebastian. "Why, as good marry a beacon on a hill, / Which all the country fix their eyes upon." By the end of the play, however, Sir Alexander will come to accept that his fear of the masses was itself a version of succumbing to them. Even his hatred of Moll, he confesses to her, was generated by letting others do his thinking for him: now, he decides, "I cast the world's eyes from me, / And look upon thee freely with mine own." While Moll's surprising integrity has helped teach him this lesson, so has her surprising indifference to the public eye. "Perhaps for my mad going some reprove me," Moll allows, but "I please myself, and care not else who loves me."[25]

As radically self-reliant as she is, however, Moll is no loner. On the contrary, she converses with nearly every character in the play: lovers, shopkeepers, gentry, and rogues. She "mingles with mankind," as Sebastian admits to his father; indeed, "the whole city" comes in view for Sebastian when he thinks of Moll. It is not merely that Moll evokes the multiplicity of London for him. Like a monarch conferring her own oneness on a kingdom, Moll in her strangely chaste promiscuousness makes it possible for Sebastian to conceptualize that multiplicity as an integral "whole," and to do so without reducing Londoners to throngs or heaps.[26] If Moll's ability to personify the city this way derives from her willingness to participate with all sorts of citizens, it also depends on her refusal to identify with any particular group of them.[27] The first time we meet her, we see her resisting the call to settle down:

ALL Moll, Moll, psst, Moll!
MOLL How now, what's the matter?
GOSHAWK A pipe of good tobacco, Moll?
MOLL I cannot stay.

"She slips from one company to another," sighs an admirer, "like a fat eel between a Dutchman's fingers." Not even the broadest of particularities can capture her. To Sir Alexander's eyes, Moll is an unaccountable hodgepodge of genders: "'Tis woman more than man," he bemoans, "man more than woman." Moll herself will later admit as much to her pretended lover Sebastian: "I love to lie o' both sides o' th' bed myself." Moll "strays" from her "kind," as Sir Alexander puts it; in stark contrast to his own tormented elitism, she maintains her "peculiar" self-possession by *mixing*.[28]

Ultimately, this urbane individuality of Moll's generates a countervision not only to Sir Alexander's elitist sense of self but also to his distanced and aestheticized representation of mass entertainment. In the next-to-last scene of *The Roaring Girl*, Moll mingles with two vastly different groups of Londoners: a coterie of gentlemen and a gang of thieves. She mediates between these two groups, or rather, she helps the gentlemen grasp the criminal intent of the rogues by translating their specialized argot or "canting" into more generally comprehensible English.[29] But the gentlemen seem as dismayed by Moll's familiarity with rogues as they are impressed by it. "I wonder how thou cam'st to the knowledge of these nasty villains," says one of the gentlemen, while another takes the occasion to ask, "And why do the foul mouths of the world call thee Moll Cutpurse? A name, methinks, damned and odious." To defend herself, Moll evokes the time she has spent in theaters:

> I must confess,
> In younger days, when I was apt to stray,
> I have sat amongst such adders, seen their stings—
> As any here might—and in full playhouses
> Watched their quick-diving hands, to bring to shame
> Such rogues, and in that stream met an ill name.[30]

The speech returns us to the scene in Sir Alexander's parlor, but now the picture of a theater audience has been redrawn in several crucial ways. The first difference is the overt rather than implicit theatrical setting; the second, that Moll as spectator is not distanced from the audience but rather sits "amongst" them, and enjoys a view that "any here" might share. This immersion in the scene gives Moll a local perspective on her fellow playgoers, not a global one like Sir Alexander's: indeed, she mentions their numbers only indirectly, by reference to the "full" playhouse. What she focuses on instead is the cutpurse, who seems, ironically, to have robbed the audience of their anonymous multiplicity: in place of the single thief in Sir Alexander's picture, Moll speaks of numerous "rogues," whom she dehumanizes as "adders" and reduces to "stings" and "hands," as the audience had been dehumanized and reduced in Sir

Alexander's account of them. Moll's scorn for the cutpurses befits her assertion that she consorts with thieves only to "bring" them "to shame"; her true allegiance, by implication, is to the otherwise victimized audience. But again, she never mentions the audience as such: moments earlier, we witnessed her forcing an unnamed cutpurse to reimburse a *single* spectator, "a knight" who had "lost his purse at the last new play i' the Swan." Characteristically, Moll presents herself as both within and apart from the theater crowd. She sees what others do not see; yet, by placing herself among the audience, by resisting the temptation to deride them as a witless throng, by transferring this disparagement to the cutpurses she betrays, and then by generalizing her capacity for wary alertness to "any" playgoer, Moll also offers herself as a model of the sturdy self-possession that all similarly honest spectators might copy. In the packed, potentially draining environment of the theater, Moll presents herself as being open to the multiplicity of the audience without being dehumanized by their massiveness and without dehumanizing them into a mass. That is how the prologue to the play first introduced her. "A roaring girl (whose notes till now never were) / Shall fill with laughter our vast theater": ascribing vastness to the theater, not to the throng who fill it, the prologue registered its mass audience only through its confidence in the positive consensual effect that a single idiosyncratic character would have on them.[31]

Moll in Part

Yet how can one character fill a whole theater, and remain whole in doing so? Near the end of *The Roaring Girl*, Sir Alexander is so deeply agitated by the thought of his son's marrying a woman "whom all the world stick their worst eyes upon" that he feels himself "drawn in pieces betwixt deceit and shame." A few moments later, when the play has ended and Moll alone remains onstage to voice the epilogue, she turns Sir Alexander's perplexity into a question about the coherence of her own character, and of the play to boot:

> A painter having drawn with curious art
> The picture of a woman—every part
> Limned to the life—hung out the piece to sell.
> People who passed along, viewing it well,
> Gave several verdicts on it. Some dispraised
> The hair; some said the brows too high were raised;
> Some hit her o'er the lips, misliked their color;
> Some wished her nose were shorter; some, the eyes fuller;

Others said roses on her cheeks should grow,
Swearing they looked too pale; others cried no.
The workman still, as fault was found, did mend it,
In hope to please all; but this work being ended
And hung open at stall, it was so vile,
So monstrous, and so ugly, all men did smile
At the painter's folly. Such we doubt
Is this our comedy.[32]

Once again the scene of mass entertainment has been redrawn for us: Sir Alexander's artwork has been moved from the rich man's private gallery to an "open" city street. Now, however, the pictured subject has one head, not a thousand, while the audience, released from direct representation, have been disaggregated into various spectators who are free to pass through the city and, as they chance to encounter the picture on display, to exercise their diverse judgments on it. This new vision of the relationship between art and the masses would seem to anticipate the revolution in entertainment that Benjamin claimed could begin only with the introduction of modern technological reproducibility. In the pre-photographic era, Benjamin asserted, art was rarely "accessible" to the common people, but now the mass production and distribution of photographic copies have brought the artwork "closer" to everyone, weakening its aura and thereby strengthening the critical agency of the masses.[33] *The Roaring Girl* enacts a similar transformation, but without the aid of modern technology, and over the course of a single play: under the urban and more specifically theatrical pressure that the play has exerted on Sir Alexander's elitism, his private artwork has been turned into a "piece" of public entertainment "hung out" for sale.

What's missing from the Benjaminian story line at this late juncture in *The Roaring Girl* is the happy outcome: the critical responses of passersby end up ruining the artwork, and the formerly blithe consensus of the audience in Sir Alexander's picture degenerates into the jeering "smile" of "all men." How has the story gone wrong? The trouble seems to begin with the artwork as a copy. At first, the picture is praised as a faithful reproduction of the woman it mirrors, with "every part / Limned to the life." Middleton's epistle to the reader had broadly hinted that *The Roaring Girl* is just such a portrait, and indeed the figure of Moll closely resembles an actual contemporary, Mary Frith, whom Katharine Maus has called "the first positively identifiable living person" in English drama "to be translated into a quasi-fictional dramatic realm." According to Valerie Forman, Moll's distinctiveness as a dramatic character must at least partially derive from this uncommon link to a real-life Londoner, who was herself a notorious cross-dresser and associate of thieves.[34]

Other commentators, however, have cast doubt on Frith's singularity as a roaring girl in Renaissance London, and in so doing they echo the prologue to the play, which claims that Moll Cutpurse is only "one" among "many" in the "tribe" of roaring girls.[35] But then the very reproduction of Frith in Moll would seem to weaken Frith's claim to uniqueness as the roaring girl. In a Derridean passage from his late writing, Adorno criticized Benjamin for failing to recognize how any representation—even a "cave drawing"—exposes the alienability of image from object and thus the reproducibility of the object.[36] *The Roaring Girl* does indeed repeatedly associate drawing with expropriation and thievery: for instance, in the cutpurse's face "drawn so rarely," or in the "gold" that marriage "would draw from" Sir Alexander, or in the "deep spendings" that Sir Alexander hopes will "draw" Moll into his trap. In the epilogue, the artist's drawing or alienation of the image from the woman makes it possible to expose that image, and therefore that woman, to mass scrutiny, and the result is a "monstrous" distortion, whereby the image comes to mirror the diverse, incompatible tastes of the passersby more than the individual it copies.[37] In effect, the woman's parts can no longer cohere because they now belong to the city, not to her.

But a play is not a picture. By comparing the two, the epilogue to *The Roaring Girl* highlights the greater flexibility of theater as an entertainment for the masses. The picture, a flat hanging portrait that carefully replicates the image of a single head, offers only one scene for viewing, and a scene so inadequate to the diversity of its viewers that it disintegrates under the pressure of urban scrutiny. The stage, by contrast, has several heads on display, and bodies, too, all given to speaking, all disguised, and all in motion. While Moll may be the title character of *The Roaring Girl*, her plot is only one of many in the play, a "mass" of alternatives, as Eliot said, for a heterogeneous audience. Even if the action onstage should be found wanting, the theater as *The Roaring Girl* advertises it has still more perspectives to offer: views of the packed galleries, or of the stealthy cutpurse, or of the standing room on the floor, which Sir Alexander says "waves to and fro" like "a floating island." It is this visual depth of field that makes the playhouse seem more "open" to the diverse tastes of its spectators than the picture could be.

At the same time, however, the epilogue distances *The Roaring Girl* from the radical commitment to openness that leads the artist to ruin his picture. Noël Carroll endorses a version of this commitment when he argues that an entertainment can claim to have been intended for the masses only if it has also been "designed to be immediately accessible" to them. This stipulation helps explain why Carroll, like Benjamin before him, shows so little interest in print as a mass delivery system:

print requires literacy, whereas "pictorial representation" is, as Carroll says, "virtually immediately accessible to untutored audiences world-wide." Greenberg, Adorno, and Horkheimer would insist on the inevitable debasement of an art that levels downward this way. But the epilogue to *The Roaring Girl* underscores a different problem: how can an artwork be made accessible to every sensibility in a mass audience? The result, according to the epilogue, is a "monstrous" incoherence for the artwork and for the audience, whose heterogeneity the artwork merely reflects back to them: "If we to every brain that's humorous / Should fashion scenes, we, with the painter, shall, / In striving to please all, please none at all."[38]

Carroll himself proposes an alternative standard for mass entertainment, although he mistakenly equates it with accessibility: if "the intended function of mass art is to elicit mass engagement," he argues, then mass art must be designed "to capture and hold the attention of large audiences." The difference between attention-getting and accessibility as artistic goals is that one is so much less value-laden and prescriptive than the other. Being accessible to everyone, in Carroll's account, means being "understood" by everyone—preferably by communicating through pictures; but attention-getting requires no such judgment about how attention must be captured and held. From the start, *The Roaring Girl* defines its own aim as engaging the audience rather than making itself accessible to them. These are the terms, indeed, in which the play first catches sight of its audience, before we ever hear of Sir Alexander's picture: "I see Attention sets wide ope her gates / Of hearing," the prologue declares, "and with covetous list'ning waits / To know what girl this roaring girl should be."[39] Like Moll in her own evocation of the theater, the prologue resists Sir Alexander's dehumanizing compression of playgoers into thronged heaps. Committed instead to acknowledging the diversity of judgment in its audience, the prologue depicts their unity in the theater as merely their attention personified, which itself reflects the as yet uncomprehended singularity of Moll.

The ensuing plots of *The Roaring Girl* take up this difference between attention-getting and accessibility as the surprising lack of fit between Moll's notoriety and her sexual availability. This is not to say that Moll is wholly unavailable: she herself acknowledges that she cannot escape the stain of promiscuity entirely. "Nothing is perfect born," a character named Mr. Openwork philosophizes in the play, and Moll agrees that individuals are just as much a mixture of foul and fair as mass audiences are. To her mind, indeed, this imperfection is what people share. "Oh, if men's secret youthful faults should judge 'em," she had earlier declared to Sebastian, "'twould be the general'st execution that e'er was seen in England!"[40] Moll excuses her fraternization with thieves in similar

terms, as a shortcoming of her "younger days." But she also defends the principle of fraternization in general. Earlier, she had drawn her sword on a libertine who had offended her by assuming the worst about her willingness to socialize:

> Thou'rt one of those
> That thinks each woman thy fond flexible whore.
> If she but cast a liberal eye on thee,
> Turn back her head, she's thine; or, amongst company,
> By chance drink first to thee, then she's quite gone,
> There's no means to help her.

For Moll, an all-or-nothing theory of virtue is not only unrealistic but also antisocial: it prevents a person from moving freely "amongst company."[41]

Seeking a way of opening herself to the city without surrendering her integrity as an individual, Moll regularly joins other characters in practicing the play's habitual form of minor vice—sexual innuendo.[42] One typically odd scene has Moll enter Sir Alexander's private rooms with Sebastian, who promptly hands her, of all things, a viola. "Well, since you'll needs put us together, sir," Moll responds, "I'll play my part as well as I can. It shall ne'er be said I came into a gentleman's chamber and let his instrument hang by the walls!" The implication of Moll's promiscuity is unmistakable, a kind of open secret in her speech; but it is no more than an implication. Throughout the play, *The Roaring Girl* represents its ubiquitous double entendres as a language only half comprehensible: "French," another character calls it, like the "peddler's French" of thieves' cant. Indeed, when Moll betrays her "odious" familiarity with cutpurses by translating their cant, she revealingly stops short of deciphering terms that would require any sexual explicitness from her. What do "wapping" and "niggling" mean? her gentlemen friends ask her. "The rogue my man can tell you," she replies, although not even the rogue will speak plainly: "'Tis fadoodling," he says. Similarly, while Moll may confess that she has consorted with thieves, she never exactly confirms nor denies that she too has cut purses: instead, she demands to know whether "any" would "dare…step forth to my face and say, / 'I have ta'en thee doing so, Moll'?" Neither does she ever definitively settle the issue of her "masculine womanhood." Rather, we watch her shop for a "Dutch" style of breeches that are "open enough" to "take up a yard more," where "yard," too, has a double meaning: what the breeches, and the scene, are meant to leave open is the question whether Moll has a "yard" of her own. "It is a thing / One knows not how to name," Sir Alexander exclaims in disgust at Moll's sexual ambiguity, but his son is more charitable, of necessity.

"Plain dealing in this world takes no effect," Sebastian philosophizes as
he justifies the deceit he practices with Moll, and that is the same
approach *The Roaring Girl* adopts toward its own mode of entertain-
ment.[43] Making oneself accessible to the world is not only reductive
and debasing: it is unproductive; it can have no broad attention-get-
ting "effect."

By comparing *The Roaring Girl* to a picture whose parts do not
cohere, the epilogue half confesses the downside of so equivocal a dram-
aturgy: that the play might not "full pay your expectation." Failing to
deliver is the repeated fate of the play's chief sexual provocateur, a
deceiver named Laxton who does indeed lack the stones to follow
through on his erotic suggestiveness; one disappointed citizen-wife con-
temptuously refers to him as "half fish, half flesh." Why should the
audience of *The Roaring Girl* not feel that they have been similarly
cheated by an ambiguously posturing main character? In its very first
lines, *The Roaring Girl* had worried that the audience would find the
play unsatisfying, particularly in relation to a medium that these lines
count not as an ally to the theater but rather as its rival:

> A play expected long makes the audience look
> For wonders, that each scene should be a book,
> Composed to all perfection. Each one comes
> And brings a play in's head with him: up he sums
> What he would of a roaring girl have writ;
> If that he finds not here, he mews at it.[44]

The rapid movement here from external to internal writing suggests that
the technological reproducibility of print fosters certain illusions in the
audience. The first is that an entertainment can be designed for "each"
consumer individually, like the mass-produced copy you each hold in
your hands. The prologue combats this deception by urging every spec-
tator to exchange the close quarters "in's head" for the more spacious
and communal arena of "our vast theater." Moll will later emphasize
the variety of spectacles available in the playhouse, and present the
mobility of vision these spectacles encourage as what keeps the threat
of the cutpurse at bay—the threat that the play, in failing to deliver,
"cheats its consumers of what it perpetually promises," as Horkheimer
and Adorno claim of mass entertainment generally. The second illusion
fostered by print, *The Roaring Girl* implies, is that an entertainment can
be "composed," summed up, amassed into a perfect whole, like the book
in your hands, once again. The epilogue acknowledges that some view-
ers may feel shortchanged by the brief episode of Moll among the cut-
purses, and "look / For all those base tricks" of rogues that are "published
in a book." Yet the completeness of a book, the epilogue suggests,

depends on its faithfully reflecting the "brains" of its author, not its reader—and for the particular book in question, this gap between producer and consumer is widened by the Laxton-like character of the author: the book is as "foul as his brains they flowed from," "as full of lies, as empty of worth or wit, / For any honest ear, or eye unfit."[45]

"Full of lies": in this final reimagining of Sir Alexander's attack on mass entertainment, the sight of thieves amongst thronged heaps gets abstracted into the comprehensive falseness of the book, "unfit" for "any" particular "honest ear, or eye." What space for individual tastes and judgment, the play keeps asking, can a piece of mass entertainment legitimately be said to provide? In the same way that *The Roaring Girl* accepts openness as a constitutive feature of mass entertainment but then diversifies the concept into competing interpretations, differentiating the theater's version of openness from the accessibility of the picture and the whore, so the play accepts and then diversifies what it treats as the equally constitutive concept of fullness, distinguishing the theater's version of fullness from the amassment of the book and the heap. While the prologue to *The Roaring Girl* admits that the performance to come may not seem "composed to all perfection," the rest of the play tries to persuade its spectators as well as Sir Alexander that there's a virtue to imperfection—that less is more.

The epilogue to *The Roaring Girl*, like the prologue, frankly acknowledges that some might feel the play did not "full pay" their "expectation"; if so, then

> The Roaring Girl herself, some few days hence,
> Shall on this stage give larger recompense;
> Which mirth that you may share in, herself does woo you,
> And craves this sign: your hands to beckon her to you.[46]

On the one hand, this promise associates the stage with a "larger recompense" than the page can afford: the fullness, it would seem, of a social experience that playgoers rather than readers may "share in." On the other hand, the epilogue tantalizes its playgoers no less than its readers with the same expectation as the prologue had raised at the start: that they will soon learn "what girl this roaring girl should be." Throughout the play, Moll had similarly frustrated observers by refusing to commit herself entirely to one group, one gender, one identity. And now, even when the epilogue pledges to bring "the Roaring Girl herself" to the stage, it's unclear whether this will be the real woman on whom the character of Moll is based or else her enactor in some better performance to come. But such questions, the prologue had already suggested, with ironic reference to the play that "each one" of the audience brings "in's head," may be preferable to answers: "what need characters, when to

give a guess / Is better than the person to express?"[47] By stressing in the end how its spectators as well as its readers can see the whole of Moll, the playhouse, and the city only imperfectly, *The Roaring Girl* presents itself as dynamically encouraging their speculations so that each one "may share" in the mirth. May share: when Moll similarly emphasizes how "any" theatergoer "might" enjoy her perspective, "might" take her place, she refrains from picturing the mass audience en masse the way Sir Alexander and other like-minded theorists do, just as she rejects any totalizing vision of herself. The fullness of mass entertainment as *The Roaring Girl* defines it lies in a potentiality that leaves each consumer "full as uncertain" as Moll leaves Sir Alexander, waiting to discover how far, in the end, she might draw him in.[48]

2

The Real John Doe

I bet you he'd know how to say it all right. And me, I, I get up
to it and around it and in back of it, but, but I never get right to it.
Do you know what I mean?

—Meet John Doe (1941)

Why, the film critic Nora Sayre once asked, did the heroes that Gary
Cooper and Jimmy Stewart played in the 1930s and '40s "have to be so
stupid?" "Again and again," Sayre marveled, "their roles proclaimed
stupidity as a virtue: with radiant pride, they uttered such lines as 'I'm
just a simple guy still wet behind the ears,' or 'I'm just a mug and I know
it.'" For Sayre, no "frontier tradition" of unassuming strength and self-
reliance could explain such fatuousness, because the Cooper and Stewart
characters were so "terribly dependent on being coached and propped
up by women ... whose brainpower outran the simpletons' [own]." In
Frank Capra's 1941 film *Meet John Doe*, for example, starring Cooper
and Barbara Stanwyck, "Cooper is ... Stanwyck's creation: not only
does she comb his hair while molding his character, but her mother has
to tell him how to propose to his beloved." "Actually," Sayre added, "he
wants the mother to do it for him."[1]

 Writing as she was in 1977, Sayre acknowledged that tastes might
have changed over the past "three to four decades" of filmmaking, and
earlier commentators were indeed often more sympathetic than Sayre
was to "the handsome stumblewits" that Cooper in particular por-
trayed. While noting in a 1942 feature article on Cooper that "ungainly
men, ungrammatical men, head-scratching men, ineloquent men draw
comfort and renewed assurance from the Cooper to whom all these
adjectives apply," the film reviewer and future screenwriter Frank

Nugent nevertheless maintained that Cooper fit "the mold most Americans like to think is their own": he "has come to represent the All-American Man."[2] These are the same terms that *Meet John Doe* applies to Cooper and to the ungainly, ineloquent character he portrays, "Long" John Willoughby. In the film, Stanwyck plays the part of a newspaper columnist named Ann Mitchell who is searching for someone her paper can present as a spokesman for "the average man," as "John Doe." She finds that spokesman in Cooper's Willoughby, who happens to be a former baseball player: "What could be more American!" Ann exclaims. "Doe" is introduced to the public by way of a radio address in which Long John proclaims his representative status: "I'm going to talk about us, the average guys, the John Does," he announces. This radio address makes him an overnight sensation, spawning the formation of John Doe clubs throughout the country.[3]

"The picture will go right to the heart of every person who sees it," declared one glowing review of *Meet John Doe*, "because its hero could be any one of this country's millions." But even the fans of *Meet John Doe* sometimes felt hard-pressed to explain what exactly Long John says that so impresses all the other average guys. While extolling the movie for the "inspiring message" it sends to "all good Americans," the *New York Times* reviewer Bosley Crowther had to admit that "John Doe may not be the most profound or incisive fellow." *Variety* could only half-heartedly praise the movie for making "something of a case for its own somewhat vague premise." Eileen Creelman of the *New York Sun* took a less charitable view: she maintained that "the ideas" in Long John's speeches, and in the film generally, were "rather juvenile in their simplicity." Writing for *The Nation*, Anthony Bower complained that the film "deserves a special academy award" for "mawkish sentiment" and "muddled thinking"; "*Meet John Doe* reeks with blatitudes," the *Scribner's* review declared. Sayre's subsequent critique was nothing new, then: it simply registered the increasing potency of an irritable skepticism in later accounts of the film. Commentators such as Steve Vineberg now generally agree that "the specific issues" in *Doe* "are kept blurry. If you pay close attention to [the film], the only lesson 'the people' seem to glean from John Doe's columns—the single basis for the John Doe clubs—is a completely apolitical one: how to be polite and neighborly." Kevin Thomas is even more critical of what Vineberg calls "the fuzzy thinking behind the film's premise": according to Thomas, the movie shows that "all it takes is a charismatic personality to electrify the public with such platitudes as 'love thy neighbor' or 'turn the other cheek.'"[4]

Simpleminded, superficial, platitudinous, vague: for the enemies of mass entertainment, and sometimes even for its friends, these were the faults not of Gary Cooper or of the characters he played but of

Hollywood movies generally—"the most effective carriers of idiocy that the civilized world has known."[5] To such critics, "the average man" for whom Hollywood produced this tripe was no all-American hero but rather a "mere negation" of individuality, "the mass-man," as Ortega y Gasset called him, "man as undifferentiated from other men," a "type" rather than an individual, who "is satisfied with thinking the first thing he finds in his head" and who thus "simply goes drifting along" through the degraded world that mass culture has fashioned for him.[6] "John Doe" would seem to be the perfect name for this nobody of an every-man, and the dim-witted Long John the perfect character to play him.

Hollywood's more radical opponents argued that movies had been drained of any intelligence not merely to increase sales but also to shore up the status quo, to oppress as well as to exploit, and here too *Meet John Doe* seems to fill the bill perfectly—except that it frankly admits the charge. Ann invents the character of John Doe on a lark, after she has been fired from her paper: in her final column, she claims to have received a letter from an out-of-work "American citizen" who calls himself "John Doe" and who pledges "to commit suicide by jumping off the City Hall roof" in protest "against the state of civilization." Surprisingly, this "fakeroo," as a fellow reporter calls it, galvanizes Ann's readers, and she persuades her cynical editor, Henry Connell, not only to rehire her but also to help her find a stand-in for Doe who can be foisted on the paper's unsuspecting public. After interviewing several pathetic "candidates" for the job, Ann and Connell come upon Long John, a lanky, hungry, homeless man with no friends or relations other than a fellow tramp named the Colonel (played by Walter Brennan). In his 1971 autobiography, Capra himself called Long John "a drifting piece of human flotsam as devoid of ideals as he was of change in his pocket." Needing money to fix his broken "wing" of a shoulder so that he can recapture his lost glory as a pitcher, Long John agrees to join the Doe conspiracy. The speeches he goes on to deliver as John Doe are all crafted by Ann, who boasts to her newspaper bosses that Long John "can say anything he wants" to his audience, "and they'll listen to him." The fraud gets worse. Ann was initially fired as part of a "streamlining" campaign by the paper's new owner, a fascist named D. B. Norton. Once he hears about the John Doe scheme, Norton quickly realizes its potential to sell more than papers. He decides to fund the John Doe clubs so that he can ultimately transform them into a third political party that will support his dark-horse bid for the presidency. Only when a drunken Connell spills the beans to Long John does John catch on that "he is being used," as Capra put it, "to delude and defraud thousands of innocent people."[7]

Was *Meet John Doe* intended, then, to *expose* the stupidity of mass entertainment? Capra suggested as much in his autobiography. Tired of

The hapless drifter Long John Willoughby

the scorn heaped on him by the "highbrow critics" who had dismissed his movies as so much pablum or "Capra-corn," he had decided to make a film that "was *aimed* at winning critical praise." With *Meet John Doe*, Capra recalled, he and his collaborator Robert Riskin courted the intelligentsia by dramatizing "a brutal story" that portrayed the average guy no longer as a hero but rather as a stooge, a dupe. In his autobiography, Capra blamed himself for pandering to the elitists this way and thus neglecting his true audience, "my John Does, about whom and for whom I made my films."[8] And yet, by shifting the impetus for *Doe*'s satire from himself to his critics, Capra belied the fact that he elsewhere frequently claimed to be "fighting a war" against "massism"—against "mass entertainment, mass production, mass education, mass everything," as he asserted in an interview the year after publishing his autobiography, and "especially" against "mass man." During the same interview, Capra appeared to sum up his own confused relation to "what we call euphemistically the average man" when he enlisted a surprising ally in his struggle for "the liberty of the individual person against the mass": "Mr. Common Man—Mr. Uncommon Man, rather—Mr. John Doe."[9] John Doe? How could a figure who would seem to personify the blank interchangeability of individuals in the mass possibly help lead the fight *for* individualism?

In what follows, I'll try to show how *Meet John Doe* responds to such questions by deliberately blurring the distinctions that the critics of the movie seek to clarify: distinctions between the individual and the mass, between fraudulence and authenticity, even between an attack on mass entertainment and a defense of it. In part, *Meet John Doe* admits the charges against Capra-corn so that it can suggest their limits. Just because sentiments are vaguely expressed doesn't mean that they're empty; just because a claim is intended to deceive doesn't mean that it can't also be true. Although the John Doe movement begins as a scam, it eventually comes to matter far more to Ann, Connell, and particularly

Long John than they ever expected it would. "It is the old 'Miracle Man' idea," the reviewer Edwin Schallert observed, "something conceived to deceive the public which turns out to be so worth while that it becomes greater than those who participated in the birth of the enterprise." At the same time, however, *Doe* seems intent on emphasizing the simple-mindedness of John and of the masses he fools in order to highlight its own ingenuity in making the John Does of the world matter to us. "There is an expressed challenge in the title of this new Capra picture, 'Meet John Doe,'" the pressbook for the movie declared. "It's like daring Robert Riskin, the writer, and Capra, the director, to make something out of nothing, or to make nonentities interesting."[10] And yet *Meet John Doe* also insists that John could have no real impact on the masses *without* his limitations: he could not represent his fellow John Does and thus distinguish himself as their hero if he did not also to some degree share their indistinctness as individuals. In the mass entertainment world of *Meet John Doe*, a nonentity can end up seeming interesting and substantial, even real, only when he becomes, precisely, *somebody*.

"I'd Know That Voice Anywhere"

The first words of Long John's first speech as John Doe interweave several different complexities about the part he plays. "I am the man you all know as John Doe," John begins:

> I took that name because it seems to describe … because it seems to describe the average man, and that's me … and that's me. Well, it *was* me before I said I was going to jump off the City Hall roof at midnight on Christmas Eve. Now, I guess I'm not average anymore.

The first complexity in this speech is apparent to us, though not to John's listeners—or not, at least, till the editor of a rival newspaper shouts from the audience that John is "an impostor" telling "a pack of lies." John never said that he was going to jump off the City Hall roof; Ann invented that fiction before John agreed to pretend that it was true. The second complexity amounts to a kind of admission that John lacks any legitimate claim to the title of John Doe: he acknowledges that he is now too famous to be considered "the average man." Of course, the very notion that "John Doe" names the average man would seem to mean that the title could never legitimately belong to any one individual. "The average man" is, after all, a personification, not a person, and even if one man were implausibly found to be the average in his society,

he would be so only in relation to everyone else in that society. John's speech accepts part of this critique, seizing on the paradox of John's anonymous celebrity to help present him as the one who is also many. Rather than stop referring to himself as John Doe, Long John proceeds "to talk about *us*," "a great family" and "team" to which John says he and all the other average guys belong.

"The uncommon common man" is what one contemporary reviewer called the hero of *Meet John Doe*. "One Man in a Million!…A Million Men in One!" declares a contemporary advertisement for the movie, filling the shadow of Gary Cooper with cartoon images of people from all walks of American life.[11] Both formulations define Long John as an individual who distinctively encapsulates the mass culture through which he strides—they define him, that is, as a mass individual. In the movie itself, John's fame correlates him with urban culture especially. Just as the "whole city" takes "note" of Moll in *The Roaring Girl*, as I discussed in Chapter 1, so Ann says that "the whole town's curious about John Doe." Moll impresses the town because she is so fully commensurate to it: "sh' has the spirit of four great parishes," her admirer Laxton proclaims, "and a voice that will drown all the city."[12] But in *Meet John Doe*, Long John drifts obscurely through life until Ann and Connell select him for their "circulation stunt" and contrive to "make a mystery out of him." "The whole town's in an uproar" about Doe before Long John even joins the act. The scene of John's first speech, which is also his first public appearance as Doe, makes this contrast with Moll particularly striking. The scene is set in a radio studio—a small theater, really, with a stage separated by curtains from the audience. John delivers his speech from the stage, but rather than command attention with a mighty voice, as Moll does, he speaks in conversational tones to a microphone. For the film critic Raymond Carney, John's reliance on such artificial amplification makes him seem even thinner than he already is: "the technology that allows Doe's voice potentially to reach thousands of individuals by the same virtue necessarily robs him of a personal presence."[13] In Carney's view, the central aim of *Meet John Doe* is to depict "a world in which even the individual human voice becomes inaudible except insofar as it can find a way to patch itself into the licensed networks of knowledge, to plug itself into the power system." From this dystopian perspective, John's placement on a stage might seem like the movie's way of registering nostalgia not only for a speaker charismatic enough to impress "thousands" on his own but also for a theater capacious enough to hold "thousands" on its own—for the kind of mass entertainment, in other words, where speaker and audience are fully present to one another. Moll speaks with a voice as big as a city so that she can be heard throughout the "vast" theater in which she speaks.[14]

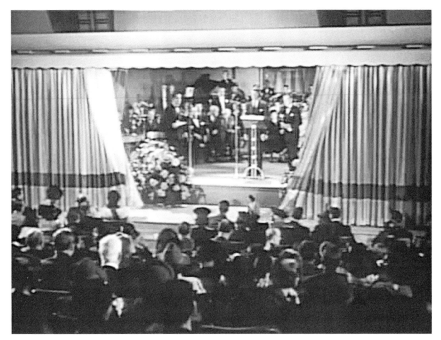

The radio theater

In *The Roaring Girl*, the theater is vast because the city is. Moll describes moving "through crowds most thick" in London; these same throngs "fill" the theater. The theater, indeed, packs its audience "so close" together that it intensifies the experience of urban crowding, but this intensiveness belongs to the city, too, in relation to the world beyond it. The farthest reaches of the action in *The Roaring Girl* are to London's suburbs, none of them more than twenty miles from the city center: Hogdsen, Brentford, Smithfield, Chelsea, Romford, Stanes, Ware. When one aristocrat in the play is asked to join some other high-class friends on "a boon voyage" to a Hogsden tavern, he replies that he would be happy "to sail to the World's End with such company," the joke being that at least two taverns outside the city's limits were called World's End, in reference to their suburban remoteness from London.[15] So comprehensive a microcosm does London appear to its citizens in *The Roaring Girl* that any land more distant than its suburbs seems to melt into an illusion. Just as they embark on their alehouse voyage, the gentlemen rovers meet two vagabonds who claim to have fought "in Hungary against the Turk," to have been taken prisoner by the Venetians, and finally to "have ambled all over Italy" before returning to England; one of the vagabonds speaks in pidgin Dutch. Moll exposes them as liars: a rogue, she explains, can "discover more countries to you than either the Dutch, Spanish, French, or English ever found out."[16] And yet, even as

Moll wrings a confession from the rogues, their fake Dutch turns into a language authentically in need of translation: the "peddler's French" of their criminal "canting." London, we learn, has a foreign country *inside* of it, "the commonwealth of rogues," to which Moll has special access.[17] While her familiarity with these rogues first troubles the gentlemen, they soon come to accept that Moll's social as well as geographical mobility reflects the internal amplitude of "a brave mind." The most compacted microcosm in the play, as even a high-class detractor of Moll's acknowledges at the start of the next scene, is Moll herself, "that impudent girl / Whom all the world stick their worst eyes upon."[18]

All eyes are fixed on Long John, too, in the theater where he delivers his first speech, but he lacks Moll's self-possession in the face of public scrutiny and runs away—easily, because the theater is so small: it takes only a few paces for him to reach the side door. We next see him at a makeshift campsite by the pathways of a river and a bridge, where he and the Colonel decide to light out for the territories once again. Another cut brings us to the open boxcar of a train and shows Long John and the Colonel there, delighting in the view of the wide-open spaces far beyond the city they have fled. But when the two stop for food, they discover that the media have easily outpaced them. From his seat in a diner, John is astonished to see vans driving by with John Doe signs; a waiter who has read about John Doe in the newspaper and heard him speak on the radio calls Long John "the spitting image of John Doe" and exclaims, "I'd know that voice anywhere." *Any*where: if the theater of *The Roaring Girl* advertises its intensiveness, the media of *Meet John Doe* are characterized by their *ex*tensiveness, their broadcast penetration of the mass market. "You want to reach a lot of people, don't you?" Ann had asked the media magnate Norton. "Well, put John Doe on the air and you can reach a hundred and thirty million of them." Believing that he has escaped his audience, John finds instead that they—and now he—are nationwide.

For Carney, again, this mass distribution of John by radio and newspaper "*necessarily* robs him of his personal presence," and yet, as the diner sequence unfolds, the fact that John has been "fractured and proliferated outward into a series of dissociated images" turns out to be only half his problem.[19] Once he is identified as Doe, John is taken like a prisoner to the mayor's office in the local city hall, where people throng to see him. The town is called Millville, and the mayor, fighting his way through the milling crowd, complains that his office is now "packed like a sardine box." Why, after the demonstration of how far and fast the media can move, has the closeness of the theatrical environment returned, and with even greater compression than before? In part, this renewed crowding seems related to the peculiar hybridity of film as a mass medium. While

John and the Colonel after the broadcast

John and the Colonel in a boxcar

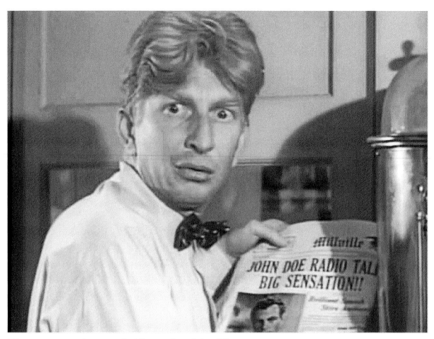

The newspaper that traveled faster than John did

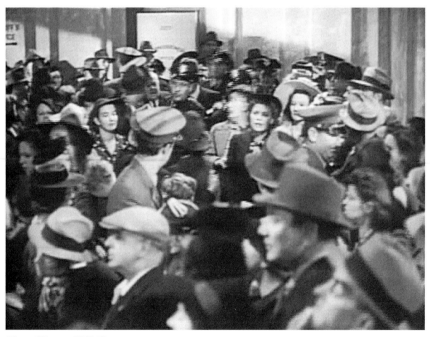

The milling at Millville

movies at the time possessed the extensive reach of newspapers and radio, they could not be enjoyed in the privacy of one's own home as these other media could, nor could they succeed commercially without crowding: they were experienced intensively, in movie theaters.[20] But the throngs that form around John also reflect the unexpected force of his otherwise meager-seeming personality. For all his tentativeness as a performer, John turns out to have "great yokel appeal," as one of his handlers will later put it. Norton instructs the mayor to hold on to John because he thinks John is "terrific" in his part. "We need *you*, John," Ann insists to him once she and Norton arrive on the scene, just as Capra insisted in his autobiography that "for the part of 'John Doe'... I had but one choice: Gary Cooper. I wouldn't have made the picture without him."[21] The pressures inflicted on the confused John are thus both centrifugal and centripetal: though he is dispersed in 130 million different directions by the media, he is also hemmed in as the surprisingly charismatic center of public attention. In *Meet John Doe*, that is what it means to be the uncommon common man.

"I Know How They Feel"

After he first fled the stage, John had expressed his own bewildered scorn for himself: "What was I doing up there making a speech anyway?" The question exposes more than his painful sense of his inadequacies as a performer. It reveals that he can no longer comprehend his own motives for performing, that Ann has succeeded in making a "mystery" of him even to himself. In part, this self-alienation derives from his attraction to Ann, which has drawn him away from his old familiar tramp life; in part, it results from his dismay at his own willingness to deceive millions of people. But there's also something about playing the part of John Doe per se that unsettles John—the idea of acting as if you're nobody in particular and yet everybody in general. "If anybody should ask you what the average John Doe is like," John had said in his radio address, "you couldn't tell him, because he's a million and one things." On this account, it would be impossible to specify who exactly John Doe is because he is defined by *all* the average guys. To think of yourself as John Doe, then, is to imagine yourself as "a million men in one." Such multiplicity disintegrates you, John discovers, turning you into parts that can never cohere in you because they never were *in* you in the first place; but it also opens you, allowing you to perform actions that you never thought you were capable of before. Inside the mayor's office at Millville, where John is asked to return to playing John Doe, he encounters members of a local John Doe club, and the experience of meeting other self-confessedly average men and women makes him feel "all mixed

up." And yet his interacting with these other John Does also reconciles him to his pretense: the role gains substantiality for him, logically enough, only when he is persuaded that he *shares* it with others.

By that same logic, John's growing commitment to playing the part of John Doe doesn't makes him feel any less mixed up or self-alienated than he did after his radio speech: on the contrary, he becomes a kind of paragon of confusion. The first time in the movie that John speaks at length in his own words is to tell Ann about a "crazy dream" he had the night before, and he begins by telling her that he dreamt he was somebody else:

> I dreamt I was your father. There was, there was something that I was trying to stop you from doing. So, er, I got up out of bed, and I walked right through the wall here, right straight into your room. Huh, you know how dreams are. And, and, and there you were in bed. But you, you were a little girl, you know, about ten. And very pretty, too. So, I, I shook you, and the moment you opened your eyes, you hopped out of bed, and started running like the devil, in your nightgown. You ran right out the window there. And you ran out over the tops of buildings and roofs and everything for miles. And I was chasing you. And, and, all the time you were running, you kept growing bigger and bigger and bigger, and pretty soon you were as big as you are now. You know—grown up. And all the time I kept, I kept asking myself, "What am I chasing her for?" And I didn't know.

As John speaks, the stammering inarticulacy that has marked him from the start is uncannily transformed into a felicitous language for conveying the perplexity of dreams. Even John's lack of self-awareness seems justified by the irrationality of the experience he is describing: "I kept asking myself, 'What am I chasing her for?'" If he is to be scrupulously faithful to the dream he is reporting, John cannot express his motives more clearly, because they aren't his to express: they belong to Ann's father. Before his radio address, Ann had confided to John that she had based the script on her father's beliefs. The dream thus manifests John's deepening internalization of the self-estrangement he experiences in his public speaking.

Carney takes a characteristically dim view of the effect that John's pretending to be John Doe has had on him. "As the film goes on," Carney maintains, "John himself grows more and more confused about which John he 'really' is," and the tale of his dream shows how John is falling ever further into "bewilderment and self-puzzled paralysis of will."[22] Yet if John's confusion has been growing, so have his powers of speech: the dream scene is the first in which John's own words capture

Ann's attention. The dream itself expresses John's desire for such influence over Ann, by identifying him not only with her father but also with an authority figure whom John himself has invented, albeit subconsciously: "Well, anyway, you ran into some place, and then I ran in after you and, and when I got there, there you were getting married.... And then I knew what it was I was trying to stop you from doing.... But here's the funniest part of it all. I was the fellow up there doing the marrying. You know, the justice of the peace or something." Now it's Ann's turn to feel confused: "You were? I thought you were chasing me." The more disparate the roles John plays in his dream, the more successful he proves at drawing Ann into a mystery she no longer stage-manages.

For Ann, it seems, these roles actualize a previously unsuspected psychological complexity to John, and the critic Nick Browne claims that they do the same for the viewer. "The multiplication and incongruity of fictional personalities" in the dream, Browne declares, are crucial to "the film's production of 'character,'" insofar as they give us a deeper sense of the "private person who projects 'John Doe' in his speeches." Yet where Carney sees too much loss for John, Browne sees too much gain: Browne claims that the distinctive "character" produced by John's dream "condenses and unifies the public and private roles" John plays, when in fact the dream emphatically registers John's fragmentation.[23]

John catching Ann's attention with the story of his dream

After acknowledging that he *had* been the man chasing Ann, John struggles to explain his metamorphosis into someone else: "But I was your father then, see? But the real me, John Doe, er, that is, Long John Willoughby, I was the fellow up there with the book. You know what I mean?" Playing the part of John Doe, feeling *mediated* by that part, has befuddled John as much as it has empowered him.

The dream further disorients both Ann and John by its rapid changes in setting as well as character. At first, John walks through a wall to penetrate the sanctum of Ann's bedroom; then he chases her "over the tops of buildings and roofs and everything for miles," until he finally pursues her "into some place" again. Applying the terms of John's performances to the dream, we might say that the dream oscillates between fantasies of intension and extension. Eventually the dream seems to settle into an intensive mode, with John and Ann contained in one place, and all the other people there (except the groom) contained in John, as the one person into whom they all turn. Yet rather than halt the oscillation, the final movement of the dream only reroutes it to an ever more dizzying alternation among John's various new identities:

> Well, I took you across my knee and I started spanking you. That is, *I* didn't do it. I mean, I did do it, but it, it, wasn't me.... And all the time, er, the guy up there, you know, with the book, me, just stood there nodding his head. And he said, "Go to it, Pop, whack her one for me because that's just the way I feel about it, too." So he says, "Come on down here and whack her yourself!" So I came down and I, I whacked you a good one, see? And then he whacked you, and I whacked you another one, and we both started whacking you.

Here once more John finds himself uncomfortably indoors and involved in a spectacle that appalls him; at the same time, however, he discovers that he is no longer confined to a single, suffering body—unlike Ann, who gets a spanking. John had felt similarly hemmed in and also scattered by the radio theater, but what differentiates his experience in the dream from his experience in the theater is his playing the part in the dream of the spectator as well as the performer. John watches "the guy up there," who himself watches Ann's father, and who so completely empathizes with the father ("that's just the way I feel about it") that the father invites him to join the action; and then John empathizes so completely with both men that he not only joins them but also becomes them. As he recounts his dream, John is at once divided and united by the multiple subject-positions he comes to occupy in a scene of performance.

This phantasmagorical revision of John's speaking engagements gets replaced by a more straightforward account of them in the film's very next sequence. Waiting to fly to a new event, John asks Ann how many people she thinks "we've talked to already," "o-outside radio, I mean"—that is, in personal appearances. "About three hundred thousand," Ann replies, and John expresses his usual mystification in response. But the terms of his confusion have strikingly changed: he now declares himself baffled by the audience's motives rather than his own. "What makes them do it, Ann? What makes them come and listen, and, and get up their John Doe clubs the way they do?" Embarrassed, even ashamed by the question, Ann tries to dismiss it, along with the whole John Doe phenomenon: "Look, John. What we're handing them are platitudes. Things they've heard a million times: 'love thy neighbor,' 'clouds have silver linings,' 'turn the other cheek.'" But Ann is no longer persuasive to John—indeed, she never fully regains her powers of persuasion over him—and John proceeds to work out an answer for himself by thinking about himself in relation not to Ann or her father but to his mass audience. "Yeah," he says of the platitudes, "I heard them a million times, too, but—"

> there you are. Maybe they're like me, just beginning to get an idea what those things mean. You know, I never thought much about people before. They were always just somebody to fill up the bleachers. The only time I worried about them was if they—is when they didn't come in to see me pitch. You know, lately I've been watching them while I talked to them. I could see something in their faces. I could feel that they were hungry for something. Do you know what I mean? Maybe that's why they came. Maybe they're just lonely and wanted somebody to say hello to. I know how they feel. I've been lonely and hungry for something practically all my life.

Speaking at length in his own words for only the second time in the movie, John captures Ann's attention even more powerfully than he did the first time. It's not a new clarity in John that compels her: with typical vagueness, John describes "something" he could see in people, "something" they were hungry for, "somebody" they wanted to say hello to. It's rather a new *indistinctness* to John that seems to impress Ann, a collapsing of the boundaries between him and an audience he now empathizes with as he never had before. Not only does John claim to "know how they feel": he tells Ann how he took their part *as* spectators, watching them watch him, which leads Ann to become absorbed in watching him.

Ann absorbed by John as he speaks
at the diner

The Roaring Girl highlighted a similar reversal of the conventional line of sight from audience to stage, when Moll's adversary, Sir Alexander, spoke of viewing "a thousand heads laid / So close that all of heads the room seems made." This reversal, I argued in chapter 1, constituted a pivotal moment in *The Roaring Girl*'s attempt to capture its mass audience as a central issue for the play. Yet where the haughty Sir Alexander resisted any correlation of himself with such an audience, the humbler John embraces the connection, in part because he is beginning to be swayed by the neighborly sentiments in his John Doe speeches: as the critic Leonard Quart says, John has started "to believe in the vague idealistic credo written for him."[24] At the same time, John's new sense of identification with his audience also seems to be stimulated by the self-alienation he experiences as Doe. The less absorbed he is by Ann's scripts, the more he can watch his audience while he talks to them, and John emphasizes the increasing element of distraction in his performances by differentiating his new work as Doe from his old career as a ballplayer. "You know, I never thought much about people before," he confesses to Ann. "They were always just somebody to fill up the bleachers." When he was pitching, it seems, John focused on the game, not on the fans. Even after he was hurt and left baseball, he never stopped focusing on the game: he initially agreed to play John Doe only so that he could get his arm "fixed." "Baseball's my racket, and I'm sticking to it," he insisted in Millville. But John's impersonation of John Doe has *un*fixed him. "Just think of yourself as the real John Doe," Ann had implored him before his first speech, asking him to surrender his identity as a ballplayer, or indeed as anyone in particular, and become attached instead to the indefiniteness of his part. ("Everything in that speech are things a certain man believed in," Ann had assured him in her own characteristically vague way.)[25] At the airport, John confides to Ann that his subsequent confusion about his identity has paradoxically opened his eyes to a preexisting self-ignorance. His focus on pitching, he now realizes, was not only callow but delusory, a way of hiding the truth

that he had been drifting all along: "I know how they feel. I've been lonely and hungry for something practically all my life."[26] How has John's role-playing brought this sense of incompleteness to his consciousness? The explanation seems to be that John Doe is a part he could never fully call his own, even if he wrote the script himself, because the part also belongs by definition to all the other John Does in his audience—just as it also never fully belongs to them either. That is why John sees his lack by seeing a lack in them.

The critic George Toles has powerfully highlighted how Gary Cooper captured this dynamic interplay between John's alienation and his self-awareness even in his first radio speech. During that speech, Toles observes, Cooper's John seems to be listening to himself as if he were his own audience, and, as a result, he becomes unexpectedly disquieted by an otherwise trite warning he reads: "Don't wait until the game is called on account of darkness." According to Toles, John "appears to be caught in the recognition that he is one of those who has been waiting on the sidelines for too long, and that the habit of waiting, which until this instant struck him as the soul of good sense, has turned into a damaging kind of withdrawal." Toles concludes that John's simultaneous distraction and absorption as a performer help him find "an unlikely route back to a forgotten, unalienated selfhood by allowing himself to believe *some* of the words and *some* of the circumstances assigned to

John moved by his first John Doe speech

him."[27] But the claim that John ends up recapturing an "unalienated selfhood" overlooks the central irony in John's two self-authored speeches to Ann, which is that he becomes more compelling to her the more disconcerted he appears to be. *Meet John Doe* is no less keen than *The Roaring Girl* to persuade its audience that they have encountered an authentically mass individual, but where *The Roaring Girl* associates that individual with Moll's conspicuous fullness of self, *Meet John Doe* continually emphasizes John's thinness, his brokenness, his uncertainty. If, as John suggests at the airport, his increasing self-identification with the masses depends on his increasing self-alienation, then the real John Doe might be the one who knows better than anyone else how unfit he is to play the part.[28]

"Don't Ask Me How I Know"

In his seminal 1939 essay on collective behavior, the sociologist Herbert Blumer spoke of the productive confusion that could result from an individual's participation in a crowd, mass, or social movement. According to Blumer, "the individual" who is caught up in a crowd "is stripped of much of his conscious, ordinary behavior, and is rendered malleable by the crucible of collective excitement." While this "break-down" of the individual's "previous personal organization" may cause her to become "more unstable and irresponsible," it may also enable her "to develop new forms of conduct and to crystallize a new personal organization along new and different lines." In a mass, where the individual feels more "detached and alienated" than in a crowd, the new "impulses and feelings" that are "awakened" in the individual are consequently more "vague," too, like the "vague and indefinite" new "conceptions of themselves" that members of a social movement experience. Yet this greater uncertainty unlocks greater creative possibilities as well, especially for "an artist or a writer who happens to sense the vague feelings of the mass and to give expression and articulation to them."[29] In a social movement, Blumer argues, that expression does not have to be especially clear to be effective: the typical "literature" of a movement only "vaguely outlines a philosophy," and yet it can still be "of great importance in spreading a message or view, however imprecise it may be."[30]

Following Blumer, one might say that Long John's experience of the John Doe movement productively confuses him: by stripping him of his "previous personal organization," it unlocks the possibility of his change and growth. "Vague and indefinite feelings" hold even greater promise for John than they do for Blumer, because the more confused

about himself John becomes, the better he connects with his fellow John Does. And where Blumer merely acknowledges that a "message" can be compelling even when it is "imprecise," John captures the attention of his audience *by means of* his vagueness: his characteristic imprecision articulates the uncertain condition of the individual in the mass. Like organized selves, organized speech gets in the way of social connection. What's needed instead, *Meet John Doe* suggests, is an indefinite middle ground where people can meet because the boundaries between them are so unclear. Though Blumer adds a new scientific gloss to it, this theory of John's necessary vagueness as a spokesman for the average man is underwritten by a much older tradition of social thought in America. As the literary historian Nancy Ruttenburg has shown, the notion that the authentic voice of American democracy is *in*articulate dates back to colonial times.[31]

The problem for that theory in *Meet John Doe*, however, is that "a new personal organization" never does "crystallize" for Long John; in fact, his climactic experience of collective behavior nearly kills him. After learning the truth about Norton, John decides to expose Norton's fascist plot at a John Doe convention so huge that it has to be held in a baseball stadium. But Norton beats John to the punch: the media mogul floods the ballpark with newspapers that declare "JOHN DOE A FAKE!" and Norton himself takes the stage to denounce John. Trying to defend

The John Doe convention

John hapless at the mike

himself in his own words "before a crowd of fifteen thousand people and talking over a nationwide radio hookup," John becomes hopelessly vague and ineffectual. "Please," he begs the ballpark crowd, which includes his Millville friends, "if you'll all just be quiet for a few minutes I can explain this whole thing to you." "I've got a couple of things to tell you about," he continues weakly; "this thing's bigger than whether I'm a fake"; and then, most pathetically, after Norton's storm troopers cut the wires to his microphone, "this thing's not working." Without the amplification of Ann's scripts and Norton's media, John's voice is simply no match for the crowd's. "Listen to that mob," a radio announcer exclaims—"a howling mob," Capra himself called it.[32]

It's at this point of radical disconnection between John and his fellow John Does that Capra believed the movie itself lost focus: "For seven-eighths of the film, Riskin and I felt we had made The Great American Motion Picture; but in the last eighth, it fizzled into The Great American Letdown." Desperate to fix the problem, Capra tried out five different endings when the film was first released—"a new world's record in indecision," one reviewer crowed—but all of them "collapsed like punctured balloons." The ending Capra finally settled on was in his view merely "the best of a sorry lot." After the debacle at the stadium, John comes to believe that the only way to demonstrate the sincerity of his commitment to his fellow John Does is to erase his particular self entirely, by

John seemingly alone on the rooftop of City Hall

Norton and his associates, also on the rooftop

The Millville Does on the rooftop as well

killing himself as Ann's fictional character promised he would. A night-marish montage sequence transports John from the mob at the stadium to the lonely rooftop at City Hall.[33] Yet, even in this ultimate moment of decision making, John finds that he cannot escape his mass marketing: first, Norton and his fellow captains of industry emerge from the shadows; next, Ann rushes in; and then the Colonel and Connell appear, along with six members of the Millville John Doe club. It ends up being *crowded* on the rooftop, and the numbers are important. Ann alone cannot stop John from jumping; what finally changes his mind are the Millville club members who assure him, "We need you, Mr. Doe."

For critics such as Glenn Phelps, this last ending to the film "reveals to John (and just as importantly, to the spectator) that *mass action* is the only hope for changing the value structure of society." But "mass" seems a strange word to apply to the action of the six John Doe club members on the roof, or even to the actions of all the people gathered there, a group far smaller than John's first audience in the radio theater and also far less anonymous, inasmuch as every individual on the rooftop is someone John has met before. Emphasizing the relative intimacy of the setting, Richard Glatzer reaches the opposite of Phelps's conclusion: he argues that "the movie's finale ultimately accepts only the personal as a valid manner of dealing with others." Yet "personal" seems just as incongruous a term for the dynamics on the City Hall roof as

"mass" is. The combination of people John encounters there represents starkly different sets of interests, as well as different levels of connection to him. Some on the rooftop are John's enemies, and, with the exception of Ann, even his supporters keep their distance from him. John's closest friend, the Colonel, makes no attempt to convince him not to jump; neither does Connell. And although Ann throws herself at John, he says nothing in response to her frenzied appeals. The most persuasive speakers in the scene, the Millville club members, really have no idea who John is in person, which is why they continue to refer to him as "Mr. Doe."[34] Plainly aligned neither with the personal nor with the mass, the small crowd on the rooftop seems intended instead to *mediate* between such disparate scales of social relation.

Capra suggested as much in a letter to a fan who had complained about an earlier ending to the movie, which the fan claimed took sides against the masses by giving viewers the impression that "the John Does" had "turned on John Doe." Capra assured the fan that he had "put a new ending on the picture in which some John Does who had faith in the man are the ones who keep him from jumping."[35] *Some* John Does: Capra's indefinite language conveys a social unit that's small enough to allow for close contact yet large enough to expand the experience beyond the merely personal. The movie's very emphasis on *meeting* John Doe implies a similar mediation between an intimate and an anonymous social interaction. When John first encounters the Millville Does who will later reappear on the rooftop, they characterize the new neighborliness that he has inspired in them as something less than warm familiarity: "We sure got a kick out of seeing how glad everybody was just to say hello to one another." Speaking to Ann at the diner, John recalls these words to help him conceptualize his new, tenuous sense of identification with his mass audience: "Maybe they're just lonely and wanted somebody to say hello to." The rooftop scene at the end of *Doe* exemplifies the movie's resistance to closing this social gap entirely, even when the number of people involved is far more manageable than at the stadium.

That gap, of course, is unbridgeable for the movie audience, who can never meet anything more than the image of John Doe, or rather the image of a man who plays the part of a man who plays the part of Doe. Early commentators on film often spoke of "the new intimacy" that movies brought to entertainment, but *Meet John Doe* qualifies this ideal of intimacy in several ways, most noticeably by placing conspicuous limits on John's romantic intimacy with Ann.[36] John never tells Ann that he loves her (though he does tell her mother); he never kisses Ann (though he does kiss her mother). Even in the scene where he lets Ann know about his dream of walking through walls to reach her—a dream

that speaks to those moviegoers who long for some deeper connection with the characters they view on the screen—John seats himself just outside the door of the bedroom he imagined himself entering, as if some transparent barrier were blocking his way. In the theater of *The Roaring Girl*, nothing stopped Moll Cutpurse from saying what she wanted to say or going where she wanted to go; the sexual effect of her free speech and movement was further enhanced by her "plump" physical presence before the audience. John's sexual timidity, by contrast, befits not only his more attenuated charisma but also his more attenuated presence to his film audience. "The great illusion of the movie theater," Capra told an interviewer in 1975, "is that you go in there and there's just shadows—Jesus Christ! No people, no life, no blood and flesh." And yet, Capra marvels, spectators are tricked into getting "involved" with these literally superficial images, into feeling that some "people-to-people" communication has taken place, simply "in watching people's faces" on the screen.[37]

We see more of filmed actors than their faces, of course, and in talking pictures we experience more of actors than our sight of them. But the face is not only Capra's favorite emblem of the actor who has been disembodied by film; it is also the form of individuation that he habitually associates with people in a crowd. "I shoot many scenes in crowds,"

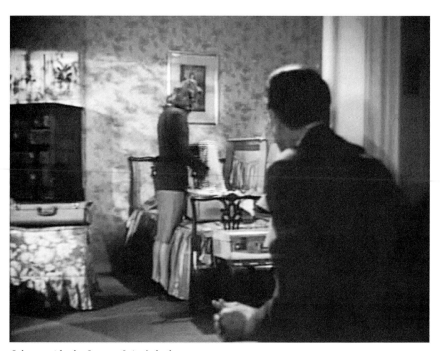

John outside the frame of Ann's bedroom

Capra told another interviewer in 1976, "because I think people are more interested in other people than they are in anything else. They love the faces; they don't know who the devil they are, but they like them because they are people."[38] John similarly has no idea who the devil the people are in his audiences, but he nevertheless starts to feel a connection with them because he can "see something in their faces." The question is, how deeply "in" can such visions go—even when it's one face rather than many that we see, and a face that the big screen allows us to see up close? "Gary Cooper had a most wonderful face," Capra assured a 1971 interviewer, "a great expressive face in the sense that you think you see a lot in that face." You *think* you see a lot in it. "That face is wonderful," Ann similarly exclaims at the start of *Doe*, as she contemplates exploiting John's look of sincerity to sustain her fraud: "they'll believe *him*."[39] By the end of the film, Ann's growing intimacy with John has convinced her to abandon her cynicism, but the situation is different for the Millville Does, who have no more reason for trusting what they see in John than filmgoers have for trusting what they see in Gary Cooper: "I don't *think* he was any fake," says one of the Millville club members as they hurry to the rooftop—"not with that face."[40]

The Millville Does never do hear John speak on the rooftop; they never do receive any deeper reassurance about his sincerity than the way he looks at them as they speak to him. Reviewers of *Meet John Doe* have from the start expressed exasperation at Capra's unwillingness to let John affirm the authenticity of his connection to the John Doe movement once and for all by killing himself. Hedda Hopper felt that she'd "been had": "if a principle is worth living for," she protested, "it's worth dying for." "At any cost," Philip Scheuer agreed, "John Doe should have jumped from that roof." In his autobiography, Capra recalled the similar frustrations of his friend Myles Connolly, who regularly denounced the "pap about *brotherhood*" that Capra was prone to "spouting." "Brotherhood is *not* just saying 'Good morning,'" Connolly insisted; "it's sacrifice."[41] But John does make a sacrifice in the end. It's just smaller and less satisfying than the one Hopper and Scheuer envisioned: he renounces the suicide that might have vindicated him. "Now take a good look, Mr. Norton," says John as he resolves to jump, but then his friends and supporters intervene, his old confusion returns, and we never hear him speak another word. When a still-troubled Capra asked in his autobiography, "Was an acceptable ending *ever* possible for *John Doe*?" his continued frustration reflected John's own dilemma at being caught on the rooftop between unsatisfactory alternatives.[42] And yet the whole thrust of *Meet John Doe* from the start had been to *require* frustration from John, whose unique though representative status as the uncommon common man had depended on the bewildering indeterminacy

of his relation to his fellow John Does.[43] However dissatisfying it might have been for Capra, he himself regarded this indeterminacy as the key to the film, and to the movie experience generally. When an interviewer asked him in 1973 what difference such illustrious stars as Gary Cooper and Jimmy Stewart had made to his movies, Capra's vague reply spoke volumes: "They had a certain something."[44]

John confused once more

PART II

Show Business

3

I Must Be Idle

> Hence! home, you idle creatures, get you home!
> Is this a holiday?
>
> —The opening lines of *Julius Caesar*

"Amusement under late capitalism is the prolongation of work." This famous dictum from Horkheimer and Adorno's essay "The Culture Industry" makes two claims that I want to disentangle from one another. The first is that amusement has lost its difference from work; the second, that this blurring of boundaries has resulted from economic conditions specific to the twentieth century. Before leisure could prolong labor, Horkheimer and Adorno argue, "capital" had first to organize itself into a "monopoly" and then utilize the mass deception of the culture industry to force its own homogeneity on the rest of society. What's more, this totalitarian project could not have succeeded without the aid of modern machinery. In order to consolidate society into a capitalist "system," Horkheimer and Adorno claim, "everything has to run incessantly, to keep moving. For only the universal triumph of the rhythm of mechanical production and reproduction promises that nothing changes, and nothing unsuitable will appear." Workers inherently threaten the system because they cannot run incessantly the way machines do. They need a break; they require amusement "as an escape from the mechanized work process, and to recruit strength in order to be able to cope with it again." But the machine solves the very problem it seems to create. Under late capitalism, Horkheimer and Adorno maintain, "mechanization has such power over a man's leisure and happiness, and so profoundly determines the manufacture of amusement goods," that it "inevitably" molds a worker's leisure "experiences" into "afterimages of

the work process." Produced and delivered by mechanization, film and radio are the amusements that Horkheimer and Adorno regard as most effective at prolonging work past normal human limits and thus assimilating the worker to the machine. The "ostensible content" of a movie or radio broadcast, they assert, is "merely a faded foreground" to the real action, which is "the automatic succession of standardized operations" in these entertainments that enables them to occupy "men's senses from the time they leave the factory in the evening to the time they clock in again the next morning" with the rhythm of mechanization.[1]

Forget the historical specificity of Horkheimer and Adorno's argument about work and amusement, however, and it turns out to have a surprising pertinence to an era before late capitalism, before mass media, before mechanization. During the English Renaissance, the Horkheimers and Adornos of their day often complained that the commercial theater had undermined the proper relationship between work and amusement, although in their view the theater had promoted a life of all play and no work rather than all work and no play. In his 1577 *Treatise* against such "idle pastimes" as plays, John Northbrooke insisted that he was not opposed to amusements generally: he was simply trying to curb the ones that had gotten out of hand and that had therefore disrupted the necessary alternation in life between recreation and labor. "There is...an honest and a necessary idleness," Northbrooke acknowledged, "whereby good men are made more apt and ready to do their labors and vocations whereunto they are called," but the theaters—in which "more Idleness" could "not be"—had turned amusement into an end unto itself. For the author of *A Refutation of the Apologie for Actors*, writing in 1615, the theaters managed not only to "nourish" idleness but to prolong it as well: "many vicious Persons when they know not how any longer to be idle, for variety of Idleness go to see Plays." In 1633, the antitheatricalist William Prynne continued to sound this theme that "Stage-plays serve for nothing else, but either to draw men on by degrees to idleness, or to foster, to foment them in it: Wherefore they are rightly called Plays." Plays themselves were nothing new in England; what made drama so much more alarming a pastime to English moralists than it had once been was the construction of permanent playhouses such as the Theater and the Curtain, built a year before Northbrooke's *Treatise*, which had given theatrical amusements a disturbing new staying power. In the past, Samuel Cox lamented in 1591, playing was conducted by amateurs, and limited to "certain festival times of rest when the people are free from labor," but now the permanent theaters allowed actors to make "their playing an occupation of idleness all the whole year." The result was calamitous not only for the actors but also for their audience, whose "whole life," Prynne declared, had become "a continued Play."[2]

"Mark the flocking and running to Theaters & curtains, daily and hourly, night and day, time and tide," complained Philip Stubbes in 1582.[3] What outraged Stubbes and his fellow theater-haters was a perceived new incessancy to entertainment.

Some writers of the period went further in their critique of the theater. Not only had the prolongation of idleness there reduced work to play: it had eroded the very distinction between them. Horkheimer and Adorno later marveled at the naked commercialism of film and radio: "they call themselves industries," the two noted in disgust. But Renaissance moralists were similarly appalled by the new professionalization of acting, which, having substituted play *for* work, now depicted play *as* work. Denouncing the "trade" of acting as "an idle loitering life," Northbrooke nevertheless acknowledged that it was a trade. "This unhonest trade," declared another theater-hater in 1580, "hath driven many from their occupations, in hope of easier thrift." The "continual and mercenary" nature of playing in the permanent theaters seemed to have generated the absurd paradox of an "idle Profession" or "idle occupation"—as Cox put it, "an occupation of idleness all the whole year."[4] In an important recent study, *Work and Play on the Shakespearean Stage*, Tom Rutter shows how Renaissance dramatists began to respond to such attacks and defend playing as an occupation "by emphasizing the industriousness and skill of professional actors." But Rutter also rightly underscores the strangeness of this show-business ethos for a society that was unused to it: even as moralists condemned the theaters for having "distracted Londoners from their work," "playing was becoming more like other forms of labor in London: repetitive, geographically fixed, carried out on weekdays." How could revelry count as labor and yet still be understood as leisure? Citing Prince Hal's worry in the first part of *Henry IV* that "if all the year were playing holidays," then "to sport would be as tedious as to work," Rutter detects an anxiety among Renaissance writers that "the growing regularity of theatrical performance" in the new playhouses was making acting "more like the daily grind of tradesmen" than a holiday release from labor.[5] For professional actors and dramatists no less than their critics, Rutter suggests, the incessancy of amusement in the permanent theaters had *confused* work and play.

Confusion is not an option in the totalitarian universe that Horkheimer and Adorno believe themselves to be describing. According to their analysis, monopoly capitalism methodically reduces play to work by demanding "a constant reproduction of the same thing," which eliminates any "distinction between the logic" of a film, say, "and that of the social system." Rutter, by contrast, opens a conceptual space in amusements that Horkheimer and Adorno foreclose, a space of "vexed"

uncertainty about the relationship between work and play. Rutter views
the theater as a "material context" in which "the status of working and
playing as discrete and separate activities is unavoidably called into
doubt." Hence, Hal's worry about incessant play in *Henry IV* "reflects
a wider phenomenon whereby acting...had assumed the controversial
status of an ongoing livelihood"; Hal gives voice to "contradictions"
that "beset the early modern stage."[6] Yet in claiming that a material
context unavoidably beset dramatists with contradictions, Rutter retains
a version of the economic determinism he complicates: what he himself
forecloses is any conceptual space in Renaissance drama for critical
detachment and creative freedom, as opposed to inescapable contradic-
tion. Nothing, however, *forced* commercial playwrights to address the
issue of their idle occupation; they *chose* to dramatize it; indeed, they
helped make an issue of it. In what follows, I'll argue that Shakespeare
repeatedly thematized a collapse of difference between "sport" and "work"
in his plays, but instead of interpreting such a collapse as turning all
amusement into labor or all labor into amusement, he emphasized the
dizzying endless convertibility of one action into the other. Taking his
cue from his own idle occupation, Shakespeare developed a distinctively
indeterminate mode of action for some of his most famous characters
that I'll call *play-work*.

 To make sense of Shakespeare's play-work and its theatrical appeal,
I'll enlarge Rutter's picture of the "material context" for Renaissance
drama by adding to it a crucial professional element that Horkheimer
and Adorno highlight in their own account of show business. As I noted
in the introduction, mass audiences are so important to Horkheimer
and Adorno's analysis that one might plausibly stand their theory on its
head and attribute their belief in a "system" that is "uniform as a whole
and in every part" not to the capitalist monopoly that employs mass
deception but rather to the masses themselves, which make individuals
seem interchangeable with one another.[7] Mass audiences are missing
from Rutter's analysis of the Renaissance theater because he assumes,
as Horkheimer and Adorno do, that such audiences belong exclusively
to modern entertainment. Yet the new arena theaters of Renaissance
England made possible a regularly returning mass audience as well as
regular amusement for them. "Very great multitudes of all sorts of peo-
ple," the Privy Council again and again complained, "do daily frequent
& resort to common plays."[8] In the rest of this chapter, I'll show how
Shakespeare associates the seeming indistinguishability of times and
actions in play-work with the seeming indistinguishability of individu-
als in a mass. I'll begin by emphasizing the city setting of *The Comedy
of Errors*, where business is constantly interrupted by farcical games
that are not intended as games but instead result from confusions about

characters who appear to be interchangeable. I'll then turn to the first part of *Henry IV*, which links the collapse of difference between work and play with the social leveling produced by a kingship in disgrace. In this later drama of Shakespeare's, however, a distinctive figure manages to arise from the confusion, when Prince Hal devises a self-promoting form of play-work for himself from his "vile participation" with the masses. Finally, I'll trace the mutations of Hal's perversely industrious play into the supposedly strategic "antic disposition" of an even more distinctive prince, Hamlet. While Hamlet's behavioral instability links him in his own mind to the idle occupation of acting, it also reaches beyond the stage to the returning audience, whose ongoing commitment to the theater *Hamlet* represents as far more difficult than the actor's to explain.[9]

The Comedy of Errors

There's a time for work and a time for play in *The Comedy of Errors*. At Ephesus, where the *Comedy* is set, the customary division of time is to work during the day and to play at night. When Antipholus of Syracuse, having just arrived in Ephesus, asks an Ephesian merchant to join him in walking about the town and then dining at his inn, the merchant must politely defer the pleasure: "I am invited, sir, to certain merchants, / Of whom I hope to make much benefit; / I crave your pardon. Soon at five a'clock, / Please you, I'll meet with you upon the mart, / And afterward consort with you till bed-time: / My present business calls me from you now." Antipholus has no other business for the moment than to become acquainted with Ephesus—we'll soon learn that he has no other business in general than to search for his lost twin brother—but even he thinks it's proper to separate business from pleasure. Before inviting the merchant to stroll with him, Antipholus had ordered his slave Dromio to take money to their inn and wait for him there. Dromio, though obedient, had responded with a joke, and Antipholus felt compelled to assure the merchant that the joke was not out of order: he called Dromio "a trusty villain, sir, that very oft, / When I am dull with care and melancholy, / Lightens my humor with his merry jests." But this extenuation of Dromio's playfulness suggests that Antipholus sets the times for "care" and "jests" to the private clock of a "humor" that must be lightened "very oft" rather than to the steadier public clock of the sun, and the comparative irregularity of the foreigner's timekeeping quickly becomes a problem for him in Ephesus when, moments after the merchant leaves on business, Dromio returns too "soon" from his task and then renews his jesting. "I am not in a sportive humor now,"

Antipholus cautions his slave. "Tell me, and dally not, where is the money?" Then, as Dromio continues to respond inconsequently, Antipholus warns him that "these jests are out of season, / Reserve them till a merrier hour than this."[10] But nothing stops Dromio's foolery until Antipholus beats him for *dallying*: for confusing work and play by delaying the one and prolonging the other.

And yet the offender is not Dromio, or rather he's not Antipholus's Dromio, or to be more precise, he's not the Dromio belonging to Antipholus of Syracuse, or to be preciser still, he's not the Dromio belonging to the Antipholus of Syracuse we first meet: he's Dromio's twin, who happens to be owned by Antipholus's twin, the other Syracusian Antipholus who now resides in Ephesus. And this second Dromio is not dallying, because the wife of Ephesian Antipholus has sent him "in post" to fetch her Antipholus home to dinner. That is the urgent business Dromio is trying to conduct even as Antipholus berates him for dallying. Baffled by his master's behavior, Dromio can only assume that Antipholus is the one who is jesting out of season. "Return'd so soon!" Dromio exclaims; "rather approach'd too late!" "I pray you jest, sir, as you sit at dinner."[11] Neither man means to interrupt the other's business; only the most farcically improbable circumstances are to blame for the confusion. But the mirth generated by this comedy of errors turns into its supposed opposites, melancholy and care, once the disrupted rhythm of work and play in Ephesus starts affecting Ephesian Antipholus as well. The only "business" that seems to concern this wealthy gentleman is deciding where to dine, until his fellow citizens mistake him for the foreigner who looks just like him and then begin to worry, as his slave had, that Antipholus no longer knows how to "keep...hours." In short order, a burst of seemingly ill-timed "merry humor" from Antipholus sparks a public altercation. A merchant in Ephesus who is anxious to get some business under way asks a goldsmith to settle a debt the goldsmith owes him; the goldsmith in turn asks Antipholus to pay him for a chain that the goldsmith had earlier mistakenly bestowed on Antipholus's twin. When Antipholus refuses to pay for the chain, the goldsmith tries at first to remain businesslike, explaining to Antipholus that the merchant "is bound to sea, and stays but for" his money. But a baffled Antipholus rebukes the goldsmith for having "run this humor out of breath," and the merchant exasperatedly complains, "My business cannot brook this *dalliance*."[12] Under such public pressure, the goldsmith has Antipholus arrested for debt—"arrested in the street" is how Antipholus describes the "open shame" he suffers. The game that others seem to be playing with him has spun wildly out of control, and yet the more he protests such inexplicable treatment, the more he appears to "demean himself" to onlookers. Within minutes, even his wife and his sister-in-law have

come to believe that he has lost his senses. "Poor souls," the sister-in-law exclaims when she hears Antipholus in seemingly frenzied banter with his slave, "how idly do they talk!" Antipholus can only conclude that his wife is cruelly dallying with him, having conspired with the rest to make a mockery of him. Comedy and tragedy cross, just as care and jesting do, when Antipholus threatens to "pluck out" the eyes of his wife for having come to "behold" the "shameful sport" of his humiliation.[13]

"Learn to jest in good time," Syracusian Antipholus had earlier admonished Dromio; "there's a time for all things." Why is time so out of joint in *The Comedy of Errors*? Applying Rutter's analysis, we might say that the *Comedy* reflects the "professional theatrical environment" in which it was devised, where actors played when they should have been working and then pretended that their play was work. By associating a confusion about time with a confusion about persons, the *Comedy* (we might argue) suggests that work and play can now be mistaken for one another because the phenomenon of professional acting has made them resemble one another, like twins. But the play itself points to a wider environment than the stage as the setting for such collapsed distinctions. In *The Comedy of Errors*, it's the city that promotes confusion. The city, where people "throng," provides the Antipholi the social space to mingle with many other characters and yet never encounter one another, and the play makes this indiscriminate mixing seem hostile not only to individuality but also to individuation generally.[14]

From the city's perspective, it's the individual who causes all the trouble. In the first scene of the *Comedy*, the city's authorities set firm temporal boundaries on the subsequent action. The play begins with the Duke of Ephesus explaining to the Syracusian father of the Antipholi, Egeon, that because Ephesus is at war with Syracuse, "our laws" have condemned Egeon to death as an enemy alien. Egeon himself explains that he has sailed to Ephesus only to search for his lost family, and the Duke, taking pity on Egeon, allows him "this day" to drum up a ransom for himself. Other Ephesians will later clarify that by "this day," the Duke means the workday in particular: Egeon is scheduled to die at "five," "ere the weary sun set in the west." The subsequent confusion about time and persons begins, as I've said, in the second scene of the *Comedy*, shortly after a second enemy alien who has entered Ephesus illegally, Syracusian Antipholus, asks an Ephesian merchant to take the day off from work. When the wrong Dromio appears moments later, addressing the wrong Antipholus, the *Comedy* farcically exaggerates Antipholus's friendly invitation to relax and unwind into a kind of cosmic lawbreaking, as if to say that one cannot capriciously disregard the public customs that regulate social activity, choosing to work or play only when one is "disposed" to it.[15]

Antipholus himself dislikes such whimsicality whenever his slave seems to manifest it. Though he and Dromio are strangers to the "manners" of Ephesus, Antipholus tries to set private limits on Dromio's behavior by insisting that Dromio observe Antipholus's humor as his law. And yet Antipholus admits that he frequently breaks his own rules, insofar as he uses Dromio to counteract his humor rather than to mirror it. This humor, an involuntary force within Antipholus, threatens his coherence as a law unto himself; the play will soon farcically exaggerate that internal disorder by presenting us with not one Antipholus but two. Before this happens, Dromio and then the merchant depart the stage, commending Syracusan Antipholus to his "own content," but instead of taking pleasure in being left to himself, Antipholus immediately succumbs to his melancholy humor:

> He that commends me to mine own content,
> Commends me to the thing I cannot get:
> I to the world am like a drop of water,
> That in the ocean seeks another drop,
> Who, falling there to find his fellow forth
> (Unseen, inquisitive), confounds himself.

A drop of water is the most ephemeral form of individuation, with nothing except space or place to distinguish it from another drop. It's easy enough to guess how this analogy has occurred to Antipholus: he would not have crossed the ocean in search of his twin if he felt that he had any "content" on his own. But Antipholus is no longer at sea when he soliloquizes: he has landed in Ephesus, and he feels like a drop of water in comparison to this foreign "world," not to the ocean. Now that his chief acquaintance in Ephesus, the merchant, has left him, Antipholus has been reduced to anonymity there. Shortly before the merchant departed, Antipholus told him that he planned to "lose" himself in the city until the merchant returned.[16] Perhaps it's his cares that Antipholus hopes to lose in the city, but the city also reinforces those cares, insofar as it heightens his sense of distinctiveness lost.

The troubles that Syracusan Antipholus faces in Ephesus stem from more, however—or perhaps less—than his foreignness, because his twin, an eminent figure there, feels the annihilating pressure of the city even more acutely than Syracusian Antipholus does. For no good reason, or so it appears to Ephesian Antipholus, his fellow citizens have chosen to treat him as their enemy, arresting and then imprisoning him. Technically speaking, he *is* an enemy to the city, as a "Syracusian born," but no one in Ephesus realizes this: they punish him for what they call his "incivility." Dazed by his inexplicable loss of position in Ephesian society, Antipholus in turn no longer recognizes his fellow citizens as the individuals they once were: to his eyes, they coalesce into a shadowy,

indefinite mass aligned against him. His wife, he claims, is "confederate with a damned pack / To make a loathsome abject scorn of me"; she's in league with "a rabble." Even before his conflict with the goldsmith and merchant, Antipholus had begun to recognize his vulnerability to the characterless mass of the city. Returning home with friends, he'd discovered that his wife was already dining with another man—his twin brother, of course—and had locked him out of his own house. Enraged, he'd planned to break down the door, but his friends had counseled him to avoid making so humiliating a spectacle of himself:

> If by strong hand you offer to break in
> Now in the stirring passage of the day,
> A vulgar comment will be made of it;
> And that supposèd by the common rout
> Against your yet ungallèd estimation,
> That may with foul intrusion enter in,
> And dwell upon your grave when you are dead.

Bowing to this advice, Antipholus implicitly acknowledges the power that "the common rout" hold over him: in effect, they have conspired with his wife to keep him in the street, where they are strongest. Though his friends speak of the crowd as ascendant only during the public hours of the workday, they also admit that this power may be prolonged indefinitely, to injure Antipholus even after he is dead. To their minds, then, the crowd threatens distinctions in time just as much as it undermines distinctions among persons. A similar anxiety about the city's throngs surfaces in Syracusian Antipholus's attack on Dromio for jesting out of season. Antipholus accuses his slave of making "a common of my serious hours": of behaving too "familiarly," he means, but also of confusing playful with serious hours and thus reducing Antipholus's time to a characterless mass, a *common*.[17]

 The city chooses a different way to disorient Syracusian Antipholus, not by persecuting him as its laws would seem to demand but rather by showering him with gifts and favors:

> There's not a man I meet but doth salute me
> As if I were their well-acquainted friend,
> And every one doth call me by my name:
> Some tender money to me, some invite me;
> Some other give me thanks for kindnesses;
> Some offer me commodities to buy.
> . . .
> Sure these are but imaginary wiles,
> And Lapland sorcerers inhabit here.

According to Syracusan Antipholus, it's Ephesus that dallies with him, not he with the city: "they say this town is full of cozenage," he'd worried from the start. Capriciously, the city appears to recognize an Antipholus that Antipholus doesn't recognize, and the experience of seeming to be "known" by "everyone" except himself leaves Antipholus feeling so bewilderingly at sea that he decides to yield to the nameless crowd and conform with them: "I'll say as they say, and persever so, / And in this mist at all adventures go." To "persever" means to continue in one course of action indefinitely; Antipholus thinks of this uninterrupted behavior as matching the "mist" of confusion in the city. But it's also to adopt the comportment of a slave, who has no choice but to endure his master's arbitrary will. In the following scene, Ephesian Dromio complains of Ephesian Antipholus that "I have serv'd him from the hour of my nativity to this instant, and have nothing at his hands for my service but blows. When I am cold, he heats me with beating; when I am warm, he cools me with beating. I am wak'd with it when I sleep, rais'd with it when I sit, driven out of doors with it when I go from home, welcom'd home with it when I return."[18] To its victims in *The Comedy of Errors*, a power that collapses different times and behaviors "all together" seems worse than capricious: it is *incessant*.

1 Henry IV

The first part of *Henry IV* generates an atmosphere of incessancy from its opening lines. King Henry confesses at the start of the play that he is "shaken" by the "care" of managing civil war without respite in England, which has left "frighted peace" no "time . . . to pant," let alone to undertake some different course of action than fighting. "Our hands are full of business" is how he later describes the situation to his son Hal. Even after he successfully concludes the so-called business of defeating Hotspur and his fellow rebels, Henry believes he cannot pause from fighting: in the final speech of the play, he continues to urge his followers to exercise their "dearest speed" in confronting other rebels who are now "busily in arms." Having lost any broadly accepted claim to a singular authority as England's one true king, Henry also seems to have lost the ability to distinguish a time for rest from a time for toil. In the next play of the series, the only way he can put an end "th' incessant care and labor of his mind" is by dying.[19]

The rebels against Henry feel the same relentless pressure to act as he does, although they blame this urgency on the king, whom Hotspur says "studies day and night" how to destroy them. According to Hotspur's wife, her husband is so wholly consumed by the business of warfare

that he cannot take a breather from fighting even when he's sleeping. Nightmares have "so bestirr'd" him

> That beads of sweat have stood upon thy brow,
> Like bubbles in a late-disturbed stream,
> And in thy face strange motions have appear'd,
> Such as we see when men restrain their breath
> On some great sudden hest.

There's a significant generational difference between Hotspur and Henry, however. Unlike the aging king, who complains of having to "crush" his "old limbs in ungentle steel," the "breathless" young Hotspur is always impatient to return to the battlefield whenever he is away from it.[20] The fate that worries him is not warfare without intermission but rather some other, more "tedious" forms of incessancy such as married life (which Hotspur likens to playing with "mammets"), or conversing with Glendower (who Hotspur grumbles "held me last night at least nine hours" in talk), or listening to poetry (which Hotspur says resembles "the forc'd gait of a shuffling nag").[21] Compulsively "valiant" as well as "active," Hotspur seems constitutionally incapable of desiring a break from battle, and yet his total commitment to warfare doesn't stop him from playing: with no time to distinguish a leisure activity from the business in which he is constantly engaged, Hotspur perversely finds his recreation in the "extreme toil" of the battlefield. "O, let the hours be short," he exclaims, "till fields, and blows, and groans applaud our sport!"[22]

In stark contrast to his father and his chief rival, Prince Hal of *1 Henry IV* seems to have time for nothing but play. Hal's first scene is set in a London tavern, where his fellow debauchee Falstaff asks him the "time of day" and Hal dismisses the question, insisting on the undifferentiated mass of leisure time that stretches before them. For all his fun and games, however, Hal faces a version of the problem that Henry and Hotspur confront in their continual fighting: his *recreation* seems incessant. "Fie upon this quiet life," Hal exclaims in mockery of Hotspur, "I want work," but his sarcasm cannot hide his own youthful fear of monotony. Worried that a life wholly given to "sport" would be "as tedious as to work," Hal secretly plans on "redeeming time," which, he believes, means restoring not only the political distinctions that allow one man to count as superior to another but also the behavioral distinctions that allow one time to count as a respite from another. Simply to play rather than to fight is, for Hal, to explore an alternative to constant warfare; by the same token, when he finally decides to join his father on the battlefield, he demands that his fighting be understood as a break from playing: "What, is it a time to jest and dally now?" he exclaims in disgust at some continued foolery from Falstaff during the heat of

battle.[23] And yet Hal proves so ineffectual at putting a stop to Falstaff's jesting out of season that he ultimately allows Falstaff's pranks to compromise his own heroics, when he joins Falstaff in the absurd pretense that Falstaff rather than Hal killed Hotspur. Hal's willingness to indulge Falstaff's jests even on the battlefield underscores how his own impetuousness repeatedly leads him, like Hotspur, to imagine a life for himself that *combines* work and play instead of parceling them out into separate behavioral modes.

A telling example of Hal's investment in such mixed behavior occurs in the ostensibly comical scene where he torments the "drawer" or tapster Francis by arranging for his own companion, Poins, to keep demanding service from Francis while Hal compels Francis to remain in idle chatter with him. "Pray stay a little, my lord," Francis begs Hal at one point, hoping to get on with his work, but the prince refuses to cease dallying with him. Once the painfully prolonged prank has ended, Poins guesses that Hal must have meant some kind of business by it: "But hark ye, what cunning match have you made with this jest of the drawer?" he asks the prince; "come, what's the issue?" Eventually Hal rationalizes the game as a send-up of Francis's pitiful "industry," but his initial response to Poins's question is to glory in a feeling of expansiveness that his jest has aroused in him: "I am now of all humors that have show'd themselves humors since the old days of goodman Adam to the pupil age of this present twelve a'clock at midnight." What seems to exhilarate Hal about his toying with Francis is the simultaneity of pressures to work and to play that he imposes on Francis and that, in the heat of jesting, he himself experiences vicariously. Earlier in the scene, Hal had exuberantly recounted to Poins how he had been carousing with Francis and other comparably base laborers, learning how to "drink with any tinker in his own language." "I tell thee, Ned," Hal concludes, "thou hast lost much honor that thou wert not with me in this action."[24] The joke is that Hal satirically compares his lowlife dissipation to a heroic military venture, but once again the sarcasm is revealing. Even as he mocks the busyness of the warfare that his father and Hotspur continually wage, Hal imagines his idleness as an uncanny form of their "action."

Rutter helps us make sense of Hal's obscure motives in this scene by tracing their connection to the professional environment of the new theaters. According to Rutter, the paradox of working players forced Renaissance theatergoers to question the accepted notion "of working and playing as discrete and separate activities," and Shakespeare channeled this deconstructive energy into his characterization of Hal, whose "creative approach to ideas of work and idleness" makes us "come to see" the distinction between them "as arbitrary rather than fixed."[25]

Yet the determinative force that Rutter grants to the professional context for Shakespeare's play ultimately simplifies the context along with the play. As the wide range of contemporary opinion on the status of professional players suggests, the new theaters never *compelled* their audiences to question the distinction between work and amusement. Nor, in *Henry IV*, does the game with Francis make that distinction seem arbitrary. On the contrary, the felt difference between work and play is crucial both to the comedy and to Shakespeare's characterization of Hal, who heightens the tension between work and play even as he fuses them together. Hal's behavior in this scene, moreover, doesn't change the way Francis or even Poins sees things: it mystifies these two participants; it mystifies Hal as well. Though Rutter assumes, as Poins does, that Hal's game must be the product of some "cunning" strategy, Hal himself attributes his jesting to his own involuntary "humors." And this is no mere whimsicality on Hal's part: he describes himself as *comprehensively* capricious, "of all humors" that have ever manifested themselves in all of human history. Hal may view this self-characterization as itself strategic, helping to distinguish him from everyone else by making him seem a bigger man on the inside than they are, a "wonder" who is superhumanly capable of incorporating all their behaviors into one.[26] But the scene also suggests that Hal can achieve such maximal complexity only at the cost of his own behavioral stability and coherence.

The best that King Henry can make of his son's "madcap" behavior is that he's out of control; the worst, that he's hopelessly twisted and perverse.[27] Hal's next scene in the play is a somber "private conference" with his father, who is astounded by the irreconcilabilities in Hal's character. How, the king asks,

> Could such inordinate and low desires,
> Such poor, such bare, such lewd, such mean attempts,
> Such barren pleasures, rude society,
> As thou art match'd withal and grafted to,
> Accompany the greatness of thy blood
> And hold their level with thy princely heart?[28]

Even as he rebukes Hal, however, Henry confesses that he, too, had once "enfeoff'd himself to popularity." His excuse is that his self-debasement was strategic: at the time, he needed the support of the people against King Richard, so he temporarily "dress'd" himself "in such humility / That I did pluck allegiance from men's hearts." Hal might similarly claim that his fraternizing with commoners amounts to shrewd politics; after all, his fellow carousers in the tavern swear that Hal "shall command all the good lads in Eastcheap" when he is king. But his father

rejects this argument in advance by attributing the success of his own politicking to the *in*frequency of his campaign appearances. Allowing himself to be "seldom seen," Henry says, he "could not stir / But like a comet I was wonder'd at," whereas Hal has made himself "so common-hackney'd in the eyes of men, / So stale and cheap to vulgar company," that the "eyes" of his subjects are "sick and blunted with community."[29] *Community*: the term mixes all the forces that Henry thinks "stand against anointed majesty"—not merely the "vulgar company" that drags Hal down, but also the "stale" tedium of his being incessantly seen, which affords "no extraordinary gaze, / Such as is bent on sunlike majesty / When it shines seldom in admiring eyes."[30] Although he admits that he was compelled to curry favor with the vulgar throng, King Henry believes that his occasional rather than regular playing to them saved him from being reduced to "their level." The common hackney to which Henry compares his son is the miserable workhorse whose "forc'd gait" epitomizes tedious labor for Hotspur; the king likens his own "seldom but sumptuous" appearance to a holiday "feast," which pleases by its "rareness."[31]

Henry is of course remarkably self-deceived about his own political effectiveness. The mere fact of the rebellion proves that he long ago "lost that title of respect" he claims to have won through his holiday performances, while the "fresh and new" figure he feels he once cut has now been heavily soiled by the incessant labor of civil warfare.[32] Even at the time of Henry's first triumphal entry into London, his uncle the Duke of York had deplored Henry's demeaning "courtship to the common people," which York thought made Henry seem more like "a well-graced actor" than "your Grace" the king. The analogy crystallizes the flaw in Henry's thinking that he managed to avoid any "vile participation" in his political campaigning. When comparing Henry to an actor, York also likens the city to "a theater"; no matter how infrequent Henry's appearances may have been, they still amounted to mass entertainment. Hal, recognizing this contradiction in his father's political theory, opts for a more sustained courtship of the common people as a means not only of admitting the masses into his new theater of kingship but also of strengthening and even regulating his relationship with them.[33] In effect, as Rutter helps us see, Hal becomes a professional rather than amateur entertainer. But Hal's calculatedly continual playing does not normalize the paradox of show business, as Rutter implies it does: rather, it *adds* complexity to the showmanship that Hal inherited from his father, making his impersonation of royalty seem as talkative, familiar, impulsive, and relentless as it is showy, aloof, strategic, and rare.[34] By ennobling the actor's play-work, Hal also magnifies its discords and perversities.

Hamlet

Hamlet begins, as *1 Henry IV* does, by associating a loss of royal distinctiveness with incessant labor. In the first scene of the play, old King Hamlet is such a busy warrior that he continues to be up in arms even after he's dead, while the sight of his ghost prompts Horatio and the other sentinels to speak of the "strict and most observant watch" that "so nightly toils the subject of the land," of workers "whose sore task / Does not divide the Sunday from the week," of the "sweaty haste" that "doth make the night joint-laborer with the day."[35] The second scene of *Hamlet*, like the second scene of *1 Henry IV*, shifts our attention from such relentless toil to the rebellious behavior of the king's son. Claudius and Gertrude want Denmark to move past its grieving for the old king, but Prince Hamlet, they complain, perversely refuses to accept that one form of behavior must give way to another; he has chosen instead to "*persever* / In obstinate condolement." This indefinite prolongation of his grief leaves Hamlet no time for the "jocund" mood that the new king his uncle wants to encourage—or rather, it leaves him no time outside his extended grieving in which to express his "mirth." From his opening lines, Hamlet jests out of season in relation to his own melancholy; later, he decides to engage in "pranks" even while plunged in a suicidal depression.[36] Rutter tries to sort out Hamlet's "antic disposition" by treating it as another version of Hal's strategic play: he calls it a "studied performance of idleness" that "aligns" Hamlet no less than Hal "with the professional actor," who must work "while appearing not to" if his performance is to be "successful." But this is Rutter's reflection theory at its weakest, because his strict analogy between conniving prince and skillful player forces him to gloss over the "wild" disjointedness of Hamlet's actions, which disturbs Hamlet almost as much as it does Claudius and Gertrude.[37]

Prince Hamlet is in any case more than merely aligned with professional acting. Rutter himself emphasizes "the *obsessiveness* with which the play *Hamlet* refers, repeatedly, to the circumstances of its production." This self-reflexiveness had already figured in the first part of *Henry IV*, where Hal, after toying with Francis in an Eastcheap tavern, had commanded Falstaff to "play" his father, and Falstaff had explicitly based his subsequent performance on an antiquated Elizabethan tragedy, *King Cambyses*; one of the tavern's crew had exclaimed, "He doth it as like one of these harlotry players as ever I see!"[38] *Hamlet* has even more to say about professional actors than *Henry IV* does, and more as well about the social context for their play-work. The "tragedians" who visit Elsinore belong to "the city": only economic circumstances have forced them to take their show on the road. During his own

time "in the city," we are told, Prince Hamlet frequently visited "the common stages" where the tragedians performed. As an aristocrat, he naturally valued the judgment of "one" elite spectator over "a whole theater of others," and he naturally deplored the kind of player who "bellow'd" like "the town-crier" to attract the attention of "the ground-lings," "the million," "the general."[39] Yet whenever Hamlet turns his mind's eye toward the theater, he sees the elite playgoer mixed and matched with the rude society of the million. In the confused environment of such *community*, as Henry IV might scornfully call it, "the unskillful laugh" at the same time as "the judicious grieve"; their contrary reactions cannot be reconciled. As much as Hamlet wants to model his own princely play-work on the masterful "quality" of the tragedians he used to "delight in," he can't help associating his own performances with the broader and less coherent array of forces he witnessed in "the whole theater." When one of the visiting players delivers a speech on the fall of Troy, Hamlet is struck, after all, by his own dissimilarity to the actor, who is never confused or tormented when he plays. According to Hamlet, the actor's "distraction" is merely superficial, "in his aspect" or his face alone, whereas the prince experiences his antic disposition as a kind of involuntary capriciousness, like a humor. Famously, Hamlet likens his own turbulent mind to a "distracted globe," linking the internal confusion that generates his tragic foolery less to the professional actor than to "the distracted multitude" in the Globe playhouse where *Hamlet* was performed.[40]

In part, these allusions to the audience in *Hamlet* befit the plot of fallen sovereignty that the play inherits from *1 Henry IV*: they register the gravitational force that the multitude exert over any figure who hopes to prove "most royal" when he is "put on" the "stage" before them. But the multitude, *Hamlet* suggests, must also come to terms with its own distraction. The more that Shakespeare develops play-work as a distinctive behavioral mode for his characters, the more he expands its professional range of reference to include the theater's spectators as well as its actors. On the two occasions when we see Hamlet watching the tragedians of the city, he repeatedly draws attention to himself as a spectator, and during the performance of *The Mousetrap*, his eyes are focused more on its audience than on its actors. The whole strategic "purpose" of staging *The Mousetrap*, Hamlet tells himself, is to elicit a reaction from the spectating Claudius: Hamlet hopes that the "cunning" of the tragedy will make the king "blench" and thus confess his crime involuntarily—"will he, nill he," as the gravedigger puts it. Hamlet wants Claudius to suffer the same loss of "sovereign power" over himself as Hamlet feels he has endured, and Hamlet's experience as a theatergoer suggests to him that the perfect means for inflicting such

distraction is a play.[41] It's not the professionalization of actors that *Hamlet* thus identifies as the most unsettling consequence of the new permanent theaters, but rather the effect these playhouses have on their audiences.

Three decades after *Hamlet* was first performed, the moralist Richard Brathwait (1630) claimed that something stranger than chronic idleness had begun to afflict the people who regularly attended plays. Brathwait told the cautionary tale of a young gentlewoman, "accustomed in her health every day to see one *Play* or another," who could not tear her thoughts away from the theater even when she was "struck with a grievous sickness" and at last confined to her deathbed. "Exhorted" in her final moments "to call upon God," the gentlewoman instead imagined herself to be witnessing a performance of *The Spanish Tragedy*: she "continued ever crying, *Oh Hieronimo, Hieronimo, me thinks I see thee brave Hieronimo!*"[42] Revealingly, Brathwait never attempts to explain why playing had come to matter so much to the dying woman that she "continued ever" obsessing about it this way. Unlike the actor who could rationalize his perpetual idleness as his occupation, the audience had no such vocational correlative to help them account for their constantly returning to the theater or for the ethos of play-work they absorbed there. *Hamlet*, accentuating the problem, ties the "mystery" of its central character to his sense not merely that he is playing out of season but also that he is being played "upon."[43] Moments before the king and his court arrive to watch *The Mousetrap*, Hamlet links his "compulsive" time-wasting with a different form of play-work than the actor's necessary or "compulsatory" dalliance. *"I must be idle,"* the prince whispers to Horatio, as he turns to join the audience.[44]

4

One Step Ahead of My Shadow

Never relax. If you relax, the audience relaxes.
—James Cagney

Movies, it was said throughout the twenties and thirties, meant escape for "the drudging millions," a release from "the chain of monotony" that bound them to "the same piece of work all day long and all the year long." But where did these toiling masses escape *to*? In Warner Bros.'s 1933 musical *Footlight Parade*, at the start of a Busby Berkeley extravaganza that has been called "perhaps the finest musical production number ever conceived and executed," the audience is invited to unwind "By a Waterfall," where a languorous Dick Powell croons of being able to "drift and dream" as he enjoys "love in a natural setting."[1] Once Powell falls asleep in the arms of Ruby Keeler, however, the action picks up considerably. First, several water nymphs appear and beckon Keeler to their forest pool, where they are joined by an ever-increasing number of other nymphs in an elaborate water ballet, until the camera pulls back to reveal that their synchronized swimming is now taking place in a grand indoor pool. After more water shows there, the nymphs reappear on a six-tiered hydraulic fountain and arrange themselves into further stunning displays before a final transition through water brings us back to the sleeping Powell. It's all a strange excursion from Powell's own getaway. "I appreciate the simple things," his character begins the number singing, but then, as contemporary reviewers pointed out, we go on to witness a series of complexly choreographed "mass-maneuvers," executed with a "drilling and precision" that clearly "reflect a prodigious amount of preparation." "It took us over a week to shoot that number," Berkeley himself stressed to the *New York Times* in 1933, "and the girls were in the water most of the time."[2] The pressbook for the film likewise advertised the round-the-clock toil that went into building the "Waterfall" set:

"Twenty-four hours a day workmen labored, sometimes as many as two hundred at a time."[3] In the film itself, the "Waterfall" number is anything but a break from work: it's rather the culmination of a backstage plot that has dramatized the grueling process of putting on musical shows. What kind of holiday from labor makes a spectacle of labor to the laborer on holiday?

Dick Powell lounging "By a Waterfall"

The water nymphs

The water ballet

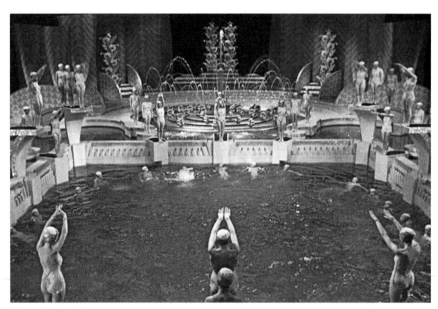

The indoor pool

Film historians usually attribute the mixed signals of *Footlight Parade* to its immediate historical context. Although musicals were enormously popular in the early years of talking pictures, that craze had ebbed by 1930, and contemporaries such as Lewis Jacobs saw the falling-off as a consequence of the Depression, which made the escapism of musicals

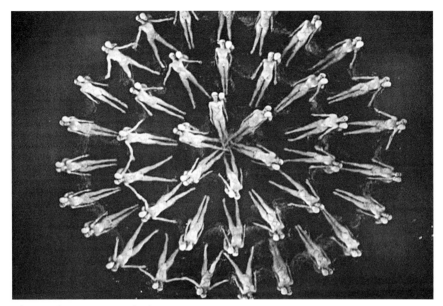

The nymphs in geometric display

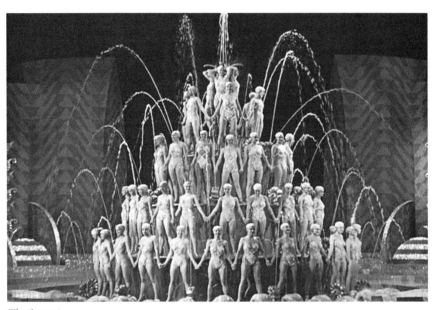

The fountain

seem "ever more incongruous with the national temper." Following
Roosevelt's election in 1932, however, the country's mood brightened,
and Warner Bros. managed to revive the musical with a string of hits—
42nd Street, *Gold Diggers of 1933*, and *Footlight Parade*—that the stu-
dio advertised as "Inaugurating a New Deal in Entertainment." This

"New Deal," Martin Rubin has argued, provided a Depression-era "rationale" for entertainment "by dwelling on the process" for producing entertainment: in the Warner musicals, Rubin claims, "entertainment is presented" no longer as escapism but rather "as *work*—demanding, exhausting, and ultimately productive." "Nobody leaves here until Saturday night," barks the in-film director of the "Waterfall" number, Chester Kent, to his troupe of entertainers: "You'll eat here, and sleep here.... We're gonna work your heads off." But "in keeping" with the patriotic "spirit" of Roosevelt's New Deal, Mark Roth has added, *Footlight Parade* also "emphasizes the importance of social cohesion and harmony" in battling the Depression.[4] When Chester asks his troupe whether "anybody" wants to leave before the grind begins, they all shout, "No!" Berkeley praised his own troupe for never having "weakened" during production: "They've developed an esprit de corps," he claimed in his *Times* interview. During the "Waterfall" number, it seems to be the appeal of this esprit that calls Keeler from her sleeping lover to the corps of swimmers, and the next number in *Footlight Parade* cements the association between the troupe's pulling together and the nation's doing so when Chester's dancers arrange themselves into images first of the American flag, then of Roosevelt, and finally of the NRA's Blue Eagle. It wasn't work that Depression-era audiences dreamed of escaping, Roth and Rubin insist, but unemployment, and the backstage plot as well as the dance numbers of *Footlight Parade* expressed the hope of prosperity through the "collective effort" that a tirelessly dedicated leader could direct.[5]

But the backstage musical was not born from the ashes of the Roaring Twenties any more than the Busby Berkeley spectacular was: both predated the Depression, and precision dancing predated them both.[6] Why, then, should the New Deal count as the definitive explanation for *Footlight Parade*? Writing in Germany, several years before the Depression began, on the subject of a British precision-dancing troupe that had become world-famous by 1900, Siegfried Kracauer in his essay "The Mass Ornament" had already characterized the musical revue as an uncanny fusion of entertainment and labor. But he saw the revue as celebrating capitalism's triumph rather than alleviating its failures. Capitalism, Kracauer argued, sacrifices everything to the "production process," and the mass ornament similarly applies the logic of "the conveyor belt" to its participants, turning "individual girls" into mere "fractions of a figure" that encourage spectators to embrace their own subordination to production. Instead of social cohesion and harmony, Kracauer maintained, the "goal" of the revue was "to train the broadest mass of people" how to "service machines without any friction." Extending this claim, Terri Gordon has more recently argued that the "esprit de corps

at the heart of" the precision-dancing "aesthetic" was the feature that made it most susceptible to "fascist appropriation." Contemporary reviewers of *Footlight Parade* were not blind to such critiques of the film's show-business ethos. Rather than compare Chester Kent to Roosevelt, as Roth does, Mae Tinee described Chester as driving his dancers "in a Mussolini-ic manner," while for Philip Scheuer the "Waterfall" number proved "that you can mechanize flesh and bones; it is the final triumph of the machine age."[7]

Yet the claim made by both the democratic and the fascist readings of *Footlight Parade*—that the film's goal is to eliminate friction—seems fundamentally out of key with the primary action of the movie, the backstage plot that dramatizes what the *Washington Post* called "the *bitter* business of planning, rehearsing and presenting" musical shows.[8] At the center of all the misery is Chester, whose round-the-clock labors in devising entertainments are driving him to the brink. "I'm too busy," he constantly complains to his faithful secretary, Nan: "I'm daffy trying to think up new ideas." *Footlight Parade* shows us Chester visiting a drugstore for aspirin, drinking Bromo-Seltzer, speaking of his need for "doctor" and "nurse." At the start of the first in the Warner series of musicals, *42nd Street*, a doctor had warned Chester's predecessor Julian Marsh that he was working himself to death: "Good lord, man," the doctor had exclaimed, "you're not a machine. That body of yours will stand just so much." In chapter 3, I discussed how Horkheimer and Adorno accused mass entertainment of exploiting its consumers by extending "the work process" even into their "leisure time," but in *42nd Street* and *Footlight Parade* it's the *purveyors* of entertainment who toil incessantly.[9] They have it worse, indeed, than Horkheimer and Adorno's consumers do, insofar as they seem to lack even the nominal leisure time that other laborers enjoy. In one shot of *Footlight Parade*, we see a crowd of men and women cheerily thronging to a movie theater during the workday, but Chester experiences no such release: when he sits to watch an entertainment after a long day of work, he's still consumed with worries about his shows. Show business stands out in *Footlight Parade* as the one occupation whose work cannot cease for entertainment because entertainment is its work. The whole point of a backstage plot, after all, is to dramatize the labor that goes into playing, and *Footlight Parade* places an especially heavy emphasis on this extension of work past normal bounds by making Chester busy himself with entertainments that are intended to precede other entertainments: his musical numbers are only "prologues," live shows in movie theaters that warm up the audience for the movies themselves. In the plot of *Footlight Parade*, the "Waterfall" performance we see is actually a "preview" of the prologue and thus two steps back from the main attraction.

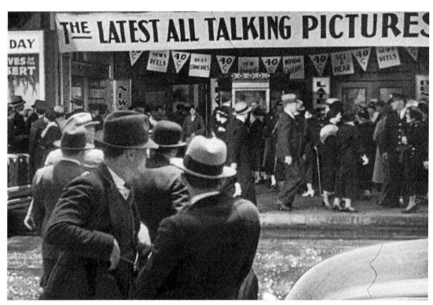

The crowd at the movie theater

Chester as the lone worrier in the audience

Critics such as Kracauer might respond that *Footlight Parade* glamorizes the idea of working all the time: in place of exhausted assembly-line workers are the trim and smiling dancers on the "Waterfall" fountain, displaying the joys of life as adjuncts to the machine.[10] But several contemporary reviewers of *Footlight Parade* described its backstage plot

as "irksome" rather than entertaining; in their eyes, Chester seemed "frantically overworked."[11] Struggling to dream up new concepts for his shows, Chester at one point asks Nan how she thinks "an insane asylum idea would go," and adds, "I could play the lead myself without any trouble." This gloomy joke captures the peculiarities of show business that intensify Chester's stress. Turning "play" into work and thus extending labor into the realm of leisure, show business counts as excessive labor by definition. And to "play the lead," for Chester, is to enact the illusoriness of his own power as a musical director. Although he insists that he's "the guy who made" the studio where he works, and he demands "absolute authority" in directing shows that he regards as "my ideas," Chester must ask his partners to "give" him the authority he wants, must hire their relatives and "protégés," must depend on the talent and professionalism of his fellow entertainers, and must contend with rivals who constantly steal his ideas. (Even when he claims that he could play the leading role of madman, Nan replies that she could, too.) Above all, Chester knows that he must please his audience. The basic aim of show business, as one of his partners declares, is "to fill your theater," and Chester acknowledges that you cannot achieve this goal without giving "the public" what they "want." It's no wonder, then, that Chester always feels like he's "falling apart": he's not running his shows, his "customers" are. "What I like ain't worth a cent," proclaims the wealthy theater owner Apollinaris, who offers Chester the possibility of a huge multi-venue contract that gets him working harder than ever; "what audiences like is worth millions."

Not everyone in the entertainment industry of *Footlight Parade* slaves at his or her job as Chester does, however. Some, like Chester's sidekick Thompson and his partners Frazer and Gould, get ahead by cheating, while others, such as Chester's fiancée, Vivian, are gold-diggers. Just as show business stands out from other occupations in *Footlight Parade*, so Chester stands out from other entertainers. He works compulsively, frantically, madly. Even though the idea of the professional entertainer had become domesticated enough by the twentieth century for film after film to focus directly on entertainers as their subjects, Chester shares something of the perversity in Prince Hal and Prince Hamlet that I connected in chapter 3 to contemporary uneasiness about the paradox of playing for a living. Chester's own play-work both anticipates and unsettles Horkheimer and Adorno's claims about the extension of labor into leisure because it represents working all the time not as a mechanical routine but rather as *over*work, or time with too much packed into it—especially insofar as Chester's labors seem all out of proportion to their end product, which is play. Chester is so overinvested in show business that his partners and fiancée easily take advantage of him, yet his compulsiveness also manifests the internal as well as external forces that

fuel what one reviewer called his "high-pressure driving." It's this excess of pressure *within* Chester that makes him and him alone the entertainer who is capable of breaking out of the routine with his shows.[12]

Those shows express Berkeley's own aesthetics of "superabundance," as Rubin calls it. "Only Warner Bros. / Producers of '42nd Street' and 'Gold Diggers of 1933' / Could Surpass the Wonders of Both With / Footlight Parade / The Greatest Musical Extravaganza of Them All," declares the trailer for *Footlight Parade*, promising audiences that they will be astounded by "the most MAGNIFICENT SPECTACLES Ever Conceived." Even while he assailed the mass ornament as a means of capitalist indoctrination, Kracauer himself celebrated the utopian potentiality in its "form-bursting [*gestaltsprengende*]" power. But in *Footlight Parade* the surplus energy that fuels Chester's breakthroughs depends on his being continually frustrated in his work: if his desires were not thwarted this way, the pressure would never build in him, and his entertainment might therefore degenerate into "the copycat tactics" of his rivals—the sort of servile imitation that some contemporaries cited as the reason for the public's having tired of earlier musical films.[13] In what follows, I'll show how Chester keeps pace with public demand not only by slaving away but also by coming to see his servitude as no less internally than externally imposed. Chester ensures his frustration, hence his creativity, by confining himself to a stage that cannot realistically enact his form-bursting visions; at the end of *Footlight Parade*, an actual fall onto this stage is what enables him to achieve his greatest success. But where does he get the energy to slave through so many disappointments? Escape for Chester, I hope to show, comes from his sense of his play-work as excessive and therefore overflowing the ordinary boundaries between himself, his troupe, and his mass audience.

The Prologue Factory

"It was all work, work, work," Cagney recalled of his years at Warner Bros. "What it amounted to, really, was factory work.... We worked all the time, six days a week, sometimes seven."[14] The production notes for *Footlight Parade* call the studio where Cagney's character, Chester, works "the Prologue factory."[15] It's his home away from home. In fact, we never see his actual home once he starts working there; the first we glimpse of Chester at the prologue factory, he's sleeping in an office chair. "Working all night again," his secretary, Nan, chides him in the morning; "I thought you said you were going home early." "I did go home," Chester insists; "that is, I mean, I started to go home, right after dress rehearsal about 3 a.m.... And then bingo! I got an idea—cats!

I was walking along the street and saw some cats. Ever see cats walk?... Regular dance rhythm." "So you came right back here?" "Just what I did." Leaving the office doesn't stop Chester from thinking about it; he sees an image of his work wherever he looks. Even his office furniture, we later learn, has been converted into ideas for prologues: "flowers, pictures, tables, radios, statues, more tables, sofas, pianos..." "There's nothing left in the world" that work hasn't exhausted already, he soon laments. "If you don't let up," Nan warns him, "you're going to meow yourself into a padded cell."

And then Chester leaves his office again—not for home this time, but for the studio at large, so that he can put his cat idea into action. In a bravura sequence made possible by our being positioned outside a cutaway of three connected sets, we watch Chester stride through three prologues in rehearsal, each at a different stage of production. It's the prologue factory's assembly line—but what's the finished product? Reaching the last set, Chester pauses for a moment to appraise a number that seems ready for the stage, although, as it happens, that show will never make it out of the studio. The first problem with the number is Chester's unhappiness with it, a dissatisfaction that is shared by his dance director, Francis, and the dancers themselves. Then Chester learns that a rival producer, Gladstone, has just staged a similar number, forcing Chester to scrap the prologue altogether and replace it with the new cat concept. "I slave day and night worrying about ideas and Gladstone steals them," Chester exclaims. This self-pitying self-characterization verbally activates a latent visual commentary

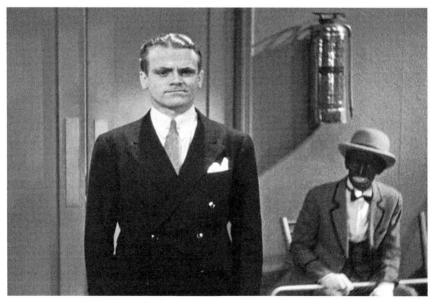

Chester and the blackface minstrel

on Chester in the scene: several times, as we watch him watching his show, we see Chester standing in front of a seated entertainer in blackface. This unexpected racial coding for Chester's troubled work life surfaces, abstractly, in the musical number itself. Although Chester refers to it as "the Prosperity unit," the number breezily emphasizes insecurity rather than good fortune: "I'm one step ahead of my shadow," the dancers sing. Originally, Chester had come up with the idea of the prologues in order to put some distance between himself and his shadow: "Breadline, I hear you calling me," he'd joked when he was earlier out of a job; "I always said they'd catch up with you," his wife had sneered as she subsequently demanded a divorce from him. But Gladstone's thievery means that Chester's shadow is outpacing him even as he slaves, robbing his labor of the productivity, the getting ahead, that helps distinguish work from slavery.

The blackface minstrel figure is nonetheless a conspicuously anti-quated presence in the scene, like several other seated entertainers there, including two men in stovepipe hats and another who sports an old-time fireman's helmet. By 1933, slavery had itself been outpaced as a paradigm of incessant labor, and not merely by its abolition. In *42nd Street*, Julian Marsh acknowledges that his critics might be "right" to brand him "a slave driver" as a musical director, but he denies the simi-lar charge that "he's a machine" who "turns 'em out like clockwork": "I'm not a machine, Andy," he ruefully confesses to his own dance direc-tor. "Efficiency" is a dirty word in *Footlight Parade*, because it sets a standard for labor that only machines can meet. And technology is Chester's enemy from the start of the film, when he loses his job as a director of live musicals thanks to the introduction of talking pictures. As his former employers Frazer and Gould (soon to be his partners) explain, "We're in the picture business—exhibitors"; "Flesh is a dead issue"; "They deliver the show in tin cans, and we got nothing to worry about." Chester can adapt to this new business climate only by devising his own version of mechanical production and distribution. "When you put on one prologue," he tells Frazer and Gould, "it's too expensive. But when the same prologue plays twenty-five, fifty, a hundred houses, it doesn't cost a cent more." At the time *Footlight Parade* premiered, this was no fanciful business model: as many reviewers noted, Chester's pro-duction company was based on an actual "musical comedy factory," Fanchon & Marco, which managed to keep forty to fifty prologues, or "Ideas," "constantly on tour" throughout the country.[16] Yet how could fifty live prologues compete with even a single movie musical that could be shown at thousands of theaters simultaneously? A few short years after *Footlight Parade* premiered, Fanchon & Marco shut down their studio. "It's too late for units," Chester moans at one point about "the race" he feels he's losing.[17] For Chester, the modern threat that makes

slavery seem old hat by comparison is the speed of technological inno-
vation and therefore of antiquation and obsolescence, which gets rewrit-
ten inside the cognitive limits of the prologue factory as Chester's shows
being stolen from him even before he can stage them.

Why doesn't Chester take the logical next step in mass-producing
prologues and start making films himself? The irony that a character in
a movie musical should overlook movie musicals as a career option
heightens the sense of doom that hangs over Chester's labors, but it also
betrays a more general anxiety in *Footlight Parade* about the belatedness
of any artistic representation. Chester habitually conceives of his pro-
logues as copies, afterimages, of the world around him, and dance sug-
gests that copying is a matter of keeping in step with the original. On
the way to the Prosperity rehearsal, Powell's character, Scotty, carefully
matches his pace to Chester's; then the Prosperity dancers try to adopt
Chester's suggestions for improvement by mirroring his footwork; finally,
Chester orders Francis to base his choreography for the cat number on
the movements of an actual cat. In each case, the imitation lags. Walter
Benjamin claimed that the talking motion picture had technologically
resolved the problem of artistic belatedness: film, he argued, was the
medium that had finally made it possible for art "to keep pace [*Schritt
halten*]" with real life.[18] Yet, logically speaking, how could any reproduc-
tion *not* lag its original—especially a ghostly, disembodied reproduction
such as film? "The Shadow Stage" is how a monthly review column in
Photoplay referred to film.

Scotty copying Chester's steps

Dancers copying Chester's steps

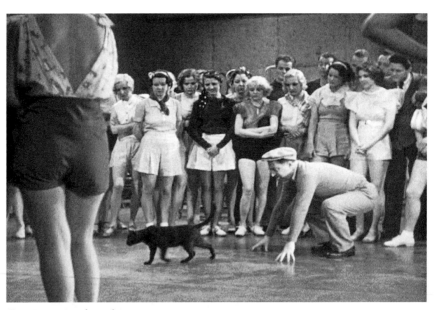

Francis copying the cat's steps

The only way that Chester can avoid falling behind in his work, *Footlight Parade* suggests, is by adopting a paradigm for his art that does not relegate it to the status of a copy or shadow of an original. The cat prologue is the first to be realized in *Footlight Parade*, the first that no outsider preempts—and, not coincidentally, it's also the first to seem

surreal. Although Chester says that he derived his inspiration for the prologue from the cats he chanced to encounter on his way home, he only noticed the cats in the first place because their "regular dance rhythm" reminded him of his work. His obsession with work casts its shadow on everything he sees, which helps explain why the cat he chooses to carry back to the studio is black: it's as if the original that art shadows were a shadow already, a shadow of Chester's art. *Footlight Parade* never shows us the cats in the street; instead, we see Chester shouting "Cats!" as he wakes from sleep. The implication that Chester has dreamed up the cat number gets reemphasized in the number itself, when one feline sings to another of "the dreams I share with you."[19] To dream of work is truly to be working all the time, but it's also to redefine work as internally rather than externally driven. And if there's nothing but work in Chester's life, which makes work an end as well as a means, then work, in a kind of dreamlike confusion, becomes its own inspiration. Once Chester decides to replace the "shadow" number with the "cat" number, the tableau of Chester and the blackface minstrel becomes more complicated: now, along with the minstrel behind him, highlighting the abjectness of Chester's efforts to get ahead, the black cat appears before Chester, as the model for his new number. No matter how hard he works, Chester can never hope to make up the gap between the object that inspires him and its shadowy reproduction in his art—unless, perhaps, the object is itself a piece of shadow art, as in a musical about a musical.

A surreal moment in the cat number

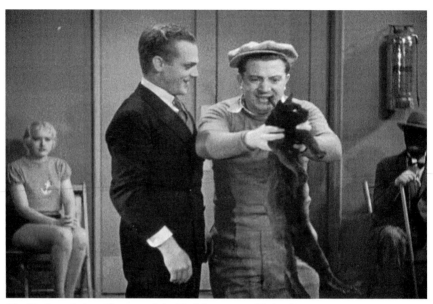

The black cat before Chester and the blackface minstrel behind him

Escaping the Factory

To stop Gladstone from stealing his numbers before they can be staged, Chester decides to barricade himself and his dancers inside the prologue factory, only to find his troubles multiplying there. First, his awful wife turns up at the studio with the news that she never divorced him and that she now demands $25,000 to stop her from suing him for becoming engaged to another woman, the equally awful Vivian, whom Chester has placed in charge of the studio's "Styles & Ideas" department. When Chester tells Vivian about this surprise development, she, too, threatens to sue him. Nan, in the meantime, acting on her hunch that Frazer and Gould have been stealing from Chester, demands $25,000 from them, which she then gives to Chester, but Chester catches on and confronts his partners: "I slave day and night for you," he roars, "and what do I get? You stab me in the back!" Finally he's had enough. With Nan right behind him, he marches from the studio into one of the taxis he "always" has "waiting" for him; sick of being "chained to that office morning, noon, and night," he has at long last made his escape.

But "where to?" the cab driver asks him. "Anywhere," says Chester, "just keep going"—and yet within seconds he orders the driver to "pull up." Just as before, when he left the studio and then saw a dance rhythm in some cats, Chester's eye has been caught by a street image of his work: this time, it's a billboard advertising "CHESTER KENT PROLOGUES: The

Ultimate in Picture Theatre Presentations." Leaping from the cab, Chester grabs a tar brush from a worker in the street and furiously starts blacking out his name on the billboard. As a cop tries to stop him and they wrestle over the brush, Chester's eye is caught by still another image of his work. "What's that?" he asks, staring off camera. "Say, that's what

Chester blacking out his poster

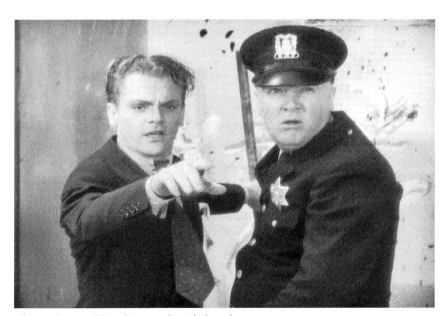

Chester distracted from his struggle with the policeman

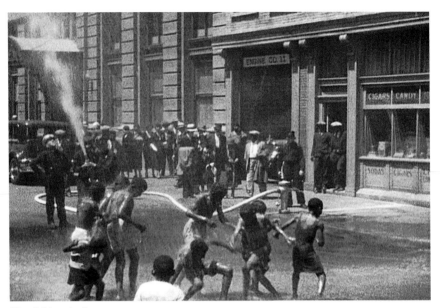

The children in the street

that wood-nymph prologue needs: a mountain waterfall splashing on beautiful white bodies!" A reverse shot startles us with the real object of Chester's vision: it's a group of black children jumping and laughing in the street beneath the spray from a fireman's hose. Somehow, the sight of these children revives Chester, as the sight of the cats had revived him. With Nan and, strangely, the cop in tow, Chester races back to the studio, arriving just in time to stop the rest of the troupe from leaving. "Where do you think you're going?" he shouts. "Come on, get back in! Everybody back in!" The escape is off—but why?

One implication of Chester's excitement about the children is that they renew his commitment to his work by reminding him of its origins in play. Filmed in a grainier, more documentary style than the rest of *Footlight Parade*, the children's effervescent movements are unchoreographed, impulsive, free—the very opposite of the regimentation and artifice in Chester's rehearsal hall. Having just emerged from his self-incarceration in the studio, Chester seems further inspired by the sheer room for play that the city offers. The fire hose in the scene recalls the fire extinguisher hanging inertly beside the seated entertainer in blackface: now that the latent power of this device has been transferred from the studio to the open streets, its pent-up energies can be released. Several times in *Footlight Parade*, Chester conceives of his imagination as a spectacular version of a fire hose—"Old Faithful," he calls it. Shortly before he quit the studio, when he'd confessed to Nan that he had no idea how to fix "that water-nymph number," Chester had moaned, "Old Faithful

has gone black on me completely." The street scene seems to have reopened the floodgates of imagination for Chester by dramatizing a freedom of creativity as well as movement in the city. After all, the street was not designed for play, as Chester's studio was; neither was the fire-hose; and neither, to Chester's eye, were the children. Tormented by the thought of being chained to his work, Chester repeatedly hearkens back to a time when black people were the ones who were forced to labor. The first theatrical number we see performed in *Footlight Parade* is a prologue for a movie that Chester jokes must be *Uncle Tom's Cabin* (it's really *Slaves of the Desert*). Later, when Chester tells Vivian that Nan "works like a slave," Vivian mentions a book she's read, *Slavery in Old Africa*, and Chester instantly imagines the book as a prologue: "Why, I can see it now…pretty girls in blackface…'Slaves of Old Africa'!" But the children offer Chester a modern vision of black people: he sees them dancing freely in the street, against his own habitual association of them with slavery.

Chester never mentions the children's skin color, however; he never even mentions the children; and these surprising omissions would appear to undercut the liberatory implications of the urban scene in two ways. First, Chester's imagined replacement of the children with water nymphs shows how his mind has never left the studio. His last words to Frazer and Gould concerned the weakness of the water nymph prologue, and in the cab he continued to obsess about how "rotten" the number was; now all he can see when he looks at the children is a fix for the job he has supposedly quit. Second, Chester does more than ignore the children when he dreams up the water nymphs: he effectively denies their exist-ence, and in the process suggests that show business thrives on such suppression. Even when Vivian had raised the subject of actual slavery, Chester had immediately replaced the Africans under discussion with Caucasians in blackface. This phantasmic exchange of white for black was a favorite move of Busby Berkeley's, too. At the same time as he was working on *Footlight Parade*, Berkeley devised musical numbers for the Goldwyn film *Roman Scandals* that featured white slave girls in one instance and a blackfaced Eddie Cantor in another. The next Bacon/Berkeley collaboration after *Footlight Parade*, the 1934 Al Jolson vehicle *Wonder Bar*, ends with a twelve-minute-long blackface extravaganza, "Goin' to Heaven on a Mule," complete with minstrel versions of the children Chester encounters in the street. But why, if he preferred to represent African Americans indirectly, did Berkeley bother to represent them at all? Gerald Mast has argued that Berkeley's interest in African Americans was literally superficial, inspired more by the visual require-ments of black-and-white film than by the urban reality we momentarily glimpse in *Footlight Parade*. In Berkeley's films, Mast maintains, "slavery and its consequences" become a "mere pretext for pretty patterns":

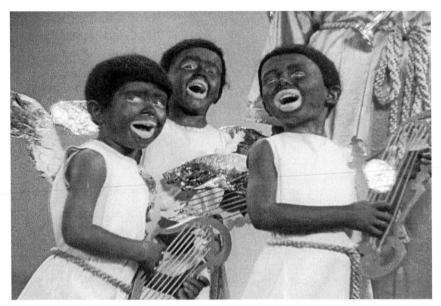

Blackface cherubs in Wonder Bar

"by reducing racial blackness and whiteness to polar opposites of visual decor, Berkeley strips them of their social and historical significance, converting them into mere elements of design." For Mast, in short, Berkeley "aestheticizes...misery."[20]

Yet Mast's notion of Berkeley's films as smoothing over racial differences seems directly in conflict with the street sequence in *Footlight Parade*, which presents Chester's response to the urban scene as a shocking inversion of what he actually sees—a substitution not only of white for black but also of female for male, adults for children, rehearsed for improvised, high-budget for low-budget, nature for the city. Chester's bizarre reaction also clearly reflects his overheated state of mind. At his wits' end almost from the start of the film, Chester has just had his world turned upside down by his wife, by Vivian, and by his partners; he encounters the children when his exasperation and desperation are at their height. In dramatic context, then, his vision of the water nymphs seems anything but the tame aestheticizing that Mast describes; instead, it seems hallucinatory, mad. Art becomes release for Chester only when its power to copy or reproduce reality can be seen as crazily overflowing the boundaries of the real. And this eruption, as the analogues of the fire hose and Old Faithful suggest, requires some form of blockage to generate the necessary pressure. For all his emphasis on Berkeley's indifference to the real world, Mast himself argues that the "tensions" between fiction and reality in Berkeley's numbers are "precisely" what give these spectaculars their power: "There is a terrific energy in the inherent

The cop copying Chester

contradiction between his film images as purely 'musical' design and the sexual, social, and moral implications of the images, which refuse to shed their signification."[21]

The cop and the firemen in the street add a further tension to the scene of entertainment that galvanizes Chester: a conflict between discipline and play. That clash of counterforces carries over into the studio once Chester returns there, when the cop becomes his new shadow during rehearsal. Is the pairing of showman with policeman meant to suggest that play can be transformed into art only when it has been restrained by social rules? Or is the point rather that art can count as mad, anarchic play only when it gets contrasted with social rules? However we interpret it, this and the other dissonances in the street sequence seem to inspire Chester by helping him break away from a simple opposition between work and escape and brainstorm some more dynamic relation between them. The seemingly poor but happy street children, neither wholly abject nor wholly emancipated, embody this dynamism for Chester: like the black cat, they attract him not only because they shadow his own slavery but also because they are unencumbered by the frustrations of a workaholic whose imagination has "gone black." Minstrel shows must always have conveyed some version of this double effect for white spectators, the effect of the carefree slave, but *Footlight Parade* makes the studio's minstrel too lifeless a figure to attract Chester's attention, as if its antiquation in referring to a time before emancipation had rendered it incapable of expressing the more volatile interplay

between slavery and freedom that Chester perceives in modern-day African Americans.[22] But Chester is not exactly mesmerized by the children, either: although he identifies with them, he also distances himself from them when he visualizes beautiful white bodies in their place. And this hallucinatory stress on racial difference effectively distances him from the water nymphs as well: by defining the nymphs no less than the children in terms of their bodies, Chester contrastingly emphasizes his own internal powers of imagination. These same powers, manifested in his counterfactual vision of the nymphs, are what free him from his physical struggle with the policeman—but where does that freedom lead him? Back to the studio; back to work. "The escape from everyday drudgery which the whole culture industry promises," Horkheimer and Adorno maintain, is an illusion "predesigned" to return moviegoers to "the same old drudgery."[23] The multiplying contradictions of the street sequence suggest, however, that Chester is not simply surrendering to the forces that imprison him; he is also reconceptualizing his jailbreak as an escape not *from* but rather *into*.

Freedom Within Limits

All along, the claustrophobia of the factory, the asylum, the padded cell, had been only half the story at Chester's studio. By comparison to the first workspace we see in *Footlight Parade*—the crowded office that holds Frazer, Gould, and their secretary—Chester's studio office is remarkably spacious. Clearly, business is good for him, but the size of Chester's office also reflects a psychological change in him: by turning his office into his home and thus multiplying the purposes that it serves, Chester makes his office loom larger in his life than it would have if he had managed to build a home for himself elsewhere. The roominess of Chester's workspace becomes even more noticeable when he leaves his office to stride through a studio whose interior appears to replicate the extensiveness of the city. According to the pressbook for *Footlight Parade*, the "huge multiple set" for the prologue factory was in fact an unprecedented achievement: "The formidable collection of offices which compass the many-sided activities of the firm is undoubtedly unique among motion picture sets, not only for its extent, but for the number of separate rooms and passageways linked into one continuous and unbroken whole." The effect of having "twelve complete" yet also "interdependent units" was cinematically liberating, the pressbook maintained, insofar as it enabled "the action—and the camera—to move freely and without interruption from one office to another."[24]

When Chester returns to the prologue factory after making his getaway from it, he doesn't renounce the spaciousness he encountered in the

city; instead, he makes his workspace seem even larger than before, by creating musical numbers that vastly exceed the scope of his previous efforts. The "Waterfall" number, for instance, moves seamlessly from a forest scene to a waterfall to an enormous pool and then back again— all, ostensibly, within the confines of a theatrical stage. Contemporary audiences were stunned by the magnitude of the display. According to a pressbook article, "gasps of astonishment were followed by thunderous applauses as one after another of the picture's spectacular sequences filled the screen." "Overwhelmingly spectacular" is how the *Los Angeles Times* reviewer Norbert Lusk described these climactic numbers. And yet, as other reviewers pointed out, there was also something crazy about the fiction that an enormous production like the "Waterfall" number could fit onto a single stage. "Although the story tells us these scenes were designed for prologues in cinemas," wrote one ingenuous critic, "it is doubtful whether there is any theater in the world big enough to house them."[25]

Cannier reviewers assumed that the sequences were meant as ironic commentaries on Chester's chosen medium, exposing the theater's limitations by comparison to the cinema that had technologically surpassed it. "There were never any prologues seen in a movie theater like those that are glimpsed in this lavish production," Edwin Schallert observed; "the screen," he concluded, "is mightier than the stage." A *Washington Post* reviewer agreed that the final numbers of *Footlight Parade* demonstrated the "seemingly illimitable magnitude" of film: for the reviewer, they were "a revelation in the stunning potentialities of the motion picture as a medium of flamboyant and stupendous effects." But Schallert also acknowledged that the screen was itself "restricted" as an artistic medium, and *Footlight Parade* goes out of its way to emphasize the screen's own physical limitations early on, when Frazer and Gould take Chester to see an example of the talking pictures that have rendered his old stage shows obsolete.[26] This film within the film is a John Wayne picture, Warner's own *Telegraph Trail*, also released in 1933. Like most other John Wayne pictures, its subject is the wide-open spaces of the West, heroically embodied in its rangy lead, Cagney's opposite in physical stature. But *Footlight Parade* presents this escapist entertainment as taking place inside the city and inside a theater, on a screen that looks surprisingly small from Chester's distanced perspective on it. Chester himself seems unimpressed by the movie (set, incidentally, in 1860, near the end of legal slavery): he has nothing to say in response to it until the curtain falls and then rises again to reveal the live performance that he mistakes for *Uncle Tom's Cabin*. This dance number fills the stage in a way that the screen did not, and the closer the camera moves to the dancers, the more the spectacle exceeds the limits of our vision: the stage, that is, comes to seem mightier than the screen. Just as the sets for

Chester's final numbers mark out a cinematic magnitude crazily in excess of the space that the stage actually affords, so the movie screen for *The Telegraph Trail* provides a similarly limited frame that the staged interlude can then appear to overflow. In both cases, a restriction in one medium helps the other seem "overwhelmingly spectacular."[27]

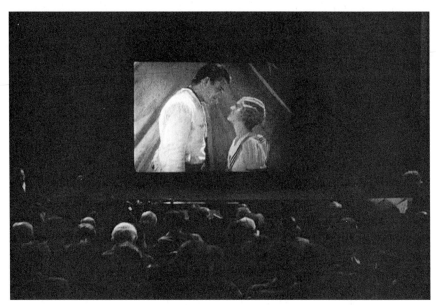

A tall John Wayne out west

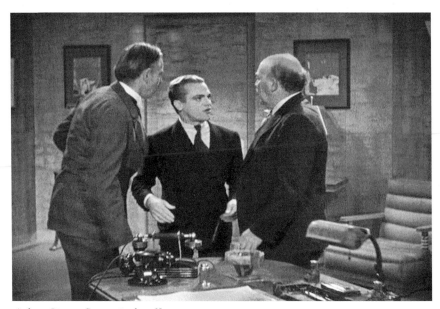

A short Jimmy Cagney in the office

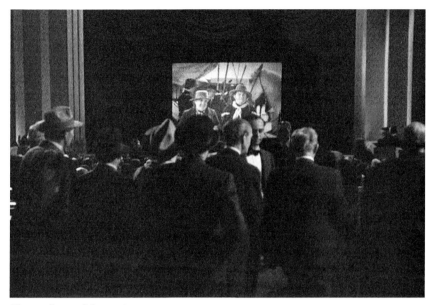

The smallness of the movie screen

The dancers on the movie-theater stage

The dancers filling the screen

Some reviewers urged moviegoers to ignore the blatant incongruities in the staging of *Footlight Parade*'s final numbers. "That no theater possibly could put them on, with their waterfalls, swimming pools, U.S. Navy drills and massive settings, matters not at all to 'Footlight Parade,'" argued one review that was incorporated into the movie's pressbook: "You are not asked to believe in it. You are expected to be entertained by it, and you will be, mightily."[28] But how were moviegoers to overlook the contradiction once the critic had highlighted it? Commenting a decade later on the by then familiar tendency of backstage film musicals to mount "a show of such elaboration that it would be quite impossible to fit it into the framework of a theater," the Shakespeare scholar S. L. Bethell took the representational mismatch as a telling instance of the "multiconsciousness" that "popular" entertainment characteristically solicits. "A popular audience, uncontaminated by abstract and tendentious dramatic theory," Bethell maintained, "will attend to several diverse aspects of a situation, simultaneously"; such an audience, indeed, derives "pleasure" from the "concurrence of seeming incompatibles." Yet Bethell was himself inconsistent about how an audience processed these representational inconsistencies. At times he maintained that the "double consciousness of play world and real world has the solid advantage of 'distancing' a play" and thus producing "an alert and critically detached audience." But at other times Bethell insisted that the audience absorbed contradictions "without confusion," without even having to "pause to reflect": far from generating "critical alertness," double consciousness

took place "unconsciously."[29] What forced both Bethell and the *Daily Mirror* critic into similar argumentative straits was the assumption that even a doubly conscious audience should respond one way to an entertainment and one way only—an assumption made particularly untenable in *Footlight Parade* not only by the complexity of its effects but also by the multiplicity of the audiences it represents.

At the screening of *The Telegraph Trail*, for instance, where some of the moviegoers are watching the film, some are talking among themselves, and some are passing through the aisles, the audience themselves constitute a representational overflow: the screen looks small in relation to them, and they exceed the limits of our vision before the stage number does. When Chester first arrives at this movie theater, we see the audience pouring in from the city street; crowds similarly gather on the streets outside the theaters where Chester's prologues are staged. But we rarely see the city's masses otherwise. Noticeably missing from *Footlight Parade* are the conventional shots, so common in other contemporary Hollywood urban scenes, of cars and pedestrians thronging the streets. Aside from theatergoers, the only other urban crowd the movie shows us are the onlookers who have gathered to watch the children playing. In *Footlight Parade*, it's not so much the city as it is show business that generates the effect of people en masse. On the open streets, the most jam-packed concentrations of people we see are the dancers crowded inside the buses that race them from one show to another. Like Chester's always waiting taxi, these buses strikingly convey the claustrophobia of show business as a closed, inescapable system. Yet the constraints imposed on show business also make it seem preternaturally energetic and alive—filled to bursting.

Falling In

The climax of Chester's frustrations comes as the curtain rises on his final extravaganza, "Shanghai Lil," his third show for a third different audience in one night. To sabotage this number, Gladstone's mole in the chorus has managed to get the show's nervous lead drunk. Even worse, Chester learns that the lead, who had been forced on him by Gould's wife, is merely an "amateur." Faced with disaster, Chester tries to bully the lead onto the stage. They struggle, and then one of them tumbles down a flight of stairs right into the show. This defeated man is Chester himself. It's hard to imagine a more painful demonstration of Chester's shortcomings as a dictatorial director. Not only is he unable to impose his will on an underling: he loses a fight with him, literally falling from his high perch above his troupe, and he ends up exposed to the audience

in the most humiliating fashion, sprawled out before them. Like a true professional, however, Chester decides that the show must go on. He signals to the company that he himself will now play the lead, and, in an astonishing reversal of fortune, his performance turns out to be his greatest personal triumph in the film. He wows the audience, wins the big contract with Apollinaris, and, in the midst of all the applause, proposes to Nan, the one woman who truly loves him. Sick of being chained to the office, Chester has found his escape, his release, on the stage.

But that release requires a fall. In part, as the sequence dramatizes, losing power means leaving the isolation of his office, which Nan worried might lead to Chester's stricter confinement in a padded cell; when Chester falls, he also enters into the fellowship of his troupe and the even more expansive society of his audience. During his earlier getaway

Chester's troupe, seen from his perspective above them

Chester after falling down the stairs

from the studio, he had obscurely sensed his desire for such a change when he stopped before the poster for his shows and tried to black out its most prominent feature, the words "CHESTER KENT PROLOGUES": "That's my name," he told the cop, "and I don't want it up there!" Having his name "up there" sets him above the rest of his company, whom the poster reduces to ghostly thin carbon copies of one another, occupying the same anonymous level in the scene as the African Americans we briefly glimpse walking past the poster. When Chester later tumbles down to the stage, he finds himself actively enjoying his loss of distinction from the troupe: the part he plays soon turns him into one among many soldiers on parade. "You did it, boss!" exclaims the ever-faithful Nan after the show. "You mean *we* did it!" Chester elatedly replies. Yet of course he has not actually sacrificed his distinctiveness in joining his company this way: he has gone from running the show to being its star. Throughout the number, moreover, he continues to be differentiated from the rest of his troupe by the care and worry that seem to affect him alone. After all, falling into the show doesn't mean breaking away from his work: it means immersing himself in it even more than he had before. But on the stage, Chester can now also experience his work as play: unable to distinguish a time for release from his round-the-clock labors, he has been compelled to find that release *within* his labors. Paradoxically, Chester's fall has so greatly expanded the arena of his labors that "work" can no longer count as an adequate description of them. The geyser, the spray, the fountain, the waterfall: these are the paradigms for entertainment

African American pedestrians in front of Chester's poster

Chester onstage as one of the troops

Chester as the only troubled soldier

that *Footlight Parade* places in competition with Kracauer's assembly line, and by their logic a fall amounts to an overflowing. When he tumbles into his show, Chester exceeds the boundaries that separate not only backstage reality from staged fiction but also boss from troupe and slaving from playing.

The exhilaration that Chester feels at the end of "Shanghai Lil" can only be temporary, of course, because the next day he must still come up with another spectacular "idea," and then another, and another. For a significant number of reviewers, *Footlight Parade* epitomized the drudgery of a wearying routine rather than any creative breakthrough. "The indefatigable Warner Brothers have rolled up their sleeves and ground out another of those lavish cinema musical comedies, all of which look and sound almost exactly alike to me," wrote a jaded Cy Caldwell. "It's the same old idea with variations," Martin Dickstein agreed. "The gags," added a *New York Times* reviewer, "wheeze with the discomforts of age."[30] Even the film's admirers wondered how any future musicals could possibly top its mad bursts of invention. Scheuer described the "Waterfall" sequence as "the apotheosis of the [musical] 'number'"; for the *Washington Post*, the closing spectacles were "the dernier cri in cinematic creation"; "it seems almost that the limit of effect has been attained," Schallert concluded.[31] Finding it "hard to imagine what tricks Director Busby Berkeley can do with his performers next, unless he chops them into pieces," the critic for *Time* caustically observed that "this problem may have suggested the plot of *Footlight Parade*, about a dunce director who has a hard time thinking up new routines."[32] All three of the closing numbers in *Footlight Parade* begin as escapes from the routine, with each new getaway wandering farther afield than the previous one had: in the first number, Powell and Keeler leave Manhattan for a "Honeymoon Hotel" across the water in Jersey City; next, they relax "By a Waterfall";

The audience in the dark

Chester in the spotlight

Chester's fade to black

finally, Cagney loiters in a Chinese saloon.[33] Yet the further these num-
bers depart from the routine, the more ostentatiously they end with the
regimentation of honeymooners, swimmers, sailors, as if by a return of
the repressed. For Chester, escaping to the stage means dancing as well
as directing and thus working even harder than he had before.

Once the "Shanghai Lil" number ends, Chester attempts one final jailbreak. Refusing to take another bow before the audience, he turns off the backstage lights so that he and Nan can get away from it all without having to leave the theater. The audience themselves had been in darkness throughout the show (a circumstance comically highlighted when Apollinaris protests that he "can't see" to sign the contract for Chester's shows). Some commentators maintained that a cinema's darkness was crucial to helping filmgoers experience movies as an escape. "In the dim auditorium which seems to float in a world of dream and where the people brushing her elbows on either side are safely remote," wrote Lloyd Lewis in 1929, "an American woman may spend her afternoon alone." Even the relentlessly skeptical Horkheimer and Adorno agreed that "in spite of the films which are intended to complete her integration, the housewife finds the darkness of the movie theater a place of refuge where she can sit for a few hours with nobody watching."[34] But when Chester steps out of the spotlight that briefly differentiated him from everybody else and proposes to his secretary in the darkness backstage, he allows the shadow of his work to swallow his domestic life completely. "Whatever you say, boss," Nan replies to his offer, as Chester and we, too, lose sight of her. The closing frames of *Footlight Parade* project a black screen, as if to preempt the movie's ending and, more generally, its obsolescence, antiquation, supersession.[35] Yet Chester keeps talking. It's the movie's final form-bursting gesture: even as Chester's shadow catches up to him at last, the show still goes on.

Junk and Art

5

Mocked with Art

> But how out of purpose, and place, do I name Art?
> —Jonson, "To the Reader" of *The Alchemist* (1612)

Kitsch is Clement Greenberg's name for the vulgar "simulacrum" of art in mass entertainment, art that has been "watered down" and even "predigested" so that the masses can swallow it.[1] Over the past several decades, theater historians have often described the commercial drama of Renaissance England the opposite way, as popular entertainment that rose to the status of art once it had been "cut off" from the vulgar "milieu" of its first audiences.[2] For the historians, this transformation of plays "from the ephemera of an emerging entertainment industry to the artifacts of high culture" falsified the popular culture they believe themselves to be celebrating rather than deploring.[3] But the logic of their position remains the same as Greenberg's, even if the polarities have been reversed: art and mass audiences don't mix.

So strong is this bias among Renaissance theater historians that it can turn its very critics into supporters. A striking example is the Shakespeare scholar Lukas Erne, who has powerfully challenged the notion that Renaissance drama was originally and authentically "subliterary" in two landmark books: his 2003 *Shakespeare as Literary Dramatist* and his 2013 *Shakespeare and the Book Trade*.[4] Although Erne concedes that Shakespeare worked in "an entertainment industry in which many writers had no literary pretensions," he characterizes Shakespeare himself as "a self-conscious artist" who was "concerned about his reputation, proud of his name," and above all "keenly aware" of his writings as "his literary property." Theater historians usually attribute such artistic ambitiousness to Ben Jonson, who they claim published his plays so

that he could dissociate them from the theater's multitude and thus present them as " 'literature' within a classical canon."[5] But Erne provides overwhelming evidence that the most frequently published dramatist during the heyday of the Renaissance theater was Shakespeare, not Jonson. "For the whole period from the beginning of the publication of professional plays to 1642, when public performances ceased," Erne writes, "Shakespeare, with seventy-four editions of playbooks, out-publishes all his contemporaries by more than 50 per cent." The numbers are even more remarkable during Shakespeare's lifetime: from the year his first play appeared in book form to the year he died, Shakespeare accounted for "more than one in six" of all printed commercial plays. Jonson had nothing like Shakespeare's cachet with Renaissance readers: the "reprint rate" of Shakespeare's plays "within both ten and twenty-five years" of their initial publication, for example, was "almost four times that of Jonson." After charting Shakespeare's prominence in contemporary libraries and commonplace books as well as in the publishing world, Erne concludes that Shakespeare's plays "were crucial agents in the process by which commercial drama was increasingly endowed with literary respectability."[6]

Yet even Erne finds it hard to swallow the idea that Shakespeare himself regarded his plays as art. In *Shakespeare and the Book Trade*, Erne devotes considerable attention to a difference between Shakespeare's published plays and Jonson's that he regards as telling: "the scarcity of ... paratextual and bibliographic features in Shakespeare's playbooks by which literary respectability could be suggested: Latin title page mottoes, dedications, prefatory epistles, commendatory poems, dramatis personae, arguments, sententiae markers, continuous printing, and act and scene divisions." Jonson eagerly exploited such bibliographical opportunities for "claiming cultural capital"; why didn't Shakespeare? Erne attributes the difference to Shakespeare's greater involvement in the entertainment industry. Unlike Jonson, Shakespeare belonged to a theater company, and Erne speculates that Shakespeare's professional ties restricted his literary ambition. He could not be "as visibly and aggressively protective of his published writings and authorial persona" as the freelancing Jonson was because "investing his playbooks with the trappings of possessive authorship would have endangered the fine balance" between his competing careers as a "solo-dramatist" and as a "member of the Lord Chamberlain's Men." But that balance was already threatened, in many of Shakespeare's published plays, by a far more prominent bibliographic marker of "possessive authorship" than commendatory poems or prefatory epistles—Shakespeare's name on the cover. And his name didn't appear only now and then. "By the end of Shakespeare's life," as Erne shows, no other contemporary playwright

had received even half the number of "title page ascriptions" as Shakespeare had.[7] Whether or not Shakespeare arranged to have his authorship publicized this way, he could hardly have helped knowing that it *was* being publicized. Why not speculate, then, that Shakespeare felt he could avoid promoting himself as ostentatiously as Jonson did because he already possessed the cultural capital that Jonson was so desperate to secure? Erne overlooks this possibility because he prefers to think of Shakespeare as subordinating his ambitions to the greater good not only of his fellow professionals but also of his popular audience. Shakespeare, Erne claims, separated "literary" from "pretensions": while he "wrote literary *texts* which he wanted to appear in print," "he had no desire to see his plays published as ' "high" culture' *books.*"[8]

If it's hard to appreciate this distinction between printed literary texts and published high-culture books, it's even more difficult to grasp why a self-conscious artist who was concerned about his reputation and proud of his name would have had "no desire" whatsoever to see his plays hailed as modern classics. But Erne is adamant: it was "Jonson and his followers," he maintains, who "were the first to promote what Zachary Lesser has called 'a "high" culture of drama written in English,' something Shakespeare *never* did."[9] For all his criticism of the theater historians who depict Shakespeare as exclusively focused on the stage rather than the page, Erne shares their suspicion that any commercial dramatist who cared too much about the literary status of his plays must have wanted to renounce the entertainment industry. Erne, too, portrays the theater as so fundamentally unrelated to "high culture" (a phrase he habitually sets off with scare quotes) that it was "antitheatrical" for anyone to pretend otherwise. Thus Jonson's too-literary approach to publication meant "turning away from" the "theatrical experience" rather than "transposing" it "into a different medium." Shakespeare's publications were different, Erne insists, because they remained wholly within the orbit of the entertainment industry: they "served the purpose" not of establishing Shakespeare's literary credentials but rather "of recommending the play in the theater."[10] After all, Erne claims, Shakespeare's theater company was not " ' "high" culture' and elite" but "popular, and this is reflected by Shakespeare's playbooks." Yet that company—first incorporated as the Lord Chamberlain's Men, then as the King's Men—regularly performed at court as well as in public amphitheaters; starting in 1609, they also alternated between the Globe and their new "private" theater in Blackfriars.[11] Why, then, should Erne conclude that Shakespeare's company or his playbooks sought one kind of audience exclusively and not another? In his concern to free the Renaissance entertainment industry from the taint of pretension, Erne never considers the possibility that Shakespeare might have understood

the theater as both popular *and* elite: as low and high, kitsch and art, simultaneously.

The paratextual material to the first collected edition of Shakespeare in 1623 suggests that at least some of his fellow professionals held this mixed conception of his work. Much to the dismay of scholars who maintain that Shakespeare lacked any high-cultural ambitions, Shakespeare's two closest friends in his theater company, John Heminge and Henry Condell, solicited commendatory poems for the First Folio that all predicted literary immortality for Shakespeare. "This Book," asserted one of the poems, "when Brass and Marbles fade, shall make thee look / Fresh to all Ages." Worse still, a commendatory poem from Jonson favorably compared Shakespeare's plays to classical drama.[12] But such declarations of Shakespeare's artistic mastery were not the only terms of assessment in the volume. When dedicating the plays to Shakespeare's former patrons the Earl of Pembroke and the Earl of Montgomery, Heminge and Condell apologized for suggesting that "your Highnesses" might "descend to the reading of these trifles" and then acknowledged that, by admitting the plays were "trifles," they had "depriv'd" themselves of any "defense" for imposing on the earls in the first place. Throughout the Renaissance, it was commonplace for moralists to scorn commercial plays as mere "toys and maygames." "Were we not so foolish to taste every drug, and buy every trifle," lamented Stephen Gosson in 1579, "players would shut in their shops, and carry their trash to some other Country." But in giving voice to this standard depreciation of plays, Shakespeare's fellow professional were also doing exactly what Erne believes Shakespeare and his acting company would never do, "claiming cultural capital by signaling classical descent," because when they reminded Pembroke and Montgomery that the earls had once "been pleas'd to think these trifles something," they were pointedly echoing Catullus's reminder to Cornelius Nepos that "you used to think my trifles [*nugas*] something."[13] For Heminge and Condell, the same terms that belittled Shakespeare's plays as idle amusements also elevated them to canonical literary status.

Modesty, disingenuous modesty, one might conclude—if Renaissance dramatists did not themselves repeatedly manifest uncertainty about the mixture of high and low in their chosen profession. In his 1612 letter to the reader of his tragedy *The White Devil*, for example, John Webster twice disparages his play in terms that counteractively align him with the classics. *"Nos haec novimus esse nihil,"* he declares, quoting Martial's *Epigrams:* "we know these things to be nothing"; and *"non potes in nugas dicere plura meas ipse ego quam dixi,"* "you can't say more against these trifles than I've said myself." The implicit hubris behind such classicizing self-deprecation comes clearer when Webster turns to the plays

of Shakespeare and other contemporary dramatists. *"Non norunt haec monumenta mori,"* Webster asserts, quoting Martial again; "these monuments do not know how to die." But when Webster thinks about *The White Devil* in relation to its theater audience rather than to the classics, his otherwise careful calibration of modesty and pretension begins to look torturously contradictory. "The only grace and setting out of a tragedy," he insists at one point, is "a full and understanding auditory." Here, like Erne's dedicated popular entertainer, Webster professes that the one true standard for judging a play is its success with a "full"— which is to say, mass—theater audience. And yet, like Erne's haughty elitist, Webster also complains that "should a man present to such an auditory, the most sententious tragedy that ever was written, observing all the critical laws" of the classics, "the breath that comes from the uncapable multitude is able to poison it." Now Webster sees the full theater as clamoring for a vulgar entertainment that compromises "true" dramatic art. To mediate between these divided views of the audience, which reflect his own divided conception of his playwriting, Webster must divide the audience themselves into the two sides of Erne's dichotomy: the popular element, or "most of the people," whom Webster calls "ignorant asses," and the elite element, or the "understanding" few.[14]

This was a conventional distinction for the playwrights Erne characterizes as antitheatrical. Webster's prefatory remarks on the audience paraphrase Jonson's own preface to the 1605 edition of his *Sejanus*, which failed on the stage as *The White Devil* did; some years later, Jonson's admirer William Fennor (1616) recalled that "the multitude" may have "screwed their scurvy jaws and look'd awry" at *Sejanus*, yet "wits of gentry did applaud" its "more than humane art." In the prefatory material to his *Faithful Shepherdess* (1610), John Fletcher similarly noted how his play, though hated by the "common people," was "redeem'd" by "the saving sense of better men." Not content with the thought that their work might receive a purely literary approbation, even the most elitist playwrights insisted that at least *some* of their theater audience had clapped for them and so underscored their desire that everyone would. Yet the essential heterogeneity of the audience, in the eyes of these dramatists, meant that a widely acclaimed play could never be distinctly high *or* low. Thus the prologue to Thomas Middleton's *No Wit, No Help Like a Woman's*, performed in 1611, reassures the audience that the play will manage to satisfy both the grave judgment of the better sort and the frivolous tastes of the hoi polloi: "I doubt not, if attention / Seize you above, and apprehension / You below, to take things quickly, / We shall both make you sad and tickle ye." A successful commercial play, the prologue suggests, provokes two different, even antithetical responses at once: it is as divided as its audience.[15]

The paratextual material to Jonson's publications only heightens this sense of the commercial drama as irresolvably mixed in its aims and effects. In his 1612 letter to the reader of *The Alchemist*, Jonson presents his play as a highly "polished" work of "art," wholly unlike the "vile" theatrical fare favored by "the many." "Be content with few readers," Jonson tells himself in a Latin epigraph to the play that he borrows from Horace; "don't labor so that the mob may wonder at you."[16] And yet *The Alchemist* opens as vilely as any mob could wish, with a scurrilous argument among thieves about who deserves the most credit for their "common work." "I fart at thee," says one to begin the play; "I'll strip you," says the other, to which the first replies, "What to do? Lick figs / Out at my—"[17] The shocking shift in tone from paratext to text cannot simply be explained as the difference between Jonson's addressing an elite literary audience in one instance and a vulgar theatergoing audience in the other, because Jonson in publishing his play made no attempt to elevate or expurgate the parts of it that might scandalize a high-minded reader.[18] For the same reason, it seems implausible to conclude that the text speaks for an earlier theatrical Jonson and the paratext for a later antitheatrical one. But then it seems equally implausible to conclude that Jonson ever definitively abandoned the goal of pleasing a mass audience. The same playwright who in 1600 refused to "prostitute" his art "to every vulgar and adulterate brain" also differentiated himself in 1609 from that "sect of writers" who "only for particular likings care, / And will taste nothing that is popular." Years later, after a series of commercial failures led him to insist in one of his last comedies, *The Magnetic Lady* in 1632, that he was "careless of all vulgar censure" and "confident" that his play would "super-please judicious spectators," Jonson still hoped that every segment of his theater audience would eventually come round to applauding him; the judicious, he felt, would simply have to "work" on "the rest by example or otherwise."[19]

Unfortunately, some of these cognoscenti viewed the coarseness in Jonson's plays as proof that he cared too much about "vulgar censure." "In his Art," as Dryden later proclaimed, "great *Jonson*" would surely have "borne away the Crown, / If less desirous of the People's praise, / He had not with low Farce debas'd his Plays."[20] To forestall such indictments, Jonson's defenders have generally tried to elevate the vulgarity of his plays into a sign of his artistic mastery. Jonson, they argue in justifying the farts and assholes of *The Alchemist*, was "the archalchemist" who "employed the most sordid, the most meticulously realistic material, and defiantly extracted from it a kind of gold of the imagination." When Jonson republished *The Alchemist* in his 1616 *Works*, he himself encouraged this reading of his play by replacing his original Horatian epigraph with an even more vaunting citation from Lucretius: now

the playwright's declared aim was "to seek a crown from where the Muses have never garlanded anyone before."[21] Yet *The Alchemist* itself resists this paratextual idealization of its low humor. "Whereas alchemy attempts to spiritualize matter," the theater scholar Katherine Maus has observed, "Jonson's satiric language" in *The Alchemist* "aggressively reverses this process, grounding the impulses of his characters in the materials of their bodies and continually ridiculing claims of transcendence." Jonson may have created "a superbly written, intricately constructed, and exquisitely funny play from squalid raw materials," Maus acknowledges, but he did so "without denying their sordidness—indeed, while continually highlighting it."[22] Maus's point is crucial for understanding Jonson's conception of the theater as mass entertainment. Although he prided himself on his ability to refine the vulgarity that he felt the multitude both demanded and embodied, Jonson did not believe that he could transmute such vileness without remainder. On the contrary, *The Alchemist* emphasizes what one might call the consubstantiality of trash and art.

In the rest of this chapter, I'll argue that *The Alchemist* bears witness to the necessary impurity of dramatic art as Jonson understood it, an impurity generated by a heterogeneous mass audience that in Jonson's view threatened to taint the playwright along with his play. To preserve his sense of artistic superiority in the face of the multitude he felt compelled to please, Jonson portrayed his apparent fellowship with them as an especially artful form of deceit that could raise them to his own high level without their knowledge or consent. In *The Winter's Tale*, a tragicomedy that Shakespeare wrote around the same time as Jonson wrote *The Alchemist*, Shakespeare, too, worried about the impurity of playwright as well as play in the full theater, but he viewed the role of elite mass entertainer as inherently more troubled than Jonson did. Only a madman or a fool, in *The Winter's Tale*, believes that he can ever rise above fellowship, and yet only a madman or fool also believes that fellowship can ever be more than partial. The final scene of *The Winter's Tale* embraces the consequences of this mixed message for Shakespeare's conception of himself as a playwright. At first glance, the scene appears to fit Erne's picture of Shakespeare as a dramatist who renounced high art for popular entertainment: an audience gathers around a statue they hail as a masterpiece, but then the statue impresses its onlookers all the more when it ceases to be an *objet* and miraculously descends from its pedestal. For many critics of the play, however, the surprise of the statue's coming to life amounts to a "crass deception" on Shakespeare's part—and rather than present himself as having bowed to the pressure of popular demand, Shakespeare, these critics insist, takes pains "to impress on us that we have been cheated." "We are mock'd with art," as

one admirer of the statue exclaims, just before discovering that the statue is a piece of mock art. What Shakespeare renounces at the end of *The Winter's Tale*, I'll argue, is any "settled" sense of his connection to his audience or to art.[23]

Jonson's Teeming Wit

The best playwrights, Jonson asserts in his preface to *The Alchemist*, "use election and a mean" in their writing, but they are rarely applauded for their self-restraint. The multitude prefer dramatists whose style matches their own superabundance. Such crowd-pleasers "always seek to do more than enough," and the reason they "utter all they can, however unfitly," is "to gain the opinion of copy"—that is, a reputation for copiousness, but also the approval of the copious "many." "I know, if it were put to the question of theirs and mine," Jonson maintains, that "the worse would find more suffrages, because the most favor common errors." Yet Jonson does not thereby concede his own lack of copiousness. Paraphrasing the classical rhetorician Quintilian, he declares that "it is only the disease of the unskillful to think rude things greater than polished, or scattered more numerous than composed."[24] For Jonson, in other words, it's merely an illusion that a rough-hewn play looks bigger and a scattered play more abundant than a work as carefully crafted as *The Alchemist*. But if Jonson thinks of himself as writing plays that are no less copious than other commercial drama, then he must also think of himself as no less invested than other commercial dramatists in writing *for* his audience, matching their superabundance.[25] What the rude multitude fail to recognize, his preface implies, is how a play can be "numerous" and artful too.

Yet where in *The Alchemist* should an audience look for the "copy" of its own copiousness? The prologue jokes that "no country's mirth is better than our own" because "no clime breeds better matter for your whore, / Bawd, squire, imposter, many persons more, / Whose manners… feed the stage." *The Alchemist* incorporates the "matter" of these "many persons" as much as their manners. "'Tis evident," Dryden remarked in 1668, "that the more the persons" in a play, "the greater will be the variety of the Plot," and Dryden found "more variety" in one Jonson comedy than in "all" contemporary French comedies put "together." Less skillful playwrights, Dryden continued, might be overwhelmed by the numerous cast of characters that Jonson typically employed, and allow such variety to degenerate into "a perplex'd and confus'd mass of accidents," but Dryden praised Jonson for the "well-knitting" as well as "copiousness" of "the intrigues" he dramatized. During Jonson's lifetime,

his disciple William Cartwright (c. 1635) wished that he too could weave "that web of Manners which the Stage requires, / That mass of Humors which Poetic Fires / Take in, and boil, and purge, and try."[26] Modern scholarship on the "astonishingly diverse" cast of *The Alchemist* often points out that Jonson imposed order on the multiplicitous "welter of characters and episodes" in the play by restricting the action to one "central situation"—the alchemical scam, conducted (as the "Argument" to the play declares) in a "house" to which the swindlers "draw" "much company."[27] The house resembles Jonson's playhouse, the company his audience.[28]

The main con artists of *The Alchemist*—Subtle, Face, and Doll— display their own copiousness by devising multiple personae to match the diversity of the company they draw. But their inventiveness has serious limits. Subtle, the title character, is effectively confined to his (borrowed) house by his need to hide the emptiness of his "art." Alchemy, he persuades one of his victims, must be kept "obscure" so that "the simple idiot should not learn it, / And make it vulgar." This imposture reflects a certain psychological as well as practical constraint on Subtle, the same fixation that makes him treat every social encounter as an opportunity for deception. Though he was once so miserably poor as to be clothed in "rags" that he had "raked and picked from dunghills," the last thing Subtle wants to believe about himself is that he's "common." He deceives not only for the money but also to disclaim any leveling connection to those around him, and while practical considerations have forced him to accept Face as "a second in mine own great art," he insists that Face has thus been made "fit / For more than ordinary fellowships." Face shares Subtle's pretensions to social superiority: he refers to himself and his fellow virtuoso deceivers as "the few that had entrench'd themselves / Safe, by their discipline, against a world." The reality is otherwise: neither removed nor apart, the cheaters find themselves constantly under siege from a heterogeneous mix of dupes, "gallants, men and women, / And of all sorts, tag-rag," who "flock" to the house "in threaves" demanding to be exploited. Subtle, Doll, and Face repeatedly express anxiety about holding off these hapless invaders: "Good wives, I pray you forbear me now," Subtle implores some unseen customers; next, Doll complains about a "fish-wife" who "will not away"; "'slight, here are more!" Face subsequently exclaims; and when the true owner of the house later shows up at the door, Doll nervously reports that "forty o' the neighbors are about him, talking." By the end of the play, the formerly "exalted" Subtle feels himself "dwindled" by all the social pressure.[29]

But a dramatist in temporary command of a playhouse is a different kind of artist. To borrow Cartwright's terms, he can "take in" a "mass"

of customers at once, and his success depends on this equivocal sociability, as the diverse fates of Jonson's three rogues suggest. While Subtle and Doll ultimately surrender all their gains to escape the "rabble" who have descended on them, Face is able to recover somewhat by ostensibly humbling himself to his returning master Lovewit and then to the audience at large. "I put myself / On you," he assures the audience in the epilogue, "and this pelf / Which I have got, if you do quit me, rests / To feast you often, and invite new guests." Newly hospitable, Face now speaks for the dramatist, and the printed text of *The Alchemist* extends Face's invitation to readers as well as theatergoers: "the doors are open," as Lovewit says of his house at the end. Yet Face remains a professional swindler, and Lovewit, placing his "candor" under "some small strain," has just joined forces with Face to continue cheating Face's victims. A similarly uneasy mixture of openness and deceptiveness characterizes Jonson's account of himself in the paratextual material to the play. "Beware," he warns the reader, "for thou wert never more fair in the way to be cozened (than in this age) in poetry, especially in plays."[30] The thought that Jonson himself might be a cheater often delighted his contemporary acolytes, one of whom called Sejanus "mere deceit; / Yet such deceit, as thou that dost beguile / Art juster far than they who use no wile; / And they who are deceivèd by this feat, / More wise than such who can eschew thy cheat."[31] For his admirers, Jonson's own fraudulence was acceptable not simply because he conducted it openly, in the obvious fictionality of the play, but also because he undertook to cheat the audience for their own good. "This pen," claims the prologue to *The Alchemist*, "did never aim to grieve, but better, men," yet since "the age he lives in doth endure / The vices that she breeds above their cure," the playwright must resort to "fair correctives" that beguile "diseased" playgoers while he heals them unawares. Shortly after the lines from *De Rerum Natura* that Jonson culled for his 1616 epigraph, Lucretius calls his own art *"deceptaque non capiatur,"* "deceiving rather than ensnaring," like the craftiness of the doctor who gives children bitter medicine in a honeyed cup.[32] Cartwright credited Jonson with a therapy more precisely fitted to his audience: Jonson, he claimed, used "sublimated follies" as both the honey and the wormwood, to "cheat those men / That first did vent them." For Cartwright, the beauty of Jonson's trick was that it turned the alchemical fiction into reality, even as it remained a con: Jonson refined his audience by deceiving them.[33]

 The problem with such a defense of Jonson's own strained candor is that the rogues of *The Alchemist* are no less effective at psychological alchemy than the playwright is. By means of their scam, as R. L. Smallwood has observed, they transform their dupes "from creatures of reason and self-control to irrational, frantic searchers after power and

self-gratification."[34] What's more, *The Alchemist* satirizes the idea of distinguishing a good deception from a bad one, as when Surly contrasts alchemy with an "honest trick" like cardsharping, or when Subtle assures Doll that "to deceive" the conniving Face "is no deceit, but justice." Even if one were to grant that Jonson's motives for cheating were more laudable than Subtle's—a concession that few theater-haters of the time would have been willing to make—it still would be no easy task to reconcile this deceptiveness with Jonson's professed hospitality toward his audience. Doll's dubious notion that it's possible to "cozen kindly"—to cheat, that is, with sociable as well as benevolent intentions—seems in any case out of keeping with Jonson's own depiction of his dramaturgy in the expanded version of the preface to *The Alchemist* that he included in the *Discoveries*. There, he claimed that the rival dramatists who maligned him as "barren, dull, lean," and thus inadequate to "the multitude," failed to recognize "how he doth reign in men's affections; how invade, and break in upon them; and makes their minds like the thing he writes." Gone here is the humble pose of invitation: the playwright who thinks of himself as civilizing his audience by conquest can have no more thought of joining their company than *The Alchemist*'s puritanical separatist Tribulation Wholesome does when he argues that "the children of perdition are oft-times / Made instruments even of the greatest works."[35]

Is it shame or shamelessness that leads Jonson to expose his own pretensions to superiority in such characters as Tribulation and Subtle? Whatever the impulse, *The Alchemist* also exposes Jonson's deflating dependence on his audience. "I love a teeming wit," Lovewit declares when he hears about the diverse horde of "company" that Face has managed to "draw" to Lovewit's house in his absence. Since Lovewit at this point in the action knows nothing about Face's various schemes, his servant's wit can seem copious to him only because of the great "resort" it has attracted. The most basic constraint on the inventiveness of the con artists in *The Alchemist* is their need for fools to gull: as Face says to Subtle, "You must have stuff brought home to you to work on." Even those "men of spirit" the puritans accept a version of this practical limit on alchemy. Although they imagine that untold wealth can be generated from "an egg / And a small paper of pin-dust," they still believe that the egg and dust are essential to the "projection." Alchemy, after all, makes gold from trash, not from nothing. Mammon, the chief dupe of the play, reflexively bases the plenitude that Subtle will create for him on the actual copiousness of the city, however contemptible he may believe that urban multiplicity to be: "My only care is, / Where to get stuff enough now to project on. / This town will not half serve me."[36] For all his own pursuit of transcendent greatness, *The Alchemist* suggests,

Jonson recognized that his wit as a dramatist could not "teem" unless his audience did too.

Shakespeare's Taking Part

In the expanded edition of the paratextual material to *The Alchemist* that appears in the *Discoveries*, Jonson provides a name for the crowd-pleasing playwright who utters all he can, however unfitly: he calls him Shakespeare. Jonson elaborates his point about composed rather than scattered plenitude by reproving Shakespeare for his too "excellent fantasy," "wherein he flowed with that facility that sometime it was necessary he should be stopped." The problem with Shakespeare's teeming wit, Jonson maintains, was that he exercised no critical judgment over it. "Whatsoever he penned, he never blotted out line": he failed to differentiate good writing from bad, art from trash. It's easy enough to detect Jonson's notorious envy at work in this assessment of his most popular rival, but for theater scholars such as Peter Womack, Jonson's critique also highlights the real incompatibility between Jonson's "model of drama" and Shakespeare's. According to Womack, the theater as Jonson understood it promoted the "humanist" values of "detachment, discrimination, judgment": Jonson felt "hostility" toward "the social and spatial miscellaneity of the audience in the playhouse" because he favored a disciplined art of "boundedness." Yet Shakespeare (in Womack's account of Jonson's account) honored no rational limits. His theater manifested "a shameful dependence on vulgar credulity"; "populist" and "theophanic," it favored an "unboundedness" that mirrored the bulk and scatter of "the multitude"—who, as Jonson wrote in the *Discoveries*, " 'love nothing that is right and proper.' "[37] Where Jonson in Womack's view dissociated himself from his mass audience, Shakespeare surrendered himself to them.

Just as *The Alchemist* undermines the terms of this stark antithesis from Jonson's side, so *The Winter's Tale* undermines them from Shakespeare's. The very title of Shakespeare's play warns theatergoers that they are "in the way to be cozened," as Jonson cautioned the readers of *The Alchemist*. One contemporary moralist defined "a winter tale" as the sort of "feigned" absurdity that draws the attention of the witless "many." And Shakespeare mocks the vulgar appetite for obvious nonsense in the fourth act of *The Winter's Tale*, when the thieving Autolycus entices simple country folk to spend their money on such rubbish as the ridiculous tale "of a fish that appear'd upon the coast on We'n'sday the fourscore of April, forty thousand fadom above water, and sung this ballad against the hard hearts of maids." Autolycus can

hardly believe his success at exploiting the "herd" who "throng" to buy the "trompery," the "trinkets," the "nothing" he sells them.[38] Like Jonson in *The Alchemist*, Shakespeare in *The Winter's Tale* thus invites his audience to consider whether he holds them in the same contempt, as an elitist without social status who thinks that the best way to prove his own distinctiveness is by making fools of everyone around him.[39]

But the satirical rogue Autolycus is only one version in *The Winter's Tale* of the man who views every social interaction as an opportunity for deception. Another is the tragic figure of Leontes, a king. And where Autolycus or "Lone Wolf" expresses disdain for any fellowship with others, King Leontes expresses an overmastering fear. Horrified by the thought that he might share the "ignorant credulity" of the "lower messes," he views everyone around him with the deepest "suspicion."[40] In his mind, the threat he faces is far graver than the duplicity of the cheat who would persuade him to "take eggs for money." Merely to "commune" with others, Leontes presumes, is to forfeit his "mannerly distinguishment": that is, his powers to distinguish as well as his social distinctiveness. Heeding what "they say" amounts to sacrificing one's own good judgment, falling prey to groupthink: one cannot believe as others do and still be oneself. Yet this blanket rejection of social relations constitutes the very loss of distinction-making that Leontes dreads. "You're liars all," he exclaims to his subjects, leveling all differences between them, and when he falsely accuses his wife of deceiving him, he makes himself "ignoble," "betrays" himself to "slander." Sharing this same strange tendency to denounce and disgrace himself, Autolycus justifies it as a sign of the self-reliance that makes him "proof against … shame," but it could just as easily be described as his capitulation to social standards rather than his rejection of them.[41] The problem for the elitists of *The Winter's Tale* is that they cannot separate themselves from community as cleanly as they believe they must in order to maintain their own sense of "distinguishment," and so they oscillate between fantasies of transcendent mastery over others and of helpless debasement before them.

Recognizing the shakiness of any peremptory claim to uncommon distinction in the public theater, both Jonson and Shakespeare tried to moderate their own elitism by openly confessing that they were playing on the audience's credulity. Jonson hoped to moderate this act of self-shaming, too, insofar as he claimed that his deceptions would "better" his audience. But Shakespeare, extending himself further on his audience's behalf, offered to mitigate their shame along with his own by defending their credulity as well as his impostures. In *The Winter's Tale*, another name for the "folly" of exchanging something for nothing is "charity," which is to "give alms" and to do so "freely." Autolycus mocks

this generous impulse when he jokes that the Good Samaritan "clown" whose pocket he has picked has done him "a charitable office." With equal cynicism, Leontes continually regrets the rashness of his emotional investments in others, as when he declares that his wife has been "too much belov'd"—prized beyond her actual value. "Affection" has such power to delude itself, the king complains, that it often "fellow'st nothing." Yet what if the return that one should expect from charity and love is no *thing* at all? Maus argues that Jonson himself located genuine "abundance" not in the "material resources" that seem so scant and contested in his comedies but rather in an ideal economy where such immaterial "goods" as "love, virtue, skill, knowledge, peace of mind" were "neither limited in quantity nor subject to private appropriation." One would guess that a playwright who proffered wit for money must have been professionally inclined toward such a theory of intangible gains. But *The Alchemist* places much less emphasis than *The Winter's Tale* does on what Maus regards as the decisive element in the ideal economy she describes: the holding of immaterial goods in common. When the guests at the sheep-shearing feast in *The Winter's Tale* throng to buy the trifles Autolycus foists upon them, their folly is counterbalanced by their conviviality. The scene suggests that the play's audience should accept the same returns on the something they spent for the nothing of the play: their money has given them "benefit of access" to a sociable entertainment where "all" are "welcom'd," "unknown friends" as well as known.[42]

After much pain suffered as well as inflicted, Leontes decides that he can no longer live without such "society," even if it means exposing himself to the threat of debasement and deceit. From the start, *The Winter's Tale* had in any case represented the king's dread of the swindler who "fixes / No bourn 'twixt his and mine" as largely self-generated, springing from Leontes's pathological inability to reconcile his individuality with his sociability. "To mingle friendship far is mingling bloods," Leontes had madly declared, as if social bonds somehow melted the physical boundaries between one person and another. Maus claims that such fears of losing oneself had no place in the ideal economy that Jonson envisioned: like the classical authors he admired, Jonson believed that "the more" a person "shares" an immaterial good, "the more he acquires himself."[43] And yet Maus notes that Jonson gave dramatic salience to this "communal emphasis" only in his masques, not in his commercial plays, which are instead "characterized by a relentless competition for a fixed number of resources." For Jonson, apparently, the sharing of immaterial goods meant one thing in relation to an aristocratic audience and quite another in relation to "common" theatergoers.[44] In *The Alchemist*, however, Jonson did try to temper his own Leontes-like

obsession with fixing a bourn between himself and "the lower messes" by outlining an economy in which he could claim the goods that were "properly" his without violating the essentially public nature of the theater. While acknowledging that his own "great art" depended on the vulgar material of his audience and that it was theft to pretend otherwise, Jonson excused such appropriation as a kind of *open* thievery. Just as Lovewit in the final scene of *The Alchemist* contrives to seize Mammon's "own stuff" by offering to release it if Mammon will publicly admit that he was cheated of it, so Jonson in his prologue asserts that he will stage the "follies" of the audience in such a way "as even the doers may see and yet not own."[45] If the audience are too ashamed to "own" the behavior they witness in *The Alchemist*, Jonson suggests, then he wrongs no one in claiming that the play belongs to him and him alone.

The final scene of *The Winter's Tale* demonstrates Shakespeare's greater commitment to *un*fixing the bourn 'twixt his and mine. By the end of the scene, Paulina has managed to revive the earlier conviviality of the sheep-shearing feast and extend it not only to Leontes and his court but also, implicitly, to the theater audience at large: "Go together, / You precious winners all; your exultation / Partake to everyone." And yet this climactic invocation of an ideal economy falls considerably short of the frictionless merger between self and others that classical writers associated with the wise man who "judges nothing more fully his own than that which he shares with the human race."[46] To "partake," as the play's continual worrying of the term "part" emphasizes, is to share by taking a part and a part only. Leontes had earlier wanted more: standing on his royal "prerogative," he had declared that nothing but his own "natural goodness" had led him to share or "impart" his power of decision making with his counselors; otherwise, "all" was "properly" his. Hermione had unnerved him by muddying the absoluteness of his sovereignty. Not only was she "a fellow of the royal bed" who claimed to "owe / A moi'ty of the throne," but her co-parentage of Prince Mamillus ruined Leontes's sense of his son as his exclusive property: "you have too much blood in him," he'd exclaimed to Hermione. Leontes's intense anxieties about partial ownership do not vanish when he later chooses to reunite with Hermione. The difference is that he has learned how to *bear* those anxieties. As his daughter Perdita had said with some resentment in the act before, "I see the play so lies / That I must bear a part." Having a part and not all is what Leontes must endure when, after regaining Hermione, the first words he hears her speak are not for him but for their daughter, whom Hermione calls "mine own."[47] And this only partial hold on his loved ones matches a similarly disturbing partialness of affection that the closing events of the play press Leontes to recognize within himself. From the start, the king had believed that he should prize one thing of

absolute value that could be as cleanly distinguished from all other things as he himself was: "most dear'st" was how he'd characterized his son. So it confounded him to hear himself calling his wife "dearest" too, and commanding that "what is dear in Sicily be cheap" for the sake of his "brother" Polixenes as well. "Next to thyself and my young rover," he had told Hermione, subverting his own emotional absolutism, Polixenes is "apparent to my heart."[48] When the king reclaims his queen at the end of *The Winter's Tale*, he must at the same time join an even more numerous inner circle than before, which further compromises his ideal singleness of affection by giving him many loved ones to value. Partaking your exultation to everyone means scattering yourself into parts.

The aesthetic consequences of part-taking in *The Winter's Tale* prove to be as irreducibly complex as the social ones. The first depiction of art in the final scene of the play befits the terms of Leontes's earlier elitism: Leontes assures Paulina that he has come to visit her only "to see the statue of our queen." This "royal piece" has all the hallmarks of high art as Benjamin conceives of it in his "Work of Art" essay. There, the exemplary model of an "auratic" artwork is an ancient Greek "statue of Venus," which, Benjamin maintains, the Greeks treated as "an object of worship," preserving its "cult value" by keeping it "out of sight" and "accessible only to the priest in the cella." Paulina similarly hides Hermione's statue behind a curtain in a "chapel" that doubles as an art "gallery"; when the curtain is drawn, Perdita is so awestruck as to "kneel" before the artwork revealed to her. For Benjamin, the "uniqueness" of the statue was as significant as its reclusion: the technical limitations of the Greeks meant that most of their artistic creations "could not be technologically reproduced." Paulina's gallery is similarly filled with "many singularities," chief among them the "peerless" statue that she keeps "lonely" and "apart." As a piece of "stone," moreover, Hermione's statue has the added virtues of composition and permanence—of "fixure," as Leontes call it—that Benjamin further regarded as essential to the auratic artwork. In the world of ancient Greece, Benjamin writes in the second version of his "Art" essay, "the pinnacle of all the arts was the form least capable of improvement—namely sculpture." With so few means of technological reproduction at their disposal, the Greeks, Benjamin claims, fashioned their art "for all eternity."[49]

But there is no incomparable statue in *The Winter's Tale*. It's merely Hermione pretending to be stone; it's not sculpture but playacting—an imposture, a con. And the exposure of the deceit amounts to a fall for the artwork: if it is to "be stone no more," Paulina emphasizes, then it must "descend." Just as this demystification would seem to cheapen the "majesty" of the artwork, so it also threatens to debase the artwork's

royal admirers: Perdita's "superstition" in kneeling to the statue of her mother recalls the credulity of the peasants who thronged to buy Autolycus's wares "as if my trinkets had been hallow'd and brought a benediction to the buyer." Finally, the revelation of the statue's fraudulence threatens to discredit Shakespeare as well, whose wares may now seem no less absurd than Autolycus's ballad about a singing flying fish. How could Shakespeare hope to persuade us that Paulina has somehow managed to keep Hermione secret for "sixteen years," and then expect that he could pass off a live actor as a statue?[50] Yet Shakespeare had all along invited skepticism toward his fictions in *The Winter's Tale*, piling "one extreme improbability on top of another," as Leonard Barkan has noted. The scene before, a character had described the miraculous rediscovery of Perdita as "so like an old tale, that the verity of it is in strong suspicion," and now Paulina herself raises the possibility that Hermione's coming to life might be "hooted at / Like an old tale."[51] Why, if Shakespeare meant us to see his play as a masterpiece, would he keep tempting us to discount it instead? Benjamin assumes that a high-cultural conception of art held sway until the invention of mass reproducibility; only then, he believes, could "the art of the Greeks," which had been "geared toward lasting," be discarded in favor of more ephemeral works such as the movies, which are "geared toward becoming worn out." Yet Leontes's first suspicion that he is being fooled by the statue arises from his perception of aging and deterioration in this supposedly faithful "likeness" of his wife: "Hermione was not so much wrinkled, nothing / So aged as this seems," he protests to Paulina. Then he sees that "the fixure of her eye has motion in't." Rather than a permanent and unwavering achievement, the statue turns out to be a moving image.[52]

Most spectators of *The Winter's Tale* are of course willing to overlook the improbabilities of its final scene. They think that the statue "moves" in another sense: that, in coming to life, it floods the theater with emotion.[53] Like-minded critics add that Hermione's resurrection succeeds at lifting the art of the theater above the art of sculpture by fulfilling, as the statue only "coldly" can, the aesthetic ideal of liveliness for which the statue is repeatedly praised.[54] If the fraudulence of Hermione's revival seems to weaken the connection between the theater and high art that the statue otherwise appears to promote, it can hardly be said to sever that connection. What it ruins instead is any absolute assertion of identity or difference between the two. Jonson hoped to replace the vulgar and scattered entertainment of other playwrights with a drama that was no less composed than it was popular; Shakespeare may have similarly aimed to combine the classical and lively arts at the end of *The Winter's Tale*, but he represented that mixture as inherently unstable.[55] This lack of "fixure" in the aesthetics of the final scene,

moreover, reflects the social heterogeneity of the audience who witness Hermione descend from her pedestal. To judge exclusively from the speaking parts in the scene, the people gathered together in Paulina's chapel are homogeneously aristocratic, but that is another of the play's illusions. Silent among the statue's admirers are the shepherd clown and his father, who have been promoted by their loving care for Perdita into the adopted "kindred" of the royalty; accompanying them is their new servant Autolycus; and equally present, of course, are all the paying customers in the theater audience.[56] It's not one class or another that partakes of the revelation at the end of *The Winter's Tale*: optimally, for Shakespeare as for Paulina, it's everyone.

In one respect, the religious overtones to the final scene suggest that Shakespeare viewed the open access of his theater as expanding his artistic range, or rather as expanding his art beyond his range. At the start of the scene, Paulina oddly insists that the statue belongs to her and to her exclusively—"the stone is mine," she declares—but her claims of ownership turn out to be part of her deception. So, too, do the rumors she spreads about the statue's authorship. The scene before, a gentleman had reported that the statue had been sculpted "by that rare Italian master, Julio Romano, who, had he himself eternity and could put breath into his work, would beguile Nature of her custom, so perfectly is he her ape." In her chapel, Paulina repeats this extravagant praise: the statue, she declares, "excels" all that "hand of man hath done." "What was he that did make it?" Leontes asks in wonder. "Still methinks / There is an air comes from her. What fine chisel / Could ever yet cut breath?" These repeated allusions to the divine authorship of the form that everyone so admires become explicit in the first words that the statue speaks: "You gods, look down / And from your sacred vials pour your graces / Upon my daughter's head!"[57] Womack shrewdly links the "theophanic" dimension of Shakespeare's plays to his sense of his audience, and here, indeed, the gods as Hermione imagines them are spectators as well as creators. But to associate the religion of *The Winter's Tale* with Shakespeare's supposedly populist commitment to "unboundedness" is to overlook the conspicuously pagan limits that Shakespeare places on Hermione's faith. Even in this scene of revelation, Shakespeare continues to emphasize the superstitious credulity of the onlookers.[58] Like the mixed and partial fellowships in the play, the impure religion of *The Winter's Tale* helps him bind his moving images to a transcendence that never quite gets off the ground.

6

Throw That Junk!

Orson Welles sent me an automaton, an admirable white rabbit
that could move its ears and play the drum. . . . This magnificent
toy was the real sign, the real signature of Welles, and whenever
an Oscar . . . arrives from America, or in France I am awarded
the little Victory of Samothrace, I think of Orson Welles'
white rabbit as the Oscar of Oscars and as my true Prize.

—Jean Cocteau

A newspaper publisher who collects art: why should *Citizen Kane* treat
this combination of careers as a mysterious paradox? In publishing, as
Kane repeatedly emphasizes, selling is the issue, and success is a matter
of circulation. But in collecting, the issue is buying, and success becomes
a matter of accumulation. To underscore these differences, the film adds
incongruities of class and medium to the mix. Kane the publisher prints
cheap American newspapers; Kane the collector acquires expensive
European *objets d'art*. The first of these *objets* are works Kane has
crammed, chaotically, into a newsroom whose culture is conspicuously
at odds with them. All the newsmen and women in the movie, or at least
all the modern newsmen and women, are depicted as bored, skeptical,
even derisory in the face of moneyed grandeur; Kane himself under-
takes his newspaper career as a direct rebellion against his upper-crust
guardian, the banker Thatcher. Newspapers, mass-produced and mass-
distributed, are by nature popular rather than exclusive; sculpture and
painting suit a more elite audience because they are harder to come by
and (theoretically) harder to produce. Kane's own habits as a consumer
exaggerate this distinction. On several occasions we see him reading his
newspaper just as his customers do, but we never see him, or anyone
else, for that matter, admiring his art. So indifferent is Kane to displaying

or even viewing his *objets* that he never bothers to unpack many of them from their shipping crates.

Although most commentary on the film has taken the incompatibility of Kane's two interests for granted, it's not hard to imagine a less discordant presentation of them. The publisher might have been shown, for instance, as making so much money from his newspapers that he could afford to become an art collector too. But in *Citizen Kane* the publisher *loses* money from his newspapers; it's his gold mine that brings him the wealth to buy his art. If the movie's insistence on the conflict between media mogul and art-lover seems puzzling in itself, that insistence looks even stranger in the context of the film that "of all major Hollywood films... most boldly and emphatically announces an artistic personality."[1] Why should so ambitious a movie as *Citizen Kane* ask its viewers to regard mass media and high art as contradictory pursuits?

Defensiveness might be part of the answer—a fear that viewers would scoff at any hint of artistic pretension in a movie. "To a great many otherwise intelligent people," a 1919 *Photoplay* article lamented, "the motion picture is only an entertainment, never anything more than a toy"; "a glittering toy for an imbecile giant" is how William Allen White phrased it in 1936.[2] By the time *Citizen Kane* was released, however, it had also become commonplace for critics (and fan magazines) to speak of film as art and individual movies as masterpieces. When in 1919 William Randolph Hearst, the chief model for Kane's double life as a publisher and a collector, partnered with Adolph Zukor to open his own film studio, Cosmopolitan Productions, Hearst confided to Zukor that he had "an ambition to make the best pictures that you distribute," and in pursuit of these high standards, he placed a renowned European painter and architect, Joseph Urban, "in complete artistic charge" of film production.[3] From the start, Hearst's eccentricities have seemed the obvious explanation for Kane's, and yet the career of Joseph Urban shows how the attempt to forge a connection between art and mass entertainment was nowhere near so anomalous at the time as Hearst or *Citizen Kane* makes it appear. Before Urban began working for Hearst, he had been the set designer for the Boston Opera, for the Metropolitan Opera—and for the *Ziegfeld Follies*.[4]

Urban himself set lofty goals for Cosmopolitan Productions. His aim, he declared, was "to make pictures that are moving compositions in the same sense that a great painting is an immobile composition." But Urban's formulation contrasts film and painting even as it equates them. His distinction between "moving" and "immobile" art was, moreover, de rigueur for contemporary cinephiles, who regularly espoused what Noël Carroll has called "the specificity thesis" about movies: the belief, as Gilbert Seldes put it in his influential *7 Lively Arts* (1924), that film

should "develop things calculated strictly for it and for no other art, made up out of its essential quality, which is visual motion."[5] Urban's defense of movies echoes this standard view among movie theorists of the time that film could be taken as art only when it became an art of its own, which it could achieve only when it incorporated motion into its affirmation of artistic status. These are precisely the terms in which the first reviewers of *Kane* hailed the movie as a "masterpiece." "*Citizen Kane* is far and away the most surprising and cinematically exciting motion picture to be seen here in many a moon," wrote the critic Bosley Crowther in 1941; "Mr. Welles has put upon the screen a motion picture that really moves." For Otis Ferguson, *Citizen Kane* was "the boldest freehand stroke in major screen production since Griffith and Bitzer were running wild to unshackle the camera"; Ferguson praised "the many places where it takes off like the Wright brothers." According to a third reviewer, Cedric Belfrage, *Kane* "shatters at every turn the complacency of the critical hack"; "suddenly tongues begin to talk, brains to operate, everything to move again."[6] And it was by means of this electrifying commitment to motion, Belfrage maintained, that *Citizen Kane* had succeeded in granting film "the dignity of being a medium different from the stage or any other, able to do things the others cannot do."[7]

Such contemporary excitement about the movie suggests that the bizarre pathology of Kane's double life might have been meant to contrast with the film's own single-minded devotion to the artistic potentiality of its medium. But the problem with this normative account of *Citizen Kane* is that the specificity thesis so fervently embraced by the movie's contemporary critics would also seem to *require* difficulties in comparing film with painting or sculpture, if film were indeed to claim a unique aesthetic value "calculated strictly for it and for no other art." For some theorists of the time, notably Walter Benjamin, film differed so radically from traditional artworks that it had shattered the very notion of art Urban tried to preserve in comparing film to painting. Benjamin was uncertain what to call the results. It was not art, exactly: only a reactionary, he argued, would try "to annex film to 'art.'" In the same spirit, though with dismay at the reactionary direction film seemed to be taking, Seldes had complained a decade earlier that film had been "best before it was an 'art' at all." For Seldes, the more that movies had sought a "dignity, gentility, refinement" for themselves, the more "the picture side, the part depending upon action before the camera," had "gone steadily down."[8] The director, co-screenwriter, and star of *Citizen Kane* would later express the same view. Defining film as "a slice of life in movement that is projected on a screen," Orson Welles in 1966 criticized the "static cinema" of directors who had committed the fatal error of "desperately trying to make Art."[9] But if it was no less of a mistake to

regard movies as art than as trivial entertainment, then what was the right way to think about them?

In the rest of this chapter, I'll argue that the tensions between publishing and collecting in *Citizen Kane* reflect the double bind for movie lovers such as Seldes and Welles who believed that film could rise to the level of great art, as traditionally conceived, only by differentiating itself from great art, as traditionally conceived. The central consequence of this double bind for *Citizen Kane* is that the movie treats the complexities in claiming artistic status for film less as hurdles to be overcome than as necessary, indispensable features of the claim—which is why the movie accentuates disparities between mass media and high art even as Kane combines interest in both.[10] Indeed, the movie's commitment to *intensifying* Urban's paradox about film as a moving composition is readily apparent in a signature feature of its visual style. Borges, reviewing *Kane* in 1941, observed that "the film teems with the forms of multiplicity, of incongruity [*inconexión*]."[11] Both the multiplicity and the incongruity conspicuously figure, in a famous shot of Kane's second wife, Susan, as the *dis*array of possessions and artistic styles in Kane's mansion, Xanadu. Perhaps the greatest discordance in that shot is between the costly *objets* of Xanadu and the child's toy, the jigsaw puzzle, whose jumble of pieces presents the heterogeneity of the scene as a scattering. And yet, for all its aesthetic disunity, the mansion *has* been assembled, and the unfinished jigsaw puzzle oddly manages to convey this formal integration also, through the seeming identicality of its strewn pieces and their provisional coalescence into a mass. Elsewhere in *Kane*, the multiplicity and the incongruity take different "forms," the most concentrated of them resembling the heaped puzzle pieces, but the central feature shared by all these images is the compositional tension of holding so many and so various visual elements together.[12] I call this pointedly unstable compound a *scatterform*.

Citizen Kane uses its scatterforms to highlight the commercial as well as visual differences of movies from *objets*: in particular, the mass production and distribution of film. One early and obtrusive instance of the scatterform registers the new commitment to mass circulation that Kane brings to an antiquated newspaper he has decided to run, the *Inquirer*. Kane has just entered the offices of the *Inquirer* for the first time and begun to torment the staid old editor with his flippancy when we hear a crash and then see Kane's "general manager," Bernstein, tumbling through the door with a mass of cheap goods and furniture. Pauline Kael finds this briefly held shot of Bernstein "confusing": it makes Bernstein look like "a junk dealer," in her view.[13] From the perspective of the old editor Carter, however, that is just the point of the scene: Kane intends to increase the circulation of the previously "respectable" *Inquirer* by cheapening it in every respect; under his regime, it will be

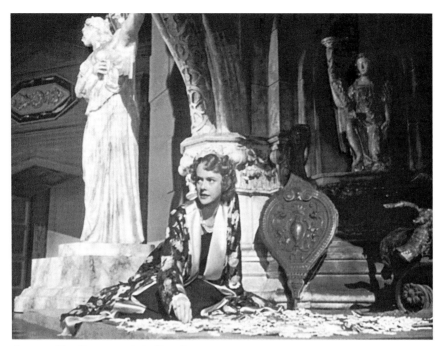

Susan and her jigsaw puzzle in Xanadu

junk in, junk out. To our eyes, of course, Kane is also bringing a dynamic new intensity to the paper, and Bernstein's pile of junk is proof of that, too. "There ain't no bedrooms in this joint; that's a newspaper building," a mover had warned Bernstein as they pulled up beside the building with Bernstein's truckload of bric-a-brac. What neither the mover nor the old editor understands is how fully Kane intends to move into the newspaper business. "Mr. Carter, I'm going to live right here in your office, as long as I have to," Kane explains as Bernstein's tumbled goods are picked up and carried past them. The visual mixed signals of arrested motion and organized disarray in the Bernstein scatterform are thus shown to bear a thematic weight as well: they highlight the "confusing" role that the scatterform's objects play in simultaneously marking up and marking down the value of Kane's newspaper.

A second scatterform image of the *Inquirer* offers a similar combination of visual and thematic complexity in momentarily fusing Kane's newspaper business with his growing interest in art collecting. We watch Bernstein, along with Kane's high-class sidekick Leland, make their way through a mass of *objets* haphazardly assembled in the office that had earlier been furnished with Bernstein's bric-a-brac. Like the bric-a-brac, the art is in a jumble because it is in the process of being moved, and the shot emphasizes this mobility by having Leland carry a crate of *objets* and Bernstein almost knock over a statue. Clearly, as Bernstein's

Bernstein and his bric-a-brac

mishap indicates, the statues do not *fit* in Kane's office, but their dislo-
cation from some more conventionally appropriate setting allows them
to impart an aesthetic coding to Kane's investment in newspapers, even
as the newspaper setting imparts a mass-media coding of precipitate
dispersion to the statues.

A third instance of the scatterform focuses on Kane's newspaper as
itself an object. The best-known version of this scatterform appears,
revealingly enough, not in the movie proper but in a still photograph
that was printed on the back cover of the souvenir program distributed
at the film's premiere, showing Welles as an elegantly dressed Kane
incongruously straddling a jumble of newspaper stacks.[14] The nearest
the movie comes to this image is a close-up on a single newspaper that
widens to show a stack of the same edition and then other stacks thrown
together with the first one. The front page of the newspaper in these
stacks is an important one for Kane, exemplifying the dynamism he has
infused into the previously musty *Inquirer*: it boldly announces Kane's
"Declaration of Principles" for the paper. We had first seen this declara-
tion as Kane's handwritten draft, which Leland had asked to keep as a
"document" that "might turn out to be something pretty important."
The distinctive value of "that particular piece of paper," as Leland calls
it, is immediately thrown into question, however, by its mass reproduc-
tion in the *Inquirer*, a process reenacted for us as the shot of the printed

Statues in the newspaper office

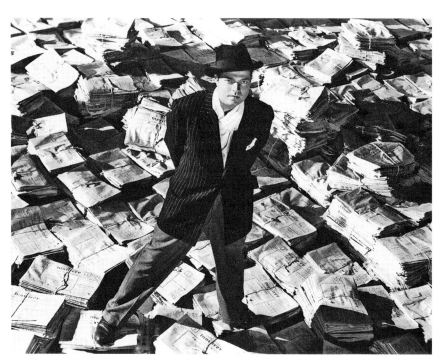

Promotional photo of Welles as Kane. Licensed by Warner Bros. Entertainment. All Rights Reserved.

Kane's handwritten "Declaration of Principles"

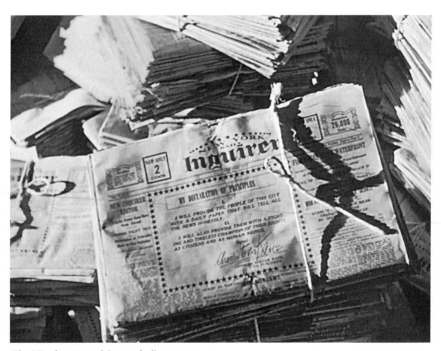

The "Declaration of Principles" in print

declaration gradually widens from one copy of the paper to many. Even as it registers the triumph of Kane's grand gesture, then, the scatterform image of the stacks seems simultaneously to cheapen that gesture, anticipating Kane's later betrayal of his principles, along with Leland's return of the holograph declaration and Kane's throwing its torn scraps into the fire.

The shot of the stacks also offers us a perspective on the newspaper as a mass medium that contrasts with the earlier, more conventional footage of high-speed printing we had seen in the movie's opening newsreel. Ideally, for the newspaper business, the stack is a provisional composition: newspapers are made to be distributed, not bundled together, and the stack is merely a convenient way to begin this distribution on a large scale. One might say that the stacks are the latent form of newspaper publication: they allow the camera to evoke the mass production and distribution of newspapers while lingering on stable and static units. But one might just as easily say that the stacks suggest the latent destiny of newspapers to be as speedily discarded as they are distributed, to end up as lifeless heaps of trash.[15] "A dying daily" is what the newsreel calls the *Inquirer* before Kane revives it, yet dying daily is the fate of all daily papers, doomed to near-immediate obsolescence. The briefly sustained image of the *Inquirer*'s consolidation into stacks that are also haphazardly strewn about leaves us uncertain whether the stacks represent the

Newspapers in mass production

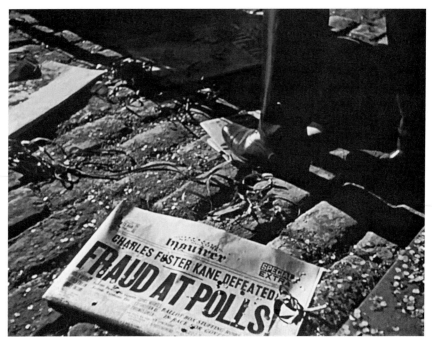

Newspapers as trash after Kane's political defeat

dynamism and plenitude of newspapers or their ephemerality and dead
weight. Similar questions occupied contemporary writers on film. "The
big social fact about the moving picture," declared Vachel Lindsay in
his 1915 *Art of the Moving Picture*, "is that it is scattered like the news-
paper." And "the life of a film," Valentia Steer observed in her 1913
Romance of the Cinema, is almost as "short" as a newspaper's: "it is
'first run' to-day and 'junk' a few short weeks hence."[16]

As a means of addressing such issues, the scatterform may be a signa-
ture feature of *Citizen Kane*, as I've said, but it is no more unique to the
movie than the problems that the scatterform was meant to convey. It is
not even unique to film, or to the modern entertainment industry. As I
emphasized in chapter 5, Jonson portrayed *The Alchemist* as a "com-
posed" rather than "scattered" form of the copiousness that he believed
mass entertainment required, while in *The Winter's Tale* Shakespeare
analogized his play to the ambiguously composed and also discom-
posed figure of a statue that moves. Within the narrower bounds of film
history, the art-house bravura of *Kane* has tended to distract critics
from the conventionality that equally characterizes the film. To high-
light the standard nature of the categorical dilemma for movies that
Citizen Kane unfolds, as well as the relative distinctiveness of *Kane*'s
response to the issue, I'll turn in the next portion of this chapter to an
earlier movie that shares many of *Kane*'s theoretical concerns—Mary

Pickford's last silent picture, *My Best Girl* (1927)—before I return to *Kane*. Why *My Best Girl*? According to Seldes, Pickford was largely to blame for the pretentiousness that he believed had corrupted movies: from her "success," he argued, "came the whole tradition of the movie as a genteel intellectual entertainment."[17] I hope to show that Seldes gets Pickford only half right: while *My Best Girl* is indeed committed to gentrifying movies, it also refuses to disavow the cheap, commercial, mass-cultural origins of film in the process.

Pickford's film ties its conception of movies as upwardly mobile junk to a plot device that it shares with *Citizen Kane*: a love affair between a shopgirl and a wealthy man.[18] In *My Best Girl*, that cross-class romance encourages both lovers to take an imaginative, even artistic approach to the distribution of cheap goods in mass culture. But in *Citizen Kane*, the same sort of romance proves insufficient to normalize the relationship between the film's elite and popular aspirations, because *Kane* demands a more robust consideration of their differences than *My Best Girl* does. For *Kane*, again, those differences have to amount to difficulties if film is indeed to claim both its comparability and its incomparability to high art. So it is that Kane's romance with a shopgirl disintegrates when he forces her to pursue a career in opera. Yet opera—an art form that ran-kled Seldes even more than Mary Pickford did—is not entirely incon-sistent with the true principles of film as *Citizen Kane* perceives them. Where newspapers may seem a better match for film in their mass distri-bution, their black-and-white flatness, and their low price, opera more closely resembles film in its human sound and movement, as well as its theatrical setting.[19] Ultimately, neither the popular medium of newspa-pers nor the elite medium of opera can hold Kane's attention or prove a decisive role model for the movie, yet that is not because Kane and the movie end up discarding every object of their investment; it is rather because they discard the notion that objects must be *adequate* to the investments made in them. In its climactic scatterforms, I will argue, *Citizen Kane* tries to preserve its specificity as a medium by searching for self-reflections that are conspicuously more strained and uncanny than newspapers, opera, or statues—a quest that ends in a snow globe and a sled.

Mobility in *My Best Girl*

At its start, *My Best Girl* seems to insist on the gap between the popular and elite worlds to which movies and art conventionally belong. We begin with the clutter and chaos of a five-and-dime store, revealed to us initially through a series of dissolves from one heap of mass-produced

trifles to another. We then turn from the store to the gated inaccessibility, symmetrical orderliness, and relative emptiness of a mansion. But the owner of the mansion, we soon learn, made his money from the store: he is Robert Merrill, the "5 and 10 magnate." *My Best Girl* aims to highlight this connection and, in the process, to integrate the store's mass culture more openly and fully with the mansion's high culture. That integration happens by way of a Cinderella story in which the magnate's son falls for a store employee.

"You might not think of romance in connection with a ten-cent store," a contemporary reviewer of the movie acknowledged, and indeed the store's commerce in *My Best Girl* appears to present more of an obstacle to the lovers than the mansion's exclusive gates do.[20] Joe, the owner's son, first meets the shopgirl Maggie at a sales table stacked with cheap toys—a setting that invites us to consider whether Joe views Maggie as a similarly purchasable amusement.[21] "Rich men's sons don't chase after shopgirls for the exercise," as a crooked boyfriend of Maggie's sister will later put it. Joe deceives Maggie when they meet, moreover: he pretends to be a mere job applicant, and he fails to tell her that he already has a fiancée, a fellow socialite named Millicent. The great advantage of the fairy-tale plot in *My Best Girl* is that it helps the lovers overcome these obstacles and thus escape a reductively commercial account of how the store and the mansion might become one. But the great difference from the Cinderella story is the movie's steadfast loyalty

A Merrill cash register, fading to the Merrill mansion

to the commercial matrix that is, after all, the means of Joe and Maggie's coming together in the first place. In *My Best Girl*, the integration of elite and mass culture requires the reconciliation of romantic love with the otherwise trivial and generic desires encouraged by mass consumption. So urgent and leveling a force is direct commercial transaction in the movie that neither Maggie nor Joe will ever return to the shop floor after their first encounter, so far as we see. But the lovers do not retreat instead to a private setting where they can more securely assert their uniqueness to each other. Joe is given a job in the store's stockroom, where Maggie promises "to make something" of him, and it is here, in this *relatively* less public and disorderly sector of the commercial enterprise, that their intimacy begins.

Their next scene together—a bravura sequence in the film—takes Joe and Maggie straight from the stockroom into the city's streets. At the end of a workday, Joe emerges from the store's employee entrance surrounded by admiring shopgirls; apparently Maggie has yet to distinguish herself in Joe's eyes from the store's other attractions. Following two fellow shopgirls who hitch a ride home in the cab of a company truck, Maggie hops onto the back of the truck, whose flatbed is filled with sacks, barrels, and crates of the goods it is transporting. As the truck pulls away, Maggie tries to draw Joe's attention by purposely dropping a belonging that she hopes he will retrieve for her. He does so, at some risk to himself from the traffic on the city street. Maggie then drops another package, and another, before Joe finally jumps up onto the back of the truck beside her. Once again, the movie has discovered a sector of the store's commercial enterprise that can afford Joe and Maggie some relative privacy together. More conspicuously than before, however, this traffic sequence insists that Joe and Maggie can overcome the social barriers between them only by immersing themselves in the universal solvent of mass culture. Although the truck removes them, as the stockroom does, from the immediacy of actual buying and selling, it also directly involves them in the movement of goods. In *My Best Girl*, there is no social mobility without this commercial mobility. Only by exploiting the movement of the truck does Maggie succeed in getting the owner's son to herself, which also means succeeding in turning Joe into a consumer of what she has to distribute—the bags she drops.

The company truck helps broaden horizons for Joe as well: by chasing after it (and for more than the exercise), Joe can begin to distinguish himself from the idle rich, while by returning Maggie's things to her, he can also begin to demonstrate that he, too, is a mover of goods. Once Joe hops up beside her on the truck, Maggie immediately rewards him with the news that his manager at the store thinks he is "a very efficient young man." We can conceive of this news as a reward because we have

Maggie's thrown-together "throne"

previously heard that Joe has been pretending to be a lowly store employee
for more than just the fun of it (although the fun remains a crucial part
of his motivation). His magnate father, who apparently has doubts about
the life that Joe might lead with Millicent, wanted Joe to make "some prog-
ress at the store" before he would allow him to announce his engagement.
Now, after thanking Maggie for having "taught me so much about the
business," Joe displays not only his growing affection for Maggie but
also the business savvy he has learned from her as well as from his father:
he engineers an ingeniously comic distribution of goods, tossing about
the crates, sacks, and barrels on the back of the truck to build Maggie a
"throne." It is an enactment, in miniature, of his father's commercial
success at making something "great" out of trifling commodities.

 Unlike Joe's father, of course, Joe isn't actually selling the goods he
moves; his actions on the truck are at best a rehearsal for commerce. But
distribution is precisely the business Joe has been mastering in the stock-
room, and on the company truck the deferral of direct sales allows him
to get at an even more fundamental requirement for successful five-and-
diming. What had at first seemed a merely idle propensity for make-
believe, when Joe played with toys and toyed with Maggie, is now redefined
as vigorous creativity. It is this dynamic quality of imagination, the film
suggests, that enables Joe to see through the settled order of things
to the hidden or potential greatness in Maggie as well as in the goods

PICKLES *and* ACME BRAND *on the throne*

surrounding her. The effect of the scene, consequently, is to make imagination rather than money seem the key to social as well as commercial success. Read in the light of Joe and Maggie's playacting, even such risibly generic markers of mass commerce as the PICKLES and ACME BRAND that are stamped on the back of Maggie's thrown-together throne end up adding to the romantic effect.

Joe and Maggie seal their love by transferring this imaginative play back to the store, or rather to its stockroom, where they can continue to rehearse the distribution of merchandise without the immediate commercial pressure of the sales floor upon them. A few scenes later, we see the lovers eating a meal together, huddled inside a strangely cramped and dilapidated space. "Why, this little café has it all over the Ritz!" Joe exclaims. The camera then pulls back to reveal that the "café" is really an empty stockroom crate, which the lovers have decorated with various tattered items from the stockroom. Like the store's consumers, Maggie and Joe have found value in junk, but where the consumers are encouraged to delight in a sham chaotic plenitude of trifles, Maggie and Joe have transformed the stockroom's detritus into distinctive expressions of their shared love and ingenuity. As the camera pulls back even further, we now also see that the stockroom has taken the shape of a miniature cityscape: under the influence of the lovers, the stockroom has come to offer a comically meager yet emotionally charged vision of the urban mass culture that has brought them together.

The stockroom café

The stockroom cityscape

The crate that attracts the lovers not for the objects it holds but as a holder of objects serves a further purpose, to our eyes: it mirrors the frame of the movie screen. At this point in the film, the analogy is hardly surprising. By promoting a vision of the five-and-dime in which imagination gives the store's otherwise trifling goods their value and charges

them with emotion, *My Best Girl* moves the business of the store closer to the business of movies. The highlighting of the frame in the stock-room scene reinforces this emphasis on the imagination as value-maker, thus helping to level the playing field between the store's goods and the mansion's *objets*. From the perspective of the stockroom, the problem with *objets* is that they foreclose imaginative investment because their worth is presupposed: they reify art as status symbol, whereas the lovers restore art to its original liveliness as a creative process.[22] Even in the Merrill mansion, wealth manifests itself at first not so much in the trea-sures the Merrills have collected as in the symmetrical design of the rooms, especially in the moldings on the walls, which dwarf the occa-sional small painting they enclose. Art as *objet* is subordinated to art as frame. But the power of the frame to confer value also raises ques-tions about the intrinsic worth of any particular set of actors, actions, or objects within the frame. A problem for the lovers' lively art is its association with *shabby* decorations in an *emptied* crate: while highlight-ing the resourcefulness of the lovers as artists, the crate as frame also appears to stress the insubstantiality of the materials the lovers deploy and, ultimately, of the artwork they create.

The happy ending of the Cinderella plot is the movie's way of pulling back from the full leveling power of the frame. Just as that plot attempts to reconcile the mansion's accumulated wealth with the dime store's distribution of bric-a-brac, so the cross-class romance also helps *My*

Interior decoration in the Merrill mansion

Vase, tapestry, statue, and "Mrs. Merrill"

Best Girl strike a compromise between an elite art of valuable *objets* and the cheaper, more plebeian lively arts. The back of the lovers' café is emblazoned with the Merrill slogan, WE ARE ALL ONE BIG FAMILY; after their meal, Joe lures Maggie to dine at his home by pretending that the Merrills want this slogan to be taken literally. In earlier shots, the minimally decorated interior of the mansion had seemed no less cold and empty than elegant. But as soon as Joe and Maggie walk through its door, the mansion fills with rich *objets*: we catch sight of a large figurine and an expensive vase in the foyer, and then, as Maggie playfully acts the part of the "Mrs. Merrill" she will shortly become in real life, we glimpse a previously unseen tapestry as well as a statue beside her. Only when the lovers convey to the mansion the mobility in class and imagination that they had first exercised in the realm of mass commerce does *My Best Girl* license *aesthetic* riches to appear.

Mobility in *Citizen Kane*

What keeps the Cinderella plot of *Citizen Kane* from succeeding the way it does in *My Best Girl*? For one, the rich man and the shopgirl are more of a mismatch in *Kane* than in *My Best Girl*: Kane is Robert Merrill's age, not Joe's; his business career is at its height, not its start; he is already a husband and father; and Susan, the "dim shopgirl" (as Welles

would later call her), lacks any of the ingenuity or verve that in Maggie's case counterbalances her low social standing.[23] This greater incongruity between the lovers provokes a defensiveness about social mobility in Kane that Joe lacked. To justify his apparent mésalliance, Kane believes that he must disclose to the world Susan's previously hidden worthiness. "We're gonna be a great opera star," he tells a crowd of newspaper reporters shortly after the scandal of his romance breaks. And yet Kane's fantasizing of a "great" career for his shopgirl also links him to Joe, insofar as it leads him to employ, and, in employing, test the same method for legitimating social mobility that *My Best Girl* had dramatized—a redefinition of mass-market commerce as the revitalizing of the staid or stagnant status quo through childlike play.

The newspaper business had, after all, first appealed to Kane as an opportunity for "fun." And fun, in Kane's view, is essentially anarchic, whether it results in a "dangerous" assault on "American traditions," as the banker Thatcher claims, or in publishing false news stories, or simply in exercising creative license: "I don't know how to run a newspaper," Kane admits to Thatcher; "I just try everything I can think of." Consorting with a shopgirl first appeals to the now older and grander Kane as an opportunity for reviving this fun. But his amusements with Susan are a private affair, performed in her room, not, as in *My Best Girl*, in a stockroom where other store employees are conducting their business, let alone in the open streets. Once scandal forces the lovers to go public, Kane tries to reconcile his sense of moneyed dignity with his desire for play by insisting that Susan elevate her amateur singing into high art.

On its face, this art seems nothing like the imaginative mobility that Maggie and Joe put into play. Opera as Susan must perform it is weighed down by the pretentiousness of its foreign libretto, its rich and exotic trappings, its inaction. *Citizen Kane* measures the distance between opera and mass culture by showing us how even the loyal newspaperman Bernstein cannot help but fall asleep during Susan's premiere. A further source of Bernstein's boredom, of course, is Susan's lack of talent, which, as Kane himself admits when finishing Leland's review of her performance, "represents a new low." "I'm not high-class like you," Susan shrieks at Kane as she sits on the floor of an expensive hotel room, with Leland's review and others ("spoilin' my whole debut") spread out in scatterform before her. The attempt to prove that Susan can meet high cultural standards seems only to have humiliated and abased her.

Yet Kane's efforts at moving Susan from one world to another also recognizably draw on the freewheeling dynamism that the film associates with mass culture.[24] Again and again the movie spins into view the headlines of Kane newspapers that pretend Susan has launched a brilliant career for herself. Behind the scenes, even opera as the film presents

Susan and the newspapers

it involves the kind of frenetic activity we witnessed in Kane's newspaper offices. In both Leland's and Susan's recollections, stagehands and actors hastily crisscross the stage before the curtain rises, hoisting a comically outlandish mixture of props such as a stuffed crocodile and a sedan chair (which recalls the out-of-place bed frame we had seen tumbling into the newsroom with Bernstein). The opera, in short, is Kane's version of Joe's thrown-together throne, complete with the make-believe that licenses them both. But Kane's throne is far costlier than Joe's, drawing attention away from the lover's imagination as the source of the throne's magnificence to the richness-in-themselves of the throne's components. A second and related difference is the *aborted* motion of the opera—what one might call its overcomposition. Quickly raised, Joe's throne is just as quickly leveled when the truck that carries it suddenly brakes. Once the splendors of Susan's opera are in place, however, they prove so lifeless and inert that, by the second setting of the opera, the props surrounding her have become lavish pillows upon which her character will eventually faint or die. In the subsequent hotel scene, these pillows reappear as the scatterform of the newspaper reviews. The visual echo suggests that the mélange of objects on the opera stage amounts less to a rejection of mass culture than to a tragicomically sublimated image of it.

Susan and the pillows

The stately jumble of the opera also anticipates the far more bizarre omnium-gatherum of Xanadu, "a collection of everything," as the newsreel calls it, where Kane and Susan retreat after Susan's failed career and, ultimately, after the fall of Kane's newspaper empire.[25] Maggie and Joe had legitimated their cross-class love affair by representing it as the desirable marriage of mass-cultural creative license with high-cultural creative mastery. In Xanadu, however, which Kane is said to have built for Susan, the mésalliance manages only to generate further mismatches. Laura Mulvey characterizes Xanadu as "a mysterious landscape which the spectator cannot reconcile into a coherent picture." Focusing more precisely on the mansion, Robert Carringer describes Xanadu itself as a kind of scatterform. "In visual terms," he writes, "Xanadu is a compositional contradiction. On the one hand, there is a strongly unified sense overall—it is literally an image of a monument and literally a monumental image. On the other hand, the individual elements not only fail to cohere, but they are radically incompatible."[26]

The incoherence is more than the consequence of Kane's indiscriminate shopping. As the banker Thatcher's stark and severely disciplined archive shows us, a profusion of incompatible elements is no inevitable feature of a rich man's collection. The source of Xanadu's chimerical mixtures, it seems, is rather Kane's increasing distance from a mass

culture in which he nevertheless remains deeply invested. Even as he insists to Susan that "our home is here" in the "palace" of Xanadu, his imagination transports him, nostalgically, to the city newsroom, where the "bulldog's just gone to press."[27] This ever-widening internal division in Kane is reflected not only in the growing unhappiness of his marriage to Susan but also in the astonishing heterogeneity of Xanadu's interior decoration, so unlike Kane's previous mansions, where high art had far more tastefully dominated the scene. At the start of his newspaper career, Kane turned his office into his home; now, in Xanadu, he turns his home into a grotesquely distorted image of his office, reproducing the seemingly anarchic commotion there in the most unlikely fashion, with *objets* costly, recherché, and carefully arranged. In the terms of *My Best Girl*, Xanadu is the mansion *as* the store. The series of dissolves that establishes the jarring mismatches of Xanadu at the start of *Citizen Kane* recalls the series of dissolves from one pile of cheap mass goods to another that opens *My Best Girl*. One contemporary reviewer of *Citizen Kane* referred to "the assembled bric-à-brac of Xanadu"; part of what makes this assemblage seem so inexplicable is that it cannot be rationalized as either artwork on display or merchandise for sale.[28]

Carringer defines "the almost perverse juxtaposition of incongruent architectural styles and motifs" in Xanadu as "the Hearstian element,"

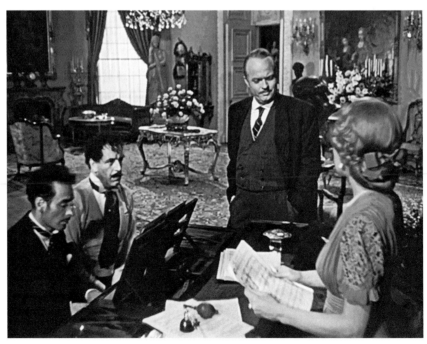

Kane's first home with Susan

and indeed this "theme" of bizarre mismatching regularly surfaced in contemporary accounts of Hearst's own über-mansions.[29] A 1935 article on Hearst in *Fortune*, for example, remarked again and again on the visual incoherencies of his home. More plainly than *Citizen Kane*, however, the article also linked these incongruities to the paradox of a rich man's immersion in mass culture. "On the priceless carpet at [Hearst's] feet," the article observes at one point, "there are spread six newspapers worth altogether from twelve to eighteen cents. They represent one week of newsgathering and editorializing by one of the twenty-eight newspapers this man owns, in one of eighteen cities in the U.S." The article's version of the scatterform simultaneously contrasts and connects the "priceless" *objet* of the carpet with a clutter of cheap, undifferentiated, interchangeable commodities that represent the national reach of Hearst's mass-media empire. At another point, the article remarks on the "wires" and "the telephones hidden away among priceless *objets d'art*" through which "Mr. Hearst talks and talks to every corner of the U.S." In this instance of the motif, the incongruity is "hidden" so that the article can charge Hearst with trying to deny the links between his mass-media business and his elite social standing: "The fact is that Mr. Hearst has made his money off the bourgeois world but he has treated it as if it came to him by divine right."[30] To the canny observer, the article suggests, Hearst betrays the pretentiousness of his mansion by the tokens of commercialism he cannot help scattering about it.

Citizen Kane modifies this critique of Hearst. Jumbling costly possessions together as if they were bric-a-brac, Xanadu *itself* expresses Kane's continuing ties to mass culture.[31] So, of course, does Kane's marriage to Susan. According to Leland, Kane had all along been attracted to a kind of allegorical potentiality in Susan: he had seen her as "a cross-section of the American public." Like Maggie to Joe, Susan also personifies the cheap goods whose real value Kane believes he has the imaginative generosity to uncover: in Leland's scathing terms, Susan is one of Kane's "precious under-privileged." Yet so powerfully alluring is the business of mass production and distribution to Kane that it competes with human attachments for his attention, as Kane's first wife, Emily, had sensed before Susan came on the scene: "sometimes," Emily had lamented in regard to her husband's newspaper, "I think I'd prefer a rival of flesh and blood." Though far less straitlaced than Emily, Susan lacks the plebeian dynamism that had enabled Maggie, and other shop-girls in similar movies, to satisfy and at the same time smooth over the seemingly disproportionate interest of their wealthy lovers in the five-and-dime world of mass culture.[32] The Cinderella plot fails in *Citizen Kane* because the mobility of objects proves more absorbing to Kane than the mobility of persons.

Rosebud Among the Statues

One might say that mass culture competes with Kane's wives not merely by rivaling them but also by undermining the notion of unique, irreproducible individuality on which his romances are predicated. When Kane's second marriage crumbles, the secondariness of personal relationships in his life seems spectacularly confirmed by his nostalgic realization that his one true love was not a wife, friend, or family member but a sled. Yet that sled, Rosebud, also appears to disprove the mass-cultural moral that any love object is substitutable for any other in Kane's life. A year after he attempted to pry Rosebud from the young Kane's hands, Thatcher had offered the boy an even fancier sled as reparation—and the boy had rejected this new plaything with disgust. Though a mere trifle by comparison to his wives or newspapers or palace, Rosebud seems to count, for Kane, as irreplaceable.

This strange double nature of Rosebud as a precious toy helps explain why *Citizen Kane* should reintroduce it in the bravura final tracking shot of Kane's collection, which, like Hearst's mansions, mixes the priceless with the five-and-dime. Here is how the shooting script for *Kane* imagines the scene: "A number of objects, great and small, are piled pell-mell all over the place. Furniture, statues, paintings, bric-a-brac—things of obviously enormous value are standing beside a kitchen stove, an old rocking chair and other junk, among which is also an old sled."[33] The first point to make about this jumble is the shocking indifference and even contempt with which Kane has treated the "things of obviously enormous value" he has collected. Susan had earlier complained about the seeming irrationality of Kane's paying "a hundred thousand dollars for a statue you're gonna keep crated up and never even look at." By throwing such treasures into crates that also hold bric-a-brac, Kane robs them of their distinctiveness not only in comparison to the bric-a-brac but also in comparison to each other, as if the aim of his collection were to give the treasures the same identicality with one another that marks mass-produced commodities. One of the few artworks to be singled out for comment in the closing sequence of the movie paradoxically exemplifies this depreciation of *objets* into an indistinguishable mass of "art stuff," as the reporter Thompson calls them. "What's that?" asks a second reporter about a headless statue. "Another Venus," replies a third as he ruefully contemplates the price tag. "Twenty-five thousand bucks: that's a lot of money to pay for a dame without a head."[34]

But if Kane's indiscriminate mixture of "the junk as well as the art" lowers *objets* to the level of the mass-produced, it has the opposite effect on the dime-store goods in his collection: it raises them to the level of the *objet*. "Throw that junk," the sardonic butler commands, gesturing

Rosebud just before it fills the screen

toward the pile with Rosebud in it, but the joke is on him: he could have made a thousand dollars from that sled if he had managed to differentiate it from the hodgepodge around him. The sled was never junk to Kane, of course, or rather, it was never *merely* junk: in the furnace of his imagination, where priceless art could substitute for bric-a-brac, a sled could also substitute for priceless art. Notoriously, *Citizen Kane* encourages its viewers to regard Rosebud the way Kane does, as a trivial plaything charged with "enormous value." Indeed, Rosebud as *objet* is only potential for Kane, who keeps it crated, yet it is actual for moviegoers, who see Rosebud first singled out from Kane's collection and then magnified, filling the screen.[35]

No art but in junk: that might be the credo for which Rosebud stands at the end of the movie.[36] But not just any junk will do: the same stake in medium specificity that helps generate this credo also suggests certain generalizable principles or conditions for identifying the kind of junk that works best as art. The first of these conditions is that the junk be mass-produced. Although Rosebud holds a talismanic power over Kane, the sled itself is not unique. As Welles pointed out in an early statement to the press, ' "Rosebud' is the *trade name* of a cheap little sled on which Kane was playing on the day he was taken away from his home and his mother."[37] When the young Kane rejected the sled that Thatcher tried to

substitute for Rosebud, he was not rejecting any and all other sleds: he was rejecting a sled with the wrong trade name, The Crusader. Mediating between the extremes of romantic singularity and commercial reproducibility was the *brand* of sled Kane loved. The film *Citizen Kane* was of course similarly branded, by its RKO label and by a title that stood not for a unique *objet* but for a mass-produced commodity.

The second condition that Rosebud appears to set for art-in-junk is that the junk be seen as a plaything before it can count as art. At the start of *My Best Girl*, toys spark a connection between the high-class Joe and the low-class Maggie by giving them a chance to demonstrate their shared capacity for imaginative play. Toys are especially effective for this purpose, the opening scenes of *My Best Girl* suggest, because they are so minimally interesting in themselves: it takes strenuous effort from Maggie, for instance, to inflate a saggy bit of plastic into a full-blown devil. If the value of *objets* depends, or appears to depend, on the quality of their artistic design, toys become valuable, it would seem, only when consumers invest them with significance. Welles was so taken by the notion of movies as opportunities for play that he perversely characterized RKO itself as "the biggest electric train a boy ever had!"[38] And from the start, he spoke of *Citizen Kane* as *under*designed, hence imaginatively open, "giving the audience the choice" of what to see and think.[39] Several early commentators agreed: for instance, Edward Tangye Lean argued that the movie allows us "to make our own selection" of data, and André Bazin maintained that the objectivity of the camera in *Kane* emboldens the spectator "to exercise his liberty and his intelligence."[40] The film invites this account of itself not only by offering multiple perspectives on Kane but also by making distinctions among playthings on the basis of their relative openness to imaginative investment. Susan's jigsaw puzzles, for instance, may require some concentration from the player in order to be composed into pictures, but the pictures are of course already composed before the player begins to work on them. The effect of this pre-design, the film implies, is to disempower the player. As in the earlier scatter-forms of Susan beside the cushions and Susan beside the newspapers, the shots of Susan beside her jigsaws always show her seated in a chair or else stretched out on the floor: thanks to their latent completeness, the puzzles demand next to no physical or imaginative exertion from her.

Yet if underdesigning is what separates good playthings from bad in *Citizen Kane*, why would a rock or stick not serve players better than a sled? In the opening scenes of *My Best Girl* and then throughout *Citizen Kane*, the junk that enables imaginative investment is also the junk that *encourages* such investment—the junk that is *manufactured* for play. Welles may have claimed that he avoided close-ups in *Kane* because their "use...amounts to forcing" the audience's perspective, but the camera

Maggie inflating a toy

Susan and her jigsaw puzzle again

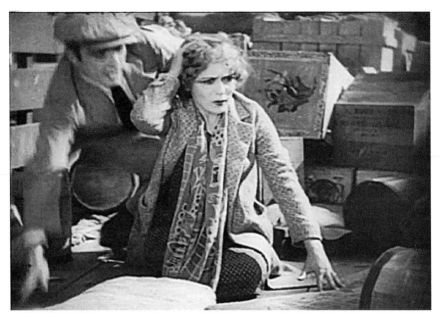

A rosebud on a crate from Maggie's throne

The cityscape of crates in Xanadu

always imposes a perspective on viewers.[41] By arguing contradictorily that *Kane* "forced" or "obliged" its viewers to exercise their free choice, both Lean and Bazin betray the difficulty of reconciling the apparent openness of *Kane* with its manifest designs on its audience. However marginally, the printing of a devil on a balloon or a flower on a sled builds aesthetic purpose into the toy. Indeed, the image of a flower figures in both *My Best Girl* and *Citizen Kane* as a kind of bare aesthetic minimum, a medium between natural objectivity and artistic subjectivity: we see it not only on Rosebud but also on one of the crates that go to make up Maggie's throne.

The form of Rosebud as a mass-produced toy suggests a third condition for the junk that can serve as art: it must also be designed to *move*. Revealingly, Kane comes to remember Rosebud when he is tearing Susan's room apart in a fit of rage after she has left him—as if throwing her things around has opened the mental space for Rosebud to return to him. Even Kane's art collection involves dislocation, the removal of *objets* from their original sites and what Benjamin calls their "embeddedness in the context of tradition."[42] The astonishing shot of Kane's crated possessions at the end of *Citizen Kane*—the climactic instance of the scatterform in the film—shows us how his artworks remain in a state of suspended motion even after he has accumulated them. Although the

The snow globe

shot reveals that Rosebud, too, is ready to move again, Kane never chooses to search for it; no longer usable for the old man, the sled stays crated. Instead, Kane fastens on the dime-store toy in Susan's room that first prompts his reverie for Rosebud: a snow globe, which we had initially glimpsed in Susan's old apartment, and which Kane now takes away with him. Not only is this object shown to be highly portable: it also has the spectacle of motion built inside it.

Although understandably overshadowed by Rosebud in the commentaries on *Citizen Kane*, the snow globe brackets our experience of Kane's life: we encounter it in the first and the last shots of Kane we see.[43] The globe also perfectly encapsulates the scatterform as the signature image of the film; indeed, it might almost seem too perfect a composition for the scatterform if it did not roll from Kane's hand and shatter at the movie's start, shortly after its snowflakes had been anticipatorily scattered across the screen.[44] Both the smallness and the fragility of the snow globe underscore the final condition for making art from junk in *Citizen Kane*: that the junk be *insubstantial*. In *My Best Girl*, Joe came to view the tattered decorations in his imaginary café as richer than the splendors of the Ritz. So Kane's costly *objets* come to mean far less to him than a "cheap little" plaything. The last we see of Rosebud in the film, it is in the process of being made more meager still, burning into

The snow globe's snowflakes scattered across the screen

twisted ash and then a column of smoke that blows across the night sky. This climactic burning replicates the introductory shattering of the snow globe by scattering another of Kane's toys across the screen.

The smoke of Rosebud at the end of *Citizen Kane* recalls one other early scene in the film: the bravura sequence in the newsreel screening room, where the smoke from the cigarettes and pipes of the newsmen made the light and shadow of the moving image almost palpable to us. What qualities, according to this sequence, do smoke and movies share that allow them to intermingle so dramatically? Ephemerality, for one.[45] "Kane's world now is history," the newsreel just informed us. By connecting this general sense of loss first to the transitory nature of the news cycle, then to the flickering movie image, and finally to fading tobacco smoke, *Citizen Kane* joins *My Best Girl* in acknowledging its own brief shelf life as a mass-market commodity.[46] Like *My Best Girl*, however, *Kane* also encourages us to view this perishability as a positive alternative to cultural stagnation. In the earlier movie, the lovers seize on toys, scraps, and cast-offs to restore vitality to the social as well as aesthetic order; their first home, again, is a crate emptied of the goods it once held.[47] Similarly, Kane seems to prize newspapers in part because they are cheap and readily discardable; even the sled and snow globe are commodities designed to be outgrown. The difference of Kane from Maggie and Joe is that his toys continue to attract him long after their planned obsolescence. The snow globe in particular exerts a visual power over him, and not merely because it recalls a long-lost childhood scene. It stands ready to restore vitality to that scene, by allowing its user to re-create the image of a scattering as natural and evanescent as smoke—a snowfall. This capacity for *replay* is the most salient point of connection between the snow globe and the film: "Stand by—I'll tell you if we want to run it again," the projectionist of the newsreel is told. Against the threat of rigidification, whose high-cultural emblem is the

Flames setting Rosebud in motion

Rosebud turned to smoke

Smoke in the newsreel screening room

statue, and of ephemerality, whose mass-cultural emblem is the newspaper, *Citizen Kane* sets the alternative of ephemerality preserved.

There are other models for this alternative in the film, such as Kane's art collection or Thatcher's archive, but not only does the snow globe have more kinetic potential than these: it is also smaller, and this second difference enhances the first. Even newspapers, as records of transitory events, seem unwieldy in comparison to the snow globe. And they generate stacks of garbage—which is how Welles described the scatterform of Kane's crated possessions at the end, as "the very dustheap of a man's life."[48] In large part, *Kane* asks us to see its reflection in a little piece of junk like the snow globe so as to highlight the *immateriality* of film, which makes movies easier to move, like dust rather than crates, and which therefore helps rescue movies from the deadly pretentious overcomposition of "art." Attempting to rise to an elite aesthetic standard that it simultaneously represents as a thing of the past, *Citizen Kane* depicts film as an *objet* that is barely an object at all.

Epilogue

THE AUTHOR OF MASS ENTERTAINMENT

I might play a small role, maybe an emperor or somebody like that.
—Charlie Chaplin on a new film project (1967)

"One man, one film": that was Frank Capra's motto as a director. When he was working on a movie, as he pugnaciously declared in his 1971 autobiography, *Frank Capra: The Name Above the Title*, "things had to be done my way." His point was not simply that he demanded full control over the films he directed: it was also that these films could never amount to anything unless he took full control of them. "Year in, year out," he insisted, "it is the creators who strive for quality, the 'one man, one film' artists, who out-succeed the industrially oriented mass producers." The mass producers, in Capra's mind, were his counterparts at the big Hollywood studios, assembly-line directors such as Lloyd Bacon at Warner Bros., who had churned out twenty-six talkies by the time he began filming *Footlight Parade* in 1933 and would complete more than thirty others before the decade was through. Such "organization" men, Capra claimed, were "as anonymous as vice presidents of General Motors," and in some respects film history has borne out his assessment.[1] There are no biographies of Lloyd Bacon; *Footlight Parade* is far more likely to be remembered today for the contributions of its lead actor, Jimmy Cagney, and its assistant director, Busby Berkeley, than for Bacon's stewardship overall.[2] Yet the power of these collaborators to make *Footlight Parade* seem memorable also obviously weakens Capra's auteur theory of moviemaking. "Everyone else in the world knows that film is a collaborative medium," the screenwriter David Rintels wrote in exasperation with Capra in 1977. "It can never be one man one film until one person figures out how to conceive, produce, write, direct,

edit, score and play all the parts himself, until he pays for it and lights and shoots it and moves and paints the scenery, and does it all in a closed room, taking suggestions from no one." According to Capra's biographer Joseph McBride in 1992, Capra was so incapable of doing "justice" to his collaborators that he couldn't even bring himself to acknowledge the people who helped him write his autobiography.[3]

Such claims and counterclaims have lost much of their urgency now. As Robert Sklar recently observed, "The thirty years' war over authorship in film culture, fought from the 1950s through the 1980s, may seem as remote in retrospect as the original Thirty Years' War of the seventeenth century." And yet the debate is in reality far older than most film historians acknowledge. Although the earliest of the thirty-two pieces reprinted in Barry Keith Grant's 2008 Blackwell reader *Auteurs and Authorship* is a 1954 essay by François Truffaut ("it all began with François Truffaut's manifesto," Grant asserts), the doctrine of "one man, one film" was already standard fare in film criticism by the 1920s.[4] In 1926, for instance, the future director of the film department at the Museum of Modern Art, Iris Barry, asserted in her *Let's Go to the Movies* that "every good film must have the impress of one mind and one mind only, upon it." Two years later, Frances Taylor Patterson contrasted the few "one-man pictures, conceived in greatness and executed with vision," to the "hundreds" of potboilers churned out by "the huge producing plants." The reason that "so few films of the last fifteen years are worth preserving," John Gould Fletcher similarly claimed in 1929, is that most of them "are the product not of a single mind, but of many minds."[5] Opposition to this auteur theory was also common. The title page of Austin Lescarboura's 1919 *Behind the Motion-Picture Screen* promised to show *How the Scenario Writer, Director, Cameraman, Scene Painter and Carpenter, Laboratory Man, Art Director, Property Man, Electrician, Projector Operator and Others Contribute Their Share of Work Toward the Realization of the Wonderful Photoplays of Today*. In 1923, Tamar Lane called the director "the spoiled child of the motion picture world" who "gets practically all of the credit for the success of a production when, in many instances, he deserves little or no credit at all." Buster Keaton satirized the "one man, one film" approach in his 1921 comedy *The Play House*. "I played all the parts" in the movie, he later recalled to Kevin Brownlow: "With double exposures, I'm the whole orchestra, I'm the people in the boxes, in the audience, on the stage. I bought a ticket from myself—I'm the ticket-taker taking a ticket from myself." As one Keaton incarnation in *The Play House* puts it, "This fellow Keaton seems to be the whole show."[6]

Keaton explained to Brownlow that he "was deliberately kidding most of the guys in motion pictures" with his comedy, especially the

filmmaker Thomas Ince, whose "mania for recognition," as the film historian William Everson called it, led Ince sometimes to "take the full directorial credit" for films he produced, sometimes to "'share' the credit, with the real director reduced to second billing," and sometimes to "release the film with no directorial credit, but with his own name appearing so prominently in the titles of the film that one could only assume that he was the sole author"—for example, "Thomas H. Ince presents A Thomas H. Ince production...supervised by Thomas H. Ince." According to Brownlow, Keaton felt free to mock Ince because Keaton himself "viewed credits with indifference." Yet Keaton admitted to Brownlow that his satire in *The Play House* had left him in an awkward position: "having kidded" others for taking too much credit, he "hesitated" to take the credit that was rightly due him.[7] Or so he claimed: there is not much of this hesitation on display in *The Play House*. "Joseph M. Schenck Presents 'Buster' Keaton in The Play House," reads the film's first title card; "Written and Directed by 'Buster' Keaton and Eddie Cline,'" reads the second; and then for the next six minutes of film time, we see no one else but Keaton on the screen. Keaton may not be the whole show in *The Play House*, but he is most of it, and his ambivalence about saying so indicates how the auteur controversy could rage not only between early film commentators but also *within* one.

Ince, long forgotten, was an easy target for satire in the 1960s, when Brownlow interviewed Keaton; a harder one was the obvious model for Keaton's own career as a writer, actor, and director—Charlie Chaplin.

The many Keatons of The Play House

When Graham Petrie in his 1973 "Alternatives to Auteurs" categorized directors "according to the degree of creative freedom they can reasonably be assumed to have enjoyed during the most important periods of their careers," he argued that "only *Chaplin* truly belongs" in the first category of "Creators": "he is the only figure in the history of the cinema to have been able to make *all* his feature-length works exactly as he wanted to make them and to release them without interference or alteration to the finished product." Even Capra's adversary Rintels conceded the title of auteur to Chaplin: "Who could quarrel with…saying that 'City Lights' was Chaplin's?"[8] Rintels's choice of *City Lights* (1931) as the quintessential Chaplin film is revealing. Chaplin had written, directed, and starred in many other films before this one, although *City Lights* was the first that he also scored (with help).[9] Virginia Cherrill, who played the flower girl in the movie, recalled that Chaplin "acted out every part" in rehearsal, but this too was his standard practice: during rehearsals for a prologue to his 1923 *A Woman of Paris*, for instance, Chaplin "was all over the room, acting the parts of the prologue actors, making them live the parts as he showed them."[10] What differentiated *City Lights* from Chaplin's earlier work and made it appear so distinctively the achievement of Chaplin only was his dogged refusal to release the film as a talking picture, years after the rest of Hollywood had converted to sound. In a contemporary review of *City Lights* that praises Chaplin as "the only one" of Hollywood's directors "who has broken free from the herd," Paul Rotha cited Chaplin's indomitable self-reliance as the quality that had enabled him to achieve true greatness with *City Lights*, a movie that Rotha regarded as unmistakably "the outcome of a single mind."[11]

"Chaplin has always been a law unto himself," one nervous Hollywood executive maintained about the success of *City Lights*. Even more than Capra, Chaplin cultivated this image of himself as the sole creative force behind his films. In Chaplin's own autobiography, as his biographer David Robinson notes with dismay, Chaplin failed to "make even passing reference to loyal collaborators who had given so much to the films; people like [Rollie] Totheroh, [Henry] Bergman, Mack Swain, Eric Campbell or Georgia Hale." "Of course I do everything," Chaplin assured an interviewer in 1957. "I create the whole thing. A film isn't just a product of mass productions to me. I'm an individualist." But not even Chaplin claimed that he did everything *alone*. While the first two title cards of *City Lights* credit Chaplin exclusively as the movie's writer, director, and star, the next title card acknowledges the work of two cameramen and three assistant directors, along with several other collaborators. In a 1930 newspaper article on Chaplin's progress with *City Lights*, Elena Boland struck the usual chords when she declared that Chaplin's "unique" studio "might almost be called 'the one-man studio,'" because

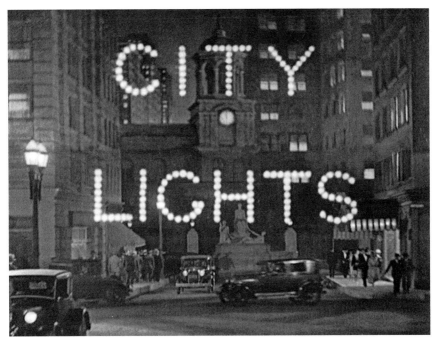

Title shot of City Lights

its "lord and master" exerted such complete control over it. But she also noted that Chaplin's "faithful crew" at the studio consisted of "forty-five" employees, and that when Chaplin "gets an idea," "three" of these "colleagues" accompany him "to an old dressing-room on the lot and talk story backward and forward until it is fashioned." Further complicating the picture of Chaplin's singularity was Boland's report that "at times" the set of *City Lights* was "filled with hundreds of extras, motor buses, cars, traffic policemen and all that goes to make a civic thoroughfare."[12] If Chaplin himself thought of his studio as a "one-man" affair, why would he build "a civic thoroughfare" inside it? If he regarded his film as "the outcome of a single mind," why would he title it *City Lights*?

In his autobiography, Capra seized on the memory of a growing rift between himself and his screenwriting partner Robert Riskin to highlight what he regarded as the director's distinctively social relation to film production. Riskin, Capra recalled, "thought I was getting too much credit for the Capra films, and he, too little," so Capra encouraged Riskin to direct his own film. The results were "disappointing." Riskin "had all the required talents of a filmmaker," Capra concluded, but "the bedlam of film production got to him. Evidently he was his sharpest and most creative when writing alone in the quiet of his thoughts." Riskin's failure underscored for Capra how his own success as a director depended on "the capacity to do one's best under pressure." "And that," he decided,

"was why I loved being a film director—I was at my best in a crowd." Chaplin, Petrie's best-case candidate for auteur status, sought far more independence from his coworkers than Capra did: on the set of *Modern Times* (1936), as his son Charles recalled, Chaplin "was the writer, the producer, the director, the chief designer, the composer, the film cutter, the makeup man. He was everything." But to play all the parts this way was to *become* a crowd, as Keaton's *Play House* suggested. Charlie junior called his father "many men in one."[13]

This notion of the mass-entertainment auteur as singularly social is not only older than Truffaut: it's older than the movies. For centuries, Shakespeare has been celebrated as incomparably "myriad-minded," and in my book *Shakespeare Only* I connected the seemingly infinite variety of Shakespeare to his no-holds-barred embrace of the Renaissance English theater, with its arena-like playhouses, its large mixed audiences, its companies of professional actors, and Shakespeare's unusually multifaceted theatrical career as a performer, a dramatist, and a part owner of his acting company and playhouses. Shakespeare's immersion in mass entertainment made him wildly popular in his own day, but it also provoked attacks on the exorbitance of his ambitions and the incoherence of his dramaturgy. The earliest surviving reference to Shakespeare as a theatrical professional (1592) ridiculed him for thinking of himself as a kind of one-man theater, "the only Shake-scene in a country," when his egomaniacal desire to play all the parts had actually reduced him to the status of a "*Johannes fac totum*," a jack-of-all-trades.[14] Even an admirer such as John Dryden felt uncertain whether to praise Shakespeare for possessing the "most comprehensive soul" of any writer or to blame him for the indiscriminancy of his writing. "Never did any Author precipitate himself from such heights of thought to so low expressions, as he often does," Dryden maintained; "he is the very *Janus* of poets; he wears almost everywhere two faces: and you have scarce begun to admire the one, ere you despise the other." In his sonnets, Shakespeare himself acknowledged the unruliness of the "public manners" that his profession had bred in him. He had made himself like the crowd in order to please them—he had become "a motley to the view." Contemporaries nevertheless extolled him as a king of poets, and Shakespeare aggressively pursued that title throughout his career, but he also habitually likened himself to a *degraded* lord and master: to Prince Hal, for instance, who both cheapens and ennobles himself by mixing with "vulgar company," or to Prince Hamlet, who is both "lov'd of the distracted multitude" and also "punish'd / With a sore distraction."[15]

In what follows, I'll focus on Chaplin's even more contradictory attempt in *City Lights* to think about his preeminence as a mass entertainer through his abjectness as the tramp. I'll begin by comparing the

opening and closing sequences of *City Lights* in order to highlight the specifically urban aesthetics that connect the statuary displayed for a crowd at the start of the film with Chaplin's close-up on himself at the end. I'll then turn to the sociological tensions in Chaplin's self-portrayal that could lead contemporaries such as Waldo Frank (1929) to describe him, incongruously, as both a "pure individualist" and "a man of the people."[16] To conclude, I'll match Chaplin with a more comparably multitalented mass entertainer than Capra, whose failure to act in his movies weakened his one-man one-film theory. The actor-writer-director Orson Welles will help me highlight the fundamentally compromised position of the author in mass entertainment, who can never securely distinguish his achievements from either surrendering to the crowd or else betraying it.

Chaplin in the City

City Lights takes us from a long shot of Chaplin at the start of the movie to a close-up of him at the end. "If I have a rule," Chaplin said about his filmmaking in a 1967 interview with Richard Meryman, "it is that I like orientation first—the camera way back." What orientation means in *City Lights* is that we initially see Chaplin singled out and elevated atop a monument, but we also see the crowd that witness him there—and they have gathered to watch the unveiling of the monument, not of him. This first view of Chaplin enables us to share the crowd's perspective on him: our distance from him makes him look incongruously small and dark atop the huge white statuary. Over the course of the opening sequence, however, the camera moves "progressively closer" to Chaplin, as Lisa Trahair has noted, "to shift the film audience's position from distant theatrical onlooker to cinematic viewer intimately engaged in the amusing details of the travesty."[17] Seeing more of Chaplin means seeing less of the crowd. By the end of *City Lights*, the camera provides us so intimate and exclusive a perspective on Chaplin that his face alone seems to fill the screen. "The theme of the Chaplin picture," wrote Waldo Frank, "is Chaplin himself."[18]

Critics such as Jonathan Goldman would insist that the man we see at the end of *City Lights* is not Chaplin at all, but rather a fictional character he portrays, the Tramp. According to Goldman, "Chaplin's films exhibit a distrust, if not actual rejection, of the idea than an image can embody the author." No image can ever embody anyone, of course: it's always an illusion that we ever see anyone on film. Conversely, Chaplin himself maintained that a film character was never entirely separable from the actor who played the part: in the Meryman interview, Chaplin

Chaplin as the tramp on the monument

Chaplin as the tramp in the final shot

Redmond as sculptor (next to the microphone)

described the task of "pretending to be someone else" as "a profound exposé of one's personality" that leaves the actor "vulnerable every moment." *City Lights* asks us to be on the lookout for its author even before Chaplin as tramp is revealed to us, when we catch a glimpse of the artist who sculpted the monument that will be shown to hold the figure of the movie's director and star. Neither the credits nor the title cards of *City Lights* identify this artist, and, though he sits on the podium before his artwork, he is inconspicuous there, always to one side of the frame. Critics describing the scene often fail to mention him. Robinson writes that "a stout civic dignitary and a hawk-like club woman make speeches, and the monument is unveiled," yet the wealthy woman also introduces a third person, who rises, mouths "thank you" three times, and then sits again.[19] The guess that this third dignitary must be the monument's creator seems more likely once we learn the identity of the man who played him: Granville Redmond, at the time a highly regarded Californian painter.[20]

If in one respect it seems entirely fitting for Chaplin to have cast this artist as the sculptor of *City Lights*, in another respect the choice appears perverse, because Redmond's art was nothing like the cold, white, super-human statuary of the civic artist he portrays. Redmond painted vibrant landscapes, the majority of them with no human figures at all. (The example I offer in color plate 1 is a Redmond painting from the same

year that *City Lights* was released.) "In such pictures," an art critic
enthused in 1933, "he makes us feel alone with nature in a Miltonian
mood." Max Eastman later wrote that Chaplin's "idea of heaven" was
"seclusion from the world with solitude"; and Chaplin was so impressed
by Redmond's ability to "paint solitude" that for many years he gave the
artist space to work inside his own studio. Here, in this "studio within a
studio," the *Los Angeles Times* art critic Antony Anderson reported in
1922, Redmond was able to find "a haven for rest and work, a safe
retreat from the turmoil that beats around him." Another journalist,
Alice Terry, wrote in 1920 that Chaplin found his own safe haven in
Redmond's studio. "When Chaplin wants to rest," Terry claimed, he
"will sit for hours, watching the artist, enjoying the silence." Adding to
the mood that Redmond loved to paint was the silence in which he
painted. Terry noted that Redmond helped rescue Chaplin "from the
fuss and babble of human tongues" because the painter was a "deaf-
mute." Physically as well as stylistically, then, Redmond seemed to pro-
vide Chaplin a compelling image of the artist as individualist, alone in
the heaven of his solitude. "Sometimes," Chaplin confided to Terry, "I
think that the silence in which [Redmond] lives has developed in him
some sense, some great capacity for happiness in which we others are
lacking."[21]

And yet of course Redmond had chosen a peculiar spot for his seclu-
sion from turmoil—a Hollywood film studio, where he did more than
paint: by the time he appeared in *City Lights*, Redmond had been acting
in movies for over a decade.[22] On occasion, Redmond maintained that
he needed such immersion in the society of "hearing people" to combat
his feeling that he was "cut off from the world, on account of not being
able to hear or speak." But at other times he admitted to "regret" that
he "could not put as much concentrative force into my art as I would
like to, due to [the] environment at the studio." "My soul is cramped in
a city of nervous tension," he confessed to his sister in 1934. While
Chaplin's admiration for Redmond helps explain why he would choose
Redmond to play the artist whose work in *City Lights* first discloses
Chaplin to the crowd, Redmond's discomfort with "the distracting
vibrations of the movie world" also helps explain why his part so quickly
fades from the film. Although Chaplin may have shared Redmond's fan-
tasy of creating in solitude, he had more resources at his command than
Redmond did to achieve "concentrative force" *inside* Hollywood. *City
Lights* marks Chaplin's dissociation from Redmond as well as his iden-
tification with him by emphasizing that Chaplin's silence in the picture
is self-imposed. The words we hear most clearly in *City Lights* are the
ones that Chaplin himself dubs for the deaf-mute Redmond—satirically,
through a kazoo.[23] With this disquieting note of difference between

Redmond and Chaplin in mind, the stony immobility of the sculptor's monument appears to signify more than an ironic contrast with Redmond's actual artwork: it also suggests that Redmond lacks the aesthetic as well as physical flexibility that Chaplin displays as he ludicrously negotiates his way down from the monument. Above all, Redmond as artist orients us to Chaplin by helping Chaplin underscore his own greater capacity for tolerating exposure to the public eye. Early in Redmond's film career, a friend of the painter had expressed his dismay at the degrading circumstances to which he felt Redmond had been reduced: "So he is in the movies with Chaplin. Fancy the idea. What a horrible contrast." Chaplin attributes a similar highbrow sensitivity to Redmond's sculptor, who sits in the company of wealthy patrons on a podium that removes him from the crowd, and who behaves so diffidently in relation to the crowd that he can barely address them. Redmond as the sculptor is shocked to see the tramp desecrate his art and distract the crowd's attention from it.[24] Yet Chaplin as the tramp manages to retain his self-possession even in the face of public hostility and ridicule.

For some commentators, Chaplin's antic behavior on the monument signals his desire to differentiate himself not only from the high art of the monument but also from any claim to being an artist himself. Noting how the tramp ruins the elevated mood that the dignitaries were trying to establish with their ceremonial blather about the monument, Richard

Redmond running a saloon in Chaplin's A Dog's Life *(1918)*

Ward concludes that "Chaplin the filmmaker is thumbing his nose at those with artistic pretensions." Contemporary pundits regularly condemned such philistinism among Hollywood's moviemakers, who "feel that they must climb down to the lowest level" of the "public," as Robert Sherwood complained in 1923, "if they are to cater to it in an inclusive way."[25] But Chaplin's climbing down from the monument to the level of the hoi polloi does not amount to a rejection of art per se. The next sequence of *City Lights* guides us from the grotesquely stark, stiff, and oversized statuary of the monument to a smaller and more vibrant version of its central female figure—to art on a more human scale. In this second sequence, Chaplin as tramp happens to glimpse a lifelike statue of a naked woman through an art shop window. One joke here is that the desecrator of art has now become its connoisseur. Changing places with the privileged art-lovers in the opening sequence, the tramp adopts a highbrow posture of cool, discerning appraisal toward the statue that is satirically undermined first by his threadbare clothes, then by his sexual attraction to the naked figure, and finally by the sidewalk freight elevator just behind him that repeatedly threatens to engulf him. The other joke is that no one but the tramp seems to be interested in the statue. Although it is enclosed behind a window, the statue is nonetheless displayed to the city as the monument was, and plenty of possible admirers stream past it in the city's traffic, yet only the tramp takes

Redmond (r.) as sculptor in shock (with hand to mouth)

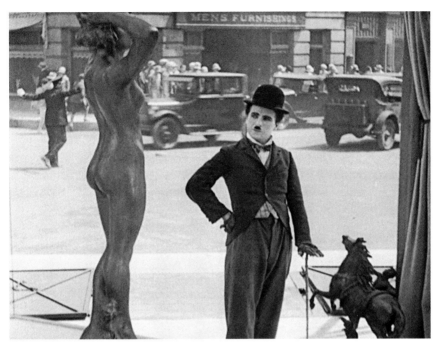

The tramp and the statuette

notice. With nowhere in particular to go, he becomes a mock version of the gentleman who has the time and resources to appreciate art. But this leisure is quickly terminated by the dangers to which the busy street exposes him.

In the third sequence of the film, the erotic sculpture that had superseded the funereal statuary of the monument is itself replaced by an even more lively art. This time the tramp happens upon an actual woman, a flower girl who sits to one side of a street amid heavy traffic, and once again he is the sole passerby who takes notice of her. Though beautiful, she captures the tramp's attention because she can call to him, as statues can't. Even so, his interest in her is limited until he realizes that she mistakes him, gratifyingly, for the gentleman he had impersonated before the naked statue. But his attraction to her is cemented by his further realization that she is blind. Pretending to walk on, he returns to gaze on her uninterrupted by the conversation he had been having with her. As they both sit in silence, he seems rapt by the sight of the disability that has cut her off from the world. Chaplin later recalled how he directed Virginia Cherrill to feign blindness: "I instructed her to look at me but to look inwardly and not to see me."[26] What arrests the tramp in contemplation of this new female figure is the appearance her blindness gives her of seeming to be engrossed in a contemplation of her own. An

absorbing artwork, the sequence thus implies, is one that models the absorption with which it should be appreciated. But since absorption means loneliness, for both the blind girl and her admirer, its dramatization in the scene would also seem to mark a fundamental difference between the girl as aesthetic spectacle and the civic art of the monument. The girl had been introduced to us by an image of flowers that yielded to the image of her face, as if her loveliness belonged more properly to a Redmond landscape than to an urban streetscape. The tramp's subsequent attention to her is once again conspicuously set against the distracting vibrations of the city. Whereas a crowd gathered to notice the monument only on the special occasion of its unveiling (in no later scene do we witness anyone so much as glance its way), the tramp returns again and again to a sight that he alone finds absorbing.[27]

Walter Benjamin famously criticized the aesthetic theory that these opening sequences of *City Lights* thus seem to be dramatizing: the "commonplace" notion, as Benjamin put it in his "Work of Art" essay, "that the masses seek distraction, whereas art demands concentration from the spectator." For Benjamin, the concentrative ideal of art appreciation was a relic of much earlier times—of ancient cult worship, in fact—and he rejected it not only as archaic and elitist but also as continuing to demand a sacrifice from the viewer. When Benjamin asserted that "a person who concentrates before a work of art is absorbed by it," he meant

The flower girl seemingly lost in thought

The flowers that introduce the flower girl

that the artwork absorbs the agency of its admirer, as an "idol" does. According to Benjamin, such alienating abjection to art had been abolished by the technological reproducibility that had liberated both the artwork and the beholder from cultic reclusion. Now, Benjamin argued, spectators could find strength in numbers, and exchange the "attentive observation" of the devotee for the more "casual noticing" of the crowd, whose *lack* of concentration "encourages an evaluative attitude" in the beholders while also freeing their minds "to perform new tasks of apperception." No longer cultish and servile, spectatorship had (in Benjamin's view) become communal and insouciant: rather than allow the artwork to absorb them, "the distracted masses" now "absorb the work of art into themselves."[28]

To a certain extent, *City Lights* shares Benjamin's views on the costs of solitary, reclusive art worship. The tramp's absorption in the statuette nearly subjects him to a disastrous accident; then, after meeting the flower girl and becoming absorbed in her, he proceeds to undertake sacrifices of increasing severity for her. In the final sequence of the film, his self-abnegating transferral of resources to his idol is shown to have cured her blindness and established her in a comfortable flower shop while at the same time leaving him poorer and lonelier than ever. When he next encounters her, the tramp catches sight of the flower girl the same way he had earlier glimpsed the naked statue—at a remove, through the class as well as glass barrier of her shop's window. But *City Lights* does not end with this division. Rather than choose between Redmond's ideal of absorption and Benjamin's ideal of accessibility, the finale of *City Lights* goes on to blend these seemingly antithetical principles and, in the process, to clarify the point of Chaplin's orienting depiction of Redmond as sculptor at the start of the film: when Chaplin brought Redmond out of the studio and into the city's streets, he meant to bring Redmond's aesthetics there as well.

The final sequence begins with our own view inside the flower shop, where we find that the flower girl's new ability to see has not entirely

The tramp absorbed by the sight of the flower girl in her shop

released her from the alienated isolation that so fascinated the tramp. After speaking with a handsome, well-heeled customer whom she momentarily hoped might be her benefactor, the flower girl returns to her old blind look of "absorption," as the critic William Rothman terms it. "Oblivious to the world we view through [her shop] window, the busy street with its traffic and its pedestrians going about their business," she becomes "absorbed," Rothman emphasizes, "in her floral arrangement and her dream."[29] What draws her out of her dream is the reappearance of the tramp, whom she has never actually seen before. At first the flower girl looks on him as nothing more than a comic spectacle, but once she steps outside her shop to reward him for amusing her, her perception of him changes, and she is stunned to recognize this homeless nobody as her special friend and lover. Rothman implies that the flower girl thus leaves behind the enclosed world of her absorption as well as her shop, but in fact her concentration is now being directed outward to the tramp: she becomes absorbed in the sight of him, as he had been absorbed in the sight of her. It is a *public* absorption—more social, indeed, than the tramp's had been, because when he had studied the naked statue and then the flower girl, he had gazed, voyeuristically, at spectacles that could not return his scrutiny. But the flower girl now gazes at someone who gazes back at her, who is absorbed in the face that is absorbed in him.

The flower girl lost in thought

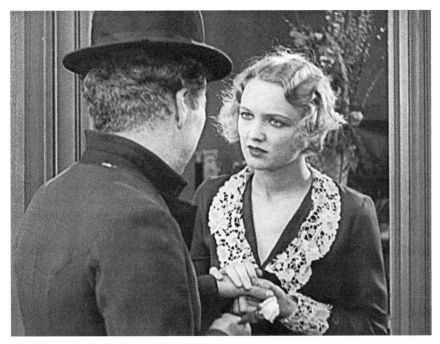

The flower girl absorbed by the sight of the tramp

The flower girl's concentration on the tramp has the further social dimension of coloring our own perception of Chaplin. The scene effectively unveils the tramp for a second time in the film, although this disclosure is far more intimate and emotionally laden than the one at the monument had been.[30] As we gaze at the tramp from the flower girl's "point of view," Rothman argues, we, too, come to understand that we are meant to recognize his true identity: we see him now as "the film's author," "who stands exposed in this frame, revealed in his mortality and his desperate longing to be loved." When recounting to Richard Meryman how he had filmed this final sequence with Virginia Cherrill, Chaplin similarly presented the climactic close-up on the tramp as a revelation of the director in the character. But he linked that revelation to the *reciprocal* gazing between the flower girl and the tramp, to what one might call their *inter*-absorption:

> I had had several takes and they were all overdone, overacted, overfelt. This time I was looking more at her, interested to see that she didn't make any mistakes. It was a beautiful sensation of not acting, of standing outside of myself. The key was exactly right—slightly embarrassed, delighted about meeting her again—apologetic without getting emotional about it. He was watching and wondering what she was thinking and wondering without any effort. It's one of the purest inserts—I call them inserts, close-ups—that I've ever done.

It's when Chaplin describes how the tramp returns the gaze of the flower girl that the "he" of the character ("he was watching and wondering what she was thinking") merges seamlessly with the "I" of the director ("I was looking at her, interested to see that she didn't make any mistakes"). Chaplin becomes two people, as if "standing outside" himself, when he recalls how the closing shot of *City Lights* captured him as both seeing and seen.[31]

At the end of this final sequence, our own point of view on Chaplin actually differs from the flower girl's, no matter how much her response to him may affect ours. We don't gaze at him through her eyes: rather, we see him from a third perspective, belonging to no character in particular, and positioned closer to the street than the tramp and flower girl are.[32] This side view is a conventional feature of the shot-reverse-shot in Hollywood films, but Chaplin orients us to the convention through a medium shot on the tramp and flower girl that establishes the more intimate views of them as following sightlines that might belong to any passerby. Refusing to present himself from within a closed world of inter-absorption between the tramp and flower girl,[33] Chaplin in the final

close-up opens the sight of himself to the street—the tramp's true home, as the film's first scene had indicated, and the public space to which he'd drawn the flower girl after she first caught sight of him.[34] Why does Chaplin want us to regard the climactic close-up on him as a specifically urban spectacle, illuminated by city lights? On the one hand, Chaplin seems to believe that the bustling city *tests* our powers of concentration, and in so doing helps us recognize and appreciate these powers, which differentiate us from the passersby who blindly overlook the drama unfolding before them. On the other hand, Chaplin seems to believe that the city can *encourage* our concentration, by providing us with models for how to focus our attention amidst distraction. In the final close-up, we become absorbed in a face (the tramp's) that's absorbed in a face (the flower girl's) that's absorbed in a face (the tramp's). Without these captivated and thus captivating models, *City Lights* suggests, we might not see how to see. Just as the flower girl comes to recognize the tramp by reversing the terms of their first encounter and placing a coin in his hand, which is to know him by occupying his subject-position, so, it seems, we are now supposed to gaze on Chaplin with the absorption that he has trained us in and that he continues to exemplify here.[35]

Even before he descended from his lofty perch on the monument, Chaplin as the tramp had begun to redefine the image of art in the film by lending his own power of sight to the monument's otherwise sightless

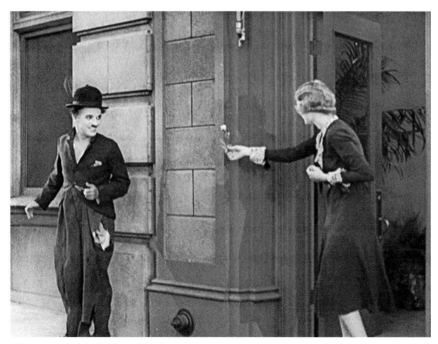

The tramp and the flower girl in the street

The tramp gazing from the monument

human figures. Through his mediation, the object of the crowd's attention grew capable of returning their gaze: it was with a vision of this audience, indeed, that the tramp himself had first come to consciousness. In the second sequence of the film, Chaplin continued to thematize the collapsing of the difference between art and audience when he switched positions with the crowd, becoming the observer rather than the observed. Now, by ending the film with the spectacle of himself as spectator, Chaplin implies that the audience too can become an absorbing sight to see—if *City Lights* can succeed in fashioning them into the kind of observers that the tramp and flower girl model for them.[36] Commenting on the interabsorption of the tramp and the flower girl, Rotha bore witness to its power not only to engross moviegoers but also to turn their own gaze inward as Chaplin had instructed Cherrill to do: "Then, as his expression is still that of hope as she looks at him with confusion, we slowly fade to a dark screen with a close up fixed in our minds that is amongst the few to be remembered for ever."[37]

Man of the People

The orienting vision of art, artist, and audience in the opening sequence of *City Lights* offers sociological as well as aesthetic guidelines for

1. *Redmond's "Spring in Southern California, 1931." Copyright © 2013 Bonhams Auctioneers Corp. All Rights Reserved.*

2. *The pitiable tramp.* The Gold Rush © *Roy Export SAS.*

3. *Capra's name above the title. Mr. Smith Goes to Washington © 1939, renewed 1967 Columbia Pictures Industries, Inc. All Rights Reserved. Courtesy of Columbia Pictures.*

4. *Welles as "The 'Four-Most' Personality." Licensed by Warner Bros. Entertainment. All Rights Reserved.*

understanding the rest of the film. "To the people of this city we donate this monument; 'Peace and Prosperity,'" reads the first title card of the movie. Art for the people is art about the people, and the monument in its lifeless immobility represents peaceful and prosperous citizens as above all orderly citizens, who are meant to appreciate the artwork they have been given with the same reverent standing-at-attention we see them display when they hear the national anthem. Chaplin as tramp ruins this ideal of urban spectatorship by his very presence in the city, which constitutes a denial of its prosperity, and whether the crowds gathered around the monument erupt in cheers or jeers, they are thrown into commotion at the sight of him. A "blot" or "stain" on the statuary, as Slavoj Žižek describes him, the little tramp also disrupts the monumental depiction of the people as heroically proportioned and immaculate. In moving closer to him, the camera declares its artistic allegiance to a vision of the city that differs from the one the monument perpetuates. "People laugh at us, and some of our productions are dreadful enough, I'll admit," Chaplin told an interviewer in 1925, "but I contend we are opening people's eyes, and not only to the delight of the eye. Why, the movies are the beginning of a keyhole into the way the other half of the world lives: people one hasn't seen, ways, conventions, wastes and savings, graces and disgraces, hearts one does not know!" At the movie's end, the close-up that Rotha believes will be forever fixed in his mind is the image of a man who is desperately poor.[38]

"Any person today can lay claim to being filmed," writes Benjamin with egalitarian satisfaction. While Chaplin may have shared Benjamin's faith in the power of movies to open our eyes to the totality of human life, *City Lights* suggests that he lacked Benjamin's optimism about the revolutionary potential of such inclusiveness. The final close-up of the film absorbs us in the sight of a homeless man without reassuring us about his future. At the same time, the bourgeois flower girl who might represent our own possible connection to "the other half" has just had her hopes for the future shattered too. Cured of her blindness, she is now able to see her hero's destitution, as he can witness her disillusionment, and this persistence of deprivation for both characters matches the persistence of our deafness to their interactions—a disablement exaggerated by the anomaly of the film's silence in an age of talkies.[39] Many critics, notably Robert Warshow (1954) and David Thomson (1975), have accused Chaplin of perversely imposing such hardships on his characters and his audience. In Thomson's view, "it was only petulance" that made Chaplin "resist sound" until after *City Lights*, and, for Warshow, the same childishness that "imprisoned" Chaplin "within the limits of his own needs and understanding" also distorted his representation of the poor, whose interests weighed little in the balance against his own

"self-absorption." "Beneath all the social meanings of Chaplin's art,"
Warshow declares, "there is one insistent personal message that he is con-
veying to us all the time"—"love *me*, love *me*." "What is the Tramp,"
after all, Warshow argues, "but the greatest of all egotists?—an outcast
by choice refusing to take the least trouble to understand his fellow
men, and yet contriving by his unshakable detachment to put everyone
else in the wrong, transforming his rejection of society into society's
rejection of him?" Just as Chaplin's "delirious egotism" led him "to fulfill
every creative function on a film," Thomson maintains, so it isolated him
from "the world's problems." According to Thomson, the only reason
Chaplin ever masqueraded as a tramp was to indulge his own "self-pity":
"the pathos in Chaplin's work," Thomson concludes, "is always focused
on himself."[40]

Making matters worse for Chaplin, in the eyes of such detractors,
was the astonishing wealth that he so quickly amassed by pretending to
be poor. From the publication of *Charlie Chaplin's Own Story* in 1916 to
the end of his career, Chaplin tried to solve the problem of his success
by advertising his own early destitution.[41] "Oh, Konrad," he exclaimed
to his friend Konrad Bercovici in a 1925 *Collier's* interview, "I shall
never be able to tell anybody all the poverty and all the misery and all
the humiliation we—my mother, my brother and I—have endured. I shall
never be able to tell, for no one would believe it."[42] Sympathetic contem-
poraries often maintained that the traumas of his youth continued to
shape him, making him the poor, lonely child still. If Chaplin seems
"hard and cold," Thomas Burke observed in 1932, "it is because his first
decade was hard and cold"; "in the city of success," wrote Frank in 1929,
"he carries with him the taste of the London slums."[43] The very charac-
ter of the tramp, with his gentlemanly pretensions, seemed to corrobo-
rate Chaplin's claims that in reality the *rich* man was the masquerade.
Much of the pathos as well as the comedy of *City Lights* depends on the
tramp's being repeatedly mistaken for a millionaire. By 1931, this was
a well-worn device for Chaplin, having figured in such early two-reelers
as *Caught in a Cabaret* (1914), *A Jitney Elopement* (1915), *The Count*
(1916), *The Rink* (1916), and *The Adventurer* (1917). In his 1921 two-
reeler *The Idle Class*, Chaplin played the tramp and the millionaire as
dual roles, while in the feature-length *Gold Rush* of 1925, the tramp actu-
ally became a millionaire—though even after he found wealth, he could-
n't "resist stooping down to pick up a cigar butt," as Chaplin stressed to
an interviewer; "I suppose this sort of impulse comes to many persons
whose youth has been full of hardship."[44] (See color plate 2.)

Money was not the only disparity between the hard-luck homeless
man and the world-famous movie star. Watching his father on the set of
Modern Times, Chaplin's son marveled at Chaplin's ability to be "the

Little Fellow," "nice but ineffectual against the powers of the world," and "at the same time the famous, awe-inspiring director who literally held the destinies of that company in his hands." As director, Chaplin did more than run the show. According to Charlie junior, "my father's towering reputation and his seething intensity make it almost impossible for those working under him to assert their own personality." "In the studio," Virginia Cherrill recalled, Chaplin "was the only person whose opinion mattered in any way"; "here," Charlie junior agreed, "he was the undisputed lord whose every word was law." Even when Chaplin was relaxing at home, his son reported, "out of a clear sky he would jump up from the couch or chair on which he was sitting, pull his hair down on his forehead and, with his hand in his coat, strut around the house looking exactly like Napoleon Bonaparte, who fascinated him."[45] Before deciding on *City Lights*, Chaplin had planned to star in a film on Napoleon, and in the last of his tramp films, *The Great Dictator* (1940), he finally put a version of this idea on the screen, choosing to play the dual role of the (now more bourgeois) tramp and Hitler—"as up-front a self-representation as the Tramp had been," some critics have maintained.[46] To Rothman's wary eye, the dictator was already a shadowy presence in *City Lights*: "all the time" that Chaplin pretends to be the hapless "Little Tramp" in the film, Rothman complains, he is in reality "the director in control—manipulative, cold, inhuman." What makes the director seem as "inhuman" as a dictator? For Rothman, apparently, it's his power of cinematic life and death over his characters, including the tramp, whose presence Rothman believes Chaplin eliminates when he reveals himself as the director at the end of the film.[47]

So disturbed is Rothman by the thought of the controlling director behind the "mask" of the ineffectual character that he subsequently attributes a "murderous aspect" to the tramp himself, whom Rothman condemns for deceiving the flower girl and then destroying her hopes. Now the contradiction between character and director has become an equation, which is the moral, Rothman decides, of Chaplin's dual roles in *The Great Dictator*: that the character no less than the director is "a monster." Rothman's claim about the unifying "central point" to *The Great Dictator* makes the same kind of sense as Warshow's account of Chaplin's "one insistent personal message" does: all the doubling of parts in *The Great Dictator* do indeed boil down to one man, the undisputed lord of his cinematic kingdom. Within the film itself, however, that doubling amounts to a farcical confusion: there, the tramp only *resembles* a monster, insofar as he can be mistaken for the dictator Hynkel, just as Chaplin only resembles Hitler, whom he satirizes as Hynkel. Chaplin's fans insisted on the distinction: the real Chaplin, they insisted, was the tramp. As a *New Republic* writer put it in 1927, Chaplin "remains fragilely,

wholly, triumphantly, of the people."[48] But in Chaplin's view not even the tramp was ever one thing "wholly." "This fellow is many-sided," Chaplin maintained, "a tramp, a gentleman, a poet, a dreamer" who "would have you believe" he is much more, "a scientist, a musician, a duke, a polo player," even though "he is not above picking up cigarette-butts or robbing a baby of its candy." Contemporaries regularly bore witness to a similar multiplicity in Chaplin. An article in the pressbook for *City Lights* took pains to highlight the "Dual Personality" of the quiet, serious, smartly dressed man who "in real life" "seems anything but the master of slapstick." Describing Chaplin in a 1932 essay as "extraordinarily versatile—proficient in business, sport, music, athletics, painting, and a half-dozen other sidelines," his friend Burke likewise insisted that Chaplin and "*Charlie*" were "two utterly distinct characters."[49] Yet how could this possibly be, Burke marveled, when Chaplin's "work" onscreen was nothing but "himself"?[50]

Which Chaplin are we meant to see at the end of *City Lights*, when the camera focuses on him exclusively? Is it the dictator who has inhumanly pared away the crowd and the monument dedicated to them so that we can concentrate on his uniqueness without distraction? Or is it the man of the people who has heroically sacrificed his dignity so as to humanize the hoi polloi and the civic art that would otherwise insist on their facelessness? The problem is not simply that it's hard to choose between these seemingly irreconcilable alternatives; it's hard even to distinguish them from one another. In his interview with Meryman, Chaplin described the self-absorption of his playing all the parts as a kind of self-exploitation too: "I've always been my own star," he claimed, "and I could do what I liked with me."[51] To conclude this epilogue and this book, I'll now turn to another actor-director, Orson Welles, whose career suggests how Chaplin's seemingly distinctive combination of mastery and abjection is an aim that mass entertainment always tends to inspire.

The Fourmost Personality

"I liked to be part of everything that went on," Capra told an interviewer in 1971. During the twenties and thirties, even directors who worked outside of Hollywood and who extolled the virtues of collaboration often thought of themselves as possessing a special comprehensive relation to their films. "As a matter of principle," the Soviet director Sergei Eisenstein declared in 1935, "I am all for the collective method of work and consider suppression of the initiative of any member of a collective body absolutely wrong." But Eisenstein also maintained that the director is uniquely "responsible for the organic unity of style of the film,"

and, since the director's "function" is to be "a unifier," he has not only the right but also the obligation to "behave like a 'tyrant'" whenever "a member of the collective does not fully perceive the importance of stylistic requirements."[52]

Michael Powell, one-half of the most famous partnership in British film history, made "the camaraderie of a film company" a frequent theme in his autobiography. "We were a band of brothers," he said of himself and his crew on the 1937 *Edge of the World* (borrowing the words of a Shakespearean king). According to Powell, a director should be regarded as nothing more than one among the "many craftsmen" contributing to a film. Every other craftsman, indeed, is "an expert in his field," while the director possesses "only a superficial skill in the various departments which serve the film": he is "a jack of all trades"—a *Johannes fac totum*, as Shakespeare's rival Robert Greene would say. It's easy enough to treat such humble protestations as false modesty. They vanish whenever Powell writes of the predecessors he most admired: Rex Ingram, for instance, who ruled his studio like a "little kingdom"; or Abel Gance, "the Master"; or Chaplin, "the genius of the silent cinema," who "created" that cinema "almost single-handed."[53] And yet, like Eisenstein in his own soft auteurism, Powell justified the director's mastery as the necessary consequence of his collaborativeness. What sets the director apart from "his fellow craftsmen," Powell suggested, is his unique role in helping his colleagues transfer the "essence" of their otherwise separate "clevernesses" to the screen. Powell gives us plenty of reasons to question the modesty of this self-characterization too, as when he boasts that by 1931 he "already had the knack of convincing technicians and actors that they were carrying out their own ideas."[54] But Powell himself perceived no contradiction: since the director who dedicates himself to the good of the collective must do everything he can to overcome the selfish interests of individual contributors, even his pretense of modesty can amount to a collaborative tool.

"Collaboration—of course. You've got collaboration with thousands of people really," Capra acknowledged to an interviewer, but "one man has to make the decisions, one man says yes or no." Although the 1941 RKO film *The Devil and Daniel Webster* conspicuously repudiated the Thomas H. Ince model of screen credits when it listed eight people "in front of the camera" and seventeen "in back of the camera" who had "all collaborated on the picture," the first credit in the picture nevertheless went to one man, the producer as well as director William Dieterle.[55] Such comparisons to other, ostensibly less auteur-minded approaches to moviemaking help us recognize that, for all his egocentricity, Chaplin's view of himself as a "unifier" was consistent with a broad range of contemporaneous film theory. Chaplin's investment in the one-man one-film

ideal had, moreover, commercial as well as institutional credibility: after all, he would not have continued to market himself as the sole creative force behind his films—any more than Columbia Pictures would have continued to place Capra's name above the title—if that concept didn't sell.[56] (See color plate 3.) As part of its publicity campaign for another of its 1941 offerings, *Citizen Kane*, RKO issued a souvenir program that devoted as many pages to "The Amazing Mr. Welles" as to the movie. "A full-length feature film, such as 'Citizen Kane,'" the pamphlet notes at the start, "has come to be the most intricate form of all the arts, and a group, not an individual production." And yet Welles, emulating "Chaplin's genius," "undertook to be a one-man orchestra" with *Kane*, choosing "to write the piece, star in it, direct it, produce it." Welles's astonishing success at such multitasking is the souvenir program's constant theme, as in the two-page spread that proclaims him "The 'Four-Most' Personality of Motion Pictures!" (See color plate 4.) Here, rather than crush individuality with its mass production, the movie industry writes individuality large, by enabling Welles to assume the multiplicity of identities that the industry's own division of labor articulates. The souvenir program ties Welles's "fourmost" personality more precisely to *Citizen Kane* on its back cover, which shows us the image of Welles as Kane atop a heap of newspapers. Once again, the individual stands out in relation to mass entertainment rather than in opposition to it: Kane's preeminence depends on the newspapers, which, by representing the many producers and consumers of the paper only metonymically, incorporate the masses into the scene while also clearing the way for Kane to be the only person we see. Cedric Belfrage's contemporary assessment of *Citizen Kane* reads almost like a caption for this vision of the one who stands for the many even as he transcends them: *Kane*, Belfrage, writes, "is the work of many artists and yet, with and above that, the work of one."[57]

Not all of the souvenir program offers so panegyric an account of Welles's "fourmost" comprehensiveness in relation to his film. Sometimes, aiming at wit, the program suggests that Welles's many roles on the film have generated an unsettling self-division in him. "Producer-Director Welles confers with himself and decides 'they' don't quite like the way the turban designed for Dorothy Comingore looks," the caption for one publicity photo declares. "Actor Welles and Director Welles slightly mixed up as he takes a look at a scene from the other end of the camera," claims another. The problem with being many men in one is that it can make you seem as conflicted as you are uncommon. "Knowing the chameleon-like nature of Charlie," wrote Chaplin's friend Bercovici, "I am never surprised when I see him being a hundred different persons in the presence of a hundred different people." "For he has no unity of char-

Welles as Kane atop the newspapers. Licensed by Warner Bros. Entertainment. All Rights Reserved.

acter, no principles or convictions, nothing in his head that, when he lays it on the pillow, you can sensibly expect will be there in the morning," Max Eastman declared more damningly; therefore, "enjoy any Charlie Chaplin you have the good luck of a chance to. But don't try to link them up into anything you can grasp. There are too many of them."[58] When Welles referred to Kane as "a man of many sides and many aspects," he, too, meant to stress the turmoil as well as the richness of

the character he played.[59] In sharp contrast to the souvenir program's triumphant image of Kane as the one distinctive man in a world of mass-produced copies is the film's tragic image of Kane as endlessly multi-plied by the mirrors of Xanadu after Susan has left him—an image given a mass-entertainment coding in the film by the crowd who are on hand to witness the spectacle of Kane's humiliation.

Welles fell short of Chaplin, of course: he could never replicate the success of *Kane*, nor win popular acclaim for doing everything on a film, as Chaplin did. Whereas Chaplin received a special award "for Versatility and Genius for Writing, Acting, Directing and Producing *The Circus*" at the very first Academy Awards in 1928, the Oscar that Welles won fourteen years later forced him to share the prize for Best Original Screenplay with his co-writer on *Kane*, Herman Mankiewicz.[60] But if Welles found it harder than Chaplin did to satisfy the taste for authorial comprehensiveness in mass entertainment, it was not because he pre-ferred to concentrate in solitude, like the screenwriter Riskin or the painter Redmond. His troubles seem to have had more to do with his inability to appear as if he had ever been poor. "In the work of the greatest of geniuses," Chaplin declared in his autobiography, "humble beginnings will reveal themselves somewhere."[61] A 1941 *Good Housekeeping* article on *Meet John Doe* similarly traced Capra's mass appeal to his having "had his share of hard luck." "There was a time," the article explains, when Capra "had to bunk on park benches and peddle five-star finals for a cup of coffee"; although he may now be "the highest-paid director in Hollywood and the only director who has won the Academy Award three times," "he is still essentially the Capra of the park bench."[62] Welles's own beginnings were anything but humble: as the souvenir pro-gram for *Kane* points out, his father was "a well-known inventor and manufacturer" and his mother "a concert pianist." According to Welles's biographer Frank Brady, Welles was so precociously sophisticated that, "at an age when most children are still mastering the rudiments of lan-guage, Orson already spoke like a miniature Brahmin."[63] *Citizen Kane* contrives to lend Welles's character a more Chaplinesque life story, but the childhood trauma suffered by "Charlie" Kane nevertheless comes from attaining wealth rather than going without it. "I always gagged on that silver spoon," Kane confides to his banker-guardian Thatcher. When Kane also admits to Thatcher that he is in reality "two people," these turn out to be not the poor child and the rich adult, as they were for Chaplin, but rather two different millionaires—a corporate share-holder and a newspaper publisher. Welles plays Kane many ways in his film, but never as someone without scads of money.[64]

This class constraint on Welles's versatility as a mass entertainer seems to be at the heart of Pauline Kael's notorious attack on him for

Kane multiplied

The crowd who witness Kane's humiliation

pretending that he was "the whole creative works" on *Citizen Kane*. In Kael's view, no film artist could ever hope to engage a mass audience without some measure of the common touch. "The greatest movie stars," she asserted in a 1975 essay on Cary Grant, "have not been highborn; they have been strong-willed (often deprived) kids who came to embody their own dreams, and the public's." But Welles was different. He "carries on in a baronial style that always reminds us of Kane," Kael complained a few years earlier in her 1971 essay "Raising Kane." With "his spoiled-baby face" and a "physical presence" that "incarnates egotism," Welles struck Kael as unmarked by hardship even after his Napoleonic career had foundered and left him "perhaps the greatest loser in Hollywood history." "The greatest loser": it's a strange assessment of a man who, according to Kael herself, "directed what is almost universally acclaimed as the greatest American film of the sound era." But the characterization has a familiar ring to it. "Mr. Kane was a man who lost almost everything he had," one of his former employees tells us in the film. What Kael refuses to countenance as anything more than a dramatic irony for Welles is that *Citizen Kane* had already conceived of Welles's life as a "failure story."[65] One might say that Welles suggested to Kael the terms in which she would attack him, if Welles's "masochism," as the film critic Jonathan Rosenbaum calls it, was not itself suggested to him by mass entertainment. In Rosenbaum's view, Welles "was too much of an artist and intellectual to endear himself to the general public unless he mocked and derided his artist temperament and intellectualism." Throughout his "many appearances" on television, therefore, Welles appeared "to be completely complicitous and comfortable with the extremely precocious, imperious, egomaniacal, and intimidating versions of himself comically presented and ridiculed on those programs."[66] Even this notion of Welles as democratizing himself through self-parody is anticipated by *Citizen Kane*. "Shameful, ignominious" is how the newsreel biography of Kane characterizes his adulterous affair with the shopgirl Susan—and it's Susan's laughing at him when a passing car ignominiously douses him with mud that first draws Kane to her.

In the closing pages of "Raising Kane," Kael tries her best to pity Welles. Conceding that "he was the catalyst for the only moments of triumph that most of his associates ever achieved," she decides that his real problem in the end was believing his own publicity, which "snowballed to the point where all his actual and considerable achievements looked puny compared to what his destiny was supposed to be. In a less confused world, his glory would be greater than his guilt."[67] It takes a moment to appreciate how smoothly the counterfactuality of this final sentence excuses Kael for accusing Welles of a guilt greater than his glory. "Guilt" is in any case her last word on Welles in "Raising Kane,"

her version of the merciless judgment that Warshow, Thomson, and Rothman pass on Chaplin for his "murderous" self-absorption. After the shocking revelation by Kael's biographer Brian Kellow that the most famous film critic of her time stole the research for "Raising Kane" from another writer and then suppressed any evidence of her collaboration with him, it's hard not to hear a kind of self-accusation at the end of her essay as well.[68] But the story is bigger than Kael or Welles. For the aspiring author of mass entertainment, "guilt" and "glory" are two sides of the same coin.

Coda

A SECOND LOOK

In the moments after Chester Kent knocks on the door of his secretary Nan's apartment in *Footlight Parade*, Nan's gold-digging guest Vivian Rich doesn't bother to adjust her clothes or hair, as Nan nervously does. Instead, she picks up a book. That's how she wants Chester to see her, book in hand, and after he enters the apartment, she enhances her performance by loftily informing him that, when she was recently in Hollywood, she "never missed a Chester Kent prologue. They were all so...what shall I say? Intellectually devised." Chester is both amused and flattered: "I wouldn't call them exactly intellectual," he replies. Vivian

Vivian answering the door with book in hand

presses on. "Most prologues," she continues, "are utterly commonplace. But yours—yours have *meaning*."

How *much* meaning, the comedy of this episode asks us to consider, can commercial entertainments such as Chester's plausibly be said to possess? Vivian doesn't know what she means by "meaning": the most she can say about Chester's shows is that there's an "intangible something" to them. Her refinement is just an act. When she'd earlier claimed to Nan that she had left Hollywood because "the pictures bored" her— "so little culture out there," she'd sighed—Nan had been suitably incredulous. "What is this culture gag all of a sudden?" Nan had asked. "Last time I saw you, your conversation was practically 'dese,' 'dems,' and 'doses.'" The lightning quickness of Vivian's transformation into an aesthete highlights the problem that Chester's own speed poses for thinking of his entertainments as intellectual. So frenetically fast does Chester work on his prologues that when a security guard at his studio tells Nan he hasn't seen Chester that morning, Nan quips, "Maybe you blinked and missed him." "Genuine culture," argued Clement Greenberg, along with other critics of mass entertainment, requires "leisure." When Vivian asks Chester whether he's read "a most interesting book" she's been perusing, *Slavery in Old Africa*, he can only reply, "I don't even have time to read my mail." In Greenberg's view, the ceaseless pressure on the entertainment industry to churn out distractions for workers who barely had time to enjoy them meant that Hollywood must of necessity generate kitsch rather than art. "Immediacy," Greenberg claimed, was all that the masses valued: it was the reason they prized "Eddie Guest and *Indian Love Lyrics*" over "T. S. Eliot and Shakespeare."[1]

Yet a breakneck speed of production was no less characteristic of the Renaissance plays Greenberg admired than of the Hollywood movies he deplored. In the Rose Theater, the residence of Shakespeare's rivals the Admiral's Men in the 1590s, "everything moved much more quickly than in a modern classical theater," the theater scholar Neil Carson points out, "and the attention to detail we expect in contemporary productions was almost certainly impossible." "No play at the Rose," explains another theater scholar, Andrew Gurr, "was staged more than four or five times in any month, and it was normal to stage a different play on each of the six afternoons of each week that they performed. A new play would be introduced roughly every three weeks." According to a third scholar, Tiffany Stern, the "demands" on Renaissance theater companies were so "tremendous" that in some instances "it is unlikely...that there was any collective rehearsal at all" before a play was performed.[2] Neither Renaissance plays nor Golden Age movies would have been possible without the astonishing level of professionalism that Shakespeare highlights when he has the Player in *Hamlet* recite on command a nearly

fifty-line speech from an old play and so instantaneously inhabit his part that by the end of the speech his color has "turned" and his eyes have filled with "tears."[3] Thanks to the similarly intense pressure that mass entertainment places on Chester, the thought of working with "an amateur" shakes him to the core.

Other contemporary detractors of film such as Horkheimer and Adorno complained about the new mind-numbing rapidity of movie viewing itself, but the original audiences of a Shakespeare play had no more power to pause a scene or ask the actors to replay it than a Golden Age movie audience did. "Remember," the dramatist John Marston said of plays in 1606, "the life of these things consists in action." It's a telling measure of Horkheimer and Adorno's contempt for movies that they never directly consider the possibility of catching what they might have missed in a film by watching it again. Yet Golden Age filmmakers had obvious commercial incentives for encouraging repeated viewings of their entertainments; so did Renaissance playmakers. In the prologue to his 1616 *The Devil Is an Ass*, Ben Jonson exhorted his audience not to judge his comedy until they'd seen it "six times," while a fictional theatergoer in the 1604 induction to Marston's *Malcontent* claimed to have "seen this play" so "often" that he could "give" the players "intelligence for their action."[4] Horkheimer and Adorno would insist that such fleeting images in *Footlight Parade* as the blackface minstrel I discussed in chapter 4 go by far too quickly for filmgoers to notice them or for filmmakers to mean anything by them. Yet these flashes—blink and you'll miss them—might just as easily be understood as sparking viewers' interest to see the film again.

Moviegoers in the 1930s were in any case constantly returning to the cinema and consequently growing ever more sophisticated about how to make sense of films.[5] Education may appear to be a target of satire throughout *Footlight Parade*, as when Bea declares that she's "sick of looking like a schoolteacher" or Vivian pompously invokes the authority of "Professor Malinkoff." But it's academic learning that the movie actually mocks. Not all education happens in schools, as the play-hating John Northbrooke underscored in 1577 when he claimed that there was no "more speedy way and fitter school" for teaching vice than the theater, or as the film enthusiast John Haynes Holmes insisted in 1936 when he called the cinema "the most powerful educational influence that exists in the modern world."[6] Plays and movies alike sought to reward returning audiences with a special knowledge, moreover, that only their trained minds could access. For moviegoers who had seen other Cagney films besides *Footlight Parade*—and there were eleven of them in the two years before *Footlight Parade* was released—something so slight as the glimpse of a grapefruit on the breakfast table before Chester and Nan had the

power to charge the scene, comically or ominously, with the memory of Cagney's gangland past in *Public Enemy* (1931), when he notoriously hit Mae Clarke in the face with a grapefruit. In *Lady Killer* (1933), another Warner Bros. film released less than two months after *Footlight Parade*, the intentionality of the reference is unmistakable: leafing through a travel

Chester and Nan with grapefruit

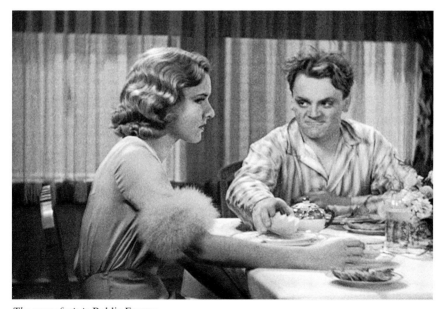

The grapefruit in Public Enemy

A closer look at Vivian's book

brochure with Cagney, Clarke reads aloud about California's "oranges," "lemons," and "prunes" before pausing to frown at the next piece of produce the brochure mentions: "grapefruit."[7]

Vivian's pretensions may seem to link books as well as academics with the kind of formal or leisured learning that *Footlight Parade* mocks. (Viewers are given a few seconds to spot the title of the particular "high-brow" volume Vivian carries: it's the modern classic *The Education of Henry Adams*.)[8] Film and theater critics have long been concerned to differentiate plays and movies from other merely verbal media such as books. Many recent theater historians, as I've shown, have gone further, characterizing the book publication of plays during the Renaissance as a grievous betrayal of the theater's intrinsically popular and performative nature. Print, these historians argue, restricted the potential audience of a play to literate buyers, transformed the play from a public to a private experience, treated actors as superfluous to the drama, and tempted readers to believe that the form of a play could be fixed, even though the very essence of the theater was the mutability and ephemerality of its action.[9] But all of the plays as well as movies I have discussed in this book were based on scripts; if it distorts these entertainments to reduce them to their scripts, it equally falsifies them to treat the scripts as somehow categorically distinct from or external to the entertainments. Just because Chester doesn't have time to read books with the same academic diligence as Vivian affects doesn't mean that he's not interested in them. On the contrary, he is so excited by the entertainment

value he anticipates finding even in the grimly titled *Slavery in Old Africa*
that he asks Vivian whether it's possible to "get that book tonight"—
and the two of them then rush pell-mell out the door for the nearest
bookshop.[10]

It's not print that another Golden Age movie, *Citizen Kane*, sets
against the manic energy of mass entertainment; if anything, *Kane*
shows newspapers being produced and consumed far more speedily
than a movie could be. In *Kane*, as in *The Winter's Tale* and *City Lights*,
it's the statue that embodies the highbrow exclusivity, weightiness, and
fixity that theater historians associate with the book. What the statue
lacks, these three different entertainments suggest, is the flexibility that
enables plays and movies to please everyone by negotiating between ver-
bal and visual representation, depth and superficiality, stability and
motion, art and junk. "I wouldn't call them exactly intellectual," says
Chester of his prologues—not *exactly*, that is. Vivian's act is Chester's
simplified: with no interest in a mass audience, she prides herself on her
flexible approach to moneymaking. "Well, well, the cultured Miss Rich,"
Chester dryly remarks when he sees her at last for the professional she
has always been. "Not cultured," she is quick to reply: "just smart."

NOTES

Introduction

1. So, e.g., Russell Jackson defines the subject of his *Shakespeare and the English-Speaking Cinema* (2014) as "the ways in which the plays in the Shakespeare canon have been adapted for a new medium" (3). For the interchangeability of "Shakespeare and film" and "Shakespeare on film" in recent scholarship, see Samuel Crowl's *Shakespeare and Film: A Norton Guide* (2007), whose introduction is titled "Shakespeare on Film and Television," and the Routledge FreeBook *Shakespeare on Film* (2016), which samples the offerings of the press "in the field of Shakespeare and Film" (4).

For a valuable survey of "Shakespeare-related mass media materials" (1.vii), see Richard Burt's two-volume encyclopedia *Shakespeare After Shakespeare*.

2. Harbage, *Shakespeare's Audience*, 90, 162, 166; Bethell, *Shakespeare*, 20 and 27; Harbage, *Shakespeare's Audience*, 65 ff., 160 ff.; Bethell, *Shakespeare*, 20. Even the charge of favoring visual over verbal representation was leveled against Renaissance plays. In the court prologue to his *Staple of News*, Ben Jonson blamed the problem on "the vulgar sort" of spectators "that only come for sight" (7–8). (Unless otherwise noted, I refer to the Cambridge edition of Jonson, even though its streamlined punctuation produces a breathless phraseology that strikes me as out of keeping with Jonson's aesthetic.)

Partly in response to Bethell's work, which he admired, Harbage modified his view of the theater-film analogy in his later *Shakespeare and the Rival Traditions* (1952). Without directly praising any particular film, he chided other critics for holding "this newest, most characteristic, complex, and universal art of the twentieth century...in a kind of quarantine" (317).

3. In 1967, Robert Weimann expanded on the work of Harbage and Bethell in a book that has deeply influenced all subsequent accounts of Shakespeare's relation to his first audiences, including mine: *Shakespeare und die Tradition des Volkstheaters*, translated in 1978 as *Shakespeare and the Popular Tradition in the Theater*. But, for all his emphasis on the social heterogeneity of Renaissance theater audiences, Weimann did not compare Shakespearean drama to modern mass entertainment.

4. Bristol, *Big-Time Shakespeare*, 233, viii, 116.

5. For a dynamic account of "medieval and early modern textual and visual culture" as "protocinematic" in a broader sense than Bristol intends, see Richard Burt's *Medieval and Early Modern Film and Media* (2008). Burt's comparative analyses are strengthened by a sympathy for modern mass entertainment that Bristol lacks.

6. See Jenemann, *Adorno*, 112, 113–15, 128–47.

7. Stanley Cavell notes how Benjamin's "speculations" on film in his famous "Work of Art" essay "are developed without consulting a film's idea of itself, or undertaking to suppose that one or another [film] may have such a thing" ("Concluding Remarks," 284). In a recent blog post, David Bordwell similarly remarks that "I haven't found any piece by Adorno and Horkheimer that troubles to analyze closely a single product of the culture

industry" ("Agee & Co.: A Newer Criticism," Feb. 9, 2014, www.davidbordwell.net/blog/2014/02/09/agee-co-a-newer-criticism).

8. Harbage, *Shakespeare's Audience*, 161–62. For more on Renaissance versions of Harbage's claim, see my *Shakespeare Only*, 86.

Bristol takes an ostensibly harder line on this issue than Harbage does: the "complexity" of Shakespeare's plays, he argues, is best described "not as an artistic achievement but rather as a shrewd strategy to curry favor with as many sectors as possible within a complex multi-cultural market" (*Big-Time Shakespeare*, 50). But in opposing art to commerce this way, Bristol seems if anything more sentimental about art than Harbage is. For the same critique of Bristol, see Burt, "To e- or Not to e-?" 5.

9. Massinger, *Roman Actor*, 1.1.1–11, in *Plays and Poems*; Prynne, *Histrio-Mastix*, 506, quoting Juvenal, *Satyrae* 11.197; Jonson, *Q. Horatius Flaccus: His Art of Poetry*, 291–93, translating Horace, *Ars Poetica*, 205–6 (*BJ* 7:1–67 reprints a later version of Jonson's translation, but the earlier version, first published in 1640, has these same lines).

10. For all his emphasis on the unprecedented nature of cinematic entertainment, Badiou himself speaks of classical Greek drama as the "cinema of Antiquity": the great popular successes in film history, he believes, "can probably only be compared to the public triumph of the great Greek tragedies" ("On Cinema," 240, 234).

11. Badiou interprets the phrase "mass art" differently: he thinks that it signifies "the paradoxical relationship between a pure democratic element" in "mass" and "an aristocratic element" in "art," which "is and can only be, an aristocratic category." But for Badiou the "impurity" expressed by the phrase "mass art" belongs to cinema in particular, not to mass entertainment generally ("On Cinema," 235).

12. Weever, *Epigrammes*, E6v. For other similar references, see my *Shakespeare Only*, 25, 163–64.

13. I.G., *Refutation*, 40; Rankins, *Mirrour*, B3v.

14. I'm quoting Alan Blackburn, who was executive secretary of the museum at the time (Blackburn, "Creating," 8, cited in Decherney, *Hollywood*, 239 n. 14). In *Hollywood Highbrow*, Shyon Baumann seriously misrepresents this period in film history when he claims that in the early 1930s "the idea of film as art" was "mainly confined to avant-garde journals" (115). For a more accurate and yet still reductive account of film's increasing cultural prestige during the Golden Age, see Peter Decherney's *Hollywood and the Culture Elite*. The mystery of Decherney's study is why a scholar so wary of the elite should insist that the notion of film as art was entirely their creation: "Film didn't become art until Hollywood moguls decided it was good business for film to become art *and* the leaders of American cultural institutions found it useful—politically useful—to embrace and promote Hollywood film" (1).

15. Rotha, *Film*, 308. Fans of the silents also argued that the talkies had narrowed the range of film and ruined its claims to artistic independence with their "wholesale surrender to the stage" (Beaton, *Know Your Movies*, 38). Cf. Dwight Macdonald: "The coming of sound, and with it Broadway, degraded the camera to a secondary instrument for an alien art form, the spoken play. The silent film had a[t] least the *theoretical possibility* of being artistically significant. The sound film, as exploited within the limits of Broadway taste and sophistication, has removed this possibility" ("Theory," 22).

16. *SW* 4:254. Unless otherwise noted, I quote the better-known third version of the "Work of Art" essay written between 1936 and 1939 and published posthumously in its original German in 1955.

17. Benjamin, "Work," 2nd version, in *SW* 3:109; Badiou, "On Cinema," 235 ("le premier grand art qui soit de masse *dans son essence*" ["Du cinéma," 6]).

18. *SW* 4:252, 256; Carroll, *Philosophy*, 3, 223, 2 (my emphasis), 186 (my emphasis), 223. Carroll's favorite examples of mass artworks that "pre-date industrialization" (208 n. 44) are Japanese woodcuts (see, e.g., 173). It's a telling preference: what Carroll likes about the woodcuts is their visuality, which makes them more widely accessible than books. I'll return to Carroll's emphasis on accessibility in chapter 1.

19. Carroll, *Philosophy*, 201, 199, 3.

20. Ibid., 187. Mass art, writes Carroll, is "art that is produced and distributed on a mass scale" (183).

21. Badiou, "On Cinema," 234. Badiou claims that this greater scale is an essential feature of movies because the movies are mass-distributed at the same time as they are "created." But again, a movie can be a movie without being mass-distributed.

22. Carroll, *Philosophy*, 206 (my emphasis). Elsewhere in his book, Carroll insists that "mass art…is designed to be easy, to be readily accessible, with minimum effort, to the largest number of people possible" (192) or to "the largest number of untutored (or relatively untutored) audiences" (196; cf. 202). Again, I'll return to Carroll's emphasis on accessibility in chapter 1.

23. Ibid., 231, 207.

24. Ibid., 206. Carroll's lack of historical imagination in this regard is clearest in his assessment of Shakespeare's "accessibility." "It does not seem plausible to suppose," he writes, "that *masses* of untutored people find *The Tempest* more accessible than 'Fight the Power'" (ibid., 228). Yet of course *The Tempest* might well have been accessible to "masses of untutored people" when it was first staged four hundred years ago.

 Amy Rodgers also questions "the importance of technology in creating a mass audience" in a book she is writing on spectatorship in Renaissance England.

25. Heywood, *Iron Age*, A4v; Carroll, *Philosophy*, 187.

26. Books, moreover, were often sold at plays. In his 1616 *Descriptions*, William Fennor imagined that his book might fall into the hands of readers "before a play begin, with the importunate clamor, of *Buy a new Book*" (n.p.). Cf. Vicar Catchmey's mockery of the puritan Sir Christopher in William Cartwright's *The Ordinary* (c. 1635):

> I shall live to see thee
> Stand in a Play-house door with thy long box,
> Thy half-crown Library, and cry small Books,
> Buy a good godly Sermon Gentlemen—
> A judgment shown upon a Knot of Drunkards—
> A pill to purge out Popery—The life
> And death of *Katherine Stubbs*. (1446–52)

Books also appeared as props in plays: for instance, Hieronimo in Thomas Kyd's *Spanish Tragedy* enters a scene "with a book in his hand" (3.13.s.d. in *ERD*), just as Shakespeare's Hamlet (in the First Folio) enters "reading on a book" (2.2.s.d.168).

27. Erne, *Shakespeare as Literary Dramatist*, 10 and 25.

28. Similar royal proclamations from other reigns specified that no one "print any books" nor "play any interlude" without license. See Wickham, ed., *English*, 35–36, 40.

29. Foxe, *Acts* (1563 ed.), 4:806.

30. Northbrooke, *Treatise*, 58; Marston, *What You Will*, 266. Cf. John Stockwood in 1578: "If you resort to the Theater, the Curtain, and other places of Plays in the City, you shall on the Lord's day have these places, with many other that I can not reckon, so full, as possible they can throng" (quoted in Chambers, *Elizabethan Stage*, 4:200). For other similar references, see appendix 2 of Andrew Gurr's *Playgoing*.

31. Prynne, *Histrio-Mastix*, **6v. Ian Munro points out that Renaissance antitheatrical-ists "continually emphasize the grotesque and violent nature of the crowding that takes place" in the theaters (*Figure*, 120).

32. Northbrooke, *Treatise*, 62 (my emphasis); *Pymlico*, C1r; Davies, *Poems*, 135–36; Rowley, *All's Lost*, A3v; Marston, *Jack Drum's Entertainment* (1600; publ. 1601), in *Plays*, 3:234. The Rowley prologue reappeared in the 1636 edition of Dekker's *The Wonder of a Kingdom* (written c. 1623–31), A2r. (All subsequent references to Dekker's plays, unless otherwise noted, are to his *Dramatic Works*.)

33. Prynne, *Histrio-Mastix*, 154; Day, *Isle*, prol. 140–42; Nicholas Downey in his com-mendatory poem to Samuel Harding's *Sicily and Naples* (1640), A1r. Cf. Nathan Field on the "confus'd cry" from the mass audience in his commendatory poem to John Fletcher's *Faithfulle Shepheardesse* (c. 1609), ¶3r.

34. Menzer, "Crowd Control," 19. Menzer is drawing on Ann Jennalie Cook's estima-tion of the "average" or "ordinary" attendance at the Rose Theater (*Privileged*, 190–91), but this evidence alone cannot warrant Menzer's blanket assertion that Renaissance theaters were half empty "far more often than not."

35. Menzer, "Crowd," 21; Jonson, *Every Man Out*, induct. 49–50. Asper later invites the audience to regard their fellow spectators as "motions" or entertainments that are them-selves worth the price of admission: "note me if in all this front / You can espy a gallant of this mark, / Who, to be thought one of the judicious, / Sits with his arms thus wreathed, his hat pulled here, / Cries 'mew' and nods, then shakes his empty head, / Will show more sev-eral motions in his face / Than the new London, Rome, or Nineveh" (157–63).

36. *2 Henry VI* 2.4.20–22. Menzer explores some other striking instances of this topos ("Crowd Control," 29).

37. Gosson, *Schoole*, C4r, in *Markets*.

38. Badiou, "On Cinema," 238; Jump, *Religious*, 11.

39. "Art and Democracy," *Photoplay* 13 (Apr. 1918): 1. The editorial was written by James Quirk; see Slide, *Inside the Hollywood Fan Magazine,* 47–72.

40. Hampton, *History*, 430; Sherwood, ed., *Best*, viii; Lewis, "De Luxe," 176.

41. Orrell, "London," 169; Dekker, *Guls Horne-booke*, 28; J. Cocke, in Chambers, *Elizabethan Stage*, 4:256; Jonson, *New Inn*, prol. 1; Jonson, *Bartholomew Fair*, induct. 62. Jeremy Lopez sheds light on the contradictory attitudes of playwrights toward mass audi-ences by noting that "open hostility to audiences from the stage is rare, even in the case of the pugnacious Jonson. More typically, such hostility is saved for prologues for readers" (*Theatrical Convention*, 19).

42. Munro, *Figure*, 117; Crosse, *Vertues*, Q1r; I.G., *Refutation*, 27.

43. Crosse, *Vertues*, P4v; I.G., *Refutation*, 40, paraphrasing Cicero's *Tusculan Disputations* 3.2; Crosse, *Vertues*, P3r; Northbrooke, *Treatise*, 67–68 (cf., e.g., Stubbes, *Anatomie*, L8v); I.G., *Refutation*, 56 (my emphasis).

44. Moretti, "Great Eclipse," 42 (my emphasis); Marston, *What You Will*, induct., in Wood, ed., *Plays*, 2:232; Harbage, *Shakespeare's Audience*, 11. By far the best recent work

on democracy and the Renaissance theater is Oliver Arnold's *Third Citizen*. See also Annabel Patterson's *Shakespeare and the Popular Voice* and chapter 8 of Michael Bristol's *Big-Time Shakespeare*.

45. Rotha, *Film*, 72; White, "Chewing-Gum Relaxation," 5; Seldes, "People," 70. Similarly, Welford Beaton dedicated his 1932 book *Know Your Movies* to "the one stalwart and unwavering champion of legitimate screen entertainment": "THE BOX-OFFICE" (10).

46. Badiou, "On Cinema," 239; Shakespeare, *Troilus*, in Riverside edition, 526; Dekker, *If It Be Not Good*, prol. 33–36; Heywood, *Apology*, B4r. For other references to the theater's power to elevate its audience, see my *Shakespeare's Tribe*, 36ff., 166–67.

47. Hampton, *History*, 121–22. Hampton is nonetheless ambivalent about "the mind of the mob." "There was no leadership of any sort" in the public demand for better films, he insists; indeed, there was little sign of any agency at all. "There was merely a ceaseless, irresistible drift of millions of plain people to little ticket-windows to buy amusement" (122).

48. Lindsay, *Art*, xxiii; Heywood, *Apology*, B4r; *Henry V* 1.chor.8, 4.3.60, 3.1.29–30, 4.3.61–63, 1.chor.12–20, 2.chor.17.

49. *SW* 4:269. For Thomas Cromwell's commissioning of anti-Catholic plays, see Happé, *John Bale*, 10, 40, 90, 104. In his 1589 *Protestation*, the radical Protestant who posed as "Martin Marprelate" complained about "all the rhymers and stage-players, which my lords of the clergy had suborned against me" (Black, ed., *Martin Marprelate Tracts*, 204). While "it may go too far to say that the late Elizabethan stage invented that elusive category Puritanism," the historian Patrick Collinson has argued, "it is likely that the fictions helped those exposed to them to label, laugh at, hate, and even become the Puritan who had all the time been in their midst, even within themselves" ("Theater," 168).

50. Albott, *Wits Theater*, 258r. This tale from Dio Cassius's *Roman History*, LIV, also shows up in Gosson's *Schoole of Abuse*, C8r, in *Markets*; Nashe's *Pierce Penilesse*, in *Works*, 1:214–15; and in Thomas Lodge's *Rosalynde*, B4v.

51. *DE* 138; Macdonald, "Theory," 21.

52. Rankins, *Mirrour*, B2v; Gosson, *Plays*, B4r, B6v, and E8v; *Refutation*, 65 (mistakenly numbered 59), to which compare Prynne, *Histrio-Mastix*, 69.

53. *DE* 121; Adorno, "Free Time," 195; *DE* 126–27. Benjamin famously quotes Georges Duhamel making the same claim: "I can no longer think what I want to think," wrote Duhamel in 1930; "my thoughts have been replaced by moving images" (*SW* 4:267).

54. *This Worlds Folly* (1615), B1v, cited in Munro, *Figure*, 119; *DE* 126; Gosson, *Plays*, F6r; [Munday?] and Salvianus, *Blast*, 96–97. Contemporaries habitually associated the mesmeric power of plays with the audience's visual experience of them: e.g., "There cometh much evil in at the ears, but more at the eyes, by these two open windows death breaketh into the soul" (*Blast*, 95–96); "it cannot be, but that the internal powers must be moved at such visible and lively objects" (Crosse, *Vertues*, P2v).

55. Jonson, *Every Man Out of His Humor*, induct. 265; Crosse, *Vertues*, P1v, Q2v; *Henry V*, 3.chor.1–3. Cf. the prologue to the 1607 *Travails of the Three English Brothers*: "First see a father parting with his sons; / Then, in a moment, on the full sails of thought / We will divide them many hundred leagues" (27–29).

56. Zweig, "Monotonisierung," 398–99; Patterson, *Scenario*, 208.

57. Barry, *Let's Go*, 26. To support his own claim that "the close-up inevitably induces a sense of intimacy and of privileged familiarity," the influential sociologist Herbert Blumer reported in 1935 that, according to inside information he had received from Thornton

Wilder, "the fan mail of movie stars appears to be much more intimate in tone than the fan mail received by theatrical or opera stars" ("Moulding," 123).

58. Harbage, *Shakespeare's Audience*, 167; *SW* 4:259–60; Harbage, *Shakespeare's Audience*, 167; *SW* 4:261.

59. The seeming exception proves the actual rule: when the disembodied voice of a newsboy directly asks Jedediah whether he wants to buy a "paper," the transaction fails; Jed replies, "No thanks."

60. *Henry V*, 2.chor.42; Hannon, *Photodrama*, 14, 34; White, *Parnassus*, 12–13.

61. Döblin, "Individual," 386; Dale, *How to Appreciate*, 191; "Shadow Stage" [Review of *The Crowd*], 52.

62. Crowther, "Manifesto," 181; Ortega y Gasset, *Revolt*, 16, 58, 63. The original Spanish-language edition of *La rebelión de las masas* appeared in 1930.

63. Mills, "Man," D2; *NYT*, May 22, 1927, X5; Mills, "Man," D2; Seldes, "Fine," 98.

64. *Washington Post*, Apr. 5, 1928, 9; Lusk, '"Crowd,"' C13. In an "Important Suggestion" added to his May 18, 1926, draft of the script for *The Crowd*, John Weaver wrote that "the whole value of this story will have to be that from the life of a particular person and his family, the universal story of all clerks will be felt by the audience" ("Clerk Story," prefatory material, n.p.).

65. Vidor, *Tree*, 153; I also quote from Vidor's Oct. 21, 1926, scenario, "March of Life," 9, and from a Jan. 3, 1927, synopsis of Vidor and Behn's continuity script for "The Mob," 1.

66. Bush, "Like," 230; for a similar but less detailed reading of the film, see Hansen, "Ambivalences."

67. For more on the changing titles, see Vidor, *Tree*, 145–46.

68. Tinee, "Mr. Common Citizen"; Rotha, *Film*, 123.

69. Vidor, *Tree*, 152. For more on the different endings, see Durgnat and Simmon, *King Vidor*, 81, 86.

70. Grimsted, "Purple Rose," 573 n. 11; Vidor, *Tree*, 149, 152 (my emphasis).

71. See Vidor, *Tree*, 146–48, for one of the many times that Vidor told the story. Murray had earlier starred in MGM's *In Old Kentucky* (1927), but according to Jordan R. Young, that film was shot after *The Crowd*. For more on Murray, see Young's *King Vidor's The Crowd*, 71–78.

72. Busby, "Murray"; St. Johns, "Mister Cinderella." Cf. *Washington Post*, Apr. 1, 1928, F4, and *LAT*, Oct. 21, 1928, A5. *Photoplay*'s account of Vidor's first encounter with Murray is very different from the one that Vidor himself tells in his autobiography.

73. Vidor, *Tree*, 149. In his autobiography, Vidor frames both his first and his last encounter with Murray as a matter of focus: "One day, as I stood chatting with a friend near the casting office, a passer-by said, 'Excuse me,' and brushed between us. *As I moved back*, I caught a momentary glimpse of a young man whose image seemed somehow familiar. Then I knew he was the exact prototype of the character for whom I had been searching." Years later, Vidor writes, "as I walked along Vine Street near Hollywood Boulevard, a man stepped in front of me, unshaven and bloated. He wanted money for a meal. *I looked closely*. It was Jimmy Murray" (*Tree*, 147, 149; my emphases).

74. Schickel, ed., *Men*, 145. For Francis Ford Coppola's halfhearted involvement with the project, see Dowd and Shepard, ed., *King Vidor*, 286.

75. Dale, *How to Appreciate*, 206.

76. Adorno, "Free Time," 189–90, 194.

77. An article in the pressbook for *The Jazz Singer* asserts that the film "breathes the spirit of tolerance" (9; cf. 16).

78. For more on Cantor Rosenblatt and his importance to *The Jazz Singer*'s account of assimilation and secularization, see my essay '"Sacred Songs Popular Prices."'

79. The singer who plays the part of Jakie, Al Jolson, was himself the son of a cantor, as the pressbook for the film repeatedly emphasizes. Samson Raphaelson, the film's screenwriter, recalled sensing this connection when he first saw Jolson perform: "This grotesque figure in blackface, kneeling at the end of a runway which projected him into the heart of his audience, flinging out his white-gloved hands, was embracing that audience with a prayer—an evangelical moan—a tortured, imperious call that hurtled through the house like a swift electrical lariat with a twist that swept the audience right to the edge of that runway. The words didn't matter, the melody didn't matter. It was the emotion—the emotion of a cantor" (Raphaelson, "Birth," 812). (Raphaelson's essay also appeared in the souvenir program for the film; see Kreuger, ed., *Souvenir Programs*, 14.)

80. I'm echoing the arguments of Susan Gubar and Linda Williams here. In *Racechanges*, Gubar observes that "the black and white faces of Jack emphasize his self-division, his divided loyalties, his sense of doubleness or duplicity" (69), while in *Playing the Race Card*, Williams points out that the scene of Jakie's "blacking up…trigger[s] the first explicit articulation of Jakie's Jewishness to Mary, his gentile girlfriend" (149).

81. In a 1929 book Will Hays recalled how the guiding spirit behind *The Jazz Singer*, Sam Warner, died shortly before the film was released, but "the show had to go on"—which "by an odd coincidence" was the "very theme" of the picture (Hays, *See and Hear*, 51).

82. Even Jakie's expression of grief is ambiguous: he sings tearfully about his mammy, never mentioning the dead father who would better account for his sorrow.

83. Whenever Jakie blacks up, as Peter Stanfield emphasizes, "we see not the exuberant and dynamic persona of earlier scenes but a cowered and pathetic figure" ("Octoroon," 412).

84. Sherwood, *Best*, viii–ix; the "cheap" remark is quoted in Baumann, *Hollywood Highbrow*, 23. As if to prove Sherwood's point, William Allen White in 1936 declared that "the best in all other arts is conceived, produced, sold and lives or dies solely and with brutal frankness for the approval of the intelligent: in all the arts except in the movies" (quoted in Baumann, *Hollywood Highbrow*, 2).

85. Read, *Art*, xiii; Seldes, *Hour*, 90; West, *Day*, 97.

86. Woollcott, "Charlie," 197; Fiske, "Art," 98. Fiske admits that "Chaplin is vulgar," but so, she says, are Aristophanes, Plautus, Terence, Shakespeare, Rabelais, Fielding, Smollett, and Swift (98).

87. Rotha, *Celluloid*, 94. Cf. the claim of J. D. Williams in 1926 that "Chaplin in 'A Woman of Paris' told a life's story in the simple action of a man helping himself to a handkerchief" ("Influence," xiii–xiv).

88. Brownlow, *Search*, 21. Brownlow thinks that the stick outtake is "quite clearly the original opening" of *City Lights* because "the statue, which is unveiled in the opening of the film as we know it, is still covered in the establishing long shot" of the sequence (19). But while the outtake may have been an alternative version of the opening, we have no way of knowing whether it was the original opening.

89. For a similar contemporary analysis, see Isabel Stephen's 1928 article "Escape from the Monotony of Life," in which Stephen quotes the psychologist David Seabury's tale of a salesman who "was peddling some small article—I don't remember just what it was.

He wasn't having much success. No matter how hard he tried to secure a street audience by clever tricks or speeches, not a person stopped or gave him a glance. Suddenly a thought struck him. He stood perfectly still, staring up into the sky. Now, 99 persons out of 100 walk along the pavement looking horizontally in front of them. As soon as the passersby saw that salesman doing something out of the routine, they immediately caught at this bit of escape mechanism, and they, too, stopped and stared up into the sky. In no time he had a small mob about him." Seabury comments, "There is an inner rebellion against being standardized in much the same manner that motorcars are standardized."

90. Seldes, *7 Lively Arts*, 13, 22; *DE* 143.

91. In his unpublished memoir, Chaplin's assistant Harry Crocker recalls that a reporter once urged Chaplin "to picture the rose in the gutter," and Chaplin later confided to Crocker that the "phrase has never left me—it is indelible in my mind, and it has been a source of great inspiration to me. In my films now I am always trying to picture the rose in the gutter" ("Charlie Chaplin," 13.5).

92. "Three Years in the making for your two hours of fun," declares the first page of the pressbook for *City Lights*. Although the record for retakes no longer appears in the print or online editions of *The Guinness Book of World Records*, the company has assured me in private correspondence that it can still be found in their database.

93. Chaplin, *My Father*, 82; Fiske, "Art," 97–98.

94. Hake, "Chaplin," 90; Hayes, ed., *Interviews*, 121; Rotha, *Celluloid*, 93, 96. Borges had a similarly negative reaction to *City Lights*, which he dismissed as "no more than a weak anthology of small mishaps imposed on a sentimental story" ("Film Reviews," 5).

95. Adorno, *Culture Industry*, 106; Prynne, *Histrio-mastix*, 547r; Beaumont, in Fletcher, *Faithfull Shepheardesse*, ¶3v; Fennor, *Descriptions*, B2v; Northbrooke, *Treatise*, 62. The author of the *Refutation of the Apologie for Actors* (1615) tells a similar story about "the wise *Cato*," who "once went into the *Theater* at *Rome*, and presently departed forth again: and being demanded why he did so; answered, *He went into the Theater only that he might be seen and known to go out of it*" (6).

96. *RG* 5.1.33, 320.

97. Capra, *Frank Capra*, 240; Rotha, *Film*, 27; Churchill, "Meet John Doe," 115.

98. *DE* 236. "In the culture industry the individual is an illusion not merely because of the standardization of the means of production. He is tolerated only so long as his complete identification with the generality [*Allgemeinen*] is unquestioned" (154; "Kulturindustrie," 177).

99. I quote from a recent reissue of C. K. Scott Moncrieff's translation of Pirandello's *Si Gira* (4).

100. Hansen, "Room-for-Play," 14. Fredric Jameson offers a similar summary of this conventional view: "As for play, it may also no longer mean very much as a reminder and an alternative experience in a situation in which leisure is as commodified as work, free time and vacations as organized and planified as the day in the office, the object of whole new industries of mass diversion of various kinds, outfitted with their own distinct high-tech equipment and commodities and saddled with thoroughgoing and themselves fully organized processes of ideological indoctrination" (*Postmodernism*, 147).

101. Earle, *Micro-cosmographie*, E3r; Webster, *White Devil*, "To the Reader," in *ERD*, 1665; *BJ* 2:228. A year after Jonson's first folio, Henry Fitzgeffrey scorned the idea of "Books, *made of* Ballads: Works: *of* Plays" (*Satyres*, A8r). Sir John Mennes's *Recreation*

for Ingenious Head-Peeces (1654) prints this exchange of epigrams on the subject: "262. *To Mr. Ben Jonson, demanding the reason why he call'd his plays works.* Pray tell me *Ben*, where doth the mystery lurk, / What others call a play, you call a work"; "263. *Thus answer'd by a friend in Ben Jonson's defence.* The Author's friend thus for the Author says, / *Ben*'s plays were works, when others' works are plays" (D7r). In 1660, Thomas Pecke wrote that Jonson "was the first gave the Name of Works, to Plays" (180; cited in Nelson and Altrocchi, "William Shakespeare," 468). But around 1600, Hamlet had already referred to the play within his play as "this piece of work" (3.2.46–47).

102. Brathwait, *English Gentleman*, 195; cited in Menzer, "Crowd Control," 32, although Menzer misses the 1630 edition of *The English Gentleman*. Brathwait repeats his point in his 1635 *Anniversaries*:

> I do hold no Recreation fitter
> Than Moral Interludes; but have a care
> You do not make them too familiar;
> For that were to invert a Recreation,
> And by day-practice make it a Vocation. (A3r)

In his 1638 *Spiritual Spicerie*, Brathwait reports that he himself was "moved" at times "to fit my buskin'd Muse for the Stage," but, he emphasizes, his aims were never "mercenary," and he never viewed his playwriting as "any fix'd employment" (429–31).

103. Earle, *Micro-cosmographie*, E3r; *1 Henry IV*, 1.2.155 (Falstaff urges "recreation" on Hal); *Hamlet*, 3.1.85–87, 1.2.84. For Hamlet's use of "actions" to mean "actings" or "gestures," see also 3.2.17–18, 3.4.128; for "action" in the classical sense of noble endeavor, see 2.2.303–6.

104. In his commendatory poem to Samuel Harding's tragedy *Sicily and Naples* (1640), Nicholas Downey implicitly associates Harding with Shakespeare when he claims that Harding's "play-work" distinguishes his dramaturgy from the more laborious efforts of Jonson: "thy brain / Vents fancies with a pleasure, his with pain" (2v). Earlier Renaissance writers use "play-work" as an expression of authorial modesty: thus Richard Carew refers to his "scribblings" in the *Survey of Cornwall* (1602) as "this playing work" (¶4r), and the lutenist John Maynard calls his song collection *The XII. Wonders of the World* (1611) "this poor play-work of mine" (A1r).

105. For an excellent introduction to the Hollywood backstage movie, see chapter 1 of Russell Jackson's *Theatres on Film*.

106. "Café Complex," B15; *Footlight Parade* pressbook, 17.

107. Huxley, *Beyond*, 274–76; Benjamin quotes this passage in a footnote to his "Work of Art" essay (*SW* 4:278).

108. Nathan, *Theatre*, 137, 135.

109. The first quotation is from a famous passage in Erasmus's discussion of the adage "Festina Lente" (*Adagiorum Opus*, 353–54); "flood" is the English translation for "*turba*" or "mob" in the Toronto *Collected Works* (33.12–13). The second quotation is from Burton's *Anatomy*, 8–9. For an absorbing account of Renaissance anxiety about the overload of "scholarly information" that print produced, see Ann Blair's *Too Much to Know*.

110. Prynne, *Histrio-mastix*, **6v; Crosse, *Vertues*, P4r-v. Time created this paucity, not the classical dramatists themselves. As Robert Miola reminds us, "Menander alone wrote over 100 plays; in the second century Aulus Gellius…noted that 130 plays were circulating

under Plautus' name; [and] Suetonius...records the story that Terence died at sea while carrying back from Greece 108 plays adapted from Menander" (*Shakespeare*, 1 n. 3).

111. Jonson, "To the Reader" of *The Alchemist*, *BJ* 3:558.

112. Seldes, *7 Lively Arts*, xvi–xvii (I quote from his 1922 proposal for the book); Kael, "Trash, Art, and the Movies," 217–18. Although Seldes claimed "that there is no opposition between the great and the lively arts" (349), he offered little praise for traditional high culture. Even the popular novels of Dickens, he believed, were at best a "mixed" bag (50). Throughout her own essay, Kael vacillates on the question whether "a piece of trash" such as the 1968 *Thomas Crown Affair* "has any relationship to art." On the one hand, she claims that the "unifying grace" of "a Lubitsch" could "transform this kind of kitsch" and "make art of it"; on the other hand, she prefers movies that are "honestly crummy," and she suggests that there is at best only "a little art in good trash." Kael is consistent, however, in opposing herself to those "ideologues" such as Horkheimer and Adorno "who denounce us for enjoying trash" ("Trash," 217–19).

113. Seldes, *Hour*, 26.

114. Heywood, *Gunaikeion*, A4v; Shirley, in Beaumont and Fletcher, *Comedies and Tragedies*, A3r; Dryden, *Works*, 13:247; cf. *Works*, 17:55.

115. In Philemon Holland's 1603 translation of Plutarch's *Moralia*, Plutarch argued that Menander was superior to Aristophanes because Menander "so framed his phrase and speech, that proportionate it is and suitable to all natures & sexes, to each state and condition, yea and to every age." "Some write to the capacity of the multitude and vulgar sort, others for men of mark and understanding," Plutarch continued, "and hardly is a man able to name the author, who can skill how to observe that which is meet and befitting two kinds of people"—yet Menander "satisfieth and contenteth all" (*Morals*, 943; cf. the Loeb *Moralia* 10.469–71).

116. Dangerfield and Howard, *Film Artiste*, 12 (as they explain on page 11, Dangerfield and Howard choose to refer to the director as "the producer"). Cf. Frances Taylor Patterson in 1928: "Of course the ideal director should combine the actor, the artist, the painter, the sculptor, the dramatist, and the technical camera expert in one. The amalgam of all these, plus perhaps a bit of the architect, of the psychologist, and of the critic, would be in very truth the perfect director" (quoted in Dale, *How to Appreciate*, 199). As early as 1912, Frederick Talbot asserted that "the producer must be a man of many parts" (147).

117. Barry, *Let's Go*, 130; Philip K. Scheuer in Hayes, ed., *Interviews*, 100. See, e.g., Robert Sherwood's praise of Chaplin as "a new type of artist" who successfully manages to "combine the offices of author, camera-man, director and producer" ("Silent," 24).

118. Chaplin, *My Father*, 170; Ward, "Even a Tramp Can Dream," 104. Chaplin's assessment of the semi-autobiographical figure of Calvero in *Limelight* shows how he thought that his own fame depended on his playing a humiliated nobody: Calvero, Chaplin explains, "acquired a feeling of dignity" that "divorced him from all intimacy with the audience" (Chaplin, *Autobiography*, 257).

Chapter 1

1. For good introductions to Aernout van Buchell's copy of de Witt's sketch, see Foakes, *Illustrations*, 52–55, and Gurr, *Shakespearean Stage*, 162–68. Other theater historians might claim that a surviving Elizabethan sketch of a *Titus Andronicus* performance also depicts a

playhouse interior, but nothing in the sketch necessarily indicates an actual stage; see Foakes, *Illustrations*, 48–51. A sketch in a letter from the theatrical entrepreneur Philip Henslowe to the actor Edward Alleyn seems as if it *should* be related to the stage, but this is not clear from the sketch itself; see Foakes, *Illustrations*, 46–47.

2. For a transcription of de Witt's Latin notes, as well as photographic reproductions of them, see Whalley, "Swan." A partial English translation can be found in Hodges, *Globe*, 108.

3. "What did the Rose or Curtain or Swan look like," Menzer asks, on the days "when the actors may even have outnumbered the auditors? As luck would have it, we do not have to imagine, since the only graphic image of the interior of a London playhouse from the period depicts just such an occasion" ("Crowd Control," 20).

4. Nagler, *Shakespeare's Stage*, 10; Gleason, "Origins," 337–38, 331, 338, 332, 331, 335. Menzer acknowledges Gleason's point: "Of course, one objects, Johannes de Witt left the audience undrawn out of mere illustrative convention." "But," he continues, "drawing an audience is the primary point of theater, and it is striking that our lone image of an early modern London playhouse in use inscribes the absence [of the audience]" ("Crowd Control," 20).

5. Gleason offers what he calls a "functional" explanation for the emperor's presence in the engraving: "He is shown because he is the central point in the social organization of the performance and his place therefore has functional importance in the print" ("Origins," 335). But there can be no "social organization" in the audience if it consists of one person only.

6. While similarly noting the apparent "failure" of contemporary theater illustrations "to include an audience," Stephen Orgel draws the different conclusion that the illustrations imply the need for an audience to complete them ("Shakespeare," 554). But Orgel does also note that de Witt's "architectural model" of the theater "belies" the "essential" importance of the audience (558).

7. *SW* 4:254, 269, 264, 267; Nashe, *Works*, 1:212. Muriel Bradbrook comments, "The English history play must have been one of the great means of unifying the spectators and creating an audience out of a throng" (*Rise*, 110). Although Talbot prominently figures in *1 Henry VI*, Nashe might be referring to some other Elizabethan history play in which Talbot appears, or he might be referring to *all* the history plays that had featured Talbot.

8. *1 Henry VI* 1.1.155, 4.2.28.

9. Northbrooke, *Treatise*, 60–64.

10. *SW* 4:269, 264, 253–54. The analogy is implicit in Benjamin's claim that mechanical reproduction makes artworks appear *massenweise*, multiplicitous, rather than unique (264; "Kunstwerk," 477). Samuel Weber first drew the attention of English-speaking critics to *massenweise* in his *Mediauras*, 84. The term appears six times in the German text: see "Kunstwerk," 474, 477, 481 n. 9, 506 n. 32. In the two instances before the passage I'm quoting, the English translation renders *massenweise* as "in large numbers." The final instance in the text unmistakably correlates the term with the masses: *"Mass [massenweisen] reproduction is especially favored by the reproduction of the masses [Massen]"* (*SW* 4:282 n. 47, "Kunstwerk," 506 n. 32).

At one point in the third version of the "Work of Art" essay, Benjamin insists that only *false* value is drained from the individual: "For the first time—and this is the effect of film— the human being is placed in a position where he must operate with his whole living person,

while forgoing its aura." Yet he never specifies what new plenitude for the individual follows "the shriveling of the aura" (*SW* 4:260–61). The second version of the essay offers a more direct account of what the film actor can achieve: "To perform in the glare of arc lamps while simultaneously meeting the demands of the microphone is a test performance of the highest order. To accomplish it is to preserve one's humanity in the face of the apparatus" (*SW* 3:111). For this and other significant differences between the second and third versions of Benjamin's essay, see Miriam Hansen's excellent article on the subject, "Room-for-Play."

11. Greenberg, "Avant-Garde," 16, 20; *DE* 149, 154–55. In the German of Horkheimer and Adorno, "the power of the generality" is "der Macht des Allgemeinen" ("Kulturindustrie," 178); "Allgemeine" connotes the public and common as well as the universal.

12. Eliot, "Thomas Middleton," 89; Bristol, "Shamelessness," 280, 304. For a related critique of the way that theorists have invidiously distinguished "mass culture" from "popular culture," see Burt, "To e- or Not to e-?" 3 ff.

13. Dekker and Middleton, *The Roaring Girl*, 1.2.17–24. Unless otherwise indicated, I quote the *ERD* edition of the play, hereafter cited as *RG*.

14. *RG* epist. 18–19. Claiming to have observed open assemblies of more than a thousand "puritans" from his prison cell at Wisbech, the Jesuit priest William Weston maintained (c. 1611–15) that "each of them had his own Bible, and sedulously turned the pages and looked up the texts cited by the preachers, discussing the passages among themselves to see whether they had quoted them to the point, and accurately, and in harmony with their tenets" (*Autobiography*, 164–65). Margaret Spufford cites a puritan preacher who was equally appalled by the prayer-book culture of his congregation: although he warned that those who "would have service said according to the book of common prayer are papists and atheists," he could not stop his parishioners from "looking in their books" (cited in Spufford, *Small Books*, 34).

15. *RG* 1.2.25–28; William Vaughan in *The Golden-grove* (1600) complains that people "gad to Stage-plays, & are seduced by flattering coney-catchers" (V7r); Gosson, *Apologie*, L8r.

16. *DE* 133.

17. *RG* 1.2.6–14. In a superb essay on the play, "Play-Making," Viviana Comensoli emphasizes among other things the relative newness of "subdivided" homes (252) such as Sir Alexander's in Renaissance England. This subdivision does, however, somewhat undermine Comensoli's distinction between the "*domus*" and "the polymorphism of the city" (251) in the play.

18. The groat, a fourpence coin, was colloquially taken to represent a trivial amount of money, as suggested by the title of Greene's *Groats-worth of Witte*.

19. *DE* 127, 145. For a more sympathetic critique of Adorno, see Huyssen, *After*, 16–43, and also David Jenemann, who tries to rescue Adorno from the charge of elitism by arguing that Adorno "thoroughly … immersed himself in America's myriad forms of entertainment and communication" (*Adorno*, xvii). But a person can hold contradictory views, whether through ambivalence, confusion, or insincerity; Middleton and Dekker dramatize such contradictoriness in Sir Alexander.

20. *SW* 4:256, my emphasis. Benjamin cites the growing interest in statistics as an example of this new sense for sameness, and statistics do help illustrate the distinction he has in mind: while they may identify likenesses that were previously unperceived, they do not create the likenesses, nor are their claims of likeness necessarily accurate or persuasive.

21. *RG* 3.3.31.

22. Ibid., 1.2.27–28; *DE* 156.

23. *RG* 1.2.128–29, 173; 1.1.84–86; 1.2.134–35; 5.2.159–60; 1.2.220–23.

24. Ibid., 1.1.99–102, 1.2.202, 2.1.181–83.

25. *RG* 2.1.152–57; Eisenstein, *Printing*, 84; *RG* 2.2.155–71, 141–44, 5.2.252–53, 5.1.350–51.

26. *RG* 2.2.181. Kelly Stage makes the same point: "Moll's ubiquity in city and suburban spaces identifies her with the entirety of London, which otherwise resists homogeneous totalization" ("London Spaces," 419).

27. Again, Stage makes the same point: "Moll cannot be limited to any one neighborhood"; "For Moll to hold the urban together…she must canvas the city" ("London Spaces," 430). Cf. Peter Womack: "The whole point of [Moll's] role is the social and spatial mobility that makes her equal to the diversity of the city" (*Renaissance Drama*, 206).

28. *RG* 2.1.185–88, 213–14, 1.2.131–32, 2.2.37–38, 1.2.216, 2.1.118.

29. Ibid., 5.1.176. By calling Moll's work of translation "cross-talking," Jodi Mikalachki suggestively links it with Moll's cross-dressing ("Gender").

30. Ibid., 5.1.311–15, 317–22.

31. Ibid., 5.1.304–5, prol. 9–10.

32. Ibid., 5.2.2, 20; epil. 1–16.

33. *SW* 4:257, 255.

34. Maus in *ERD* 1371; Forman, "Marked," 1541. For the fullest account of the surviving evidence on Frith's life, see Ungerer, "Moll Frith."

35. *RG* prol. 16. For other female cross-dressers at the time, see Rose, "Women," 369ff., and Howard, "Crossdressing," 420; for other women who took the stage as Frith did, see Orgel, *Impersonations*, 7–8. Natasha Korda challenges Frith's "exceptional status by suggesting that her classification as a player, cut-purse, and roaring-girl (the terms ordinarily used to situate her within the social order) only serves to mystify her quite unexceptional status as a worker within the networks of commerce surrounding early modern London's public theaters" ("Case," 71).

36. "There is an obvious qualitative leap between the hand that draws an animal on the wall of a cave and the camera that makes it possible for the same image to appear simultaneously at innumerable places. But the objectivation of the cave drawing vis-à-vis what is unmediatedly seen already contains the potential of the technical procedure that effects the separation of what is seen from the subjective act of seeing. Each work, insofar as it is intended for many, is already its own reproduction. That in his dichotomization of the auratic and the technological artwork, Benjamin suppressed this element common to both in favor of their difference, would be the dialectical critique of his theory" (Adorno, *Aesthetic Theory*, 33; I'm grateful to Richard Lee for this reference).

37. The 1611 quarto of *The Roaring Girl* emphasizes this sense of the artist's having extracted life from the woman by stating that "every part" of the woman has been "*limb'd* to the life*" (M3r) in the artist's drawing.

38. Carroll, *Philosophy*, 189, 192; *RG* epil. 28–30.

39. Carroll, *Philosophy*, 206, 192 (my emphasis), 233; *RG* prol. 13–15.

40. *RG* 4.2.239, 4.1.143–45. Like so many other comedies of the period, *The Roaring Girl* contrasts the gregarious tolerator of vice with the "Puritan" whose scrupulousness inevitably generates "contention" (3.3.45).

41. *RG* 5.1.318, 3.1.73–78. By contrast with the libertine, the exceptionally tolerant husband Mr. Openwork views even attempted adultery as no worse than a venial misstep— "a trick of youth," he calls it (4.2.249).

42. In his prefatory letter to *The Roaring Girl*, Middleton defends the play itself as a form of minor vice. True, he confesses, the play has sex or "venery" in it "enough for sixpence." But not only is sixpence of licentiousness a tolerably small amount, it is also "good" to keep you from worse dissipations such as "dice," and it is even better for warding off the hypocrisy of the puritan who denounces "vice" while he "keeps a mystical bawdy house himself" (epist. 10–27).

43. *RG* 4.1.87–90; 2.1.51; 5.1.178, 207–10, 316–17; 2.1.363–64; 2.2.85–94; 1.2.129–30; 2.2.200.

44. *RG* epil. 34, 4.2.99–100, prol. 1–6.

45. *RG* prol. 10; Horkheimer and Adorno, *DE*, 139; RG epil. 21–22 (my emphasis), 23–26.

46. RG epil. 34–38. As Anthony Dawson points out, Frith's own theatricality "blurred" the "boundaries" between real and fictional. Well before the epilogue, Dawson adds, the play offers "a continually revised and reconstructed image of the 'real' Moll" ("Mistris," 390, 401).

47. *RG* prol. 15, 3–4, 27–28. The note to these lines in *ERD* seems to get their meaning backward: "Why give away the 'character' of Moll now, under the (false) assumption that such an abstract speculation would be better than letting Moll enact her own story in her own person?" But the prologue states that a "guess" is "better" than "express" representation.

48. RG 5.2.46. Cf. Madhavi Menon: "Instead of sexual and metaphoric completion, the epilogue leaves behind an audience full of lackstones who metonymically desire more than can satisfy their desire" (*Wanton*, 64).

Chapter 2

1. Sayre, "Did Cooper," D11.

2. Ibid., D11, D12; Nugent, "All-American," SM18.

3. I refer throughout to the VCI Entertainment DVD of *Meet John Doe*.

4. *Box Office Digest*, Apr. 3, 1941, 20; Crowther in *MJD* 222; *Variety*, Mar. 19, 1941, 16; Creelman, "The New Movies," 24; Bower, "Films," 390; *Scribner's*, May 1941, 105; Vineberg, "Master," 31; Thomas, "Capra," F18.

5. Nathan, *Theatre*, 134. Even the film enthusiast Seldes made much the same point: "The majority" of movies, he wrote in 1929, "are so stupid, tasteless, and wearisome that no man of average intelligence could bear to look at them twice" (*Hour*, 7). *Meet John Doe* irritated Sayre, however, because she thought that most other "movies made for the mass market" during the 1930s "assumed that the audience was quickwitted" ("Did Cooper," D12).

6. Ortega y Gasset, *Revolt*, 190, 48, 13–14, 63, 49. In 1936, the film critic Seymour Stern claimed that Hollywood reduced everything it touched "to the lowest level of human intelligence"—that is, to the level of "the universal Average Man" ("Bankruptcy," 135).

7. Capra, *Frank Capra*, 303.

8. Ibid., 303, 305.

9. Poague, ed., *Frank Capra*, 93–94.

10. Schallert in *MJD* 224; *Meet John Doe* Pressbook, 25.

11. Otis Ferguson, Mar. 24, 1941, in *MJD* 236. The ad can be found in the *Meet John Doe* files of the Warner Bros. Archives; copyright issues have prevented me from reproducing it here. Another ad in the movie's pressbook says that Cooper's character is "3000 MILES WIDE AND 1000 MILES TALL!" (20).

12. *RG* 2.1.194–95.

13. Carney, *American Vision*, 372–73. As Carney puts it earlier in his chapter, "There is a fluidity and ethereality to Doe's existence, as his processed voice and presence are distributed outward away from his body, in which Capra almost rejoices, but there is also a frightening thinness of presence and a loss of identity that Capra dreads and from which he ultimately recoils" (363).

14. Ibid., 374; *RG* prol. 10.

15. *RG* 5.2.162, prol. 10, 5.1.57–60. For "World's End," see Sugden, *Topographical Dictionary*, 571.

16. *RG* 5.1.86, 93, 133–34. Tearcat admits that he "instructed" Trapdoor "in the rudiments of roguery, and by my map made him sail over any country you can name" (143–45).

17. *RG* 5.1.178, 176, 131–32. For more on the commonwealth of rogues as a kind of domestic foreignness, see chapter 2 of my *Shakespeare's Tribe*.

18. *RG* 5.1.352, 5.2.1–2.

19. Carney, *American Vision*, 361.

20. In recognition of this intensive extensiveness, Capra habitually envisioned movie audiences as being close in size to John's audience in the radio theater: "a thousand people" (Poague, ed., *Frank Capra*, 78, 79, 168), like the "thousand heads" in the theater of *The Roaring Girl*.

21. Capra, *Frank Capra*, 302.

22. Carney, *American Vision*, 352, 356.

23. Browne in *MJD* 282–83.

24. Quart, "*Meet John Doe*," 60.

25. Initially, Ann had felt stymied in her job as John's speechwriter. "I simply can't get it to jell," she complained to her mother. "I created somebody who's going to give up his life for a principle,... and, unless he says something that's, well, that's sensational, it's just no good!" Her mother gives Ann direction, but not by replacing the blurriness of her "somebody" and "something" with specificity. "Why don't you let him say something simple and real, something with hope in it?" she advises Ann before presenting her with her father's diary. And what exactly does the diary contain? "Things," says the mother vaguely, that "people ought to hear nowadays" (79–80).

26. As an earlier scene of John pitching in an imaginary ballgame suggests, his baseball career is now only a fiction, and it may always have been so: in his next scene after his airport conversation with Ann, John admits to Ann's mother that "the best I ever was was a bush-league pitcher" (134).

27. Toles, "Believing," 48, 40.

28. Falling short of the "real" John Doe is a constant theme of John's: for instance, when he says to Ann and Norton that "a fellow'd have to be a mighty fine example himself to go around telling other people how to..."

29. Blumer, "Collective Behavior," 219–80, 241, 242, 244, 256, 257, 241.

30. Ibid., 241, 242, 244, 256, 257, 241.

31. See Ruttenburg, *Democratic Personality*. In *Doe*, Connell becomes absorbingly sincere only when alcohol has compromised his usual articulacy.

32. Letter from Capra, Apr. 8, 1941, in *MJD* 206.

33. Capra, *Frank Capra*, 304–5. For his next film, Capra chose a project far more limited in scope than *Doe*—the hit Broadway play *Arsenic and Old Lace*. He later recalled how comforting it was to know that "the whole picture" could "be shot in the studio, on one

stage, in *one set*"—"no great social document 'to save the world,' no worries about whether John Doe should or should not jump; just good old-fashioned theater" (310–11).

34. Phelps, "Frank Capra," 56; Glatzer in *MJD* 252. As Wolfe points out, the closing moments of the film emphasize the multiplicity of social roles to which John submits himself as he turns away from the brink: "Alternatively hailed by the Colonel and Mrs. Hansen as 'Long John' and 'Mr. Doe,' John does not appear headed toward a world in which his identity has been any more sharply defined" (*MJD* 28).

35. Letter from Capra, Apr. 8, 1941, in *MJD* 206. Capra is responding to an undated letter from M. Gluck, now in the Capra Archives at Wesleyan, in which Gluck declares, "You showed us that you *don't* believe in us. You think we're a lot of silly sheep. That's what Hitler said about his people and that's what he made them into." Another fan, Keith Gordon, makes the same point in another undated letter: "We 'John Does' are made to look like a bunch of Judases."

36. Among many possible examples, I single out the chapter "The New Intimacy" in Arthur Edwin Krows's 1930 monograph *The Talkies* (115–41).

37. *RG* 2.1.281; Poague, ed., *Frank Capra*, 139.

38. Poague, ed., *Frank Capra*, 160. Discussing the "number of very important scenes in crowds" in his 1932 film *American Madness*, Capra said, "I like to fill the screen with people. I love faces, I love to look at people, and I think others do too—all kinds of people, walking in and out" (113). And again in a later interview: "I like people, especially faces. Even in a crowd I always study faces. I think the audience is the same way. They want to see faces. That's the 'people-to-people' communication" (194).

39. Capra in Poague, ed., *Frank Capra*, 74. For Capra, "a close-up is an emphasis" that makes the audience wonder, "What are her thoughts at this moment?" (157).

40. The emphasis is mine.

41. Hopper in *LAT*, Mar. 15, 1941; Scheuer in *LAT*, Mar. 16, 1941; Capra, *Frank Capra*, 121. Cf., e.g., Schallert: "All that lacks in the picture is the spell of a great sacrifice to make the whole impression convincing" (*MJD* 223). Fans made the same complaint to Capra directly. "Why pull your punches," wrote Elizabeth B. Phillips in a Mar. 19, 1941, letter to Capra preserved in the Capra Archives at Wesleyan: "why not let the guy die for his principals [*sic*]"? Capra admitted to these fans that the question "whether he should jump or not worried me for 18 months," but "now," he pointed out in an Apr. 8, 1941, letter to Fay Stanley, "its [*sic*] worrying the audience, and they are about equally divided."

42. Capra, *Frank Capra*, 305. In the final scene, Ann insists that John doesn't have to kill himself for the movement because the sacrifice of "the first John Doe," Christ, was sufficient in itself. She might have added that Christ achieved his John Doe status providentially rather than through a publicity campaign.

43. In a 1935 article on mass behavior and film, Blumer argued that whenever "individual conspicuousness or difference" becomes too "pronounced," "the individual is in a true sense divorced from the mass" ("Moulding," 118).

44. Poague, ed., *Frank Capra*, 105.

Chapter 3

1. *DE* 137, 121, 134, 137, 131. Adorno expands on this position in his essay "Free Time," where he claims that, even in "the inanity of many leisure activities," "the contraband of modes of behavior proper to the domain of work, which will not let people out of

its power, is being smuggled into the realm of free time" (190). So it is that free time has become "nothing more than a shadowy continuation of labor" (194).

2. Northbrooke, *Treatise*, title page, 39, 69; I.G., *Refutation*, 60; Prynne, *Histrio-Mastix*, 505; Cox in Wickham et al., eds., *English Professional Theatre*, 169; Prynne, *Histrio-Mastix*, 504.

3. Stubbes, *Anatomie,* L8r; this passage is repeated, with minor changes, in I.G., *Refutation*, 61. In his *Poore Mans Jewell* (1578), Thomas Brasbridge urges "all them that are in authority, to ask counsel of God...whether these daily customs of running to plays, and interludes, and to bearbaitings, as well upon the Sabbath day, ordained for the service of God, as upon other days, appointed for men to work...do displease God, and provoke him to plague us, or no?" (B3r–v).

4. *DE* 121; Northbrooke, *Treatise*, 71; [Munday?] and Salvianus, *Blast*, 122; Wybarne, *New Age*, 53; I.G., *Refutation*, 1; Gosson, *Plays*, B3r, in *Markets.*

5. Rutter, *Work*, 3, 37; *1 Henry IV*, 1.2.204–5; Rutter, *Work*, 36, 33.

6. *DE* 134, 121; Rutter, *Work*, 27, 86, 88, my emphasis.

7. *DE* 120.

8. This 1594 instance is quoted in Chambers, *Elizabethan Stage*, 4.314.

9. *1 Henry IV*, 3.2.87; *Hamlet*, 1.5.172.

10. *Comedy of Errors*, 1.2.24–29, 19–20, 42, 59, 68–69.

11. Ibid., 1.2.63, 43, 62.

12. Ibid., 2.1.11, 3.1.2, 4.1.27, 33, 57, 59 (my emphasis).

13. Ibid., 4.1.106, 4.4.67, 4.3.82, 4.4.129, 104-5.

14. Ibid., 2.2.64–65; Rutter, *Work*, 86; *Comedy of Errors* 5.1.38.

15. *Comedy of Errors*, 1.1.4, 1.1.150, 5.1.118, 1.2.7, 80 (Antipholus says he is currently "undispos'd" for jesting).

16. Ibid., 1.2.12, 33–38, 30–31.

17. Ibid., 1.1.18; 4.4.46, 102–3; 5.1.236; 3.1.98–104; 2.2.29, 26.

18. Ibid., 4.3.1–11, 1.2.97, 2.2.214–16, 4.4.32–37.

19. *1 Henry IV*, 1.1.1–2; 3.2.179; 5.5.43, 36, 38; *2 Henry IV* 4.4.118.

20. *1 Henry IV*, 1.3.184, 2.3.57–62, 5.1.13, 1.3.32.

21. Ibid., 3.1.157, 2.3.92, 3.1.154, 133.

22. Ibid., 5.1.90, 1.3.31, 301–2.

23. Ibid., 1.2.1; 2.4.104–5; 1.2.205, 217; 5.3.55.

24. Ibid., 2.4.30, 57, 89–91, 100, 92–95, 19–21.

25. Rutter, *Work*, 86.

26. *Henry V*, 1.1.53.

27. Both Hal (*1 Henry IV*, 1.2.142–43) and Hotspur (4.1.95) refer to Hal as a "madcap."

28. *1 Henry IV*, 3.2.2, 12–17.

29. Ibid., 3.2.69, 51–52; 2.4.14–15; 3.2.46–47, 40–41, 76–77.

30. Ibid., 4.3.40, 3.2.78-80. The *OED* lists Henry's line about "community" under the heading of "Frequent occurrence; prevalency, commonness" (13.a); it adds William Covell's statement in *Polimanteia* (1595) that "Custom hath made it a thing common, & the community hath made it a thing credible, that the worse things have masked under good names" (Aa2r). For "community" as "baseness, vulgarity" (13.b), the *OED* cites William Cornwallis's essay "Of Alehouses" (1600–1601), which says that if great men were "banished from the Heralds' books," they would be "without any evidence of preeminence" and thus unable to "defend" themselves "from Community" (*Essayes*, M6v–M7r).

31. *1 Henry IV* 3.2.58–59. A common hackney is the opposite of the warhorse that Hotspur wants to bear him into battle "like a thunderbolt" (4.1.120).

32. Ibid., 1.3.8, 3.2.55. For labor as soiling, see Henry's description of his "true industri-ous friend" Sir Walter Blunt as "stain'd with the variation of each soil / Betwixt... Holmedon and this seat of ours" (1.1.62–65).

33. *Richard II* 1.4.24, 5.2.24, 3.2.2; *1 Henry IV* 3.2.87; *R2* 5.2.23. For the theater's regula-tion of its audience, see Menzer, "Crowd Control."

34. Rutter himself associates Hal's "creative approach" to work and play with a royal exceptionalism that makes the distinction between them seem "a matter of monarchical will" (*Work*, 86, 84).

35. *Hamlet*, 1.1.71–78. In an absorbing essay on *Hamlet*, Richard Halpern anticipates my point here in two respects: he highlights the play's emphasis on "forms of activity that take place ceaselessly," and he links that emphasis to the Elizabethan theater's status as "a kind of continuous carnival or holiday transposed to the heart of the workday itself" ("Eclipse," 461, 459). For Halpern, *Hamlet* dramatizes the "eclipse" of ostensibly pur-poseful "action" by ostensibly purposeless "activity." But, like Horkheimer and Adorno, Halpern associates this eclipse with a particular stage of capitalism, rather than with the generic concerns of mass entertainment.

36. *Hamlet*, 1.2.92 (my emphasis), 125, 12; 3.4.2.

37. Rutter, *Work*, 154, 119; *Hamlet*, 1.5.133. Rutter paints himself into the corner of defining Hamlet's tragic behavior as "successful" when he treats any theatrical reference to play-work as a *defense* of the actor's profession (*Work*, 119).

38. Rutter, *Work*, 114, my emphasis; *1 Henry IV*, 2.4.110, 387, 395–96.

39. *Hamlet*, 2.2.328, 335, 342; 3.2.26–28, 33, 3, 11; 2.2.436–37.

40. Ibid., 3.2.25–26; 2.2.432, 327–28; 3.2.28; 2.2.555; 1.5.97; 4.3.4.

41. Ibid., 5.2.396–98; 3.2.20; 2.2.588–98; 5.1.17; 2.2.27.

42. Brathwait, *English Gentleman*, 195. The story is repeated, with some variation, in Prynne's *Histrio-Mastix*, 556r.

43. After joking that his performance as a spectator at *The Mousetrap* could "get me a fellowship in a cry of players," Hamlet accuses Guildenstern of hoping to "play upon" him and thus "pluck out the heart of my mystery" (*Hamlet*, 3.2.275–78, 364–72).

44. Ibid., 1.1.103, 3.2.90.

Chapter 4

1. Sills, "Actor's Part," 190; Barry, *Let's Go*, 6–7; Spivak, *Buzz*, 84. Many contempo-raries similarly regarded the waterfall number as incomparable. "Busby Berkeley is thought by every reviewer and every show-conscious habitue of Broadway to have outdone himself in the 'By a Waterfall' number," wrote Norbert Lusk for the *Los Angeles Times* (Oct. 15, 1933, A2); "this number," Edwin Schallert agreed "is the most exceptional created so far for the talking and musical screen" (*LAT*, Nov. 10, 1933, A9). Cf. "Shadow Stage" [Review of *Footlight Parade*], 59.

2. "New Pictures," 30; *Washington Post*, Oct. 18, 1933, 16; *NYT*, Oct. 1, 1933, X4. Robert Birchard offers this dizzying summary of the number's actual shooting schedule: "The shooting of 'By a Waterfall' began on Saturday, June 24, with a 9 a.m. call for 126 girls, 31 singers, a 30-piece orchestra and a piano player for rehearsals. After recording the song, the orchestra was dismissed at 4:45 p.m. Berkeley then began shooting underwater

shots with the chorus girls, and continued until 2:48 a.m. on Sunday morning.... On Sunday afternoon, shooting resumed at 3 p.m. and continued till 2 a.m. Monday. And so it went: 131 extras, a piano player and a nurse came back at 10 a.m. and labored on till 1:20 the following morning, then returned at 10 a.m. and worked until 7:40 a.m. on Wednesday the 28th" ("Song-and-Dance," 70).

3. *Footlight Parade*, Pressbook, 23.

4. Jacobs, *Rise*, 508; Rubin, "1933," 103; Roth, "Warners Musicals," 51, 44.

5. Roth, "Warners Musicals," 48. Roth describes Roosevelt as a "strong" (48) leader who "cared about the 'little man'" (55).

6. The first talking picture, *The Jazz Singer*, was a backstager, as was the talkie "chosen by exhibitors nationwide as their premiere sound attraction" (Balio, *Grand*, 212): *The Broadway Melody*, which won the Oscar for Best Picture in 1929. For Broadway's own earlier backstage musicals, see Altman, *American Film Musical*, 205–6.

7. Kracauer, "Mass Ornament," 76–78; Gordon, "Fascism," 173; Roth, "Warners Musicals," 54; Tinee, "This Musical," 21; Scheuer, *LAT*, Nov. 12, 1933, 3. The pressbook itself describes the film as "the gripping story of a producer turned dictator" (6). Roth also compares Busby Berkeley to Roosevelt, but he ends his essay wondering how nearly allied the New Deal spirit was to fascism ("Warners," 55–56).

8. "Great Musical Spectacle," *Washington Post*, Nov. 3, 1933, 18 (my emphasis).

9. *DE* 137.

10. The culture industry, according to Horkheimer and Adorno, uses entertainment to "recommend" work "to the masses" (ibid., 144).

11. *Washington Post*, Nov. 3, 1933, 18; *NYT*, Oct. 6, 1933, 21; cf. *NYT*, Oct. 15, 1933, X3. A review in the pressbook calls the plot of the movie "harum-scarum" (2).

12. *Washington Post*, Nov. 3, 1933, 18. In a valuable essay on art/work in classical Hollywood musicals, Eric Smoodin argues that *Footlight Parade* eases the "oppressive" burden of "business" on Chester's art by differentiating between the crass "corporate capitalism" of Chester's partners and the more creative "entrepreneurial capitalism" that Chester practices ("Art/Work," 79–80). But when he goes on to claim that Chester achieves "economic stability" (81) through his creativity, Smoodin exaggerates the extent to which *Footlight Parade* reconciles work and art.

13. Rubin, *Showstoppers*, 15; Kracauer, *Mass Ornament*, 83, and *Das Ornament der Masse*, 60. I quote from an article in the April 1930 issue of *Motion Picture News*: "The copycat tactics which have prevailed in this industry ... unloosened on the market near and far melodic films in such a flood that it was inevitably apparent the public would tire of them" (cited in Barrios, *Song*, 325).

14. Cagney, quoted in McCabe, *Cagney*, 113, and in Schickel, *Cagney*, 63.

15. For instance, Hal Wallis in an Oct. 4, 1932, memo offered an outline of "the idea that we would follow in developing a story around a so-called Prologue Factory." This story, centered on "the Fanchon and Marco prologue idea—the prologue factory," was further elaborated in a Mar. 27, 1933, "Story Idea" by "Melville Crosmon" (a pen name for Darryl Zanuck). And the June 10, 1933, screenplay for *Footlight Parade* by James Seymour and Manuel Seff called for a shot of a newspaper headline about the "MILITARY TACTICS USED IN PROLOGUE FACTORY/Studio in State of Siege" (117).

16. Griswold, "Let's Be Ourselves," 46, 105. An article in the Jan. 18, 1932, issue of the *Milwaukee Sentinel* claims that "never less than 52 Fanchon and Marco companies are on the road" (6). The Oct. 10, 1933, *Variety* review of *Footlight Parade* states that "the exterior

of the presentation production factory" is "almost a replica of the F&M offices on Sunset Boulevard" (17).

17. See Wagner, "America," 264.

18. *SW* 4:252–53; Benjamin, "Kunstwerk," 474–75.

19. Rubin highlights the similarly ambiguous "reality-status of the events" in the "Waterfall" number: "We appear to be witnessing a dream within a dream or, even more intricately, Ruby's dream within Dick's dream" (*Showstoppers*, 109).

20. Mast, *Can't Help Singin'*, 120, 135. Berkeley's "penchant for rendering the chorus into white-and-black patterns" (Rubin, *Showstoppers*, 94) was more conventional than it might now appear. For example, the Feb. 13, 1929, *Variety* review of *The Broadway Melody* pointed out that the "chorus dance stuff has been aided by dressing the girls in black and white to make them stand in relief" (13).

21. Mast, *Can't Help Singin'*, 137.

22. The children are more explicitly assimilated to the prejudicial figure of the minstrel in Seymour and Seff's June 10, 1933, screenplay, which envisioned the street scene this way: "A ragged colored gardener watering lawn with hose. Two pickaninnies in improvised bathing suits gurgle happily and tumble about as the gardener turns the hose on them" (136).

23. *DE* 142.

24. *Footlight Parade*, Pressbook, 22.

25. Ibid., 3; Lusk in *LAT*, Oct. 15, 1933, A2; L.H.C. in *To-Day's Cinema*, Nov. 10, 1933, 10.

26. Schallert, '"Footlight Parade' Spectacular Picture"; *Washington Post*, Nov. 3, 1933, 18; Schallert, '"Footlight Parade' Spectacular Picture."

27. The movie reviewer for the Oct. 21, 1933, issue of the *Literary Digest* makes a similar point when he notes that *Footlight Parade* combines "extravagant, frantically spectacular chorus numbers" that "couldn't possibly be presented on any stage in the known and restricted theater" with "a strange effort" at backstage "realism." The effect, he concludes, is "curiously fantastic" (31).

28. Johaneson, "Footlight Parade," 25; reprinted in *Footlight Parade*, Pressbook, 3.

29. Bethell, *Shakespeare*, 26, 25, 21–22, 30–31, 39, 25, 199, 31, 26.

30. Caldwell in *New Outlook*, Nov. 1933, 43, cited in Roth, "Warners Musicals," 45; Dickstein, '"Footlight Parade' Has"; A.D.S., "Screen," *NYT*, Oct. 6, 1933, 21. Positive reviews often struck the same note, as when the *Wall Street Journal* (Oct. 7, 1933) called the film "a worthy addition to the formula" (3).

31. Scheuer, "A Town"; *Washington Post*, Nov. 11, 1933, 9; Schallert, '"Footlight Parade' Spectacular Picture." Looking back on the film nearly a decade later, Scheuer still regarded the "Waterfall" number as "the super-duper of them all" ("This Town").

32. *Time*, Oct. 9, 1933, 36.

33. In the first number, the New York provenance is established by a newspaper ad for the "Hotel Hammond" on "Broadway at 32nd" beneath the ad for Honeymoon Hotel.

34. Lewis, "De Luxe," 175; *DE* 139. What seems to recommend the housewife as an exemplary filmgoer to Horkheimer, Adorno, and Lewis is their shared desire to think of the theater's darkness as special: men work during "the afternoon," all three writers assume, so only the housewife can relax in the theater's darkness when the sun is shining.

35. This ending also neatly reverses the experience of silent pictures, whose death had been proclaimed at the start of *Footlight Parade*. Now, instead of an image with no sound, we hear sound but see no image.

Chapter 5

1. Greenberg, "Avant-Garde," 12, 16. Cf. Dwight Macdonald: "Popular Culture is merely a vulgarized reflection of High Culture" ("Theory," 21).

2. Marcus, *Puzzling Shakespeare*, 26. Marcus adds, "It is as though, in the case of Shakespeare, the very fact that the plays had been acted (and were still being acted) was in some way peculiarly damaging" to their artistic status.

3. Kastan, *Shakespeare and the Book*, 48.

4. Ibid., 31.

5. Erne, *Shakespeare as Literary Dramatist*, 18, 2; Stallybrass and White, *Politics*, 76.

6. Erne, *Shakespeare and the Book Trade*, 37, 45, 54, 232, 99.

7. Ibid., 99, 111, 128, 124, 43–45. By the end of his discussion of "Shakespeare's para-textual silence," Erne speaks of the paratext as if it were the only "bibliographical locus which foregrounds the authorial self" (129).

8. Ibid., 124 (Erne's emphases). Erne too acknowledges that Shakespeare "may well have realized . . . his plays and poems were entering the literary canon" (232), but he stops short of claiming that Shakespeare *wanted* them to do so.

9. Ibid., 124 (my emphasis).

10. Ibid., 124–25.

11. Ibid., 124. Noblemen and other wealthy patrons also commissioned private perfor-mances of plays (see Chambers, *Elizabethan Stage*, 1.219–23) and even private transcripts of plays (see Chambers, *William Shakespeare*, 1.125).

12. I quote from the reproduction of the First Folio's prefatory material in *The Riverside Shakespeare*, 90–103. Erne excludes this material from his analysis on dubious grounds. Even though some of the chapters in *Shakespeare and the Book Trade* adduce evidence from the 1640s and '50s, Erne maintains that the 1623 First Folio is too late for him to consider because it "inaugurates a new time as far as Shakespeare's place in the book trade is concerned," a time "distinctly posthumous to Shakespeare" (6). What counts for Erne as distinctly different about the 1623 paratext, it seems to me, are its moments of high-cultural emphasis.

13. Beard, *Theatre*, 374; Gosson, *School*, D3r, in *Markets*; Erne, *Shakespeare and the Book Trade*, 111.

14. Webster, "To the Reader," *The White Devil*, in *ERD* 1664–5, quoting Martial, *Epigrams* 13.2, 10.2.

15. Jonson, "To the Readers" of *Sejanus*, in *BJ* 2.213–15; Fennor, *Descriptions*, B2v; Fletcher, *Faithfull Shepheardesse*, ¶1r; Middleton, *No Wit*, prol. 11–14, in *Collected Works*. The class coding for "mirth" in Middleton's prologue is also common in plays that refuse to indulge the multitude: consider among many possible examples the prologue to James Shirley's *Coronation* (acted 1635, published 1640), which assures the audience that the play will contain "no undermirth, such as doth lard the scene / For coarse delight" (A2r).

16. *"Neque, me ut miretur turba, laboro: / Contentus paucis lectoribus"* (*BJ* 3.555). The epigraph paraphrases Horace, *Satires* 1.10.73–74; Jonson so enjoyed these lines that he moved them to the front of his 1616 *Works*.

17. *Alchemist*, 1.1.1–4.

18. The printer Richard Jones made precisely this choice when publishing Marlowe's *Tamburlaine* in 1590: "I have purposely omitted and left out some fond and frivolous ges-tures, digressing and, in my poor opinion, far unmeet for the matter, which I thought might

seem more tedious unto the wise than any way else regarded, though haply they have been of some vain conceited fondlings greatly gaped at, what times they were showed upon the stage" (*ERD* 189). It's important to note, however, that contemporary readers familiar with the vulgarity of classical drama might well have viewed the coarseness in printed commercial plays as a learned, classicizing feature. For a brilliant account of Jonson's complex relation to classical obscenity, see Hutson, "Ben Jonson's Closet Opened."

19. *Cynthia's Revels*, prol. 7–8; *Epicene*, prol. 4–6; *Magnetic Lady*, induct. 93–96. The most poignant expression of Jonson's gradualist approach to winning over his audience appears in the prologue to his last, unfinished play, *The Sad Shepherd*:

> He that hath feasted you these forty years
> And fitted fables for your finer ears,
> Although at first he scarce could hit the bore—
> Yet you with patience heark'ning more and more,
> At length have grown up to him and made known
> The working of his pen is now your own. (1–6)

For more on the difficulty of applying the term "antitheatrical" to a former actor whose career as a commercial dramatist spanned four decades, see chapter 2 of my *Shakespeare Only*.

20. Dryden, additions to Sir William Soame's translation of Boileau's *L'Art Poétique*, quoted in Craig, ed., *Ben Jonson*, 320.

21. Thayer, *Ben Jonson*, 110; Barton, *Ben Jonson*, 152; *BJ* 3.555, from Lucretius, *De rerum natura*, 1.929–30: *"petere inde coronam / unde prius nulli velarint tempora Musae"* (I have used my own translation).

22. Maus in *ERD* 863, 865.

23. Mueller, "Hermione's Wrinkles," 227; Edwards, "Seeing," 91; *Winter's Tale*, 5.3.68, 72.

24. Jonson, "To the Reader," *BJ* 3.558. Jonson is paraphrasing Quintilian, *Institutio Oratoria*, 2.12.1–3: *"et rudia politis maiora et sparsa compositis numerosiora creduntur"*; "it is believed that rough objects are larger than polished ones, and scattered things are more numerous than things which are arranged well" (I quote Lorna Hutson's translation in *BJ* 7.521). As I'll shortly discuss, portions of *The Alchemist*'s letter to the reader appear again in Jonson's *Discoveries*, in *BJ* 7.521, 525–26.

25. When Jonson repeats one of the sentences from his *Alchemist* letter in *Discoveries*, he more clearly emphasizes this commitment to his audience: "The true artificer will not run away from nature, as he were afraid of her, or depart from life and the likeness of truth, *but speak to the capacity of his hearers*" (*BJ* 7.526; my emphasis).

26. Dryden, *Works*, 17.49, 45; Cartwright, *Ordinary*, prol. 15–17. (Cartwright doesn't name Jonson directly, but the reference is unmistakable.)

27. Barton, *Ben Jonson*, 137; Beaurline, "Ben Jonson," 52. In the prologue to *The Magnetic Lady*, Jonson is explicit about building the action around a "center attractive" that has the power to "draw thither a diversity of guests" (induct. 83–84).

28. Andrew Gurr, for instance, refers to the characters as "a deliberate conspectus of the kind of society that might have been reflected in the audience at the Blackfriars in 1610" (Gurr, "Prologue," 13). Barton similarly describes them as "like a cross-section of London society" (*Ben Jonson*, 137). But Maus cautions that, "despite the illusion of social comprehensiveness produced by such plays as *The Alchemist* or *Bartholomew Fair*, Jonson generally excludes from his comedies the artisan classes that populate Shakespeare's cities" ("Satiric," 44).

29. *Alchemist*, 2.3.200–2, 1.1.33–34, 2.6.11, 1.1.77, 1.1.72–73, 3.3.34–35, 5.2.17–19, 1.3.1, 1.4.1–2, 3.3.81, 4.7.111–12, 1.1.68, 5.4.15.

30. *Alchemist*, 5.3.74; 5.5.162–65, 26, 151–52; Letter, 2–4 (cf. 23).

31. *BJ* 2.227. For more on Jonson as a salutary cozener, see chapter 1 of my *Shakespeare's Tribe*.

32. *Alchemist*, prol. 11–18 (with some of Jonson's punctuation retained); Lucretius, *De rerum*, 1.941. To clarify the somewhat obscure distinction that Lucretius makes here, his English translator John Evelyn (1656) adds that Lucretius's poetry is a "*harmless* cheat" (Evelyn, *Essay*, 69; my emphasis).

33. Cartwright, *Ordinary*, prol. 18–19. For modern versions of this reading, see Thayer, who asserts that Jonson "effects a theoretical transformation in his audience" (*Ben Jonson*, 109), and Barton, who claims that "fundamentally, *The Alchemist* is a play about transformation, as it affects not metals, but human beings" (*Ben Jonson*, 137).

34. Smallwood, "Here," 154–55.

35. *Alchemist*, 2.3.284, 5.4.102–3, 1.1.137; *BJ* 7.526; *Alchemist*, 3.1.15–16.

36. *Alchemist*, 5.1.1–17, 1.3.104, 3.4.84, 2.5.64–71, 2.2.11–13.

37. *BJ* 7.521–22; Womack, "Comical Scene," 47–50; *BJ* 7.591. In an earlier book on Jonson, Womack rejects the idea that Jonson ever embraced the heterogeneity of his audience: while his comedies do often dramatize a "linguistic pluralism," they always brand it as "impertinency, clatter, unnecessary tumult"—a kind of "junk language" (*Ben Jonson*, 106–7, 102).

38. Harrison, *Difference*, 31; *Winter's Tale*, 4.4.275–78, 596–613.

39. In his essay on *The Winter's Tale*, "Ekphrasis," Richard Meek points out that critics often acknowledge the analogy between Autolycus and Shakespeare without seriously weighing its implications for the play.

40. *Winter's Tale*, 2.1.192, 1.2.227; Leontes and others refer to his "suspicion" at 1.2.460, 2.1.160, 3.2.151, 5.3.149.

41. Ibid., 1.2.161; 2.1.162, 86; 1.2.129; 2.3.146, 120, 86; 4.4.840.

42. Ibid., 1.2.151, 3.3.110, 4.4.138, 1.1.18, 4.3.76, 3.2.4, 1.2.138–42; Maus, "Satiric," 49, 48, 52; *Winter's Tale*, 5.2.109–10, 4.4.55–66.

43. *Winter's Tale*, 5.1.135, 1.2.134, 109; Augustine, quoted in Maus, "Satiric," 52.

44. Maus, "Satiric," 54, 63; *Alchemist*, 2.3.210. Maus attributes the difference between the masques and the plays to "the suddenly heightened interest in material relations characteristic of the early modern culture [Jonson] inhabits" (60–61).

45. *Winter's Tale*, 2.1.170; *Alchemist*, 5.5.66–70, prol. 20–24.

46. *Winter's Tale*, 5.3.130–32; Seneca, quoted in Maus, "Satiric," 55.

47. *Winter's Tale*, 2.1.163–70, 3.2.38–39, 2.1.58, 4.4.655–56, 5.3.123.

48. Ibid., 1.2.137, 88, 15, 175–77.

49. Ibid., 5.3.10, 38; *SW* 4:256–57; *Winter's Tale*, 5.3.86, 10, 44; *SW* 4:252; *Winter's Tale*, 5.3.12, 14, 18, 24, 67; *SW* 3:108–9.

50. *Winter's Tale*, 5.3.99, 39; 4.4.600–2; 4.1.6.

51. Barkan, "Living," 641; *Winter's Tale*, 5.2.27–29, 5.3.115–17. Jonson famously mocked the absurdity of *The Winter's Tale* when he complained to Drummond of Hawthorden that "Shakespeare in a play brought in a number of men saying they had suffered shipwreck in Bohemia, where there is no sea near by some hundred miles" (*BJ* 5:370). Yet the nonsensicality of a Bohemian "coast" figures explicitly *as* an absurdity in Autolycus's fish ballad (*Winter's Tale*, 4.4.276).

52. *SW* 3:142; *Winter's Tale*, 5.3.15, 28–29, 67.

53. The first time it appears in the play, the word simultaneously signifies motion, emotion, and persuasion: "There is no tongue that moves, none, none i' th' world, / So soon as yours could win me" (1.2.20–21).

54. *Winter's Tale*, 5.3.36. The most influential essay on this subject is Leonard Barkan's "Living Sculptures," which associates the final scene of *The Winter's Tale* with the topos of "the rivalry among the arts." Barkan treats "Shakespeare's medium" as "the equivalent of sculpture" rather than as its competitor, arguing that, even if theater in the final scene seems to "triumph over the frozen medium" of sculpture, "great statues" are equally able to "triumph over their frozenness" (662–63). This is special pleading—statues can never be as lively as actors—but the ideal of liveliness for sculpture does help explain the credulity of Leontes and his fellow onlookers in taking the mock statue for a real one.

55. Philip Edwards erases the tensions between the statue-as-art and the statue-as-fraud when he insists that Shakespeare's emphasis on his own deceptiveness only "serves to affirm rather than sabotage the power of art" ("Seeing," 91–92). But this is to ignore the testimony of the many spectators who find the ending of *The Winter's Tale* preposterous.

56. In the First Folio text of the play, the opening stage direction reads, *"Enter Leontes, Polixenes, Florizel, Perdita, Camillo, Paulina: Hermione (like a Statue:) Lords, etc."* (301). The previous scene had ended with the clown's saying to Autolycus, "Hark, the kings and the princes, our kindred, are going to see the Queen's picture. Come, follow us" (5.2.172–74): the clear implication is that the clown, his father, and Autolycus help make up the "etc."

57. *Winter's Tale*, 5.3.58; 5.2.96–100; 5.3.16–17, 63, 77–79, 121–23.

58. For a different take on partial religion in Shakespeare, see McCoy, *Faith in Shakespeare*. There is a slim possibility that, in attributing the statue to Giulio Romano, Shakespeare may have intended to place further compromising limits on high artistry: Giulio designed a series of erotic pictures, the *Modi*, that achieved notoriety throughout Europe when Marcantonio Raimondi engraved them and Pietro Aretino wrote pornographic sonnets to accompany the engravings. For the evidence that Shakespeare may have known about Giulio's erotic "postures," see Talvacchia, "That Rare Italian Master"; for more on the *Modi*, see Talvacchia, *Taking Positions*, and Turner, "Marcantonio's Lost *Modi*."

Chapter 6

1. Carringer, *Making*, 119.

2. Brady, "How the Motion Picture Saved the World," 25; White, "Chewing-Gum Relaxation," 12.

3. Hearst, quoted in Nasaw, *The Chief*, 284; Urban's daughter Gretl, quoted in Carter and Cole, *Joseph Urban*, 148. Nasaw comments on the range of consumers Hearst hoped to reach: "In publishing, he had made his fortune by extending the audience for daily and Sunday papers downward into the working classes. In moving pictures, he would extend the audience up the social ladder by producing pictures so stylish and expensive-looking that even 'society' would flock to them" (*The Chief*, 283).

4. See Nasaw, *The Chief*, 284.

5. Urban, quoted in Levkoff, *Hearst*, 77; Seldes, *7 Lively Arts*, 53. Seldes is quoting another contemporary writer, Stark Young; his own slightly modified definition of film is *"movement governed by light"* (324). The bibliography of Carroll's work on the specificity

thesis is extensive; for the best brief introduction to his views on the subject, see Carroll, "Specificity Thesis."

6. Review of *Kane* in *Photoplay*, July 1941, 24; for the other reviews, see Gottesman, ed., *Focus*, 47, 51, 53, 56, 58 (these reviews also appear in Gottesman, ed., *Perspectives*). In his own review of *Kane*, Seldes claimed that Welles "has made the movies young again" ("Radio Boy," 111).

7. Belfrage, in Gottesman, ed., *Focus*, 55. Cf. the contemporary review by Genee Kobacker Lesser, which praises *Kane* for having liberated film from its parasitical dependence on the theater and the novel: "Tonight I was present at the birth of a new art form: The Motion Picture" (in Gottesman, ed., *Perspectives*, 30). Commenting on such reviews, Paul Arthur states that "there is little doubt that the occasion of *Citizen Kane* provided ammunition for those seeking broad acceptance of cinema as a credible art form" ("Out of the Depths," 265). Looking in a different although complementary direction, J. Hoberman maintains that *Citizen Kane* also "inspired" American avant-garde film ("Pop," 169).

8. *SW* 4:259; Seldes, *7 Lively Arts*, 326, 338. "Of what use are sets by Urban," Seldes asked, "if the action which occurs in them is invisible to the naked eye?" (*Lively*, 334). Seldes repeated this attack on movie "art" in his 1937 film history *The Movies Come from America*: "Often the movies which fail to move are called great art" (16).

9. Welles, in Cobos et al., "Trip," 10–11.

10. My account here is indebted to Harold Rosenberg's conception of the modern "art object" as an "anxious object" that is uncertain whether it amounts to "a masterpiece" or "an assemblage of junk" (*Anxious Object*, 17). I differ from Rosenberg in arguing that such an object can be ambitious as well as anxious: *Kane* stakes its claim to be a masterpiece on its embrace of its trashiness.

11. "Las formas de la multiplicidad, de la inconexión, abundan en el film"; Borges, "Un Film," 88; "Film Reviews," 13. (Gottesman in his *Focus* and *Perspectives* uses a different translation.)

12. Depth of focus is the film's most famous method for keeping many compositional elements together while at the same time registering the uncanniness of their integration.

13. Kael, "Raising Kane," 292.

14. The souvenir program is reproduced in Kreuger, ed., *Souvenir Programs*, 217–36.

15. Not only do we see old newspapers under Leland's feet after the election, but we also glimpse them blowing across the screen in a newsreel shot of a Kane newspaper after it has been closed.

16. Lindsay, *Art*, 130; Steer, *Romance*, 30.

17. Seldes, *7 Lively Arts*, 331.

18. For the conventionality of this plot in early cinema, see Siegfried Kracauer's 1927 essay, "The Little Shopgirls Go to the Movies," in *Mass Ornament*, 290–304.

19. In his 1938 essay "A New Laocoön: Artistic Composites and the Talking Film," Rudolf Arnheim claimed that "in the entire recorded history of art we find only one example of some weight that involves" the same "collective effort of two media" as in talking pictures: "namely, the opera" (*Film as Art*, 221). For a searching account of the rivalry between film and other media in *Citizen Kane*, see Jackson, "Writing."

20. "Shadow Stage" [Review of *My Best Girl*], 52.

21. Kristen Whissel quotes Jane Addams in 1912 on the "danger…of easy access" for shopgirls in department stores, and then applies Addams's perspective to the representation

of shopgirls in the early silent film *Shoes*: they "seem to have the same status within modern traffic as do the goods they sell by day from behind the counter: easily and cheaply purchased, widely available, and utterly expendable, they are quickly disposed of upon satisfying the purchaser's desire" (*Picturing*, 196, 203).

22. The artistic deployment of refuse was of course a hallmark of modernist art, particularly of the Dada movement. Jacques Rancière asserts that "Dadaist canvases had bus tickets, clock springs and other such items stuck on them as a way of ridiculing art's pretensions to separate itself from life" (*Aesthetics*, 51).But satire against pretension was only half the issue: the other half was the alchemical transformation of trash into art.

23. Welles, "Foreword," n.p.

24. Kane twice characterizes a person, jokingly, as an "anarchist."

25. According to John Houseman, the libretto of the opera was itself "a potpourri" (quoted by Mulvey, *Citizen Kane*, 69). The stuffed crocodile hoisted by the opera's stagehands recalls the newsreel's shots of animals lifted by cranes into ships bound for Xanadu.

26. Mulvey, *Citizen Kane*, 28; Carringer, *Making*, 98. Lawrence Clipper, among many others, makes the same point about the opening montage of Xanadu: "The mind struggles to synthesize, to impose a unity on the flow of these images" ("Art,"12).

27. A bulldog, as the *Oxford English Dictionary* notes, is "the earliest edition of a daily or Sunday newspaper."

28. I am quoting Tangye Lean's 1941 review, reprinted in Gottesman, ed., *Focus*, 61 (the review also appears in Gottesman, ed., *Perspectives*).

29. Carringer, *Making*, 54, 60.

30. "Hearst," 43–45. Chaplin painted a similar picture in his *Autobiography*: "Many times I saw [Hearst] seated in the center of Marion's reception room, with twenty or more newspapers spread all over the floor," until "Marion would appear in all her finery" and say, "Get rid of all this junk, it's cluttering up my dressing-room" (314).

31. Lesley Brill makes a similar point when he refers to the "crowd symbols" in Xanadu, which according to Brill include not only its "crated treasures" but also "the flames consuming these goods and the smoke ascending darkly from Xanadu's chimney" ("Crowds," 101–3).

32. For another movie that follows the convention of pairing a shopgirl with a store owner's son, see the nearer contemporary to *Citizen Kane*, the 1939 RKO comedy *Bachelor Mother*, which starred Ginger Rogers as the shopgirl and David Niven as the owner's son; Rogers works in the toy department of the store. This plot was not confined to comedies: it also figured in melodramas such as *Within the Law*, which was based on a 1912 play by Bayard Veiller that, according to an article in the *New York Times*, "has the enviable record of being the most popular and financially successful melodrama produced within the last decade" (Apr. 30, 1917, 11). The first movie version of *Within the Law* appeared in 1917; two other versions followed in 1923 and 1939.

33. In Kael, Mankiewicz, and Welles, *The* Citizen Kane *Book*, 288.

34. The headless Venus contrasts with the statue of Thatcher that is prominently displayed, and of course prominently identified, in his archive.

35. So, too, do newspapers make a lot out of a little, according to Kane: "If the headline is big enough, it makes the news big enough."

36. I have avoided the term "kitsch" here for several reasons. The film itself refers to "junk," not "kitsch"; "junk" is an appropriately more colloquial and less mystified term for

a mass-cultural phenomenon than "kitsch" is; and junk as *Kane* defines it seems theoretically the opposite of kitsch as Clement Greenberg defines it. According to Greenberg, again, kitsch is "genuine" art that has been "watered down" into junk ("Avant-Garde," 12). But in *Kane*, art arises from junk—which is not to say that a piece of junk stops being junk when it starts serving as art. Welles himself repeatedly disparaged Rosebud, for instance, as "a rather tawdry device," "kind of a dollar-book Freudian gag, you know, really"; see *Orson Welles: The Paris Interviews*, dir. Allan King.

37. Welles, quoted in Brady, *Citizen Welles*, 285 (my emphasis). The filmed Rosebud was not unique, either: Carringer notes that "three identical sleds were built; two were burned in the filming" (*Making*, 50).

38. So Roy Fowler reports in his 1946 biography of Welles (excerpted in Gottesman, ed., *Focus*, 79).

39. "In the early days," Welles told Peter Bogdanovich, "I talked a lot about that 'giving the audience the choice' business. It strikes me as pretty obvious now" (interview in Naremore, *Orson Welles's Citizen Kane*, 30). Cf. Welles's Feb. 14, 1941 letter to the periodical *Friday*, in which he claims that "the point of the picture is not so much the solution of the problem as its presentation"; "it is for the audience to judge" (in Gottesman, ed., *Focus*, 68; also in Gottesman, ed., *Perspectives*, 27).

40. Lean, in Gottesman, ed., *Focus*, 63; Bazin, *Orson Welles*, 80. The contemporary reviewer for *Time* makes the same point: "Orson Welles treats the audience like a jury, calling up the witnesses, letting them offer the evidence, injecting no opinions of his own" (*Time*, Mar. 17, 1941, 90). For a more recent instance of this view, see Fabe, *Closely*, 84–85. In his own reading of *Kane*, Carroll, too, maintains that "the film leaves it to the audience to determine" how the protagonist should be understood; he then turns this claim into a defense of mass entertainment, which, he argues, is capable of encouraging "participant spectatorship" rather than "unreflectiveness" (in Gottesman, *Perspectives*, 261, 264).

41. Welles, in Gottesman, ed., *Focus*, 20. Cf. Arthur's quite different analysis of the "concerted effort" in the movie "to activate the viewer's capacity to assimilate and respond kinesthetically to rapid alterations in represented depth" ("Out of the Depths," 272).

42. *SW* 4.256.

43. A major exception is Carringer, who asserts that "the little glass globe, not Rosebud, incorporates the film's essential insight into Kane. It is a crystallization of everything we learn about him—that he was a man continually driven to idealize his experiences as a means of insulating himself from human life" ("Rosebud," 192). See also Beverle Houston's "Power and Dis-Integration in the Films of Orson Welles," which stresses the importance of the snow globe in Kane's return to his childhood.

44. As Bates and Bates suggest, Kane's dropping of the snow globe pathetically mirrors his throwing of a snowball as a child ("Fiery," 13).

45. According to Kracauer, film "is uniquely equipped . . . to picture transient material life, life at its most ephemeral," which is why the Lumière films, "the first ever to be made," recurred to "the motif of smoke" (*Theory*, xlix, 31; I'm grateful to James Schamus for this reference).

46. In later years, Frank Capra remembered his early movies as "nickel and dime affairs," "like today's newspaper—you don't save today's newspaper." The film students of "today" may "study [film] as an art form," he told another interviewer, but "we had no reverence for this stuff. We'd make a picture and throw it out" (Poague, ed., *Frank Capra*, 108, 134).

47. For an influential account of "why so many modern paintings and sculptures are deliberately produced out of materials that change or fall apart" (91), see Rosenberg's essay "The Art Object and the Esthetics of Impermanence" in his *Anxious Object*. An *objet* by a modern artist such as Kurt Schwitters nevertheless differs significantly from the decorated crate of *My Best Girl* insofar as the *objet* is more abstract than the crate, and the crate is more discardable than the *objet*.

48. Welles, quoted in Brady, *Citizen Kane*, 285. In his 1971 essay on the film, David Bordwell refers to Kane's crated artwork as "costly rubbish" (in Gottesman, ed., *Focus on Orson Welles*, 117).

Epilogue

1. Capra, *Frank Capra*, 377, 34, 118. It's unclear from the title page of Capra's autobiography whether the words "Frank Capra" are intended to name the author only or the book as well.

2. Bacon undoubtedly anticipated this response to *Footlight Parade*. In *42nd Street*, another Bacon film, the musical director Marsh overhears a theatergoer who says of Marsh's show, "These directors kill me! Take Marsh: sticks his name all over the program and gets all the credit. Wasn't for kids like Sawyer, he wouldn't have a show. I can't see that Marsh did a thing."

3. Rintels, "Someone Else's Guts," 13; McBride, *Frank Capra*, 649, 651–53.

4. Sklar, "Authorship," 1; Grant, *Auteurs*, 2.

5. Barry, *Let's Go to the Movies*, 170; Patterson, *Scenario*, 208; Fletcher, *Crisis*, 16.

6. Lane, *What's Wrong*, 56–57; Keaton in Brownlow, *Parade's Gone By*, 491.

7. Brownlow, *Parade's Gone By*, 491; Everson, *American Silent Film*, 246; Brownlow, *Parade's*, 491–92.

8. Petrie, "Alternatives," 32; Rintels, "Someone's Been Sitting," R42.

9. The pressbook to *City Lights* repeatedly emphasizes Chaplin's scoring of the film: e.g., "Charlie Chaplin undertakes to master another phase of motion picture making in his forthcoming super-production 'City Lights'…adding to his accomplishments of author, director, star and producer that of composer of music" (4). For Chaplin's actual dependence on collaborators in scoring *City Lights*, see Raksin, "Music."

10. Cherrill, quoted in Brownlow, *Search*, 59; Hayes, ed., *Charlie Chaplin: Interviews*, 72. One of the newsboys in *City Lights* was played by the future director Robert Parrish, who later recalled that Chaplin "would blow a pea and then run over and pretend to be hit by it, then back to blow another pea. He became a kind of dervish, playing all the parts, using all the props, seeing and cane-twisting as the Tramp, not seeing and grateful as the blind girl, peashooting as the newsboys….Finally, he had it all worked out and reluctantly gave us back our parts. I felt that he would much rather have played all of them himself" (quoted in Robinson, *Chaplin*, 409).

11. Rotha, *Celluloid*, 102–3.

12. Babcock, "Chaplin," B9; Robinson, *Chaplin*, 606; Hayes, *Charlie Chaplin: Interviews*, 120; Boland, "Chaplin," B5, 12. Another *LAT* article (Sept. 23, 1930) noted that, "in the making of his picture, which has taken him two and one-half years to complete, the comedian has employed 11,500 persons, not including his staff of forty-one."

13. Capra, *Frank Capra*, 244; Chaplin, *My Father*, 83, 53.

14. Coleridge, *Biographia*, 2.13; Greene, *Groats-Worth*, 85.

15. Dryden, *Essay*, 55; Dryden, "Defence," 213 (with some emendation); Shakespeare, Sonnets 110–11; *1 Henry IV*, 3.2.41; *Hamlet*, 4.3.4, 5.2.229–30.

16. Frank, "Charles Chaplin," 242–43.

17. Hayes, ed., *Charlie Chaplin: Interviews*, 133; Trahair, "Figural," 188; I refer throughout to the Criterion DVD of *City Lights*. It's interesting to compare this opening sequence to the scaled-down version of it at the start of Eddie Cantor's 1933 comedy *Roman Scandals*.

18. I've cut Frank short; here is his complete sentence: "The theme of the Chaplin picture is Chaplin himself, in relation (opposition) to the world" (240). Aphoristically, Frank tries to integrate three different and somewhat competing conceptions of *City Lights*: as a film about Chaplin, as a film about Chaplin's relation to the world, and as a film about Chaplin's opposition to the world. My point throughout this chapter is that Chaplin himself was either unwilling or unable to separate these conceptions in his own mind.

19. Goldman, *Modernism*, 120–22; Hayes, ed., *Charlie Chaplin: Interviews*, 133; Robinson, *Chaplin*, 400.

20. Robinson omits Redmond from his discussion of *City Lights* and even from the cast list for the movie.

21. Quoted in Albronda, "Granville Redmond," 151; Eastman, *Heroes*, 183; Alice Terry quoting Chaplin, in Albronda, "Granville Redmond," 135 ("Redmond paints solitude"); Anderson, "Of Art," III.27, cited in Albronda, "Granville Redmond," 133; Terry, quoted in Albronda, "Granville Redmond," 135; A. V. Ballin, quoted in Albronda, "Granville Redmond," 136.

22. Albronda, "Granville Redmond," 131ff. Apparently Redmond contributed to the movies in other ways as well. The child actor Dean Riesner reported that when Riesner was unable "to grab a goldfish out of a goldfish bowl" for a scene in Chaplin's *The Pilgrim*, "they had Granville Redmond, an artist in residence—he was a deaf and dumb man who lived at the studio—he carved a goldfish out of a carrot, and they put this carrot goldfish in there" (quoted in Brownlow, *Search*, 55).

23. Albronda, "Granville Redmond," 144, 153. Chaplin adds a further joke on Redmond by having Redmond's character first appear beside a microphone. It's telling that Chaplin the perfectionist should also have chosen to retain a shot in the movie that revealed Redmond's deafness: when *The Star-Spangled Banner* begins playing, Redmond's character is the last to react to it.

24. Albronda, "Granville Redmond," 137. Shortly after the release of *City Lights*, Redmond did indeed declare that he was "through with acting" (148).

25. Ward, "Even a Tramp," 113; Sherwood, *Best Moving Pictures*, ix.

26. Chaplin, *Autobiography*, 323.

27. For Chaplin's association of his own artistic creativity with blind absorption, consider Georgia Hale's memory of Chaplin's surprisingly bare and shabby office on location for *The Gold Rush*: she recalled Chaplin's explaining to her that "I wanted it plain, so I can think. I don't want to see things and have my thoughts go to what I'm seeing. I want to think within myself. If I had my way, I'd just have big black square walls put around the place where I couldn't see a thing" (quoted in Brownlow, *Search*, 149).

28. *SW* 4:268–69, 256. In "First Sight," Therese Davis makes a similar connection between Benjamin and *City Lights*. For a critique of Benjamin's position here, and a summary of the scholarship on it, see Turvey, *Filming*, 163–82.

29. Rothman, "Ending," 46, 48.

30. Julian Smith writes, "The monumental public unveiling at the beginning will be repeated at the end by the more personal and private 'unveiling' of Charlie as the benefactor who has brought sight and prosperity to the poor blind flower girl" (*Chaplin*, 92).

31. Rothman, "Ending," 52–53; Hayes, ed., *Charlie Chaplin: Interviews*, 134. Eastman said of Chaplin that "he has the gift of admiring others, and the rarer gift of listening to them with vivid and prolonged interest" (*Heroes*, 158).

32. Jonathan Rosenbaum points out that "the alternating close-ups" between the tramp and flower girl are also "flagrantly mismatched": "Viewed from behind, the Tramp grasps one of the flower girl's flowers against his leg; viewed from the front, he holds the same flower in the same hand against his mouth and cheek, and this discontinuity of angle/reverse-angle even gets repeated along with the same camera setups" (*Goodbye Cinema*, 89).

33. An interviewer in 1917 wrote that "Charlie hates overacting and the emotional, distorted, tear-stained close-ups that some directors of 'serious' pictures throw on the screen and carelessly call 'art'" (Hayes, ed., *Charlie Chaplin: Interviews*, 31).

34. Chaplin's early notes for the film imagined the ending this way: "Girl finally recognizes him—takes him by hand and leads him into flower shop" (Robinson, *Chaplin*, 391). But in the actual ending, the tramp resists being coaxed into the flower shop and instead lures the flower girl into the street.

35. By associating the flower girl's recognition of the tramp with the *physical* contact between them, Chaplin emphasizes that our gaze must strenuously overcome the disability of not being able to touch as well as hear.

36. I must surely owe my interest in absorption as an aesthetic issue to Michael Fried's remarkable *Absorption and Theatricality* (1980). In that book, Fried argues that eighteenth-century French painting modeled absorption for the beholder by pretending that the beholder didn't exist, so that the painting would not appear to be striving theatrically for effect. *City Lights* clearly fits this absorptive paradigm insofar as the tramp does not initially intend to be observed when he is first unveiled to us.

Figures who are literally blind to observation are also common presences in the paintings Fried discusses: *Absorption and Theatricality* climaxes with Fried's extraordinary readings of Jacques-Louis David's Belisarius painting and Homer drawings. However, Fried does not ask whether the link between absorption and blindness in these final images might count as a critique of absorption, nor does he sufficiently address why David places both Belisarius and Homer in a conspicuously urban setting.

37. Rotha, *Celluloid*, 92.

38. Žižek, "Death," 10, 5; Hayes, ed., *Charlie Chaplin: Interviews*, 83. Jonathan Rosenbaum asks, "Has there ever been another artist—not just in the history of cinema, but maybe in the history of art—who has had more to say, and in such vivid detail, about what it means to be poor?" (*Goodbye Cinema*, 90).

39. *SW* 4:262. Part of the reason that Chaplin kept *City Lights* silent, the pressbook explained, was his sense of responsibility toward "the hundreds of thousands of deaf people who cannot enjoy talking pictures" (12).

40. Thomson, "Demon," 63; Warshow, "Feeling," 201, 207, 193, 194, 201–2; Thomson, "Demon," 59, 61–62. Similarly, Renaissance theater haters often characterized actors as beggars who had grown rich by engrossing the alms that should have gone to the deserving poor.

41. Robinson dismissed *Charlie Chaplin's Own Story* as a fraud, but more recent commentators have persuasively argued for its authenticity, at least in parts of the book; see the introduction to Harry M. Geduld's edition.

42. Bercovici, "Charlie," 6. Forty years later, Chaplin similarly emphasized how "it is the humiliation of poverty which is so distressing" (Hayes, ed., *Interviews*, 131).

43. Burke, *City*, 164; Frank, "Charles," 238.

44. Hayes, ed., *Charlie Chaplin: Interviews*, 78. The actual millionaire in *City Lights* is self-absorbed. Even when he drunkenly embraces the tramp, he keeps his distance from others. The festivities at a nightclub, party, or theater give him no pleasure: his idea of revelry is to "burn up the town," as he tells the tramp. But the tramp tends to get absorbed in whatever comes his way, such as the dancers or the confetti at the nightclub—and he never stops worrying about the flower girl.

45. Chaplin, *My Father*, 91, 254; Cherrill, quoted in Brownlow, *Search*, 62; Chaplin, *My Father*, 110.

46. Dale, *Comedy*, 32. Harry Crocker recalled that Chaplin began making plans to portray "the great French conqueror" after he had completed *The Circus* ("Charlie Chaplin," 12.28). Julian Smith has argued that "Hitler supplied Chaplin with an opportunity to look at himself as man and artist while pretending to be looking at someone else" (*Chaplin*, 109).

47. Rothman, "Ending," 53. Warshow offers a similar, though more tempered, demystification of the tramp in *City Lights*. Describing the scene in which the tramp "tactfully permits the Blind Girl to unravel his underwear in the belief that she is rolling up her knitting wool," Warshow points out that the director has arranged this scene of voluntary impoverishment: "it is he, that contriving artist there, who has created the occasion for the delicacy in the first place" ("Immediate," 193–94). For both Warshow and Rothman, a "contriving" artist is necessarily a guilty one.

48. Rothman, "Ending," 53; "The Movies and the Masses," 62. In the eyes of Nazis and their fellow travelers, Chaplin was "der Held des Untermenschlichen": the hero not merely of the underprivileged but also of the subhuman (cited in Hake, "Chaplin," 91).

49. Chaplin, *Autobiography*, 146; Pressbook, [4]; Burke, "Comedian," 171, 143–44. Eastman similarly calls Chaplin "an actor of infinite versatility. It is hard to think up a character that Charlie cannot portray with startling realism on a moment's notice" (*Heroes*, 197).

50. Burke, "Comedian," 143–45. Although Chaplin was "the sole creator and inspirer of *Charlie*," Burke added, he always spoke of the tramp "in the third person" (144). Cf. Ivor Montagu's reminiscence in Kevin Brownlow's *The Search for Chaplin*: "It was quite clear from the way he was talking and the way he was telling the story that he was not identifying with the Chaplin figure at all. He was calling it 'the tramp' all the time, speaking of it in the third person, and he was the director who invented these things that were happening, who did these things with that figure there" (81).

51. Hayes, ed., *Charlie Chaplin: Interviews*, 132.

52. Poague, ed., *Frank Capra*, 81; Eisenstein, *Notes*, 112–13. For Eisenstein's views on Chaplin's "genius," see *Notes*, 167–202.

53. Powell, *Life*, 93, 252, 48, 148–49, 168, 180. For Powell's own stake in playing all the parts, consider his account of his work with the director Harry Lachman on the silent comedy *The Compulsory Husband*. "I joined Harry in my usual capacity as stills photographer, location editor, interpreter, assistant director, and stuntman," Powell writes, while adding

that he also played "the boy with the luge, the girl at the door, the mother cooking, the peasant entering, and the furious old man in the snowdrift" (198–99).

54. Ibid., *Life*, 48, 217. For further indications of the broad consensus among Chaplin's contemporaries that the director is the one who unifies a film, compare the very different filmmakers Vsevolod Pudovkin in his *Film Technique* (1929) and Cecil B. De Mille in his 1924 article "Directorial Opportunities of the Future." Pudovin calls the director "the single organizing control that guides the assembling of the film from beginning to end" (91–92), while De Mille asserts that "a director's job...is that of taking individual excellences made by artists, actors, designers, authors and cameramen and fashioning all these separate, perfect things into a perfect finished, SINGLE whole" (20).

55. Poague, ed., *Frank Capra*, 89. Cf. the credits for *Snow White and the Seven Dwarfs* (1937), which express Disney's "sincere appreciation to the members of my staff whose loyalty and creative endeavor made possible this production," but only after first making clear that the film is "A Walt Disney Feature Production."

56. Capra never claimed to be the first director to receive top billing on his films. "Griffith, Ince, De Mille, Chaplin," he acknowledged, had all been advertised this way, but "they owned their own companies"; Capra thought of himself as "the first American 'working' director...to be featured over the picture and stars in marquee lights" (*Autobiography*, 186).

57. Kreuger, *Souvenir*, 218, 228–29; Belfrage in Gottesman, *Focus*, 58.

58. Kreuger, *Souvenir*, 221; Bercovici, "Charlie," 36; Eastman, *Heroes*, 161, 178. Crocker begins his memoir by cautioning his readers that "Chaplin was a man of many facets," like Napoleon ("Charlie Chaplin," 1); he later calls Chaplin "a mental chameleon" (11.27). Julian Smith persuasively characterizes the split personality of the millionaire in *City Lights* as "a projection of the Chaplin described by the wives, mistresses, friends, and children who wrote of his moodiness, of the difficulty of knowing from day to day what to expect of him" (*Chaplin*, 94).

59. Welles in appendix to Mulvey, *Citizen Kane*, 80.

60. See Robinson, *Chaplin*, 677. "In a way," writes Frank Brady, the shared Oscar "was a direct humiliation of Welles for causing all the trouble. All Hollywood knew of the controversy and mystery surrounding both the legal credit and the creative accolades that were due both men" (*Citizen Welles*, 311).

61. Chaplin, *Autobiography*, 359. Shakespeare as Chaplin understood him presented a serious problem for Chaplin's theory of genius: Chaplin thought it "inconceivable" that the Stratford man, a mere "farmer's boy," could have become "the greatest of all poets" (358–59). This apparent contradiction would seem to manifest the uncertainty of the once-poor Chaplin about the elite status of his own achievements.

62. Hamman, "Meet Frank Capra," 11. In his 1941 *Sullivan's Travels*, the writer-director Preston Sturges both undermined and reinforced the idealization of filmmakers who had known poverty. At the start of the film, the Hollywood director John L. Sullivan, a scion of wealth, insists that he will be unable to "realize the potentialities of film as the sociological and artistic medium it is" until he first experiences the life of a tramp. The film exposes his folly: after terrible suffering, Sullivan returns to making the light comedies he used to direct. But he creates them now with the hard-earned knowledge of how important such entertainment is to the poor. "There's a lot to be said for making people laugh," he decides at the end: "did you know that's all some people have?"

63. Kreuger, *Souvenir*, 220; Brady, *Citizen Welles*, 5.

64. Welles tried to solve this problem in *The Lady from Shanghai* (1947) by giving himself the part of "Black Irish" Michael O'Hara, a sailor who has "always found it very . . . sanitary to be broke." But Welles never really brings off the illusion. In one scene at the docks, O'Hara is the only one among other down-at-heels seamen who is busily typing on a typewriter.

65. Kael, *For Keeps*, 274, 625, 289, 293, 302, 283, 286; Welles in appendix to Mulvey, *Citizen Kane*, 81. In *For Keeps* Kael does partially attribute the irony to the spiteful pre-science of Mankiewicz, who "wrote Welles the capricious, talented, domineering prodigy into the role" of Kane (289).

66. Rosenbaum, *Discovering*, 279, 277.

67. Kael, *For Keeps*, 324–25. Although "Raising Kane" helped make Kael the most renowned critic of the auteur theory, her views on directing actually resembled Eisenstein's and Powell's. In "Raising Kane," she even echoed Capra's dismissal of studio directors: "The director should be in control not because he is the sole creative intelligence but because only if he is in control can he liberate and utilize the talents of his co-workers, who languish (as directors do) in studio-factory productions" (316).

68. See Kellow, *Pauline Kael*, 157–66. According to Kellow, the researcher was a UCLA English professor, Howard Suber. "Nowhere in the piece was Suber's name mentioned" (161), Kellow asserts, and yet "the only research materials in [Kael's] personal archive, housed at Indiana University's Lilly Library," are "copies" of Suber's work (166).

Coda

1. Greenberg, "Avant-Garde," 11–13, 17.

2. Carson, *Companion*, 74; Gurr, "Shakespearean Stage," 95; Stern, *Rehearsal*, 56–57. Even the best of plays, the dramatist James Shirley recalled in 1647, were "as suddenly removed as represented" (in Beaumont and Fletcher, *Comedies and Tragedies*, A3r).

3. *Hamlet*, 2.2.467–520.

4. Marston, *Parasitaster*, "To My Equal Reader," 66; Jonson, *Devil*, prol. 25–26; Marston and Webster, *Malcontent*, "Induction," 14–15. Menzer makes the same point: "London's theatrical industry relied on repeat business and therefore needed through its practices to encourage and routinize playgoing" ("Crowd," 30). See also Cook, *Privileged*, 193–95.

5. "By 1930, the year the Census Bureau counted 123 million Americans," the historian David Kyvig notes, "the weekly sale of movie tickets, stimulated by the popularity of talk-ies, reached three-fourths that number." And, "despite the severe economic problems of the 1930s, movie attendance, while slipping somewhat, remained strong throughout the decade" (*Daily Life*, 99).

6. Northbrooke, *Treatise*, 59; Holmes, "Movies," 196.

7. For a dazzling account of how Hitchcock's films encourage "too-close reading," see D.A. Miller's "Hitchcock's Understyle." "Even in the epoch before VHS," Miller writes, "to watch a Hitchcock film was always to dream of inspecting its images ad libitum" (30 n. 16).

8. Seymour and Seff's June 10, 1933, screenplay specifies that Vivian "picks up highbrow book, holding it open as if she'd been reading" (52).

9. In his epistle "To the Reader" of *The Malcontent*, Marston himself expresses regret about the publication of his play. "Only one thing afflicts me," he asserts, "to think that scenes invented merely to be spoken should be enforcively published to be read" (26–28).

He ends his epistle with the hope "that the unhandsome shape which this trifle in reading presents may be pardoned for the pleasure it once afforded you when it was presented with the soul of lively action" (34–37). A writer's lament that he has been forced to publish his work is of course a standard flourish in the prefatory material of a Renaissance book. Marston's ambivalence about print might nevertheless have been real: he might have sincerely worried that his play would suffer in its translation from the stage to the page. But his epistle proves that he was unwilling to forgo the opportunity of addressing readers as well as playgoers.

 10. *The Education of Henry Adams* is a complex choice as a satirical prop, since the book itself famously criticizes academic learning.

WORKS CITED

Abbreviations of Frequently Cited Works

BJ Jonson, *Cambridge Edition of the Works*
DE Horkheimer and Adorno, *Dialectic of Enlightenment*
ERD Bevington et al., eds., *English Renaissance Drama*
LAT *Los Angeles Times*
MJD Wolfe, ed., *Meet John Doe*
NYT *New York Times*
RG Middleton and Dekker, *The Roaring Girl,* in ERD
SW Benjamin, *Selected Writings*

Unless otherwise noted, all citations of classical authors refer to Loeb Classical Library editions.

42nd Street. Dir. Lloyd Bacon. Warner Bros, 1933. Film. Turner Entertainment and Warner Bros. Entertainment, 2006. DVD.

Adorno, Theodor W. *Aesthetic Theory*. 1970. Ed. Gretel Adorno and Rolf Tiedemann. Trans. and ed. Robert Hullot-Kentor. Minneapolis: University of Minnesota Press, 1997.

———. *The Culture Industry: Selected Essays on Mass Culture*. Ed. J. M. Bernstein. New York: Routledge, 1991.

———. "The Culture Industry Reconsidered." Trans. Anson G. Rabinbach. In *The Culture Industry,* ed. J. M. Bernstein, 98–106. New York: Routledge, 1991. [Orig. pub. 1975.]

———. "Free Time." Trans. Wes Blomster. In *The Culture Industry,* ed. J. M. Bernstein, 187–97. [Orig. pub. 1977.]

A.D.S. "A Screen Musical Comedy." [Review of *Footlight Parade*.] *New York Times*, Oct. 6, 1933, 21.

Albott, Robert. *Wits Theater*. [London], 1599.

Albronda, Mildred. "Granville Redmond." Rochester Institute of Technology, Rochester, NY, n.d. www.rit.edu/~w-dada/paddhd/publicDA/main/articles/GranvilleRedmond ManuscriptbyMildredAlbronda.pdf.

"All-Star Cast Makes Fete of Salary Battle." [Preview of *Footlight Parade*.] *Washington Post*, Oct. 18, 1933, 16.

Altman, Rick. *The American Film Musical*. Bloomington: Indiana University Press, 1987.

Anderson, Antony. "Of Art and Artists." *Los Angeles Times*, June 4, 1922, III.27.

Arnheim, Rudolf. *Film as Art*. Expanded ed. Berkeley: University of California Press, 1957. [Orig. pub. as *Film* in 1933; trans. of *Film als Kunst*, 1932.]

Arnold, Oliver. *The Third Citizen: Shakespeare's Theater and the Early Modern House of Commons*. Baltimore: Johns Hopkins University Press, 2007.

"Art and Democracy." *Photoplay* 13 (Apr. 1918): 19.

Arthur, Paul. "Out of the Depths: *Citizen Kane*, Modernism, and the Avant-Garde Impulse." In *Orson Welles's Citizen Kane*, ed. James Naremore, 263–84. Oxford: Oxford University Press, 2004. [Orig. pub. 1996.]

Babcock, Muriel. "Chaplin Still Stands Alone." *Los Angeles Times*, Feb. 8, 1931, B9.

Badiou, Alain. "On Cinema as a Democratic Emblem." *Cinema*, 233–41. Cambridge: Polity Press, 2013.

———. "Du cinéma comme emblème démocratique." *Critique* 692–693 (2005): 4–13.

Balio, Tino. *Grand Design: Hollywood as a Modern Business Enterprise, 1930–1939*. Berkeley: University of California Press, 1993.

Barkan, Leonard. "'Living Sculptures': Ovid, Michelangelo, and *The Winter's Tale*." *ELH* 48 (1981): 639–67.

Barrios, Richard. *A Song in the Dark: The Birth of the Musical Film*. New York: Oxford University Press, 1995.

Barry, Iris. *Let's Go to the Movies*. New York: Payson & Clarke, 1926.

Barton, Anne. *Ben Jonson, Dramatist*. Cambridge: Cambridge University Press, 1984.

Baumann, Shyon. *Hollywood Highbrow: From Entertainment to Art*. Princeton: Princeton University Press, 2007.

Bates, Robin, and Scott Bates. "Fiery Speech in a World of Shadows: Rosebud's Impact on Early Audiences." *Cinema Journal* 26 (1987): 3–26.

Bazin, André. *Orson Welles: A Critical View*. Trans. Jonathan Rosenbaum. Los Angeles: Acrobat Books, 1991. [Orig. pub. 1950; rev. 1958.]

Beard, Thomas. *The Theatre of Gods Judgements. . . . Translated out of French [Histoires Mémorables* by Jean Chassanion (1581)] *and Augmented by More than Three Hundred Examples*. London, 1597.

Beaton, Welford. *Know Your Movies: The Theory and Practice of Motion Picture Production*. Hollywood: H. Hill, 1932.

Beaumont, Francis, and John Fletcher [et al.]. *Comedies and Tragedies*. London, 1647.

Beaurline, L. A. "Ben Jonson and the Illusion of Completeness." *PMLA* 84, no. 1 (Jan. 1969): 51–59.

Benjamin, Walter. "Das Kunstwerk im Zeitalter seiner technischen Reproduzierbarkeit." Dritte Fassung. MS 1936–39. In *Gesammelte Schriften*, vol 1, part 2, ed. Rolf Tiedemann and Hermann Schweppenhäuser, 471–508. Frankfurt am Main: Suhrkamp, 1991. [Orig. pub. 1974.]

———. *Walter Benjamin: Selected Writings*. Ed. Marcus Bullock and Michael W. Jennings. 4 vols. Cambridge, MA: Harvard University Press, 1996–2003.

———. "The Work of Art in the Age of Its Technological Reproducibility." Third version. MS 1936–1939. Trans. Harry Zohn and Edmund Jephcott. In *Walter Benjamin: Selected Writings*, vol. 4, ed. Howard Eiland and Michael W. Jennings, 251–83. Cambridge, MA: Harvard University Press, 2003.

Bercovici, Konrad. "Charlie Chaplin." *Collier's*, Aug. 15, 1925, 5–6, 36.

Bethell, S. L. *Shakespeare and the Popular Dramatic Tradition*. Durham, NC: Duke University Press, 1944.

Bevington, David, et al., eds. *English Renaissance Drama: A Norton Anthology*. New York: Norton, 2002.

Birchard, Robert S. "A Song-and-Dance Spectacular." *American Cinematographer* 86, no. 11 (Nov. 2005): 66–73.

Black, Joseph L., ed. *The Martin Marprelate Tracts: A Modernized and Annotated Edition*. Cambridge: Cambridge University Press, 2008.

Blackburn, Alan R., Jr. "Creating Motion Picture Departments in Museums of Art." *National Board of Review Magazine* 8, no. 6 (June 1933): 7–8.

Blair, Ann. *Too Much to Know: Managing Scholarly Information Before the Modern Age.* New Haven: Yale University Press, 2011.

Blumer, Herbert. "Collective Behavior." In *An Outline of the Principles of Sociology*, ed. Robert E. Park, 219–80. New York: Barnes & Noble, 1939.

———. "Moulding of Mass Behavior Through the Motion Picture." *Publication of the American Sociological Society* 29 (1935): 115–27.

Bogdanovich, Peter. "Interview with Orson Welles." In *Orson Welles's Citizen Kane*, ed. James Naremore, 19–69. Oxford: Oxford University Press, 2004.

Boland, Elena. "Chaplin Studio Unique in Films." *Los Angeles Times*, Aug. 31, 1930, B5, 12.

Bordwell, David. "Agee & Co.: A Newer Criticism." *David Bordwell's Website on Cinema*, Feb. 9, 2014, www.davidbordwell.net/blog/2014/02/09/agee-co-a-newer-criticism.

———. "*Citizen Kane*." In *Focus on Orson Welles*, ed. Ronald Gottesman, 103–22. Englewood Cliffs, NJ: Prentice Hall, 1976. [Orig. pub. 1971.]

Borges, Jorge Luis. "Film Reviews from *Sur*." Trans. Gloria Waldman and Ronald Christ. *October* 15 (Winter 1980): 3–15. [Gottesman, ed., *Focus*, and Gottesman, ed., *Perspectives*, use a different translation.]

———. "Un film abrumador." [Review of *Citizen Kane*.] *Sur* 83 (1941): 88–89.

Bower, Anthony. "Films." [Review of *Meet John Doe*.] *The Nation*, Mar. 29, 1941, 390.

Bradbrook, M. C. *The Rise of the Common Player: A Study of Actor and Society in Shakespeare's England.* Cambridge, MA: Harvard University Press, 1962.

Brady, Frank. *Citizen Welles: A Biography of Orson Welles.* New York: Charles Scribner's Sons, 1989.

Brady, William A. "How the Motion Picture Saved the World!" *Photoplay*, Jan. 1919, 25, 100.

Brasbridge, T[homas]. *The Poore Mans Jewell.* London, 1578.

Brathwait, Richard. *Anniversaries upon His Panarete; Continued.* London, 1635.

———. *The English Gentleman.* London, 1630.

———. *A Spiritual Spicerie.* London, 1638.

Brill, Lesley. "Crowds, Isolation, and Transformation in Welles's *Citizen Kane*." In *Crowds, Power, and Transformation in Cinema,* 99–120. Detroit: Wayne State University Press, 2006.

Bristol, Michael D. *Big-Time Shakespeare.* New York: Routledge, 1996.

———. "Shamelessness in Arden: Early Modern Theater and the Obsolescence of Popular Theatricality." In *Print, Manuscript, and Performance: The Changing Relations of the Media in Early Modern England*, ed. Arthur F. Marotti and Michael D. Bristol, 279–306. Columbus: Ohio University Press, 2000.

The Broadway Melody. Dir. Harry Beaumont. MGM, 1929. Film.

Browne, Nick. "System of Production/System of Representation: Industry Context and Ideological Form in Capra's *Meet John Doe*." In *Meet John Doe*, ed. Charles Wolfe, 269–88. New Brunswick, NJ: Rutgers University Press, 1989. [Orig. pub. 1984.]

Brownlow, Kevin. *The Parade's Gone By....* Berkeley: University of California Press, 1968.

———. *The Search for Charlie Chaplin.* 2005. London: UKA Press, 2010.

Burke, Thomas. "A Comedian." In *City of Encounters: A London Divertissement,* 129–77. Boston: Little, Brown, 1932.

Burt, Richard. "To e- or Not to e-? Disposing of Schlockspeare in the Age of Digital Media." In *Shakespeare After Mass Media*, ed. Richard Burt, 1–32. New York: Palgrave, 2002.

———. *Medieval and Early Modern Film and Media.* New York: Palgrave, 2008.

———, ed. *Shakespeare After Shakespeare: An Encyclopedia of the Bard in Mass Media and Popular Culture.* 2 vols. Westport, CT: Greenwood Press, 2007.

Burton, Robert. *The Anatomy of Melancholy*. Oxford, 1621.

Busby, Marquis. "Murray Still Would Roam." *Los Angeles Times*, Feb. 5, 1928, C9.

Bush, Gregory W. "Like 'A Drop of Water in the Stream of Life': Moving Images of Mass Man from Griffith to Vidor." *Journal of American Studies* 25, no. 2 (Aug. 1991): 213–34.

"Café Complex Harries Bacon." *Los Angeles Times*, July 21, 1929, B13, B15.

Capra, Frank. *Frank Capra: The Name Above the Title: An Autobiography*. New York: Macmillan, 1971.

———. "'One Man, One Film'—The Capra Contention." Sunday Calendar, *Los Angeles Times*, Jun. 26, 1977, 12.

Carney, Raymond. *American Vision: The Films of Frank Capra*. Cambridge: Cambridge University Press, 1986.

Carringer, Robert L. *The Making of* Citizen Kane. Berkeley: University of California Press, 1985.

———. "Rosebud, Dead or Alive: Narrative and Symbolic Structure in *Citizen Kane*." *PMLA* 91, no. 2 (Mar. 1976): 185–93.

Carroll, Noël. "Interpreting *Citizen Kane*." In *Perspectives on* Citizen Kane, ed. Ronald Gottesman, 254–67. New York: G. K. Hall, 1996. [Orig. pub. 1989.]

———. *A Philosophy of Mass Art*. Oxford: Clarendon Press, 1998.

———. "The Specificity Thesis." In *Film Theory and Criticism: Introductory Readings*, 6th edition, ed. Leo Braudy and Marshall Cohen, 332–38. Oxford: Oxford University Press, 2004. [Orig. pub. 1988.]

Carson, Neil. *A Companion to Henslowe's Diary*. Cambridge: Cambridge University Press, 1988.

Carter, Randolph, and Robert Reed Cole. *Joseph Urban: Architecture, Theatre, Opera, Film*. New York: Abbeville Press, 1992.

Cartwright, William. *The Ordinary*. In *The Plays and Poems of William Cartwright*, ed. G. Blakemore Evans. Madison: University of Wisconsin Press, 1951. [Orig. pub. c. 1635.]

Cavell, Stanley. "Concluding Remarks Presented at Paris Colloquium on *La Projection du monde*." In *Cavell on Film*, ed. William Rothman, 281–86. Albany: State University of New York Press, 2005. [Orig. pub. 1999.]

Chambers, E. K. *The Elizabethan Stage*. 4 vols. Oxford: Oxford University Press, 1923.

———. *William Shakespeare: A Study of Facts and Problems*. 2 vols. Oxford: Clarendon Press, 1930.

Chaplin, Charles. *My Autobiography*. London: Penguin, 2003. [Orig. pub. 1964.]

Chaplin, Charles Jr., with N. and M. Rau. *My Father, Charlie Chaplin*. New York: Random House, 1960.

"Chaplin Defies Prophets with New Silent Film." *Los Angeles Times*, Sept. 23, 1930, A12.

Churchill, Douglas. "Meet John Doe." *Redbook*, Mar. 1941, 10–11, 115.

"Cinema: Kane Case." [Review of *Citizen Kane*.] *Time* 37, no. 11 (Mar. 17, 1941), 90, 92.

Citizen Kane. Dir. Orson Welles. Mercury Productions, 1941. Film. Turner Entertainment, 2011. DVD.

City Lights. Dir. Charles Chaplin. Charles Chaplin Productions, 1931. Film. Criterion, 2013. DVD.

———. Pressbook. In *Cinema Pressbooks from the Original Studio Collections*, reel 27. [Reading, Berks.?]: Research Publications, 1988.

Clipper, Lawrence J. "Art and Nature in Welles' Xanadu." *Film Criticism* 5, no. 3 (1981): 12–20.

Cobos, Juan, Miguel Rubio, and J. A. Pruneda. "A Trip to Don Quixoteland: Conversations with Orson Welles." In *Focus on* Citizen Kane, ed. Ronald Gottesman, 7–24. Englewood Cliffs, NJ: Prentice-Hall, 1971. [Orig. pub. 1966.]

Cocteau, Jean. "Profile of Orson Welles." Trans. Jonathan Rosenbaum. In *Orson Welles: A Critical View*, ed. André Bazin, 28–35. Los Angeles: Acrobat Books, 1991. [Orig. pub. 1949; rev. 1958.]

Coleridge, Samuel Taylor. *Biographia Literaria*. Ed. J. Shawcross. Oxford: Clarendon Press, 1907. [Orig. pub. 1817.]

Collinson, Patrick. "The Theater Constructs Puritanism." In *The Theatrical City: Culture, Theatre and Politics in London, 1576–1649*, ed. David L. Smith, Richard Strier, and David Bevington, 157–69. Cambridge: Cambridge University Press, 1995.

Comensoli, Viviana. "Play-Making, Domestic Conduct, and the Multiple Plot in *The Roaring Girl*." *Studies in English Literature, 1500–1900* 27, no. 2 (Spring 1987): 249–66.

"Coming Attractions." [Review of *The Crowd*.] *Washington Post*, Apr. 5, 1928, 9.

Cook, Ann Jennalie. *The Privileged Playgoers of Shakespeare's London, 1576–1642*. Princeton: Princeton University Press, 1981.

Cornwallis, William. *Essayes*. London, 1600[–1601].

Covell, William. *Polimanteia*. Cambridge, 1595.

Craig, D. H., ed. *Ben Jonson: The Critical Heritage, 1599–1798*. London: Routledge, 1990.

Creelman, Eileen. "The New Movies." [Review of *Meet John Doe*.] *New York Sun*, Mar. 13, 1941, 24.

Crocker, Harry. "Charlie Chaplin: Man and Mime." n.d. Harry Crocker Papers. Academy of Motion Picture Arts and Sciences, Margaret Herrick Library, Beverly Hills, CA.

Crosmon, Melville [Darryl Zanuck]. "Story Idea: 'Prologue.'" Mar. 27, 1933. "Footlight Parade," Story—Memos & Correspondence file 2170. Warner Bros. Archives, School of Cinematic Arts, University of Southern California.

Crosse, Henry. *Vertues Common-wealth.* London, 1603.

The Crowd. Dir. King Vidor. Metro-Goldwyn-Mayer Corp., 1928. Film.

"'Crowd' Bears Semblance of 'Big Parade.'" [Review of *The Crowd*.] *Los Angeles Times*, Apr. 15, 1928, C27.

Crowl, Samuel. *Shakespeare and Film: A Norton Guide*. New York: Norton, 2008.

Crowther, Bosley. "Vidor's Individualist Manifesto." *New York Times*, Nov. 13, 1938, IX.5.

Dale, Alan. *Comedy Is a Man in Trouble: Slapstick in American Movies*. Minneapolis: University of Minnesota Press, 2000.

Dale, Edgar. *How to Appreciate Motion Pictures: A Manual of Motion-Picture Criticism for High-School Students*. New York: Macmillan, 1938.

Dangerfield, Fred, and Norman Howard. *How to Become a Film Artiste: The Art of Photo-Play Acting*. London: Odhams Press, 1921.

Davies, Sir John. *The Poems of Sir John Davies*, ed. Robert Krueger. Oxford: Clarendon Press, 1975.

Davis, Therese. "First Sight: Blindness, Cinema, and Unrequited Love." *Journal of Narrative Theory* 33, no. 1 (Winter 2003): 48–62.

Dawson, Anthony B. "Mistris Hic & Haec: Representations of Moll Frith." *Studies in English Literature, 1500–1900* 33, no. 2 (Spring 1993): 385–404.

Day, John. *The Isle of Guls*. Ed. Raymond S. Burns. New York: Garland, 1980. [Acted and pub. 1606.]

[Day, John, William Rowley, and George Wilkins.] *The Travails of the Three English Brothers.* In *Three Renaissance Travel Plays*, ed. Anthony Parr. Manchester: Manchester University Press, 1995. [Written and pub. 1607.]

Decherney, Peter. *Hollywood and the Culture Elite: How the Movies Became American.* New York: Columbia University Press, 2005.

Dekker, Thomas. *The Dramatic Works of Thomas Dekker.* 4 vols. Ed. Fredson Bowers. Cambridge: Cambridge University Press, 1953–62.

———. *If This Be Not a Good Play, The Devil Is in It.* In *The Dramatic Works* of Thomas Dekker, ed. Fredson Bowers, 3:113–223. Cambridge: Cambridge University Press, 1966.

———. *The Guls Horn-book.* London, 1609. [Acted 1611–12, pub. 1612.]

Dekker, Thomas, and T[homas] Middleton. *The Roaring Girl.* London, 1611. [Acted 1611.]

———. *The Roaring Girl.* In *English Renaissance Drama: A Norton Anthology*, ed. David Bevington et al. New York: Norton, 2002.

DeMille, Cecil B. "Directorial Opportunities of the Future." *The Director* 1, no. 3 (1924): 7, 20.

Dickstein, Martin, "'Footlight Parade' Has Broadway Screen Premiere." [Review of *Footlight Parade*.] *Brooklyn Daily Eagle*, Oct. 5, 1933, 24.

Döblin, Alfred. "May the Individual Not Be Stunted by the Masses." In *The Weimar Republic Sourcebook*, ed. Anton Kaes, Martin Jay, and Edward Dimendberg, 386–87. Berkeley: University of California Press, 1994. [Orig. pub. 1932.]

Dowd, Nancy, and David Shepard, eds. *King Vidor.* Metuchen, NJ: Scarecrow Press, 1988.

Dryden, John. "Defence of the Epilogue" to *The Conquest of Granada, Part II.* 1672. In *The Works of John Dryden*, gen. eds. Edward Niles Hooker and H. T. Swedenberg Jr., vol. 11, *Plays*, ed. John Loftis et al., 203–18. Berkeley: University of California Press, 1978.

———. *An Essay of Dramatick Poesie.* 1668. In *The Works of John Dryden*, gen. eds. Edward Niles Hooker and H. T. Swedenberg Jr., vol. 17, *Prose, 1691*, ed. Samuel Holt Monk et al., 1–81. Berkeley: University of California Press, 1971.

Durgnat, Raymond, and Scott Simmon. *King Vidor, American.* Berkeley: University of California Press, 1988.

Earle, John. *Micro-cosmographie.* London, 1628.

Eastman, Max. *Heroes I Have Known: Twelve Who Lived Great Lives.* New York: Simon and Schuster, 1942.

Edwards, Philip. "'Seeing Is Believing': Action and Narration in *The Old Wives Tale* and *The Winter's Tale*." In *Shakespeare and His Contemporaries: Essays in Comparison*, ed. E. A. J. Honigmann, 79–93. Manchester: Manchester University Press, 1986.

Eisenstein, Elizabeth. *The Printing Press as an Agent of Change: Communications and Cultural Transformations in Early-Modern Europe.* 1979. Cambridge: Cambridge University Press, 1980.

Eisenstein, Sergei. *Notes of a Film Director.* Trans. X. Danko. 1947. Moscow: Foreign Languages Publishing House, [1959?].

Eliot, T[homas] S[tearns]. "Thomas Middleton." In *Elizabethan Essays,* 87–100. London: Faber & Faber, 1934. [Orig. pub. 1927.]

Erasmus, Desiderius. *Adagiorum Opus.* Basil, 1528. Online through the Hathi Trust.

———. *Collected Works.* Ed. Peter G. Bietenholz et al. Toronto: University of Toronto Press, 1974–.

Erne, Lukas. *Shakespeare and the Book Trade.* Cambridge: Cambridge University Press, 2013.

———. *Shakespeare as Literary Dramatist*. Cambridge: Cambridge University Press, 2003.

Evelyn, John. *An Essay on the First Book of T. Lucretius Carus De Rerum Natura*. London, 1656.

Everson, William K. *American Silent Film*. New York: Oxford University Press, 1978.

Fabe, Marilyn. *Closely Watched Films: An Introduction to the Art of Narrative Film Technique*. Berkeley: University of California Press, 2004.

"Fanchon and Marco Idea 10 Years Old This Week; Its Fame Covers Nation." *Milwaukee Sentinel*, Jan. 19, 1932, 8.

Fennor, William. *Fennors Descriptions*. London, 1616.

Fiske, Minnie Maddern. "The Art of Charles Chaplin." In *The Essential Chaplin: Perspectives on the Life and Art of the Great Comedian*, ed. Richard Schickel, 97–99. Chicago: Ivan R. Dee, 2006. [Orig. pub. 1916.]

Fletcher, John. *The Faithfull Shepheardesse*. London, [1610?].

Fletcher, John Gould. *The Crisis of the Film*. In *Screen Monographs II*. New York: Arno Press and the New York Times, 1970. [Orig. pub. 1929.]

Foakes, R. A., ed. *Illustrations of the English Stage, 1580–1642*. Stanford: Stanford University Press, 1985.

Footlight Parade. Dir. Lloyd Bacon. Warner Bros. Pictures, 1933. Film. Turner Entertainment and Warner Bros. Entertainment, 2006. DVD.

———. Pressbook. In *Cinema Pressbooks from the Original Studio Collections*, Reel 6, Part 1. [Reading, Berks.?]: Research Publications, 1988.

"Footlight Parade." [Review of *Footlight Parade*.] *Variety*, Oct. 10, 1933, 17.

Forman, Valerie. "Marked Angels: Counterfeits, Commodities, and *The Roaring Girl*." *Renaissance Quarterly* 54, no. 4 (Winter 2001): 1531–60.

Foxe, John. *Actes and Monuments*. In *The Unabridged Acts and Monuments Online*. Sheffield: HRI Online Publications, 2011. [Orig. pub. 1563–83.]

Frank, Waldo. "Charles Chaplin: A Portrait." *Scribner's* 86, no. 3 (Sept. 1929): 237–44.

Fried, Michael. *Absorption and Theatricality: Painting and Beholder in the Age of Diderot*. Chicago: University of Chicago Press, 1980.

Geduld, Harry M. *Charlie Chaplin's Own Story*. 1916. Bloomington: Indiana University Press, 1985.

Glatzer, Richard. "*Meet John Doe*: An End to Social Mythmaking." In *Meet John Doe*, ed. Charles Wolfe, 243–52. New Brunswick, NJ: Rutgers University Press, 1989. [Orig. pub. 1975.]

Gleason, John B. "The Dutch Humanist Origins of the De Witt Drawing of the Swan Theater." *Shakespeare Quarterly* 32 (1981): 324–38.

Gold Diggers of 1933. Dir. Mervyn LeRoy. Warner Bros, 1933. Film. Turner Entertainment and Warner Bros. Entertainment, 2006. DVD.

Goldman, Jonathan. *Modernism Is the Literature of Celebrity*. Austin: University of Texas Press, 2011.

Gordon, Terri J. "Fascism and the Female Form: Performance Art in the Third Reich." *Journal of the History of Sexuality* 11, nos. 1–2 (Jan.–Apr. 2002): 164–200.

Gosson, Stephen. *Markets of Bawdrie: The Dramatic Criticism of Stephen Gosson*. (Contains *The Schoole of Abuse* [1579], *An Apologie of the Schoole of Abuse* [1579], and *Playes Confuted in Five Actions* [1582].) Ed. Arthur F. Kinney. Salzburg: Institut für Englische Sprache und Literatur, Universität Salzburg, 1974.

Gottesman, Ronald, ed. *Focus on* Citizen Kane. Englewood Cliffs, NJ: Prentice-Hall, 1971.

———, ed. *Perspectives on* Citizen Kane. New York: G. K. Hall, 1996.

Grant, Barry Keith, ed. *Auteurs and Authorship: A Film Reader.* Oxford: Blackwell, 2008.

"Great Musical Spectacle Has Unique Beauty." *Washington Post*, Nov. 3, 1933, 18.

Greenberg, Clement. "Avant-Garde and Kitsch." In *Clement Greenberg: Collected Essays and Criticism*, ed. John O'Brian, 1:5–22. Chicago: University of Chicago Press, 1986. [Orig. pub. 1939.]

Greene, Robert [and Henry Chettle?]. *Greenes, Groats-Worth of Witte.* Ed. D. Allen Carroll. Binghamton, NY: Medieval and Renaissance Texts and Studies, 1994. [Orig. pub. 1592.]

Grimsted, David. "The Purple Rose of Popular Culture Theory: An Exploration of Intellectual Kitsch." *American Quarterly* 43, no. 4 (Dec. 1991): 541–78.

Griswold, J. B. " 'Let's Be Ourselves': A Closeup of Fanchon & Marco." *American Magazine* 114, no. 3 (Sept. 1932): 46–47, 105–8.

Gubar, Susan. *Racechanges: White Skin, Black Face in American Culture.* New York: Oxford University Press, 1997.

Gurr, Andrew. *Playgoing in Shakespeare's London.* Cambridge: Cambridge University Press, 1987.

———. "Prologue: Who Is Lovewit? What Is He?" In *Ben Jonson and Theatre: Performance, Practice and Theory*, ed. Richard Cave, Elizabeth Schafer, and Brian Woolland, 5–18. London: Routledge, 1999.

———. "The Shakespearean Stage." In *The Norton Shakespeare*, 2nd ed., ed. Stephen Greenblatt et al., 79–99. New York: Norton, 2008.

———. *The Shakespearean Stage, 1574–1642.* 4th ed. Cambridge: Cambridge University Press, 2009.

Hake, Sabine. "Chaplin Reception in Weimar Germany." *New German Critique* 51 (Fall 1990): 87–111.

Hall, Mordaunt. "An Air Mail Drama." *New York Times*, Oct. 15, 1933: X3.

Halpern, Richard. "Eclipse of Action: *Hamlet* and the Political Economy of Playing." *Shakespeare Quarterly* 59 (2008): 450–82.

Hamman, Mary. "Meet Frank Capra Making a Picture." *Good Housekeeping*, March 1941, 11, 74–75.

Hampton, Benjamin B. *History of the American Film Industry from Its Beginnings to 1931.* New York: Dover, 1970. [Orig. pub. as *A History of the Movies*, 1931.]

Hannon, William Morgan. *The Photodrama: Its Place Among the Fine Arts.* New Orleans: Ruskin Press, 1915.

Hansen, Miriam. "Ambivalences of the 'Mass Ornament': King Vidor's *The Crowd*." *Qui Parle* 5, no. 2 (Spring-Summer 1992): 102–19.

———. "Room-for-Play: Benjamin's Gamble with Cinema." *October* 109 (2004): 3–45.

Happé, Peter. *John Bale.* New York: Twayne, 1996.

Harbage, Alfred. *Shakespeare's Audience.* New York: Columbia University Press, 1941.

———. *Shakespeare and the Rival Traditions.* New York: Macmillan, 1952.

H[arding]., S[amuel]. *Sicily and Naples.* Oxford, 1640.

Harrison, William. *The Difference of Hearers.* London, 1614.

Hayes, Kevin B., ed. *Charlie Chaplin: Interviews.* Jackson: University Press of Mississippi, 2005.

Hays, Will. *See and Hear: A Brief History of Motion Pictures and the Development of Sound.* In *Screen Monographs II.* New York: Arno Press and New York Times, 1970. [Orig. pub. 1929.]

"Hearst." *Fortune* 12, no. 4 (October 1935): 42–55, 123–162.

Heywood, Thomas. *An Apology for Actors.* Ed. Richard Perkinson. New York: Scholars' Facsimiles & Reprints, 1941. [Orig. pub. 1612.]

———. *Gunaikeion.* London, 1624.

———. *The Iron Age.* London, 1632.

Hoberman, J. "Pop Before Pop: Welles, Sirk, Hitchcock." *Artforum* 49, no. 5 (Jan. 2011): 168–175, 242.

Hodges, C. Walter. *The Globe Restored: A Study of the Elizabethan Theatre.* 2nd ed. London: Oxford University Press, 1968. [Orig. pub. 1953.]

Holmes, John Haynes. "The Movies and the Community." In *The Movies on Trial: The Views and Opinions of Outstanding Personalities Anent Screen Entertainment Past and Present*, ed. William J. Perlman, 196–205. New York: Macmillan, 1936.

Horkheimer, Max, and Theodor Adorno. *Dialectic of Enlightenment: Philosophical Fragments*, trans. John Cumming, 120–67. New York: Continuum, 2000. [Orig. pub. 1944; trans. from 1972.]

———. "Kulturindustrie: Aufklärung als Massenbetrug." *Dialektik der Aufklärung: Philosophische Fragmente.* In Theodor Adorno, *Gesammelte Schriften*, ed. Rolf Tiedemann et al., 3:141–91. Frankfurt am Main: Suhrkamp, 1996. [Orig. pub. 1944.]

Houston, Beverle. "Power and Dis-Integration in the Films of Orson Welles." *Film Quarterly* 35, no. 4 (Summer 1982): 2–12.

Howard, Jean E. "Crossdressing, the Theater, and Gender Struggle in Early Modern England." *Shakespeare Quarterly* 39, no. 4 (Winter 1988): 418–40.

Hutson, Lorna. "Ben Jonson's Closet Opened." *ELH* 71 (2004): 1065–96.

Huxley, Aldous. *Beyond the Mexique Bay.* London: Chatto & Windus, 1934.

Huyssen, Andreas. *After the Great Divide: Modernism, Mass Culture, Postmodernism.* Bloomington: Indiana University Press, 1986.

I.G. *A Refutation of the Apology for Actors.* Ed. Richard Perkinson. New York: Scholars' Facsimiles & Reprints, 1941. [Orig. pub. 1615.]

Jackson, Russell. *Shakespeare and the English-Speaking Cinema.* Oxford: Oxford University Press, 2014.

———. *Theatres on Film: How the Cinema Imagines the Stage.* Manchester: Manchester University Press, 2013.

Jackson, Tony. "Writing, Orality, Cinema: The 'Story' of *Citizen Kane*." *Narrative* 16, no. 1 (Jan. 2008): 29–45.

Jacobs, Lewis. *The Rise of the American Film: A Critical History.* New York: Harcourt, Brace, 1939.

Jameson, Fredric. *Postmodernism, or, The Cultural Logic of Late Capitalism.* Durham, NC: Duke University Press, 1991.

The Jazz Singer. Warner Bros. Pictures, 1928. Film. Warner Home Video, 2007. DVD.

———. Pressbook. In *Cinema Pressbooks from the Original Studio Collections*, reel 9. [Reading, Berks.?]: Research Publications, 1988.

Jenemann, David. *Adorno in America.* Minneapolis: University of Minnesota Press, 2007.

Johaneson, Bland. "'Footlight Parade' Is Great." *New York Daily Mirror*, Oct. 5, 1933, 25.

Jonson, Ben. *The Cambridge Edition of the Works of Ben Jonson.* Ed. David Bevington et al. 7 vols. Cambridge: Cambridge University Press, 2012.

———, trans. *Q. Horatius Flaccus: His Art of Poetry.* London, 1640.

J.P.K. "The Theatre." [Review of *Footlight Parade*.] *Wall Street Journal*, Oct. 7, 1933, 3.

Jump, Herbert A. *The Religious Possibilities of the Motion Picture*. Private Distribution, 1911.

Kael, Pauline. *For Keeps: 30 Years at the* Movies. New York: Penguin, 1994.

———. "Raising Kane." In *For Keeps: 30 Years at the Movies*, 233–325. New York: Penguin, 1994. [Orig. pub. 1971.]

———. "Trash, Art, and the Movies." In *For Keeps: 30 Years at the Movies*, 200–27. New York: Penguin, 1994. [Orig. pub. 1969.]

Kael, Pauline, Herman J. Mankiewicz, and Orson Welles. *The* Citizen Kane *Book*. Boston: Little, Brown, 1971.

Kastan, David Scott. *Shakespeare and the Book*. Cambridge: Cambridge University Press, 2001.

Kellow, Brian. *Pauline Kael: A Life in the Dark*. New York: Viking, 2011.

"King Vidor Discusses Motion Pictures—His New Film Is Built Like a Play." *New York Times*, May 22, 1927: X5.

Knapp, Jeffrey. " 'Sacred Songs Popular Prices': Secularization in *The Jazz Singer*." *Critical Inquiry* 34 (2008): 313–35.

———. *Shakespeare Only*. Chicago: University of Chicago Press, 2009.

———. *Shakespeare's Tribe: Church, Nation, and Theater in Renaissance England*. Chicago: University of Chicago Press, 2002.

Korda, Natasha. "The Case of Moll Frith: Women's Work and the 'All-Male Stage.' " In *Women Players in England, 1500–1600: Beyond the All-Male Stage*, ed. Pamela Allen Brown and Peter Parolin, 71–88. Aldershot: Ashgate, 2005.

Kracauer, Siegfried. *Das Ornament der Masse*. Frankfurt am Main: Suhrkamp, 1977. [Orig. pub. 1927.]

———. "The Mass Ornament." In *The Mass Ornament: Weimar Essays*, trans. and ed. Thomas Y. Levin, 75–86. Cambridge, MA: Harvard University Press, 1995.

———. *Theory of Film: The Redemption of Physical Reality*. Princeton: Princeton University Press, 1997. [Orig. pub. 1960.]

Kreuger, Miles, ed., *Souvenir Programs of Twelve Classic Movies 1927–1941*. New York: Dover, 1977.

Krows, Arthur Edwin. *The Talkies*. New York: Henry Holt, 1930.

Kyvig, David E. *Daily Life in the United States, 1920–1940*. Rev. ed. Chicago: Ivan R. Dee, 2004.

Lady Killer. Dir. Roy Del Ruth. Warner Bros. Pictures, 1933. Turner Entertainment and Warner Bros. Entertainment, 2008. DVD.

Lane, Tamar. *What's Wrong with the Movies?* Los Angeles: Waverly, 1923.

Lescarboura, Austin. *Behind the Motion-Picture Screen*. New York: Scientific American, 1919.

Levkoff, Mary L. *Hearst the Collector*. New York: Abrams and Los Angeles County Museum of Art, 2008.

Lewis, Lloyd. "The De Luxe Picture Palace." *New Republic*, Mar. 27, 1929, 175–76.

L.H.C. [Review of *Footlight Parade*.] *To-Day's Cinema*, Nov. 10, 1933, 10–12.

Lindsay, Vachel. *The Art of the Moving Picture*. New York: Random House, 2000. [Orig. pub. 1915; rev. 1922.]

Lodge, Thomas. *Rosalynde*. London, 1592.

Lopez, Jeremy. *Theatrical Convention and Audience Response in Early Modern Drama*. Cambridge: Cambridge University Press, 2003.

Lusk, Norbert. "'The Bowery' and 'Footlight Parade' Smash Hits of New York Show Week." *Los Angeles Times*, Oct. 15, 1933, A2.

———. "'Crowd' Piece of Rare Skill." *Los Angeles Times*, Feb. 26, 1928, C13.

Macdonald, Dwight. "A Theory of 'Popular Culture.'" *Politics* 1 (Feb. 1944): 20–23.

Marcus, Leah. *Puzzling Shakespeare: Local Reading and Its Discontents*. Berkeley: University of California Press, 1988.

Marston, John. *Jack Drum's Entertainment*. In *The Plays of John Marston*, ed. H. Harvey Wood, 3:175–241. Edinburgh: Oliver and Boyd, 1934–39. [Acted 1600; pub. 1601.]

———. *Parasitaster, or The Fawn*. Ed. David A. Blostein. Manchester: Manchester University Press, 1978. [Acted c. 1604; pub. 1606.]

———. *What You Will*. In *The Plays of John Marston*, ed. H. Harvey Wood, 2:227–95. Edinburgh: Oliver and Boyd, 1934–39. [Acted 1601; pub. 1607.]

Marston, John, and John Webster. *The Malcontent*. In *English Renaissance Drama: A Norton Anthology*, ed. David Bevington et al., 545–613. New York: Norton, 2002. [Acted 1600–1604; pub. 1604.]

Massinger, Philip. *The Plays and Poems of Philip Massinger*. Ed. Philip Edwards and Colin Gibson. 5 vols. Oxford: Clarendon Press, 1976.

Mast, Gerald. *Can't Help Singin': The American Musical on Stage and Screen*. Woodstock, NY: Overlook Press, 1987.

Maus, Katharine Eisaman. "Satiric and Ideal Economies in the Jonsonian Imagination." *English Literary Renaissance* 19, no. 1 (Dec. 1989): 42–64.

McBride, Joseph. *Frank Capra: The Catastrophe of Success*. New York: Simon & Schuster, 1992.

McCabe, John. *Cagney*. New York: Carroll & Graf, 1997.

McCoy, Richard. *Faith in Shakespeare*. Oxford: Oxford University Press, 2013.

Meek, Richard. "Ekphrasis in *The Rape of Lucrece* and *The Winter's Tale*." *Studies in English Literature* 46 (2006): 389–414.

Meet John Doe. Frank Capra Productions, 1941. Film. VCI Entertainment, 2010. DVD.

———. Pressbook. ["Advance Campaign Plan for Frank Capra's Production 'Meet John Doe'."] Academy of Motion Picture Arts and Sciences, Margaret Herrick Library, Beverly Hills, CA.

"Meet John Doe." [Review of *Meet John Doe*.] *Box Office Digest*, Apr. 3, 1941, 20.

"Meet John Doe." [Review of *Meet John Doe*.] *Variety*, Mar. 19, 1941, 16.

Mennes, Sir John. *Recreation for Ingenious Head-Peeces*. London, 1654.

Menon, Madhavi. *Wanton Words: Rhetoric and Sexuality in English Renaissance Drama*. Toronto: University of Toronto Press, 2004.

Menzer, Paul. "Crowd Control." In *Imagining the Audience in Early Modern Drama, 1558–1642*, ed. Jennifer A. Low and Nova Myhill, 19–36. New York: Palgrave Macmillan, 2011.

Middleton, Thomas. *Thomas Middleton: The Collected Works*. Ed. Gary Taylor and John Lavagnino et al. Oxford: Oxford University Press, 2007.

Mikalachki, Jodi. "Gender, Cant, and Cross-Talking in *The Roaring Girl*." *Renaissance Drama* n.s. 25 (Jan. 1994): 119–43.

Miller, D. A. "Hitchcock's Understyle: A Too-Close View of *Rope*." *Representations* 121 (2013): 1–30.

Milles, Robert. *Abrahams Suite for Sodome*. London, 1612.

Mills, Kay. "Man of Ideas in the Land of Deals: A Talk with King Vidor." *Los Angeles Times*, Sept. 13, 1981, D2.

Miola, Robert S. *Shakespeare and Classical Comedy: The Influence of Plautus and Terence.* Oxford: Clarendon Press, 1994.

Modern Times. Dir. Charlie Chaplin. Charles Chaplin Film Corp, 1936. Film. New York: Criterion Collection, 2010. DVD.

Moretti, Franco. "The Great Eclipse." In *Signs Taken for Wonders: Essays in the Sociology of Literary Forms*, trans. Susan Fischer, David Forgacs, and David Miller. Rev. ed. London: Verso, 1988. [Orig. pub. 1979.]

"The Movie and the Masses." *New Republic*, Jun. 8, 1927, 61–62.

Mueller, Martin. "Hermione's Wrinkles, or, Ovid Transformed: An Essay on *The Winter's Tale*." *Comparative Drama* 5 (1971): 226–39.

Mulvey, Laura. *Citizen Kane.* London: British Film Institute, 1992.

[Munday, Anthony?], and Salvianus. *A Second and Third Blast of Retrait from Plaies and Theaters.* Ed. Arthur Freeman. New York: Garland, 1973. [Orig. pub. 1580.]

Munro, Ian. *The Figure of the Crowd in Early Modern London: The City and Its Double.* New York: Palgrave Macmillan, 2005.

My Best Girl. Dir. Sam Taylor. Mary Pickford Corp., 1927. Film. Milestone Film & Video, 1999. DVD.

Nagler, A. M. *Shakespeare's Stage.* 1958. Expanded ed. New Haven: Yale University Press, 1981.

Naremore, James, ed. *Orson Welles's* Citizen Kane*: A Casebook.* Oxford: Oxford University Press, 2004.

Nasaw, David. *The Chief: The Life of William Randolph Hearst.* New York: Houghton Mifflin, 2000.

Nashe, Thomas. *The Works of Thomas Nashe.* Ed. R. B. McKerrow. 5 vols. Reprint ed. F. P. Wilson. Oxford: Basil Blackwell, 1958. [Orig. pub. 1903–10.]

Nathan, George Jean. *The Theatre, the Drama, the Girls.* New York: Alfred Knopf, 1921.

Nelson, Alan H., and Paul H. Altrocchi. "William Shakespeare, 'Our Roscius.'" *Shakespeare Quarterly* 60 (2009): 460–69.

"The New Pictures." [Review of *Footlight Parade*.] *Time*, Oct. 9, 1933, 30, 32.

Northbrooke, John. *A Treatise Wherein Dicing, Dauncing, Vaine Playes or Enterluds with Other Idle Pastimes etc. Commonly Used on the Sabboth Day, Are Reproved.* Ed. Arthur Freeman. New York: Garland, 1974. [Orig. pub. 1577?]

Nugent, Frank S. "'The All-American Man.'" *New York Times*, July 5, 1942, SM18–19, 27.

"On the Screen." [Review of *Footlight Parade*.] *Literary Digest*, Oct. 21, 1933, 31.

Orgel, Stephen. *Impersonations: The Performance of Gender in Shakespeare's England.* Cambridge: Cambridge University Press, 1996.

———. "Shakespeare Imagines a Theater." *Poetics Today* 5 (1984): 549–61.

Orrell, John. "The London Stage in the Florentine Correspondence, 1604–1618." *Theatre Research International* 3 (1977–78): 157–76.

Orson Welles: The Paris Interview. Dir. Allan King, 1960. Television. West Long Branch, NJ: Kultur International, 2010.

Ortega y Gasset, José. *The Revolt of the Masses.* Trans. of *La rebelión de las masas.* New York: Norton, 1993. [Orig. pub. 1930; anon. trans. 1932.]

Patterson, Annabel. *Shakespeare and the Popular Voice.* Oxford: Blackwell, 1989.

Patterson, Frances Taylor. *Scenario and Screen.* New York: Harcourt Brace, 1928.

Perlman, William J., ed. *The Movies on Trial: The Views and Opinions of Outstanding Personalities Anent Screen Entertainment Past and Present.* New York: Macmillan, 1936.

Petrie, Graham. "Alternatives to Auteurs." *Film Quarterly* 26, no. 3 (Spring 1973): 27–35.

Phelps, Glenn A. "Frank Capra and the Political Hero: A New Reading of *Meet John Doe*." *Film Criticism* 5, no. 2 (Winter 1981): 49–57.

Pirandello, Luigi. *Si Gira*. Chicago: University of Chicago Press, 2005. [Orig. pub. 1915; trans. as *Shoot!* by C. K. Scott Moncrieff, 1926.]

The Play House. Dir. Buster Keaton. *Buster Keaton: Short Films Collection 1920–1923*. Joseph M. Schenck Productions, 1921. Film. New York: Kino International, 2011. DVD.

Plutarch. *The Lives of the Noble Grecians and Romanes*. Trans. Thomas North. London, 1579.

———. *The Philosophie, Commonlie Called, the Morals*. Trans. Philemon Holland. London, 1603.

Poague, Leland, ed. *Frank Capra: Interviews*. Jackson, MS: University Press of Mississippi, 2004.

Powell, Michael. *A Life in Movies: An Autobiography*. 1986; London: Faber and Faber, 2000.

"Projection Jottings." *New York Times*, Oct. 1, 1933, X4.

Prynne, William. *Histrio-Mastix*. Ed. Arthur Freeman. New York: Garland, 1974. [Orig. pub. 1633.]

Public Enemy. Dir. William A. Wellman. Warner Bros. Pictures, 1931. Film. Turner Entertainment and Warner Bros. Entertainment, 2013. DVD.

Pudovkin, V. *Film Technique*. 1926. Trans. Ivor Montagu. London: George Newnes, 1929.

Pymlico. London, 1609.

Quart, Leonard. "*Meet John Doe*." *Cineaste* 36, no. 3 (Summer 2011): 60.

Raksin, David, with introduction and notes by Charles M. Berg. "'Music Composed by Charles Chaplin': Auteur or Collaborateur?" *Journal of the University Film Association* 31, no. 1 (Winter 1979): 47–50.

Rancière, Jacques. *Aesthetics and Its Discontents*. Trans. Steven Corcoran. Cambridge: Polity Press, 2009. [Orig. pub. 2004 as *Malaise dans l'esthétique*.]

Rankins, William. *A Mirrour of Monsters*. Ed. Arthur Freeman. New York: Garland, 1973. [Orig. pub. 1587.]

Raphaelson, Samson. "Birth of 'The Jazz Singer.'" *American Hebrew*, Oct. 14, 1927, 812, 821.

Read, Herbert. *Art and Society*. New York: Macmillan, 1937.

Rintels, David W. "Someone's Been Sitting in His Chair." Sunday Calendar, *Los Angeles Times*, Jun. 5, 1977, R42.

———. "'Someone Else's Guts'—The Rintels Rebuttal." Sunday Calendar, *Los Angeles Times*, Jun. 26, 1977, 12–13.

Robinson, David. *Chaplin: His Life and Art*. 1985. New York: Da Capo, 1994.

Roman Scandals. Dir. Frank Tuttle. Howard Productions (Goldwyn), 1933. Film. Fox Home Entertainment, 2000. VHS.

Rose, Mary Beth. "Women in Men's Clothing: Apparel and Social Stability in *The Roaring Girl*." *English Literary Renaissance* 14 (1984): 367–91.

Rosenbaum, Jonathan. *Discovering Orson Welles*. Berkeley: University of California Press, 2007.

———. *Goodbye Cinema, Hello Cinephilia: Film Culture in Transition*. Chicago: University of Chicago Press, 2010.

Rosenberg, Harold. *The Anxious Object*. Chicago: University of Chicago Press, 1966. [Orig. pub. 1964.]

Roth, Mark. "Some Warners Musicals and the Spirit of the New Deal." In *Genre: The Musical*, ed. Rick Altman, 41–56. London: Routledge & Kegan Paul, 1981. [Orig. pub. 1977.]

Rotha, Paul. *Celluloid: The Film To-Day.* London: Longmans, Green, 1931.

———. *The Film Till Now: A Survey of the Cinema.* London: Jonathan Cape, 1930.

Rothman, William. "The Ending of *City Lights.*" In *The "I" of the Camera: Essays in Film Criticism, History, and Aesthetics*, 2nd ed., 44–54. Cambridge: Cambridge University Press, 2004. [Orig. pub. 1988.]

Rowley, William. *All's Lost by Lust.* London, 1633. [Acted c. 1619.]

Rubin, Martin. "1933: Movies and the New Deal in Entertainment." In *American Cinema of the 1930s: Themes and Variations*, ed. Ina Rae Hark, 92–116. New Brunswick, NJ: Rutgers University Press, 2007.

———. *Showstoppers: Busby Berkeley and the Tradition of Spectacle.* New York: Columbia University Press, 1993.

Ruttenburg, Nancy. *Democratic Personality: Popular Voice and the Trial of American Authorship.* Stanford: Stanford University Press, 1998.

Rutter, Tom. *Work and Play on the Shakespearean Stage.* Cambridge: Cambridge University Press, 2008.

Sayre, Nora. "Did Cooper and Stewart Have to Be So Stupid?" *New York Times*, Aug. 7, 1977, D11–12.

Schallert, Edwin. "'Footlight Parade' Spectacular Picture." [Review of *Footlight Parade*.] TK. Nov. 10, 1933, A9.

Scheuer, Philip K. "A Town Called Hollywood." [Review of *Footlight Parade*.] *Los Angeles Times*, Nov. 12, 1933, B1, B3.

———. "Town Called Hollywood." [Review of *Meet John Doe*.] *Los Angeles Times*, Mar. 16, 1941, C2.

———. "This Town Called Hollywood." *Chicago Daily Tribune*, Dec. 6, 1942, I7.

Schickel, Richard. *James Cagney: A Celebration.* New York: Applause Books, 1999.

———, ed. *The Essential Chaplin: Perspectives on the Life and Art of the Great Comedian.* Chicago: Ivan R. Dee, 2006.

———, ed. *The Men Who Made the Movies.* Chicago: Ivan R. Dee, 1975.

Seldes, Gilbert. *The 7 Lively Arts.* Mineola, NY: Dover, 2001. [Orig. pub. 1924.]

———. "A Fine American Movie." *New Republic*, Mar. 7, 1928, 98–99.

———. *An Hour with the Movies and the Talkies.* Philadelphia: J. B. Lippincott, 1929.

———. *The Movies Come from America.* New York: Charles Scribner's Sons, 1937.

———. "The People and the Arts." *Scribner's Magazine*, March 1937, 68–70.

———. "Radio Boy Makes Good." *Esquire*, Aug. 16, 1941, 57, 111.

Seymour, James, and Manuel Seff. "Footlight Parade." Screenplay. June 10, 1933. "Footlight Parade," Story—Revised Final, file 2170 (special). Warner Bros. Archives, School of Cinematic Arts, University of Southern California.

"The Shadow Stage Reviewing Films of the Month." [Review of *Citizen Kane*.] *Photoplay*, Jul. 1941, 24.

"The Shadow Stage: A Review of the New Pictures." [Review of *The Crowd*.] *Photoplay* 33 (Dec. 1927), 52–53.

"The Shadow Stage: A Review of the New Pictures." [Review of *Footlight Parade*.] *Photoplay*, 45 (Dec. 1933), 58–59.

"The Shadow Stage: A Review of the New Pictures." [Review of *My Best Girl*.] *Photoplay*, Dec. 1927, 52.

Shakespeare, William. *The Riverside Shakespeare*. 2nd ed. Ed. G. Blakemore Evans et al. Boston: Houghton Mifflin, 1997.

Shakespeare on Film. A Routledge FreeBook. London: Routledge, 2016.

Sherwood, Robert E., ed. *The Best Moving Pictures of 1922–23*. Boston: Small, Maynard, 1923.

———. "The Silent Drama." *Life*, Oct. 29, 1925, 24.

Shirley, James. *The Coronation*. London, 1640. [Acted 1635.]

Sills, Milton. "The Actor's Part." In *The Story of the Films*, ed. Joseph P. Kennedy, 175–202. Chicago: A. W. Shaw, 1927.

Sklar, Robert. "Authorship and Billy Wilder." *The Wiley-Blackwell History of American Film*, ed. Cynthia Lucia et al., 3:177–198. Oxford: Blackwell, 2012.

Slide, Anthony. *Inside the Hollywood Fan Magazine: A History of Star Makers, Fabricators, and Gossip Mongers*. Jackson: University of Mississippi Press, 2010.

Smallwood, R. L. "'Here, in the Friars': Immediacy and Theatricality in *The Alchemist*." *Review of English Studies* n.s. 32, no. 126 (1981): 142–60.

Smith, Julian. *Chaplin*. Boston: Twayne, 1984.

Smoodin, Eric. "Art/Work: Capitalism and Creativity in the Hollywood Musical." *New Orleans Review* 16 (1989): 79–87.

Spivak, Jeffrey. *Buzz: The Life and Art of Busby Berkeley*. Lexington: University of Kentucky Press, 2010.

Spufford, Margaret. *Small Books and Pleasant Histories: Popular Fiction and Its Readership in Seventeenth-Century England*. London: Methuen, 1981.

Stage, Kelly J. "*The Roaring Girl*'s London Spaces." *Studies in English Literature, 1500–1900* 49, no. 2 (Spring 2009): 417–36.

Stallybrass, Peter, and Allon White. *The Politics and Poetics of Transgression*. London: Methuen, 1986.

Stanfield, Peter. "'An Octoroon in the Kindling': American Vernacular and Blackface Minstrelsy in 1930s Hollywood." *Journal of American Studies* 31 (1997): 407–38.

Steer, Valentia. *The Romance of the Cinema: A Short Record of the Development of the Most Popular Form of Amusement of the Day*. London: C. Arthur Pearson, 1913.

Stephen, Isabel. "Escape from the Monotony of Life." *Washington Post*, Aug. 5, 1928, SM2.

Stern, Seymour. "The Bankruptcy of Cinema as Art." In *The Movies on Trial: The Views and Opinions of Outstanding Personalities Anent Screen Entertainment Past and Present*, ed. William J. Perlman, 113–40. New York: Macmillan, 1936.

Stern, Tiffany. *Rehearsal from Shakespeare to Sheridan*. Oxford: Oxford University Press, 2007.

St. Johns, Ivan. "Mister Cinderella." *Photoplay*, March 1927, 91, 124–25.

Stubbes, Phillip. *An Anatomie of Abuses*. Ed. Arthur Freeman. New York: Garland, 1973. [Orig. pub. 1583; revised eds. 1583, 1584, 1595.]

Sugden, Edward. *A Topographical Dictionary to the Works of Shakespeare and His Fellow Dramatists*. Manchester: University of Manchester Press, 1925.

Sullivan's Travels. Dir. Preston Sturges. Paramount Pictures, 1941. Film. The Criterion Collection, 2015. DVD.

Talbot, Frederick A. *Moving Pictures: How They Are Made and Worked*. New York: Arno Press, 1970. [Orig. pub. 1912.]

Talvacchia, Bette. *Taking Positions: On the Erotic in Renaissance Culture*. Princeton: Princeton University Press, 1999.

———. "That Rare Italian Master and the Posture of Hermione in *The Winter's Tale*." *LIT: Literature Interpretation Theory* 3 (1992): 163–74.

The Telegraph Trail. Dir. Tenny Wright. Warner Bros., 1933. Film. Warner Home Video, 2007. DVD.

Thayer, C. G. *Ben Jonson: Studies in the Plays*. Norman: University of Oklahoma Press, 1963.

Thomas, Kevin. "Capra Retrospectve: 'Little People' Win the Day." *Los Angeles Times*, Sept. 10, 1971, F18.

Thomson, David. "The Demon Tramp." In *The Essential Chaplin: Perspectives on the Life and Art of the Great Comedian*, ed. Richard Schickel, 59–64. Chicago: Ivan R. Dee, 2006. [Orig. pub. 1975.]

Tinee, Mae. [A shared byline for *Chicago Daily Tribune* movie reviewers, jokingly derived from "matinee."] "Mr. Common Citizen and Wife Walk onto Screen." *Chicago Daily Tribune*, Apr. 15, 1928, G1.

———. "This Musical Has Something New to Offer." *Chicago Daily Tribune*, Nov. 16, 1933, 21.

Toles, George. "Believing in Gary Cooper." *Criticism* 45, no. 1 (2003): 31–52.

Trahair, Lisa. "Figural Vision: Freud, Lyotard and Early Cinematic Comedy." *Screen* 46, no. 2 (Summer 2005): 175–93.

Turner, James. "Marcantonio's Lost *Modi* and Their Copies." *Print Quarterly* 21 (2004): 363–84.

Turvey, Malcolm. *The Filming of Modern Life: European Avant-Garde Film on the 1920s*. Cambridge, MA: MIT Press, 2011.

Ungerer, Gustav. "Mary Frith, Alias Moll Cutpurse, in Life and Literature." *Shakespeare Studies* 28 (2000): 42–84.

The Vagabond. Dir. Charles Chaplin. Mutual Films, 1916. Film. In *Chaplin Mutual Comedies*. Image Entertainment, 2006. DVD.

Vaughan, William. *The Golden-grove*. London, 1600.

Vidor, King. *A Tree Is a Tree*. New York: Harcourt, Brace, 1952.

———. "March of Life." Scenario. Oct. 21, 1926. MGM Collection, "The Crowd," Folder 1 of 1. Cinematic Arts Library, University of Southern California.

Vidor, King, and Harry Behn. "The Mob." Continuity Script. Dec. 21, 1926. With Synopsis by J. Dale Eunson. Jan. 3, 1927. MGM Collection, "The Crowd," Folder 1 of 1. Cinematic Arts Library, University of Southern California.

Vineberg, Steve. "Master of Manipulation." [Review of *Frank Capra: The Catastrophe of Success* by Joseph McBride.] *Threepenny Review* 54 (Summer 1993): 28–31.

Wagner, Phil. "'An America Not Quite Mechanized': Fanchon and Marco, Inc., Perform Modernity." *Film History* 23, no. 3 (Sept. 2011): 251–67.

Wallis, Hal. Memo to Joseph Hazen. Oct. 4, 1932. "Footlight Parade," Story—Memos & Correspondence file 2170. Warner Bros. Archives, School of Cinematic Arts, University of Southern California.

Ward, Richard. "Even a Tramp Can Dream: An Examination of the Clash Between 'High Art' and 'Low Art' in the Films of Charlie Chaplin." *Studies in Popular Culture* 32, no. 1 (Fall 2009): 103–16.

Warshow, Robert. "A Feeling of Sad Dignity." In *The Immediate Experience: Movies, Comics, Theatre and Other Aspects of Popular Culture*, 193–209. Cambridge, MA: Harvard University Press, 2001. [Orig. pub. 1954.]

Weaver, John V. A. "The Clerk Story." May 18, 1926. MGM Collection, "The Crowd," Folder 1 of 1. Cinematic Arts Library, University of Southern California.

Weber, Samuel. *Mass Mediauras: Form, Technic, Media*. Stanford: Stanford University Press, 1996.

Webster, John. *The White Devil*. In *English Renaissance Drama: A Norton Anthology,* ed. David Bevington et al. New York: Norton, 2002. [Acted 1609–12, pub. 1612.]

Weever, John. *Epigrammes*. In *John Weever: A Biography . . . Together with a Photographic Facsimile of Weever's Epigrammes (1599)*. Ed. E. A. J. Honigmann. New York: St. Martin's Press, 1987. [Orig. pub. 1599.]

Weimann, Robert. *Shakespeare und die Tradition des Volkstheaters*. Trans. as *Shakespeare and the Popular Tradition in the Theater: Studies in the Social Dimension of Dramatic Form and Function*. Ed. Robert Schwartz. Baltimore: Johns Hopkins University Press, 1978. [Orig. pub. 1967.]

Welles, Orson. "Foreword." In Marion Davies, *The Times We Had: Life with William Randolph Hearst*, ed. Pamela Pfau and Kenneth S. Marx. New York: Ballantine Books, 1975.

West, Nathanael. *The Day of the Locust*. New York: Time, 1965. [Orig. pub. 1939.]

Weston, William. *William Weston: The Autobiography of an Elizabethan*. Trans. Philip Caraman. London: Longmans, 1955. [Written c. 1611–15.]

Whalley, Joyce I. "The Swan Theatre in the 16th Century." *Theatre Notebook* 20, no. 2 (Winter 1965–66): 73.

Wheeler, G. W., ed. *Letters of Sir Thomas Bodley to Thomas James, First Keeper of the Bodleian Library*. Oxford: Clarendon Press, 1926.

Whissel, Kristen. *Picturing American Modernity: Traffic, Technology, and the Silent Cinema*. Durham: Duke University Press, 2008.

White, Eric Walter. *Parnassus to Let: An Essay About Rhythm in the Films*. London: Hogarth Press, 1928.

White, William Allen. "Chewing-Gum Relaxation." In *The Movies on Trial: The Views and Opinions of Outstanding Personalities Anent Screen Entertainment Past and Present*, ed. William J. Perlman, 3–12. New York: Macmillan, 1936.

Wickham, Glynne, et al., eds. *English Professional Theatre, 1530–1660*. Cambridge: Cambridge University Press, 2000.

Williams, J. D. "The Influence of the Screen." In *The Mind and the Film: A Treatise on the Psychological Factors in the Film*, ed. Gerard Fort Buckle, xi–xiv. London: George Routledge & Sons, 1926.

Williams, Linda. *Playing the Race Card: Melodramas of Black and White from Uncle Tom to O. J. Simpson*. Princeton: Princeton University Press, 2001.

Wolfe, Charles. "*Meet John Doe*: Authors, Audiences, and Endings." In *Meet John Doe*, ed. Charles Wolfe, 3–29. New Brunswick, NJ: Rutgers University Press, 1989.

———, ed. *Meet John Doe*. New Brunswick, NJ: Rutgers University Press, 1989.

Womack, Peter. *Ben Jonson*. Oxford: Basil Blackwell, 1986.

———. "The Comical Scene: Perspective and Civility on the Renaissance Stage." *Representations* 101, no. 1 (Winter 2008): 32–56.

———. *English Renaissance Drama*. Oxford: Blackwell, 2006.

Wonder Bar. Dir. Lloyd Bacon. Warner Bros, 1934. Film. Turner Entertainment and Warner Bros. Entertainment, 2010. DVD.

Woollcott, Alexander. "Charlie—As Ever Was." In *The Essential Chaplin: Perspectives on the Life and Art of the Great Comedian*, ed. Richard Schickel, 192–98. Chicago: Ivan R. Dee, 2006. [Orig. pub. 1943.]

Wybarne, Joseph. *The New Age of Old Names*. London, 1609.

Young, Jordan R. *King Vidor's The Crowd: The Making of a Silent Classic*. [Orange, CA:] Past Times Publishing, 2014.

Žižek, Slavoj. "Death and Sublimation: The Final Scene of *City Lights*." In *Enjoy Your Symptom! Jacques Lacan in Hollywood and Out,* 1–11. New York: Routledge, 2008. [Orig. pub. 1990.]

Zweig, Stefan. "Die Monotonisierung der Welt." In *The Weimar Republic Sourcebook*, ed. Anton Kaes, Martin Jay, and Edward Dimendberg, 396–400. Berkeley: University of California Press, 1994. [Orig. pub. 1925.]

INDEX

absorption *vs.* distraction, 2, 205–216, 263n27, 264n36
academic learning *vs.* theater learning, 229–232
Academy Awards, 224, 253n6
accessibility of art, 3, 8, 9, 12, 13, 60, 62
 as constitutive feature of mass entertainment, 65
 defined, 237nn22, 24
 vs. art worship, 211
accountability of directors, 220–222
accountability of playwrights, 161
actors
 as beggars grown rich, 218, 264n40
 as pickpockets, 53
 as professionals, *see* professionalism
 as servants of the people, 13
 separability from characters, 203
Acts and Monuments (Foxe), 10
Adorno, Theodor, 3, 4, 16–19, 24, 34, 38, 39, 51, 54–56, 61–64, 95–98, 117, 119, 132, 143, 230
The Adventurer, 218
The Aeneid (Virgil), 12
African Americans, 129–133, 139
 blackface, 28–30, 37, 121, 126, 130, 140
 race issues, 122, 130, 132
 slavery, 122, 123, 129–133
The Alchemist, 37, 41, 147, 152–161, 174
alienation, 39, 52, 61, 155, 159, 162
 alienability of image from object, 61
 City Lights, 206, 210–212
 individualism, *see* individualism
 Meet John Doe, 77, 78, 82, 84, 86
 solitary, reclusive art worship, 211
 see also camaraderie and fellowship
all-American, 68, 69
Altman, Rick, 253n6
ambiguity, 49, 52, 63, 64, 174, 241n82, 254n19
amphitheaters, 10–11
 construction of England's first amphitheaters, 5
 cutaway illustration, 49
 permanency, 96
 "photographic" *vs.* "schematic" view, 48
anarchism, 131, 183, 186
Anderson, Antony, 206

anonymity, 21, 22, 37, 52, 58, 72, 88, 89, 102, 139, 197
Antipholus of Syracuse, 99–104
antitheatricality, 5, 10–11, 13, 16–17, 96–97, 149–152, 238n31, 256n18
Antony and Cleopatra, 19
"anyman," 21
Apollinaris, 119, 138, 143
April Follies, 25, 28, 30
aristocracy. *see* sophistication and pretension
Arnheim, Rudolf, 259n19
Arnold, Oliver, 238n44
Ars Poetica (Horace), 4
Art and Society (Read), 32
Art of the Moving Picture (Lindsay), 15, 174
art *vs.* entertainment, 4, 10, 147–150, 162–164, 207–216, 233
art *vs.* trash or junk, 19, 32–37, 41, 42, 150, 152–154, 157–160, 163, 165–196
art worship, 162, 210, 211
Arthur, Paul, 259n7
assembly line directors, 197, 198
assimilation, 254n22, 261n41
 of entertainment and work, 24
 of worker and machine, 96
attention getting *vs.* accessibility, 62, 64
audience
 essential *vs.* inessential to theater, 48
 photos of, 23, 26–27, 29–30, 34–35, 49–50, 73, 76, 79, 82, 85, 87–88, 90, 118, 121, 124, 126, 127–128, 134–135, 141, 199, 204, 208–210, 212, 213, 235
 representation of, 10–11, 21–22, 25–26, 33–35, 38, 52–55, 58–62, 74–77, 81–83, 85–90, 110–111, 117–118, 128, 134–135, 137, 141, 143, 151, 155–156, 160, 162–164, 195, 198–199, 203–204, 207–216, 224–225, 229
 see mass audience
auteurism, authors of mass entertainment, 43, 197–227
Auteurs and Authorship (Grant), 198
authenticity, 51, 70, 84, 85, 91, 147, 265n41
"automatic" production and distribution of entertainment, 7, 17–18, 36–37, 116–117, 123, 168–174
"automatic" viewing of entertainment, 17, 95–96

autonomy, 38
"average man," 69–71, 85

Bachelor Mother, 260n32
Bacon, Lloyd, 40, 41, 197
Badiou, Alain, 6–8, 12, 236n10 and n11
Barkan, Leonard, 163, 258n54
Barry, Iris, 3, 18, 198
Bartholomew Fair (Jonson), 13
Barton, Anne, 256n28, 257n33
baseball, 68, 82, 85
Baumann, Shyon, 236n14
bawdiness. *see* vulgarity or lewdness
Bazin, André, 190, 193
Beaton, Welford, 236n15, 239n45
Beaumont, Francis, 38
bedlam. *see* chaos and confusion
Belfrage, Cedric, 167, 222
Benjamin, Walter, 1, 3, 4, 6, 7, 9, 15, 18, 19, 48,
 51, 53, 54, 60, 61, 123, 167, 210, 211,
 217, 239n53
Bercovici, Konrad, 218, 222
Bergman, Henry, 200
Berkeley, Busby, 112, 116, 120, 129, 130, 141, 197
Bethell, S. L., 2, 136, 137
Big-Time Shakespeare (Bristol), 2
Birchard, Robert, 252n2
black cat, 124, 125, 126, 131
blackface, 28–30, 37, 121, 122, 125, 126,
 128–131, 140
Blair, Ann, 243n109
blind girl, 209–215
Blumer, Herbert, 84, 85, 239n57, 250n43
Boland, Elena, 200, 201
Bonaparte, Napoleon, 219
books
 chaos and confusion of, 41
 fixed *vs.* ephemeral form of play, 231, 232
 "'high' culture" books, 149
 novels, 7, 244n112, 259n7
 plays as, 9, 17, 231
 prayer-book culture, 246n14
 print version of *The Roaring Girl*, 52–53
 signifying intellectualism, 228–233
 see also print production
The Book of Common Prayer, 53
Bordwell, David, 235n7, 262n48
Borges, Jorge Luis, 168, 242n94
Bower, Anthony, 68
Bradbrook, Muriel, 245n7
Brady, Frank, 224, 266n60
Brasbridge, Thomas, 251n3
Brathwait, Richard, 40, 111
Brennan, Walter, 69
bric-a-brac, 169, 186
Brill, Lesley, 260n31

Bristol, Michael, 2, 3, 52, 236n8
The Broadway Melody, 253n6
Browne, Nick, 79
Brownlow, Kevin, 33, 198, 199
Buchell, Aernout van, 49
Burke, Thomas, 218, 220
Burt, Richard, 235n1 and n5, 236n8, 246n12
Bush, Gregory W., 21
"By a Waterfall," 112, 113, 116–118,
 128, 133, 141

Cagney, James, 40, 112, 120, 133, 134, 140, 142,
 197, 230–232
Caldwell, Cy, 141
camaraderie and fellowship, 48, 50, 52, 53, 211
 of dance troupes, 116–117
 of film companies, 221
 of theater companies, 148–149
 see also alienation
Campbell, Eric, 200
Cantor, Eddie, 129
capitalism, 17, 95–98, 116, 120, 252n35,
 253n12
Capra, Frank, 38, 39, 67–71, 77, 86,
 89–92, 197–227
"Capra-corn," 70
Carew, Richard, 243n104
Carney, Raymond, 72, 74, 77–79
Carringer, Robert, 185
Carroll, Noël, 7–9, 61, 62, 166, 258n5
Carson, Neil, 229
Cartwright, William, 155, 156, 237n26
Catholicism, 10, 16, 239n49
cats, 120, 121, 123–126, 128, 131
Catullus, 150
Caught in a Cabaret, 218
Cavell, Stanley, 235n7
Celluloid, 32
Chambers, E.K., 255n11
chaos and confusion, 41, 97, 110, 201
 Citizen Kane, 175, 179
 Meet John Doe, 69–71, 77–85, 91, 92
Chaplin, Charlie, 32–37, 43, 197, 199–227,
 260n30, 266n61
 absorption and obsessiveness, 36–37, 219, 227
 as auteur, 43, 200–226
 as chameleon, 222–223
 as dictator, 218–220
 compared to Orson Welles, 224
 photos, 33, 36, 204, 209, 210, 212, 215, 216
 and silent cinema, 200, 217, 220, 221
 tramp character, explanation of, 220
 wealth of, 218
Chaplin, Charlie, Jr., 36, 202, 218, 219
characters
 audience influence, 155

"commonplace," 21
separability from actors playing the parts, 203
Charlie Chaplin's Own Story (Geduld), 218
chastity, 51
chaste promiscuousness, 57
see also vulgarity or lewdness
cheap art, 19, 32–37, 42, 187
Cherrill, Virginia, 200, 209, 214, 216, 219
Cinderella stories, 176, 181, 182, 187
circulation numbers, 18, 165, 168
The Circus, 224
Citizen Kane, 18, 37, 42, 165–196, 222,
224, 226, 233
souvenir program, 170, 222
City Lights, 20, 32–37, 43, 201, 203–220, 233
orienting vision of art, artist, and audience, 216
outcast, 218
photo, 201
refusal to release as talking film, 200, 217
"civilizing" of audiences, 14–15, 157
Clarke, Mae, 231
class boundaries, 8, 164, 224
amphitheaters, 10
audiences spanning, 49
belittling of audiences, 54
newspapers for working class, 258n3
"popular," use of word, 10
and romance, 176
social mobility, 177, 183, 187
the tramp, 217, 218
translation of class languages, 58, 63, 74
see also common people; democratization
Claudius, 109, 110
Cline, Eddie, 199
Clipper, Lawrence, 260n26
close-ups, 18, 22, 43, 170, 190, 203, 214, 215, 217,
239n57, 250n39, 264nn32–33
Cocteau, Jean, 165
collaborative *vs.* auteur theory of movie-making,
197–227
collecting objects, 165–169, 181, 185, 188,
189, 193, 196
Collier's, 218
Collinson, Patrick, 239n49
The Comedy of Errors, 40, 99–104
Comensoli, Viviana, 246n17
Comingore, Dorothy, 222
commercialization, 2, 13, 24
and audiences, 11
effect on relationship between work and
amusement, 96, 97
flops, 47
common people, 5, 56, 69–72, 77, 102, 103
"average man," 69–71, 85
"common players," 13
debauchery, *see* vulgarity or lewdness

directors' common touch requirement, 226
embraced, 150
fear of, 159
lowest grade of intelligence, 38, 71, 158
oppression and exploitation, 69
uncommon *vs.* common man, 72, 77, 91
vs. elite, 159, 182
yokels, 32, 77
see also class boundaries; democratization
community
as commonness, 251n30
communal spectatorship, 211
community building, 12–15, 48–50, 52, 53, 59,
68, 81–83, 84–85, 160–164
explained, 108
con artists
pickpocketing, 53, 55–56, 61
playwrights as, 42, 153–160, 162–163
concentration or absorption of directors,
206, 210–216
Condell, Henry, 150
Connell, Henry, 69, 72, 88, 89
Connolly, Myles, 91
consumer culture, 21, 165, 177, 179, 188
beginnings of modern culture industry, 2, 3
control, directorial, 197–227
Cooper, Gary, 67, 68, 72, 77, 83, 91, 92
copies of artwork, 60, 61
mass reproduction, 6–7
sameness *vs.* "sense for sameness," 54
copycat tactics of entertainment, 120
Cornwallis, William, 251n30
"corporate capitalism" *vs.* "entrepreneurial
capitalism," 253n12
The Count, 218
Covell, William, 251n30
Cox, Samuel, 96, 97
creative freedom of directors, 197–227
credulity, 39, 158, 159, 163, 164
Creelman, Eileen, 68
crime in theaters, 13, 53–55, 58–59
Crocker, Harry, 242n91, 265n46, 266n58
cross-dressing, 60
Crosse, Henry, 13, 17, 41, 239n54
The Crowd, 20–24
crowds, 5, 10, 38, 77, 88
as collections of free individuals, 38
as distinguished from the mass, 84
The Crowd, 20–24
fear of, 55–57, 100–101, 102–104
see also audience, camaraderie and fellowship,
community, mass, mass
audience, the public
Crowther, Bosley, 68, 167
"cultivated spectators," 51, 54
cultural capital, 148–150

culture industry, 2, 3, 54, 132, 242n98, 253n10
 16th-century beginnings, 2
 deception, 16, 17
 and leisure, 95–99
 "The Culture Industry" (Horkheimer and
 Adorno), 95–98
Cutpurse, Moll, 55–56, 72–74, 82, 84, 90
cutpurses/pickpockets, 53, 55–56

"dallying," 100, 101
dancers, photos, 124, 135, 136
Davies, John, 10
Davis, Therese, 263n28
Dawson, Anthony, 248n46
The Day of the Locust, 32
De Amphitheatro, 48, 50
De Mille, Cecil B., 266n54
De Rerum Natura, 156
de Witt, Johannes, 47–52
deaf movie-goers, 264n39
debauchery. *see* vulgarity or lewdness
deception, 3, 54, 64, 65, 69–71, 85, 86, 91,
 97, 155–157
 culture industry, 16, 17
 good deception *vs.* bad deception, 157
 Miracle Man, 71
 statue-as-art *vs.* statue-as-fraud, 258n55
 systematic, 16
Decherney, Peter, 236n14
dehumanization, 19, 20, 22, 51, 54, 59
Dekker, Thomas, 12, 13, 15, 40, 51, 52, 54
democratization, 12–14, 16
 egalitarianism, 3
 new conceptions of civic and national
 idealism, 15
 "ordinary" spectators, 15
demystification. *see* accessibility of art
depression-era entertainment, 115, 116
depression-era rationale for
 entertainment, 116
depth of field, 61, 259n12
desecration of art, 207, 208, 217
detachment, 3, 98, 158, 218
 see also alienation
The Devil and Daniel Webster, 221
The Devil Is an Ass (Jonson), 230
Dialectic of Enlightenment (Horkheimer and
 Adorno), 24
Dick Powell, photo, 113
Dickens, Charles, 244n112
Dickstein, Martin, 141
Dieterle, William, 3, 221
diner scene, photo, 78
Dio Cassius, 239n50
Diogenes, 38

directors, auteur theory of movie-making,
 43, 197–227
disconnection. *see* alienation
Discoveries (Jonson), 157, 158
Disney, Walt, 266n55
dissociation of the actor from the audience, 18
distribution on large scale, 7–8, 17, 173–174
Döblin, Alfred, 20
Doe, John, 67–92
A Dog's Life, 207
Don Quixote, 8
Downey, Nicholas, 243n104
"dream dump," 32
dream of Long John Willoughby, photo, 79, 80
Dromio, 99–101
Dryden, John, 43, 152, 154, 202
dystopian *vs.* utopian accounts of masses, 51–66

Earle, John, 39, 40
Eastman, Max, 206, 223, 264n31, 265n49
Edge of the World, 221
education of audiences, 157, 175, 229–232
The Education of Henry Adams, 231, 268n10
Edward VI, 10
Edwards, Philip, 258n55
Eisenstein, Elizabeth, 56, 221
Eisenstein, Sergei, 220, 265n52
electrically powered production and
 distribution, 7–8
Eliot, T. S., 51, 52, 61, 229
elitism, 54, 58, 149–151, 159, 176, 182
 described, 182
 exclusivism, 25
 see also class boundaries; common people;
 sophistication and pretension
entertainment *vs.* art, 4, 165–175, 181–184, 186
"entrepreneurial capitalism," 253n12
Ephesian Antipholus, 100–102, 104
Erasmus, 41
Erne, Lukas, 9, 147–151, 153
escapism, 114, 126–132
"esoteric," defined, 9
ethnic boundaries, 8
Evelyn, John, 257n32
Everson, William, 199
Every Man Out of His Humor (Jonson), 11
"everyman," 21, 43
exclusivism, 25

Faithful Shepherdess, 151, 238n33
Falstaff, 105, 106, 109
Fanchon & Marco, 122
fascism, 16, 39, 51, 69, 85, 253n7
Fennor, William, 38, 151, 237n26
Ferguson, Otis, 167

Field, Nathan, 238n33

Fiske, Minnie Maddern, 32, 37

Fletcher, John, 38, 151, 198

Foakes, Reginald, 244n1

Footlight Parade, 37, 40, 41, 112, 114–143, 197, 228, 230, 231

Forman, Valerie, 60

42nd Street, 115, 117, 120, 122, 262n2

fountain, photo, 115

Foxe, John, 10

Frank, Waldo, 203, 218

Frank Capra: The Name Above the Title (Capra), 197

Frankfurt School, 3

fraternization with criminals, 62, 63

fraud. *see* deception

Frazer and Gould, 119, 122, 126, 129, 130, 132, 133

free time. *see* idleness and leisure

freedom within limits, 132–137

Fried, Michael, 264n36

Frith, Mary, 60, 61

Gance, Abel, 221

garbage, 32, 41, 196

gender boundaries, 8, 58, 60, 62, 63, 65

gentry. *see* sophistication and pretension

Gladstone, 122, 126, 137

Glatzer, Richard, 88

Gleason, John, 47, 48

Goddard, Paulette, 36

"Goin' to Heaven on a Mule," 129

Gold Diggers of 1933, 115, 120

Gold Rush, 218

golden age of film, explained, 5

golden age of Renaissance drama, explained, 5

Goldman, Jonathan, 203

Good Housekeeping, 224

Gordon, Terri, 116

Gosson, Stephen, 11, 16, 17, 53, 150, 239n50, 251n4

Gould, Frazer and, 119, 122, 126, 129, 130, 132, 133

Grant, Barry Keith, 198

Grant, Cary, 226

grapefruit, 230, 231

Great Depression, 115, 116

Great illusion of the movie theater, 90

The Great Dictator, 219

Greek art, 4, 19, 162, 163

Greenberg, Clement, 51, 54, 62, 147, 228, 229

Greene, Robert, 221

Grimsted, David, 22

groupthink, 38, 159

Guest, Eddie, 229

Gubar, Susan, 241n80

Gurr, Andrew, 229, 238n30, 244n1, 256n28

Hake, Sabine, 37

Hale, Georgia, 200, 263n27

Halpern, Richard, 252n35

Hamlet, 37, 40, 99, 108–111, 229, 237n26

Hampton, Benjamin, 12, 15

Hannon, William, 19

Hansen, Miriam, 39

Harbage, Alfred, 1, 2, 4, 18

Hays, Will, 241n81

Hearst, William Randolph, 166, 187, 188

Heminge, John, 150

1 Henry IV, 9, 37, 40, 50, 97–99, 104–110

Henry V, 15, 17, 19

Henry VI, 11, 48

herd mentality, 38, 159

Hermione, 42

Heywood, Thomas, 9, 15, 40, 42

high art. *see* sophistication and pretension

historical contexts, 11–19

History of the Movies (Hampton), 12, 15

Histrio-mastix (Prynne), 41

Hitchcock, Alfred, 267n7

Hitler, Adolph, 219, 250n35

Hoberman, J., 259n7

holidays. *see* idleness and leisure

Holmes, John Haynes, 230

holy days, 25, 28, 29

honesty and integrity

 "honest tricks," 157

 The Roaring Girl, 51, 56, 57, 59, 63, 65

 see also deception

Hopper, Hedda, 91

Horace, 4, 152, 255n16

Horkheimer, Max, 3, 16, 17, 24, 34, 39, 51, 54–56, 62, 64, 95–98, 117, 119, 132, 143, 230

Hotspur, 104–108

Houseman, John, 260n25

How to Appreciate Motion Pictures (Dale), 24

How to Become a Film Artiste (Dangerfield, and Howard), 43

Hugo, Victor, 8

Huxley, Aldous, 41

Huyssen, Andreas, 246n19

Hynkel, Adenoid, 219

hyperactivity, 2

idleness and leisure, 19, 24–32, 95–143, 209, 228

 acting as idle occupation, 97

 amusement as an end unto itself, 96

 The Comedy of Errors, 99–104

 and culture industry, 95–99

 "dallying," 100, 101

idleness and leisure (*continued*)
 double consciousness of play world and real
 world, 136, 137
 erosion of distinction between work and
 leisure, 97, 98, 106
 Footlight Parade, 116–143
 "free time" as shadowy continuation
 of labor, 24
 Hamlet, 109–111
 Henry IV, 104–108
 holidays, 95, 97, 108, 113
 incessancy of amusement, 97
 The Jazz Singer, 20, 24–32, 40
 leisured learning, 231
 vs. work, *see* work
 see also "play-work"
The Idle Class, 218
If This Be Not a Good Play, the Devil's in It
 (Decker), 15
"immediacy," 18, 229
imperfection, virtue in, 65–66
Ince, Thomas, 199, 221
incessancy, 97, 98, 104–106, 108, 109
inclusivism, 25, 29–30, 217
independence. *see* individualism
Indian Love Lyrics, 229
individualism, 19–23, 38, 39, 47–92,
 101, 206, 222
 crisis of individual in mass, 19–23
 The Crowd, 20–24
 dichotomies between individual and the
 mass, 19–21
 of directors, 200
 disengagement, social distance, and acknowl-
 edgment of difference, 52
 groupthink, 38, 159
 "individual conspicuousness or differ-
 ence," 250n43
 individuals as copies of each other, 22, 54
 as mixed, 57–59, 62–66, 77–80, 106–109,
 156, 159, 202–203, 218–220, 222–227
 Meet John Doe, 67–92
 productively confused by participation in
 crowds, 84
 The Roaring Girl, 52–66
 see also alienation; self
inferiority
 superiority of performer/inferiority of
 audience, 54
 see also class boundaries
Ingram, Rex, 221
integrity. *see* honesty and integrity
intellectualism, 166, 226, 228
 books as signifying, 228–233
 intellectual flexibility, 3

 thinking individuals, 51
 transformation to aesthete, 228
 see also sophistication
"intelligentsia," 32
Isle of Gulls (Day), 10
isolation. *see* alienation

jack-of-all-trades
 in relation to auteur theory, 197–227
 Shakespeare as, 202
Jackson, Russell, 235n1, 243n105
Jackson, Tony, 259n19
Jacobs, Lewis, 114
James I, 13
Jameson, Fredric, 242n100
Japanese woodcuts as mass art, 237n18
The Jazz Singer, 20, 24–32, 40
Jenemann, David, 235n6, 246n19
A Jitney Elopement, 218
John Doe clubs, 39, 68, 69, 77, 81, 88, 89, 91
Jolson, Al, 129, 241n79
Jones, Richard, 255n18
Jonson, Ben, 4, 11, 13, 38, 40–42, 147–161,
 163, 174, 230
Judaism, 25–29
Julius Caesar, 95
Jump, Herbert, 12
junk *vs.* art, 19, 32–37, 41, 42, 150, 162–163,
 169–170, 175, 179, 181–184, 188–189
 Citizen Kane, 165–196
 kitsch, 147, 260n36
 The Winter's Tale, 158–164
Juvenal, 4, 16

Kael, Pauline, 42, 168, 224, 226, 227, 267n67
Kastan, David, 255n3
Keaton, Buster, 198, 199, 202
Keeler, Ruby, 112, 116, 141
Kellow, Brian, 227, 267n68
Kent, Chester, 40, 41, 117–134, 137–142
kings
 monarchic societies, 12, 14
 see also Henry
kitsch, 147, 260n36
Knapp, Jeffrey, 42, 43, 202, 239n46, 241n78,
 249n17, 256n19, 257n31
Korda, Natasha, 247n35
Kracauer, Siegfried, 3, 116, 118, 120, 140, 259n18
Krow, Arthur Edwin, 250n36
Kyvig, David, 267n5

labor. *see* work
The Lady From Shanghai, 267n64
Lady Killer, 231
Lane, Tamar, 198

Laxton, *The Roaring Girl*, 72
Lean, Edward Tangye, 190, 193, 260n28
leisure. *see* idleness and leisure
Lescarboura, Austin, 198
Lesser, Genee Kobacker, 259n7
Lesser, Zachary, 149
Let's Go to the Movies (Barry), 198
lewdness. *see* vulgarity or lewdness
Lewis, Lloyd, 12, 143
Lindsay, Vachel, 15, 174
lines of sight/points of view, 19, 38, 48, 52, 54, 58, 59, 61, 82, 203, 207, 214
 long shots, 203
 see also close-ups
Lipsius, Justus, 47–50
literacy, 62, 149, 231
Lodge, Thomas, 239n50
loneliness. *see* alienation
long shots, 203
longue durée, 2
Lopez, Jeremy, 238n41
Lucretius, 152, 156
Lusk, Norbert, 21, 133

Macdonald, Dwight, 16, 236n15, 255n1
The Magnetic Lady, 152
Malcontent (Marston), 230
Mankiewicz, Herman, 224
Marcus, Leah, 255n2
Marsh, Julian, 117, 122
Marston, John, 14, 230, 267n9
Martin Marprelate, 239n49
Marxist commentators, 48
"masculine womanhood," 63
mass
 as distinguished from the crowd, 84
 crisis of individuals in, 19–24
 dystopian *vs.* utopian accounts of, 51–66
mass action, 88
"mass art"
 defined, 8
 vs. mass entertainment, 4
mass audience, defined, 8–9
 "giddy multitude," 15
 groupthink, 38, 159
 fear of, 13–14, 16–17, 38–39, 50–51, 60–62, 74, 85–86
 mixed, 10–11, 52–53, 101, 155, 163–164
 new cultural low, 5
 pickpockets in, 55
 vs. popular audience, 10
 witless many, 158
 yokels, 32, 77
 see audience, camaraderie and fellowship, community, crowd, mass, the public

mass culture theories, 1
mass deception, 16, 17
mass production and distribution, 6–9, 17–18, 52–53, 74, 122–123, 165–166, 170–174, 177–179, 183–184, 187, 197
mass entertainment, 6
mass entertainment, defined, 12
"mass individual," 38–39, 56–59, 60–66, 72, 74, 77–84, 91–92, 222–224
Massinger, Philip, 4
"massism," war against, 70
"the mass-man," 20, 69, 70
"The Mass Ornament" (Kracauer), 116, 120
Mast, Gerald, 129, 130
Maus, Katherine, 60, 153, 160, 256n28, 257n44
Maynard, John, 243n104
McBride, Joseph, 198
McCoy, Richard, 258n58
mechanization, 6–8, 17–18, 33–34, 37, 39, 95–96, 116–118, 122
Meek, Richard, 257n39
Meet John Doe, 37–39, 67–92, 224
Menon, Madhavi, 248n48
Menzer, Paul, 11, 47, 238n36, 252n33, 267n4
Merrill, Robert, 176
Meryman, Richard, 203, 214, 220
Middleton, Thomas, 51–66, 151
Mikalachki, Jodi, 247n29
Miller, D.A., 267n7
Milton, John, 12
minstrelsy, 28–30, 37, 121, 122, 125, 126, 128–131, 140
Miola, Robert, 243n110
Mirrour of Monsters (Rankin), 16
Mitchell, Ann, 68–72, 74, 77–84, 86, 88–91
mobilization of masses, 48
modern culture industry. *see* consumer culture
Modern Times, 36, 37, 202, 218
modernity theories, 1, 9
monarchic societies, 12, 14
monotonization, 19, 105, 112
"The Monotonization of the World" (Zweig), 17
Montagu, Ivor, 265n50
moralists, 39, 53, 96, 97, 111, 150, 158
Moretti, Franco, 14
The Mousetrap, 110, 111
movable type. *see* print production
multiperspectivality, 19
Mulvey, Laura, 185
Munday, Anthony, 239n54, 251n4
Munro, Ian, 13, 238n31
Murray, James, 22, 24
Museum of Modern Art Film Library, 5
My Best Girl, 42, 175–177, 181–183, 186, 190, 193–195

Nagler, A. M., 47
Napoleon Bonaparte, 219
Nasaw, David, 258n3
Nashe, Thomas, 49–51, 239n50
Nathan, George, 41
The Nation, 68
Nazism, 16, 265n48
Nepos, Cornelius, 150
New Deal, 115, 116
New Republic, 12
New York Sun, 68
New York Times, 68
newspapers as art, 169–170
The New Inn (Jonson), 13
"no art but in junk," 189–196
No Wit, No Help Like a Woman's
 (Middleton), 151
Northbrooke, John, 10, 13, 38, 51, 96, 97, 230
Norton, D.B., 69, 74, 77, 85–88, 91
Nugent, Frank, 67, 68

"one-man one-film" ideal, 197–202, 221–222
One of the Crowd, 21
One of the Mob, 21
"open presence," 49–50
Opera, 175, 184
"organization men," 197
Orgel, Stephen, 245n6, 247n35
orientation. *see* lines of sight/points of view
Ortega y Gasset, José, 20, 69
Oscar winners, 224, 253n6
overcomposition, 184
overstimulation, 17

Paradise Lost (Milton), 12
Parrish, Robert, 262n10
Patterson, Frances Taylor, 17, 18, 198, 244n116
permanent vs. moving art, 163, 195–196
perspective. *see* lines of sight/points of view
Petrie, Graham, 200, 202
Phelps, Glenn, 88
philistinism. *see* sophistication
A Philosophy of Mass Art (Carroll), 7
"photographic" *vs.* "schematic" view of
 theater, 48
photography bringing artwork "closer" to
 masses, 60
Photoplay, 12
Pickford, Mary, 174
pickpocketing, 53, 55–56, 61
Pirandello, Luigi, 39
"play-work," 40, 98, 99, 108–111, 119, 120,
 243n104, 252n37
 defined, 98
 see also idleness and leisure; work

The Play House, 198, 199, 202
Plutarch, 244n115
point of view. *see* lines of sight/points of view
policemen, 127, 131, 132, 201
political boundaries, crossing, 8
popular culture *vs.* mass culture, 52
poverty, 33, 131, 155, 217, 218, 224,
 264n38, 266n62
Powell, Dick, 112, 113, 123, 141
Powell, Michael, 221, 265n53
pretension. *see* sophistication
Prince Hamlet, 98, 99, 105–107, 119
print production, 6–10, 61, 62, 147–149, 165,
 168, 231, 232
 chaos and confusion of books, 41
 conceptual reciprocity between theater
 and print, 53
 differentiating plays and movies from print
 media, 231
 illusions fostered by print, 64–65, 232
 literacy required for consumption of
 print, 62, 231
 newspapers for working class, 258n3
 plays in, 9, 17, 231
 print version of *The Roaring Girl*, 52–53
 publication as a betrayal of theater, 147–
 150, 232–233
 scripts, 231, 232
 souvenir program, 222, 224
 as spreading trouble, 10
 translation from stage to page, 268n9
 transposing literature to theater, 149
 type as setting off atypical, 56–57
 see also books
The Printing Press as an Agent of Change
 (Eisenstein), 56
professionalism, 148, 229–30
 play-going as profession, 40, 110–111
 professionalization of acting, 39, 96–99, 101,
 106–110, 229–230
the "prologue factory," 120–125
promiscuity. *see* lewdness; vulgarity or lewdness
propaganda, 16, 39
proscenium, 50
prosperity unit, racial coding, 122
"protocinematic," 235n5
Prynne, William, 4, 10, 41, 96, 239n52, 252n42
Pudovkin, Vsevolod, 266n54
the public, 14
 see crowd, mass
Public Enemy, 231, 232
publishing. *see* print production
puritanism, 16, 157, 237n26, 239n49,
 246n14, 248n42
Pushkin, Alexander, 8

Quart, Leonard, 82
"Quarto-Play-books," 41
Quintilian, 154
Quirk, James, 238n39

Rabinowitz, Cantor, 24–32
Rabinowitz, Jakie, 24–32
race issues, 122, 130, 132
Raksin, David, 262n9
Rancière, Jacques, 260n22
Rankins, William, 16
Read, Herbert, 32
reading. *see* literacy
reclusion. *see* alienation
Redmond, Granville, 205–208, 210, 211, 224,
 263n22 and n24
refinement, 167, 228
 see also sophistication and pretension
A Refutation of the Apologie for Actors (I.G.), 13,
 96, 242n95
Religion and entertainment
 entertainment crossing religious boundaries, 8
 Judaism and entertainment, 25–29
 prayer-book culture, 53, 246n14
 puritanism, 16, 157, 237n26, 239n49,
 246n14, 248n42
 Shakespeare and religion, 158, 164
 working on the Sabbath, 251n3
The Religious Possibilities of the Motion Picture
 (Jump), 12
Renaissance drama, defined, 2
repeated viewings, 230
responsibility of director, 220–222
responsibility of playwright, 161
Revolt of the Masses (Ortega y Gasset), 20
The Rink, 218
Rintels, David, 197, 200
Riskin, Robert, 69–71, 86, 201, 224
The Roaring Girl, 37–39, 52–66, 72–74, 82, 84, 90
Robinson, David, 200, 205, 263n20
Rodgers, Amy, 237n24
Roman Colosseum, 47–49
Roman dramas, 4, 5
Roman Scandals, 129, 263n17
Romance of the Cinema (Steer), 174
Romano, Julio, 164
The Roman Actor (Massinger), 4
Roosevelt, Franklin, 115–117
Rosenbaum, Jonathan, 226, 264n32 and n38
Rosenberg, Harold, 259n11, 262n47
Rosenblatt, Cantor Josef, 25–27
Roth, Mark, 116, 117
Rotha, Paul, 3, 5, 14, 21, 32, 37, 38, 200,
 216, 217
Rothman, William, 212, 214, 219, 227

Rubin, Martin, 116, 120, 254n19
Ruttenburg, Nancy, 85
Rutter, Tom, 97, 98, 101, 106–109

"salesmanship," 2
sameness *vs.* "sense for sameness" within mass
 reproduction, 54
"Satan's Synagogue," 16
Sayre, Nora, 67, 68
scatterform, 42, 168–170, 173–175, 183–187,
 190, 193–196
Schallert, Edwin, 70, 71, 133, 141, 250n41, 252n1
Schary, Dore, 3
"schematic" vs. "photographic" view of
 theater, 48
Schenck, Joseph M., 199
Scheuer, Philip, 91, 117, 141
Schickel, Richard, 24
Scotty, photo, 123
screen credits, 198–200, 221
Scribner, 68
scripts, 231, 232
sculpture. *see* statues
Sejanus (Jonson), 151
Seldes, Gilbert, 3, 14, 20, 21, 32, 42, 166–168,
 175, 248n5, 259n6 and n8
self. *See also* individualism
self-alienation, 77, 78, 82, 84
self-awareness, 38, 83, 84
self-possession, 58, 59, 207
self-reflexiveness, 109
self-reliance, 57
self-worth, 57
"sense for sameness" within mass
 reproduction, 54
The 7 Lively Arts, 42, 166
sexual innuendo. *see* vulgarity or lewdness
sexual timidity, 90
Seymour, James and Manuel Seff, 253n15,
 254n22, 267n8
"The Shadow Stage," 123
Shakespeare, as performer, dramatist, and
 owner, 202
Shakespeare and the Book Trade
 (Erne), 147, 148
Shakespeare and the Popular Dramatic Tradition
 (Bethell), 2
Shakespeare as Literary Dramatist (Erne), 147
Shakespeare's Audience (Harbage), 1
shame, 59, 81, 100, 101, 157–161, 226
Shanghai Lil, 137, 141, 143
Sherwood, Robert, 3, 12, 32, 208, 244n117
Shirley, James, 42, 255n15, 267n2
Shoot (Pirandello), 39
shot-reverse-shot, 214

"show business," 2, 24–32, 39–41, 97–98, 108–109, 112–143

Si Gira (Pirandello), 39

sightline. *see* lines of sight/points of view

silent films, transition to talking, 5, 20, 254n35

Sims, John, 21–23

Sklar, Robert, 198

slapstick comedy, 34, 220

slavery, 122, 123, 129–133

Slavery in Old Africa, 129, 229, 233

Slaves of the Desert, 129

Smallwood, R. L., 156

Smith, Julian, 264n30, 266n58

social classes. *see* class boundaries

social interaction. *see* camaraderie and fellowship

social mobility, 57–59, 175–184, 187, 218, 224, 229

sociological transformations, 12

soldiers, 139, 140

solitariness. *see* alienation

sophistication and pretension, 207, 208, 217, 230
 "aristocratic element" in "art," 236n11
 art worship, 162, 210, 211
 City Lights, 32–37, 207–209
 Dada movement's attack on pretension, 260n22
 high theory and criticism, 3, 69–70, 207, 228–229
 "intelligentsia," 32
 Jonson and high culture, 152–155, 159–161
 keeping art "obscure," 155
 royal art patrons, 12
 Shakespeare and high culture, 147–150, 159–164
 see also accessibility of art; intellectualism

sound in pictures, introduction of, 5

souvenir program, 170, 222, 224

spaciousness, 54, 64, 65, 132–137, 206

The Spanish Tragedy (Kyd), 111, 237n26

speed of production, 6–7, 229, 230

Spufford, Margaret, 246n14

Stage, Kelly, 247n26–27

standardization, 17, 18, 37, 57, 96, 242n89

Stanwyck, Barbara, 67, 68

statues, 153, 154
 Citizen Kane, 169–171, 174, 175, 182, 188, 196
 City Lights, 208–212, 233
 statue-as-art *vs.* statue-as-fraud, 258n55
 The Winter's Tale, 162–164

status
 artistic status, 167, 168
 vs. amusement, 150
 see also sophistication and pretension

Steer, Valentia, 174

Stephens, Isabel, 241n89

Stern, Seymour, 248n6

Stern, Tiffany, 229

Stewart, Jimmy, 67, 92

Stockwood, John, 238n30

Stubbes, Philip, 97

stupidity as virtue, 67

Suber, Howard, 267n68

Sudgen, Edward, 249n15

suicide, 67, 69, 71, 87–91

Sullivan's Travels, 266n62

superficiality, 2, 68, 90, 110, 129, 221, 233

Swain, Mack, 200

Swan theater, 47–49, 55–66

swimming pool, photo, 114

Syracusian Antipholus, 99–104

Talbot, 48, 50, 245n7

talking pictures, introduction of, 5, 20

Talvacchia, Bette, 258n58

technological change, effect of, 5–11, 39

The Telegraph Trail, 133, 134, 137

Terry, Alice, 206

Thayer, C.G., 257n33

thievery, 53, 55–56, 60, 61

Thomas, Kevin, 68

Thomson, David, 217, 218, 227

"Tinee, Mae," 21, 117

Toles, George, 83

totalitarianism, 16, 39, 51, 69, 85, 253n7

Totheroh, Rollie, 200

Trahair, Lisa, 203

the Tramp, 32–37, 203, 204, 218
 explanation of, 220
 photo, 33, 36

translation of class languages, 58, 63, 74

trash, art *vs.*, 19, 32–37, 41, 42

The Travails of the Three English Brothers, 239n55

Treatise (Northbrooke), 96

A Tree Is a Tree, 21

trivialization, 19, 32–37, 168, 177, 189

Troilus and Cressida, 14, 47

Truffaut, François, 198, 202

Turner, James, 258n58

Turvey, Malcolm, 263n28

type, movable. *see* print production

Uncle Tom's Cabin, 129, 133

uncommon *vs.* common man, 72, 77, 91

Ungerer, Gustav, 247n34

unity of production, director's responsibility, 220–222

unity of time and place, 19

"the universal Average Man," 248n6

Urban, Joseph, 166–168
utopian *vs.* dystopian accounts of masses, 51–66

The Vagabond, 36
van Buchell, Aernout, 49
Variety magazine, 68
Vaughan, William, 246n15
Vidor, King, 20–22, 24
Vineberg, Steve, 68
violence in theaters, 13
Virgil, 12
virtue, all-or-nothing theory, 63
visual *vs.* verbal representation, 235n2
Vivian, 119, 126, 129, 130, 228–233
vulgarity or lewdness, 13–15, 41, 107, 152–154,
 158, 202
 coarseness in printed plays as learned,
 classicizing feature, 256n18
 "community" as "baseness, vulgarity," 251n30
 eroticism/sexual attraction, 208–209
 The Roaring Girl, 52–66

wages of "common player," 13
war as sport, 105
Ward, Richard, 43, 207
Warner, Jack, 3
Warshow, Robert, 217, 219, 227, 265n47
water ballet, photos, 112, 114, 115
"waterfall" number, 112, 113, 116–118,
 128, 133, 141
Wayne, John, 133, 134
Weber, Samuel, 245n10
Webster, John, 40, 150, 151
Weever, Thomas, 5
Weimann, Robert, 235n3
Welles, Orson, 165–171, 189, 190, 203, 220–226
 compared to Charlie Chaplin, 224
 egotism, 226
 one-man, one-film auteur model, 222–223
 photo, 223, 224
 "the greatest loser," 226
West, Nathanael, 32
Weston, William, 246n14
What You Will (Marston), 14
Whissel, Kristen, 259n21

White, Eric, 19
White, William Allen, 14, 166, 241n84
The White Devil (Webster), 150, 151
Williams, Linda, 241n80
Willoughby, Long John, 68–71, 74–77, 79,
 81–87, 90, 92
The Winter's Tale, 42, 153, 158–164, 174, 233
Witt, Johannes de, 47–52
Wolfe, Charles, 250n34
Womack, Peter, 158, 164, 257n37
A Woman of Paris, 200
Wonder Bar, 129, 130
Woollcott, Alexander, 32
work
 arbitrariness of distinction between work and
 idleness, 106
 assimilation of entertainment and work, 24
 assimilation of worker and machine, 96
 distractions for workers, creating, 229
 diversion from, 95–112
 division of labor, 222
 double consciousness of play world and real
 world, 136, 137
 erosion of distinction between work and
 leisure, 97, 98, 106
 excessive labor of show business, 40–41,
 119–121
 The Jazz Singer, 20, 24–32, 40
 play-going as profession, 40, 110–111
 play-work mode of characters, 98
 professionalization of acting, 39, 96–99,
 101, 106–110
 royal distinction lost with incessant labor, 109
 Sabbath, working on, 251n3
 vs. leisure, *see* idleness and leisure
 workaholism, 40, 41, 119–120, 131
 see also "play-work"
Work and Play on the Shakespearean Stage
 (Rutter), 97
Works (Jonson), 40, 152

Ziegfeld Follies, 166
Žižek, Slavoj, 217
Zukor, Adolph, 166
Zweig, Stefan, 17